THE A-Z OF ROCK 'N' ROLL

Terry O'Neill

ACC EDITIONS

Edited by Robin Morgan
Design direction by Stephen Reid

TERRY O'NEILL'S
ROCK 'N' ROLL ALBUM

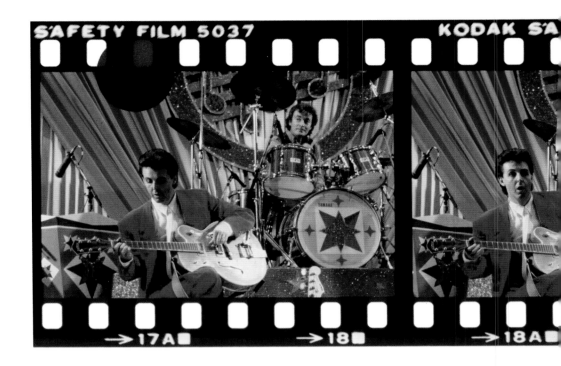

In 2008, I spent a week with the late, great Nelson Mandela, a man who moved me immensely with his charm and grace. It was his 90th birthday and the world was paying homage to him in London. Presidents, prime minsters, Hollywood stars and music greats attended upon him — he was royalty on the world stage, a man who stood for something that brought out the best in all of us — an appreciation of greatness and humility.

There was to be a dinner and concert in his honour. I was invited to chronicle the event, in private and public. It kind of summed up my entire life. It was the first time it really struck that I had been enormously lucky to be in the right place, at the right time and witness extraordinary people in extraordinary times.

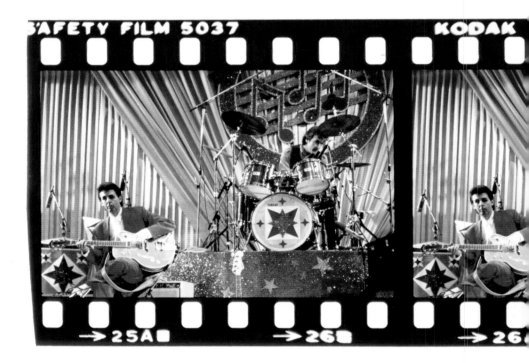

For more than 50 years I have been given a front-row seat to photograph the most iconic people of our times: from my first big stroke of luck, picking a young, unknown band called The Beatles to photograph in 1963, to sitting in the Dorchester hotel with Mr Mandela in his private suite, chatting with the likes of Bill Clinton.

The night of the concert in his honour Amy Winehouse was driven from hospital, where she'd been in rehab, to sing for him. I persuaded her to pose for a few shots before she went on stage.

For some years I'd thought there was nobody left who I wanted to photograph. I'd become very disillusioned as the age of celebrity became this commercial circus. I'd almost given up taking photographs, because famous people now had managers and lawyers and publicists who wouldn't let photographers take pictures unless they controlled the images that the public were allowed to see.

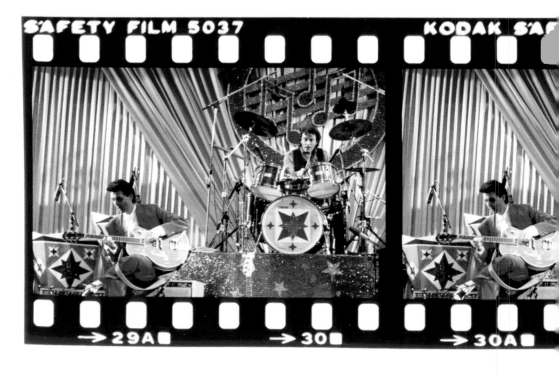

The digital age meant management wanted photographs to be manipulated by computer technicians to make the subjects look better. Models were slimmed down and given better bodies, actresses' portraits were Photoshopped to plump-up lips and breasts, to soften wrinkles or lengthen legs. Their heads were being superimposed on body doubles.

Management would insist photographers signed contracts, giving away control of their work and placing it in the hands of lawyers and publicity managers, who wanted faked images.

The honesty and integrity of photographing the famous and infamous was not only compromised, it was fraudulent. I didn't want any part of it any more.

Photographers became part of a marketing and advertising machine. I always felt it was my job to take photographs that told

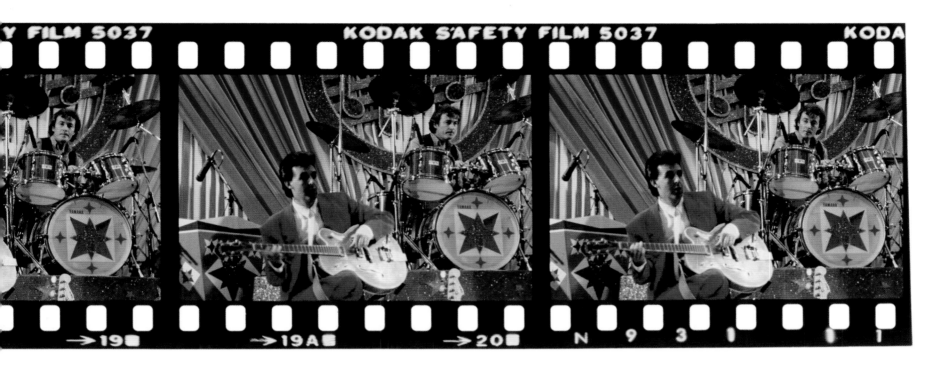

"When it comes to photographic legends, there can be few more prolific or revered than Terry O'Neill, the man who shot the greats"

a story. I always felt that the stars and their management weren't the boss. It was the people who bought tickets to the cinema or theatre or concerts, who paid good, hard-earned money for records or books.

I thought back to the days when The Rolling Stones, an unknown band in 1963, asked me to help them get noticed. I photographed them all over London. They came to me, because I was too busy to go to them. I remember when I walked up to Frank Sinatra in Miami, then in 1967 the biggest star in the world, and introduced myself. I spent the next three weeks photographing him in private and backstage. I could take pictures of him anywhere after that, and did so for the next 30 years. Nobody ever asked me to sign a contract, to stop taking pictures, to hand over my film or tear up a print.

Photographing Nelson Mandela and Amy Winehouse that night persuaded me that there were still people in this world, among the famous, talented, gifted people, who hadn't sold

out, who were honest enough to understand that a photographer was there to represent and inform the audience, not advertise an image.

When I looked at the thousands of photographs I took that week, one of Mr Mandela reading his newspaper with his glasses perched on the end of his nose and another, a portrait of Amy, stood out. And someone said to me — do you realise you've photographed everyone from Winston Churchill to Nelson Mandela; John F. Kennedy to Tony Blair? You've photographed Elvis, The Beatles and Amy Winehouse; Elizabeth Taylor, Audrey Hepburn and Nicole Kidman. It was the first time I really stopped to think about how long I'd been photographing famous people.

The result was that I spent three years going through my negatives — there are millions. They were all stored in cardboard boxes. I was approached to do a book of my life's work, I call it the Opus. I was stunned when it sold out in four months and had to be reprinted. And then I realised how much I'd left out.

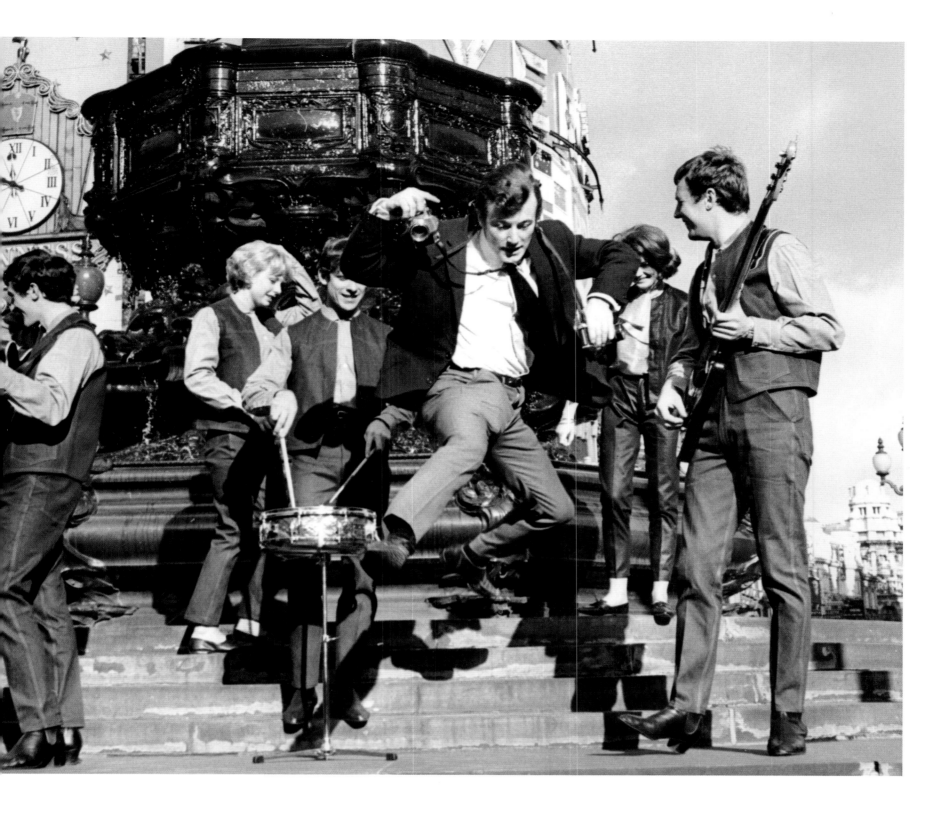

I'd selected hundreds of pages of pictures and there were still thousands of amazing images, spanning 50 years. So many were of the great musicians, rock stars and pop stars of our age, that I was asked to go back through the archive again and do a rock 'n' roll book.

I struggled with this. If I do a book on rock 'n' roll. How can I include Frank Sinatra's jazz, or Diana Ross's soul, or Joan Baez's folk? They all deserved to be in a book about music — even the Osmonds. But the more I thought about this, the more I realised it was okay to include people not immediately identifiable with our image of sex, drugs and rock 'n' roll.

Rock 'n' roll is not just about the act and the music, it's about inspiration. Where would rock 'n' roll be without jazz? Where would pop be without rhythm and blues? If Freddie Mercury can duet with Montserrat Caballé the great opera diva, if Sting can make an album with the great contemporary jazz musicians, if Paul McCartney can write a symphony, if Amy Winehouse can

sing for Mandela, why can't my rock 'n' roll book cover the universe of music? Any great rocker will tell you how much they admire Frank Sinatra or Roy Orbison. Is there any great rock 'n' roll band out there who hasn't written a ballad or love song those men could have crooned? Take it from me, Frank Sinatra or Tom Jones could have belted out Born to Run with Springsteen if they'd wanted to.

Rock 'n' roll isn't just about riffs and amplified electric guitar. It isn't just Hendrix. It's a genre of popular music that encompasses passion, expression and exploration. Rock 'n' roll is the language of youth, the voice of the post-war generations. It's blues, jazz, country, gospel, pop and folk, rocked and rolled over decades.

So, as you leaf through the pages of this book, don't be surprised to find Shirley Bassey up there with Janis Joplin or Tina Turner. Don't be surprised to find David Cassidy after David Bowie. Don't be shocked that Engelbert Humperdinck is in here with Led Zeppelin. They all rocked us, we all rolled with them ■

TO' 060990 R

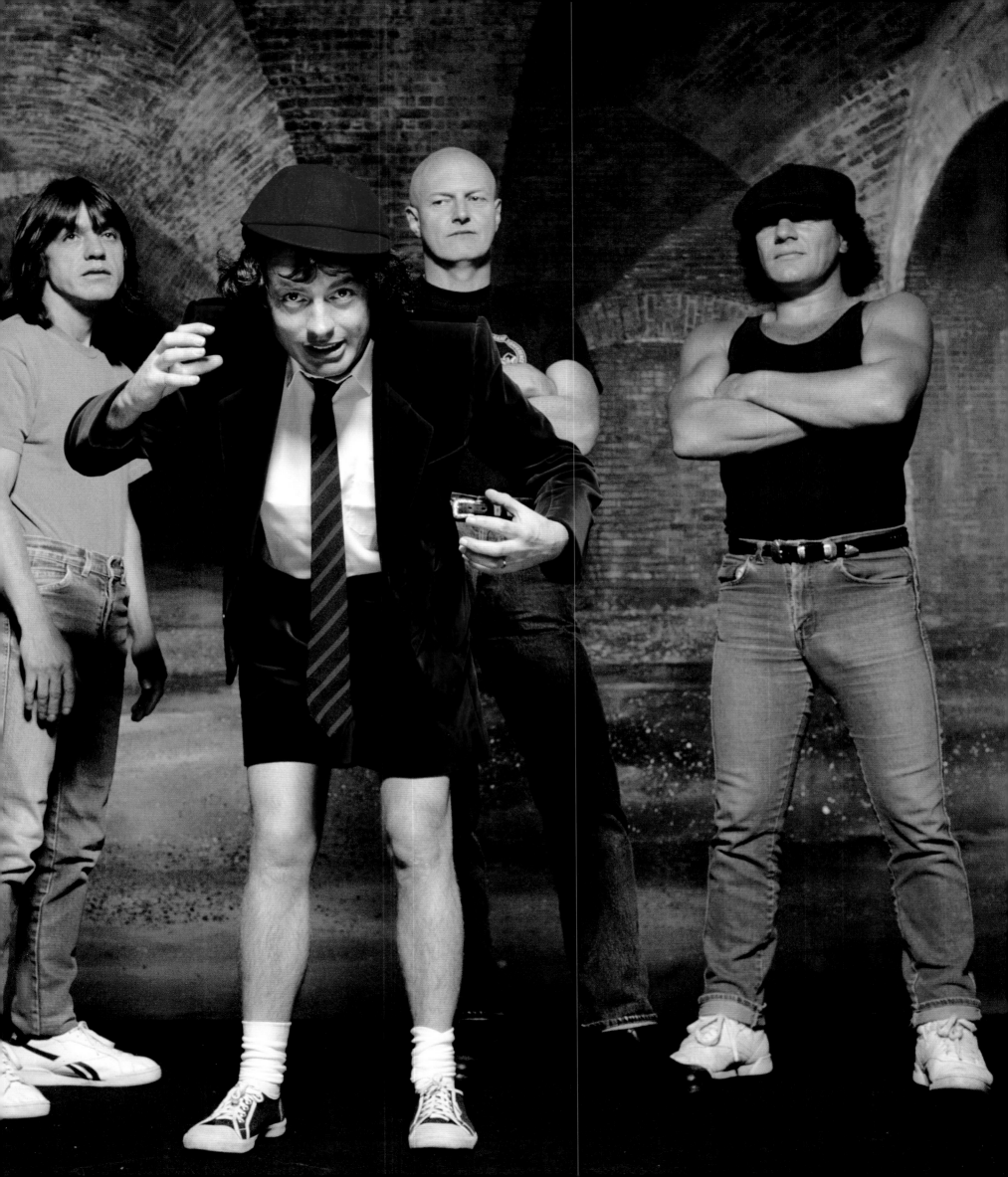

Musicians involved in Live Aid, 1985

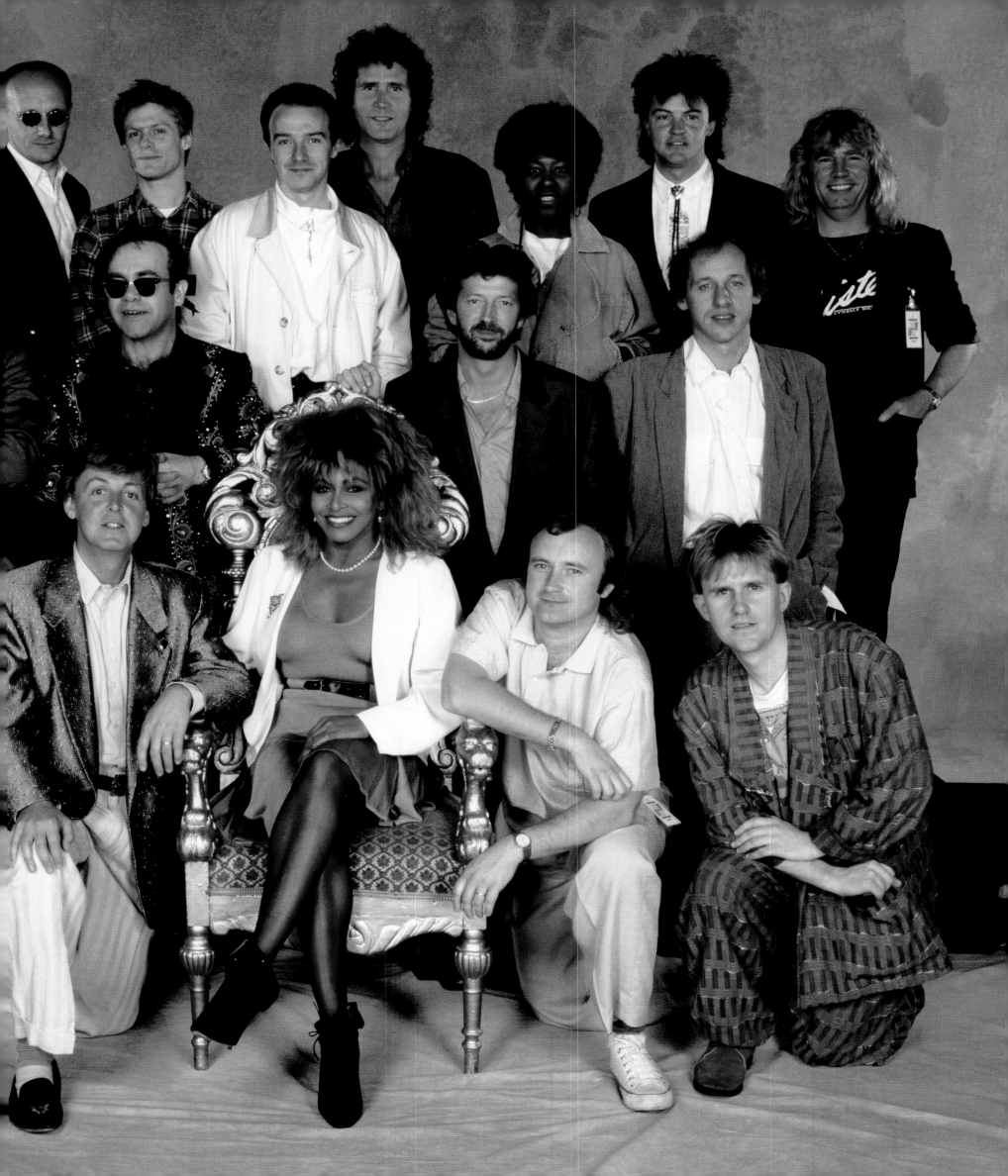

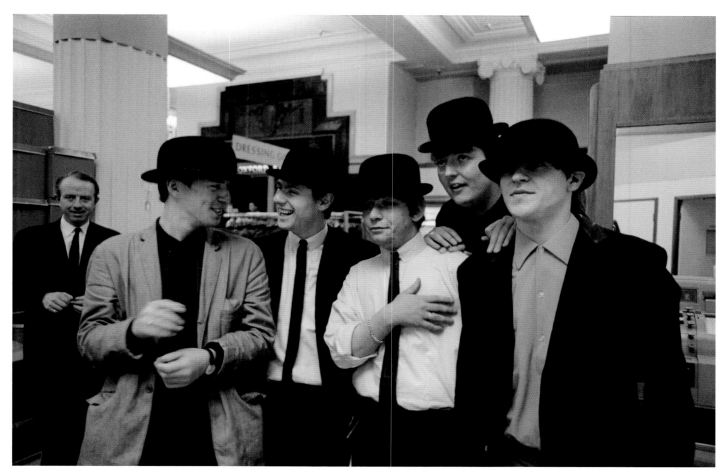

"I heard about this band The Animals coming to London from Newcastle," says Terry. "I took them shopping first, then to a studio, because they didn't look the business. They looked like labourers"

THE ANIMALS

I remember this Newcastle band called The Animals getting off the train in London in 1963. I had just put The Beatles on the front page of a newspaper and I'd photographed The Rolling Stones to get them noticed. I was looking for new talent.

When I met The Animals at the station they were wearing working-men's clothes. They were just working-class lads from a town famous for coal and ship-building. The first thing I did was to take them shopping.

It was funny — they fooled around trying on bowler hats and looking at suits, but they weren't interested in changing their style. They only thing they shared with us in London was a love of rock.

They were appearing in a club in Soho, the Scene, where a band called The Yardbirds — featuring a very young guitarist called Eric Clapton — was playing. The club owners did a swap. The Yardbirds went north for a few gigs and The Animals came south.

I took the band to a studio to photograph them, but they played so loud we were thrown out. This was a cutting-edge time, when the Sixties really began. The Beatles had just exploded into the charts. The Rolling Stones were a struggling band, but new television shows for young people needed talent. Record producers and music publishers were all looking for bands like The Beatles, hoping to emulate their sudden success.

The Animals had a unique sound, they were wild, hard men — they were bouncing all over the stage, unlike the other bands of the day who stood still, smiled and wore suits. In London, they were spotted by the record producer Mickie Most. He recorded 'House of the Rising Sun' with them in early 1964 ∎

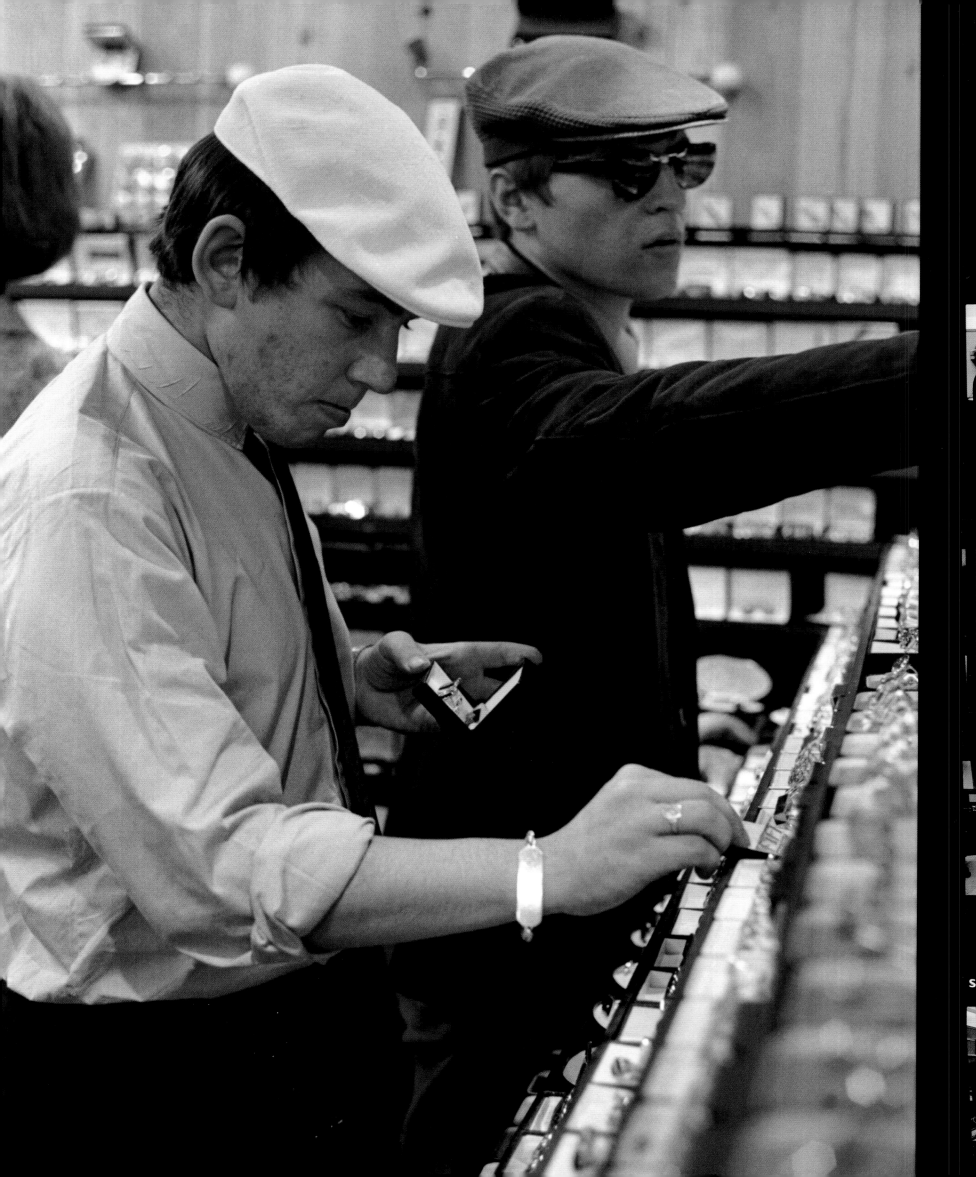

8A 9 9A 10 10A 11 11A 12 12A

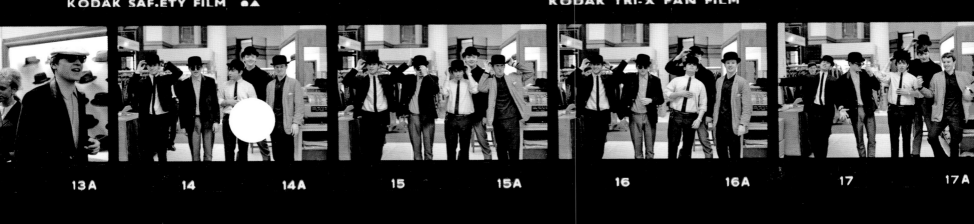

13A 14 14A 15 15A 16 16A 17 17A

22 21A 21 20A 20 19A 19 18A 18

23A 24 24A 25 25A 26 26A 27 27A

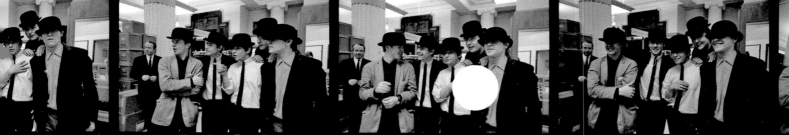

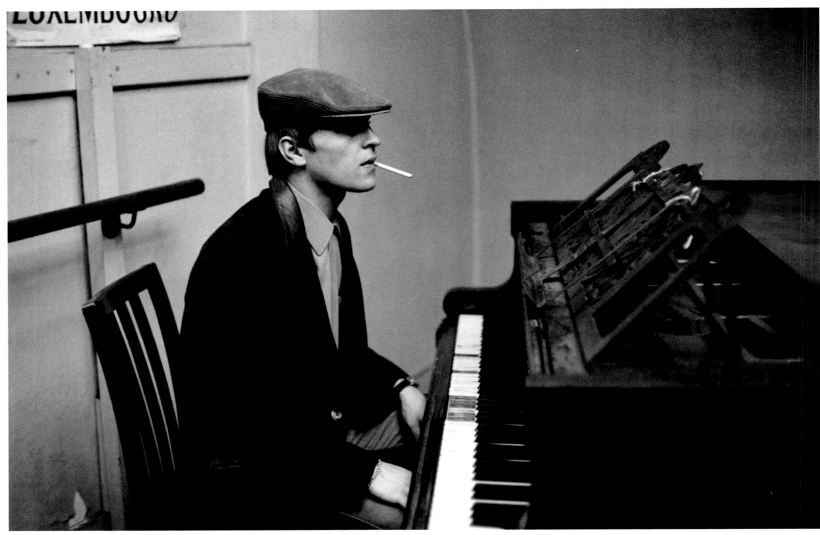

The Animals frontman, Eric Burdon, contemplates the piano

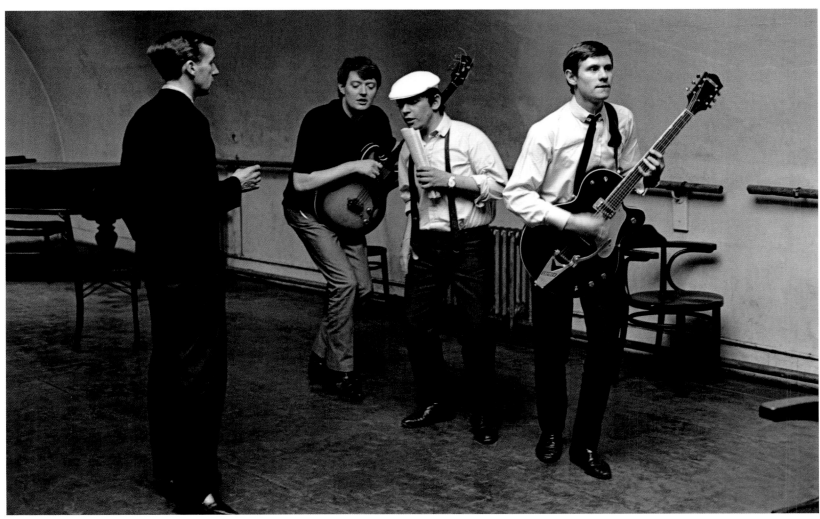

"I took the band to a studio to photograph them, but they played so loud we were thrown out," remembers Terry

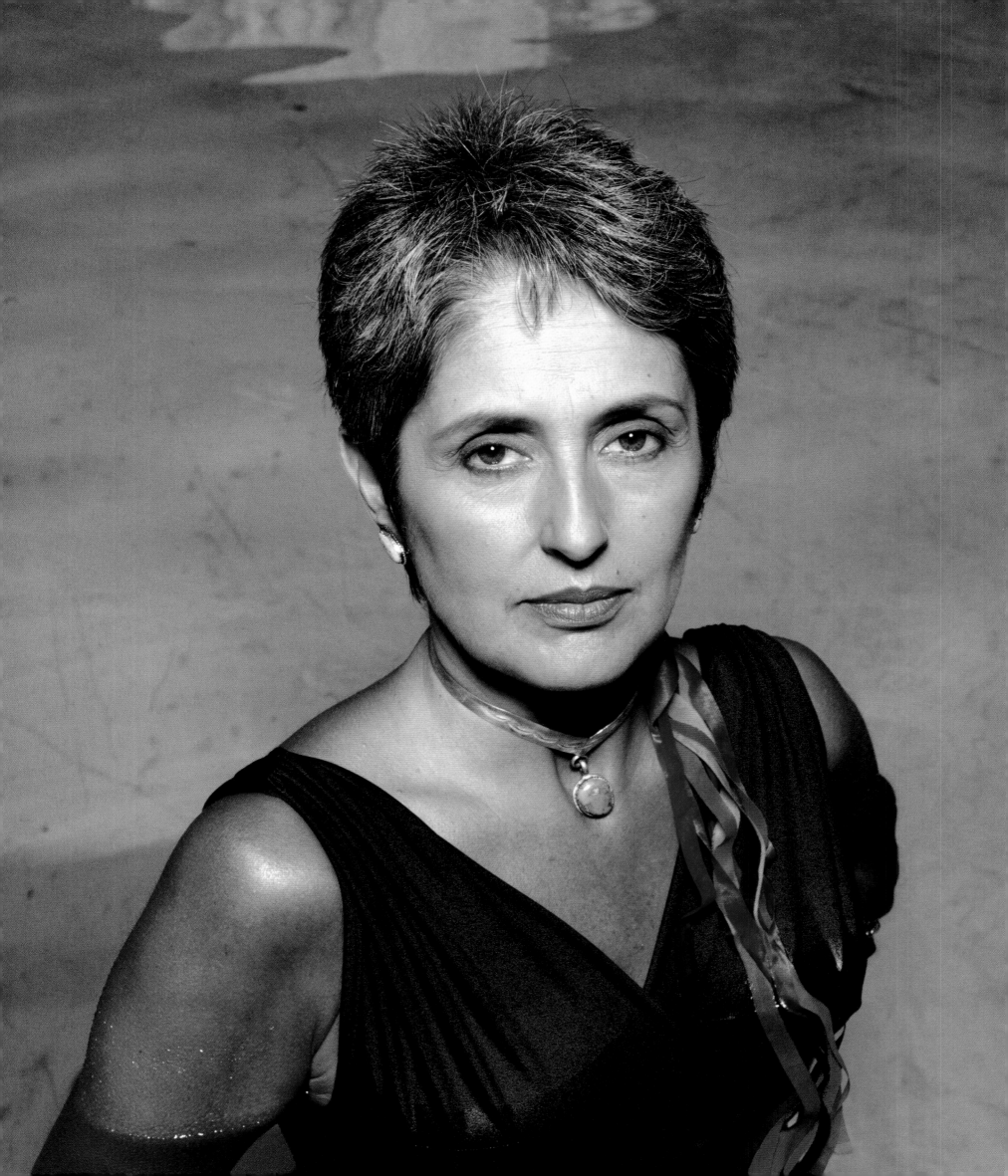

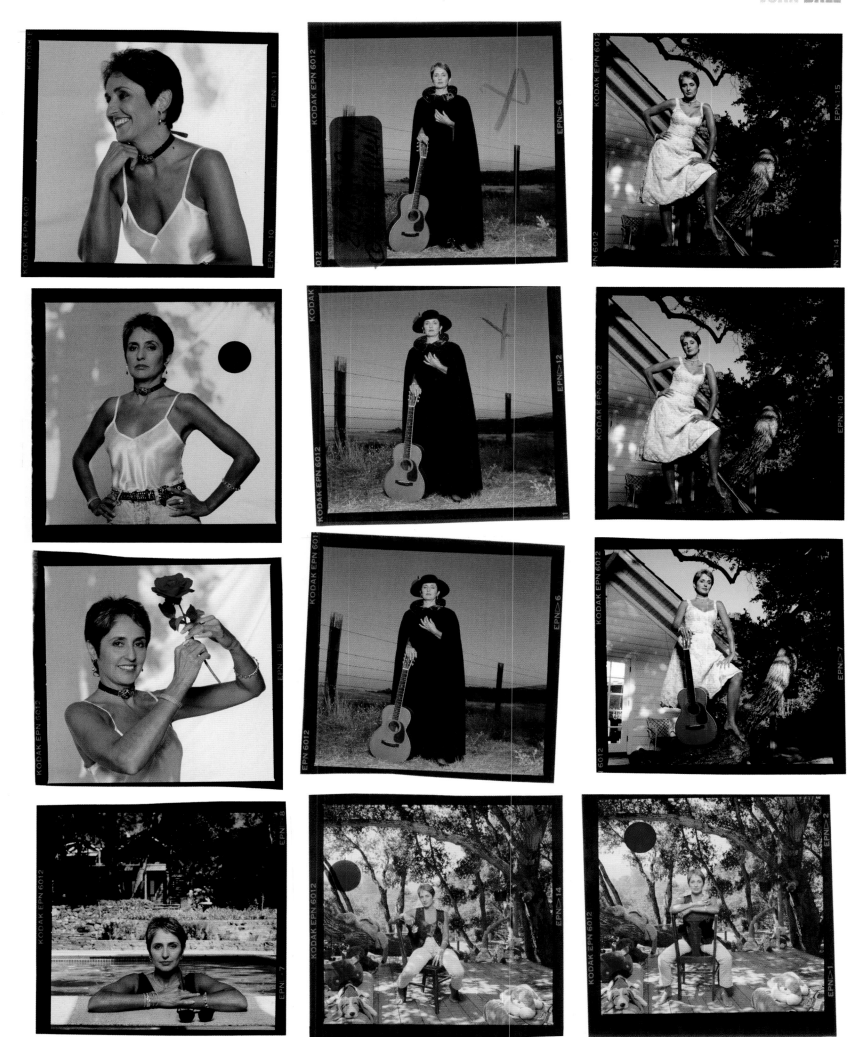

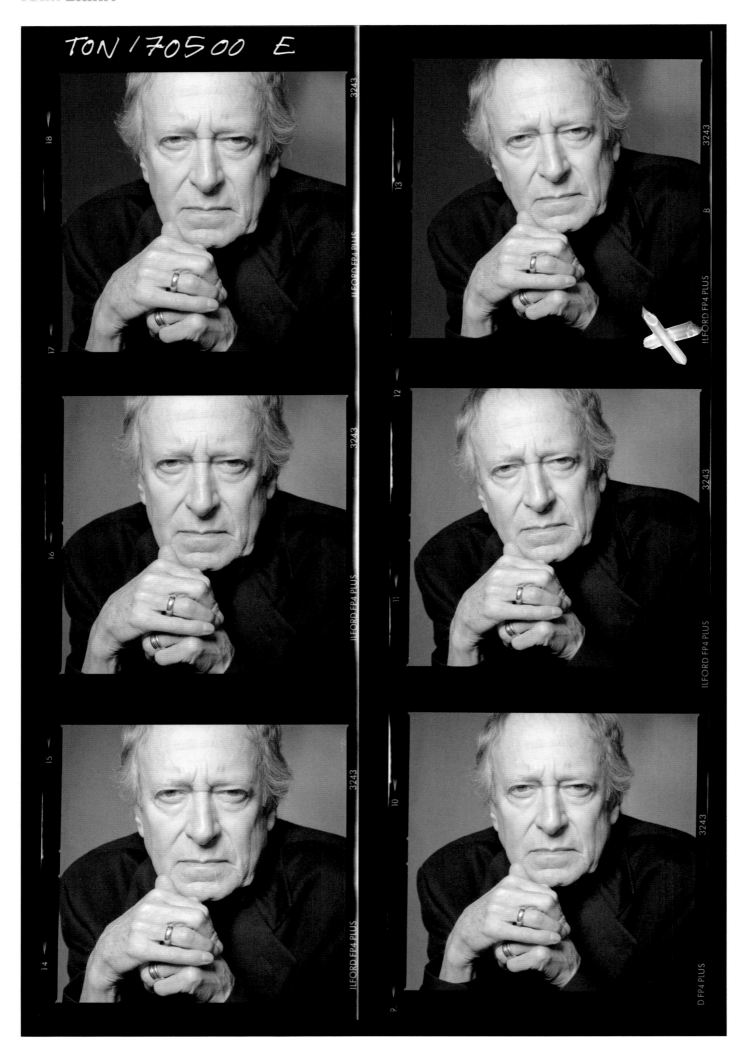

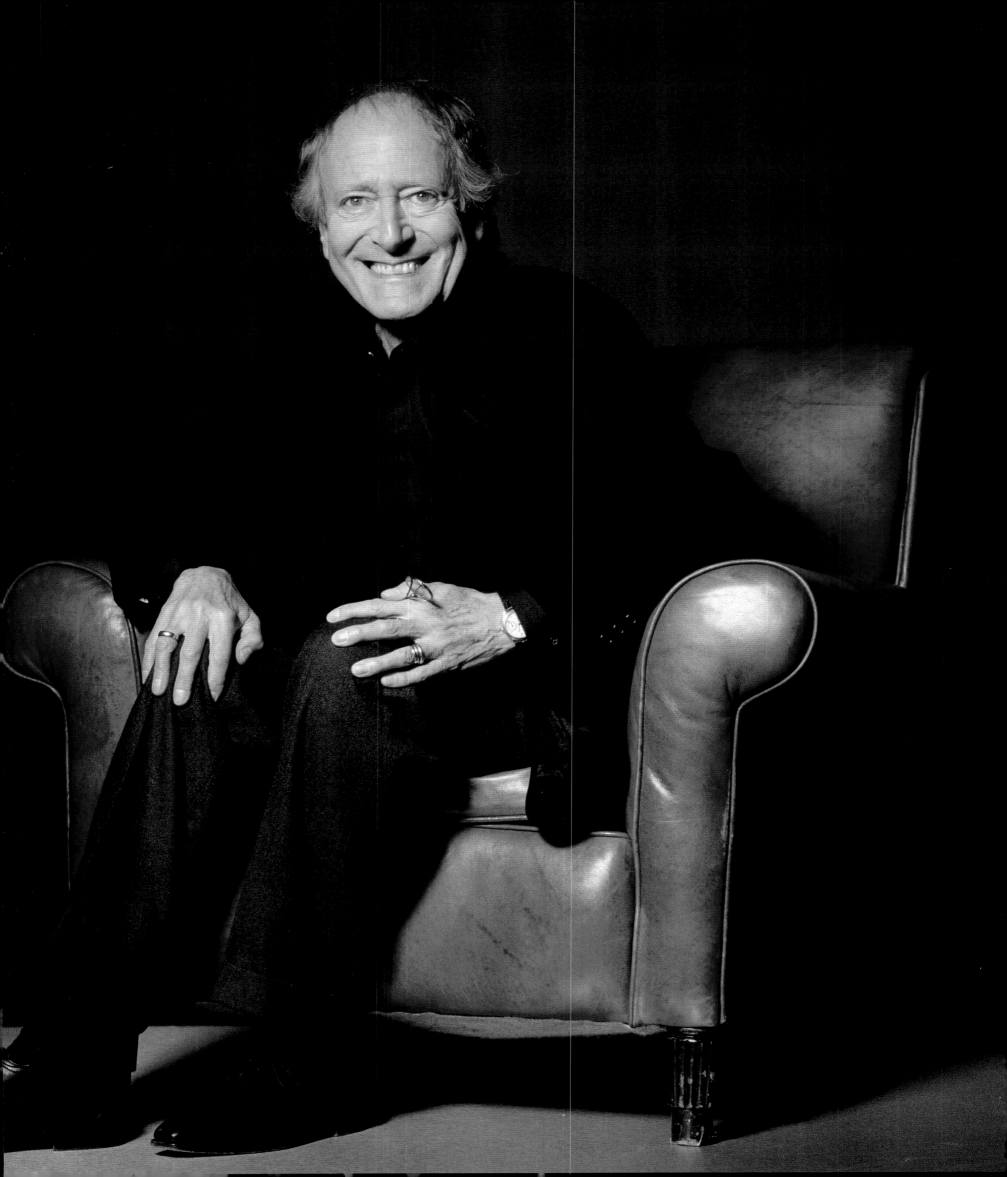

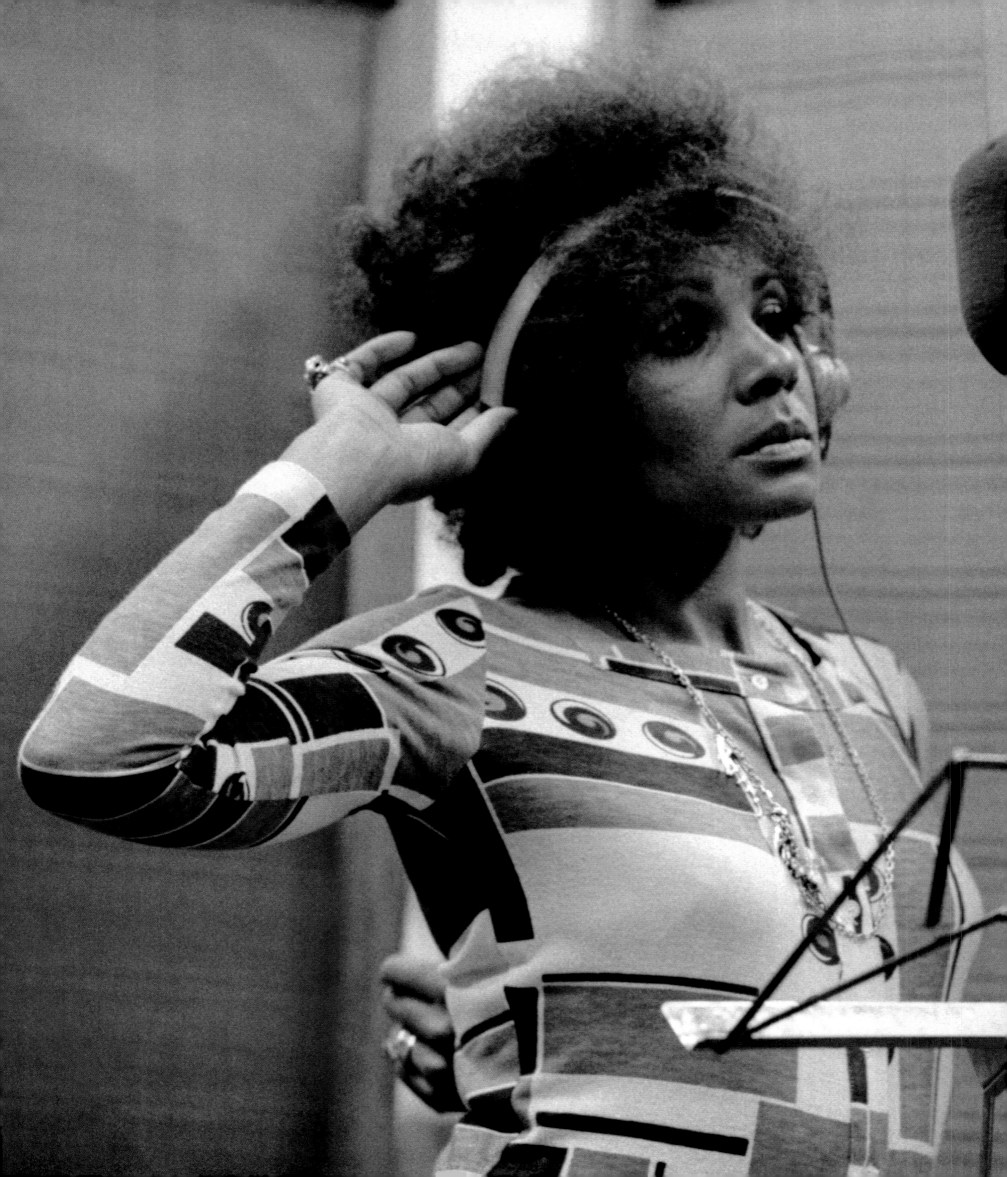

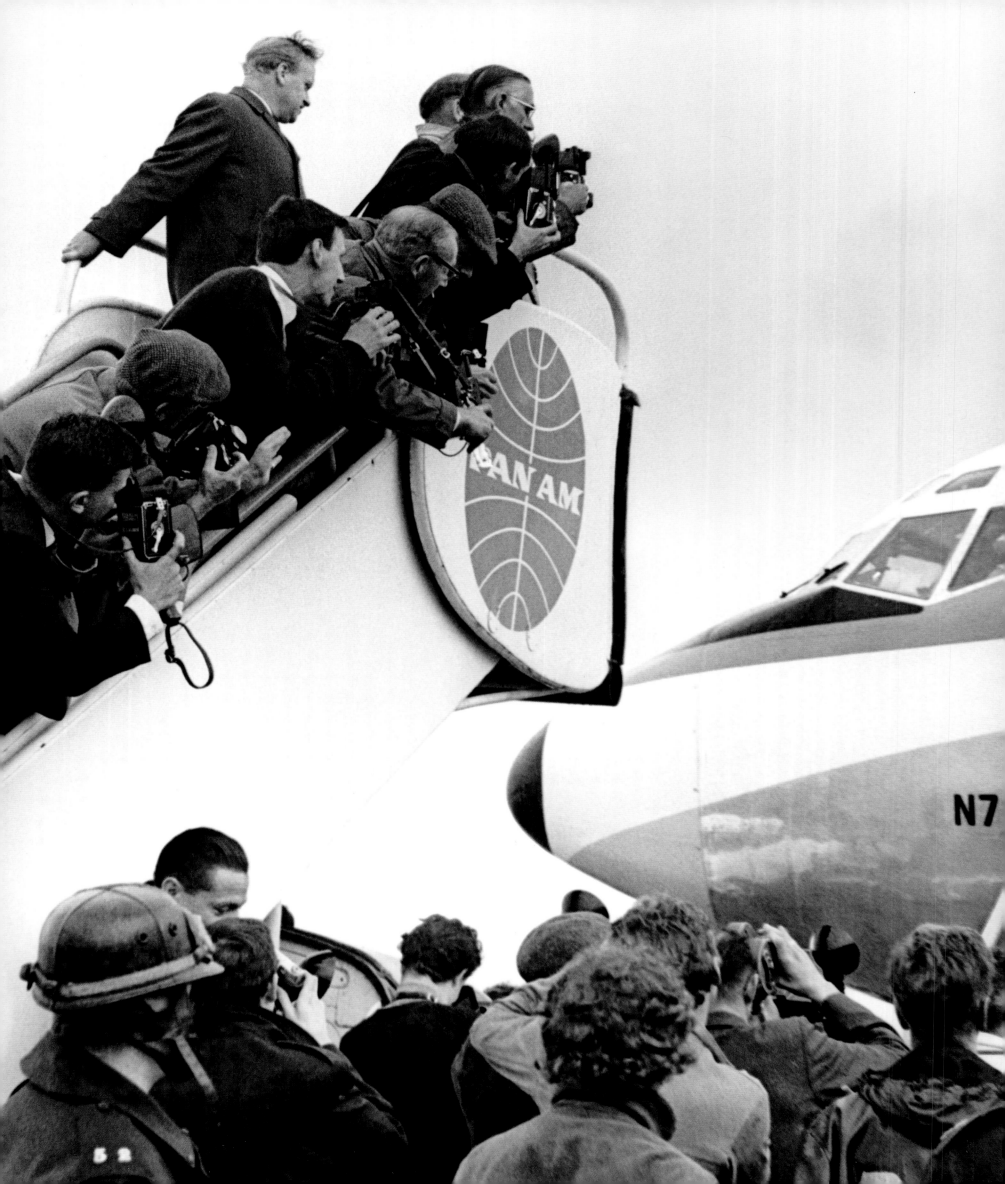

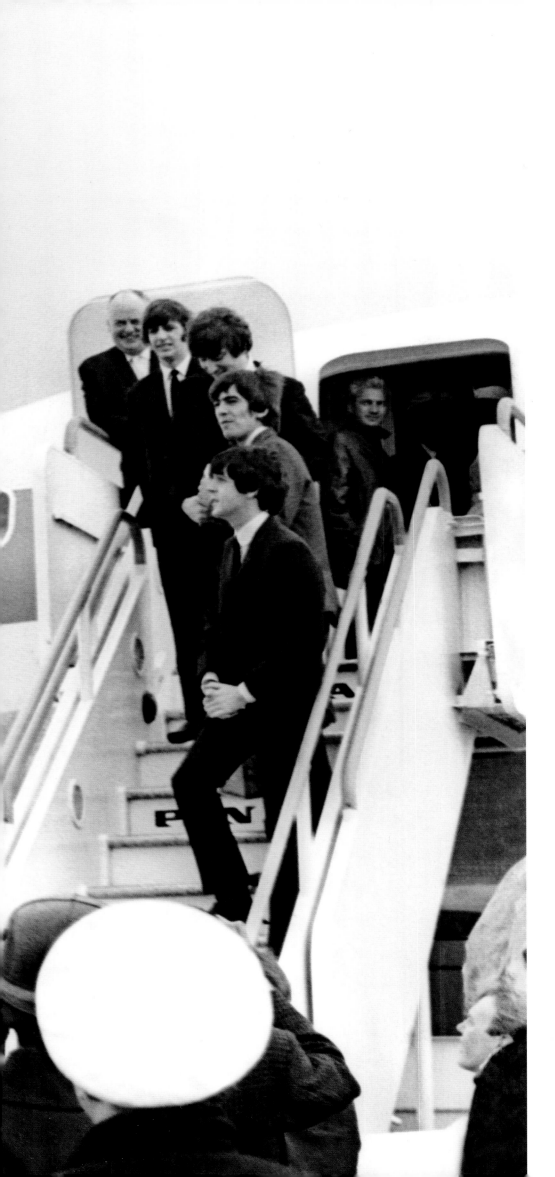

*"The Beatles just seemed to sum up
the changing mood of the times.
They had hair that was long for
the day, and their clothes were
smart, but relaxed, almost casual"*

THE BEATLES

In February 1964, I was at Heathrow photographing The Beatles getting on a plane to New York. Thousands of girls lined the airport buildings, hundreds of photographers were there to see them off. It's incredible that only a year earlier they were virtually unknown outside Liverpool, even in London.

In late 1962, there had been a buzz in the air. Times were changing. Young men were no longer being conscripted into the army, compulsory national service had ended and kids suddenly had the freedom to explore their identity. There was prosperity. Young people had money and jobs — they were beginning to show their independence in the ways they dressed, looked and spent their money.

Clubs and coffee bars had opened for them and all over Britain young men were starting bands instead of working in banks, offices or factories. Girls were showing an interest in clothes and hairstyles, instead of dressing like their mothers. The boys too, were experimenting, buying cheap mohair suits made in the Italian style.

An editor asked me to photograph the emerging youth culture. I'd heard about this band in a studio called Abbey Road. They had come down from Liverpool to make a record. You have to remember that at this time, music was all about Sinatra and Elvis, basically a solo act with a backing group. A group of boys with guitars and drums banging out rock 'n' roll was something quite new.

I took a taxi to the Abbey Road studios and found this group calling themselves The Beatles. They were lads, rough and ready, joking and laughing and jamming. They just seemed to sum up the changing mood of the times. They had hair that was long for the day, and their clothes were smart, but relaxed, almost casual.

They were recording a song and an album called *Please Please Me.* I photographed them in the studio and took the pictures back to the newspaper.

They sat in the editor's in-tray for a while, but one day there were no train crashes or wars or sensational trials to put on the

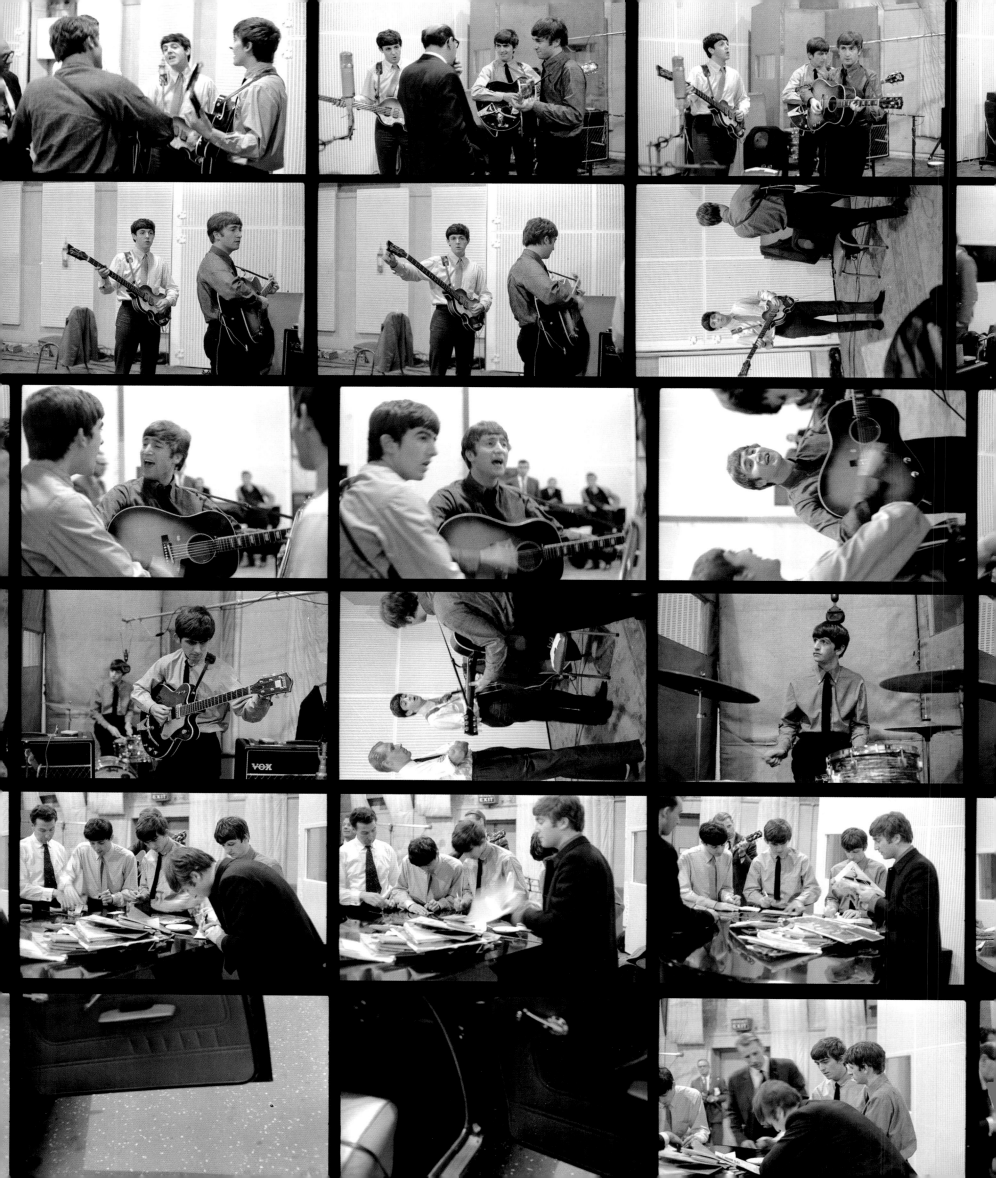

Terry first photographed The Beatles
when they were recording the song
and album *Please Please Me*

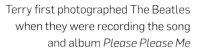

front page, so he put The Beatles on it — and there was this amazing response. The newspaper sold out.

It was a revelation — young people had bought the paper because a young unknown band was on the front page. A few weeks later the record was released and it went straight to No 1 in the charts. This was February 1963.

Within weeks, they were the biggest news in Britain; within months the biggest news anywhere in the world — and the Sixties took off. Suddenly working-class lads like The Beatles were everywhere — they were actors like Michael Caine, Terence Stamp and Albert Finney; they were photographers like me and David Bailey, they were fashion icons like Vidal Sassoon.

Within a year, the world turned upside down. Jean Shrimpton, a willowy, coltish girl, became the world's first supermodel, the miniskirt and contraceptive pill became available, and The Beatles were the messiahs of this golden age.

They'd gone from obscurity in a Liverpool basement to playing to 73 million Americans on the Ed Sullivan Show — in a year. When I first photographed them they weren't allowed to play on the BBC, but 12 months later they had an invitation to the White House and Buckingham Palace. Thousands of girls would line the streets screaming hysterically to catch a glimpse of them as they arrived at a stage door.

Today people realise that this was one of those great moments in history when the world changes. Before 1963, young people weren't considered important — they were fodder for the factory, the office or war. But after 1963, young people couldn't be ignored. Culturally, politically, commercially — they were a force. They had money, they had votes, they had opinions. Politicians wanted to be photographed with bands like The Beatles so they would appear "with it".

Television produced shows specifically for young people, even cinema realised there was a demographic they couldn't ignore

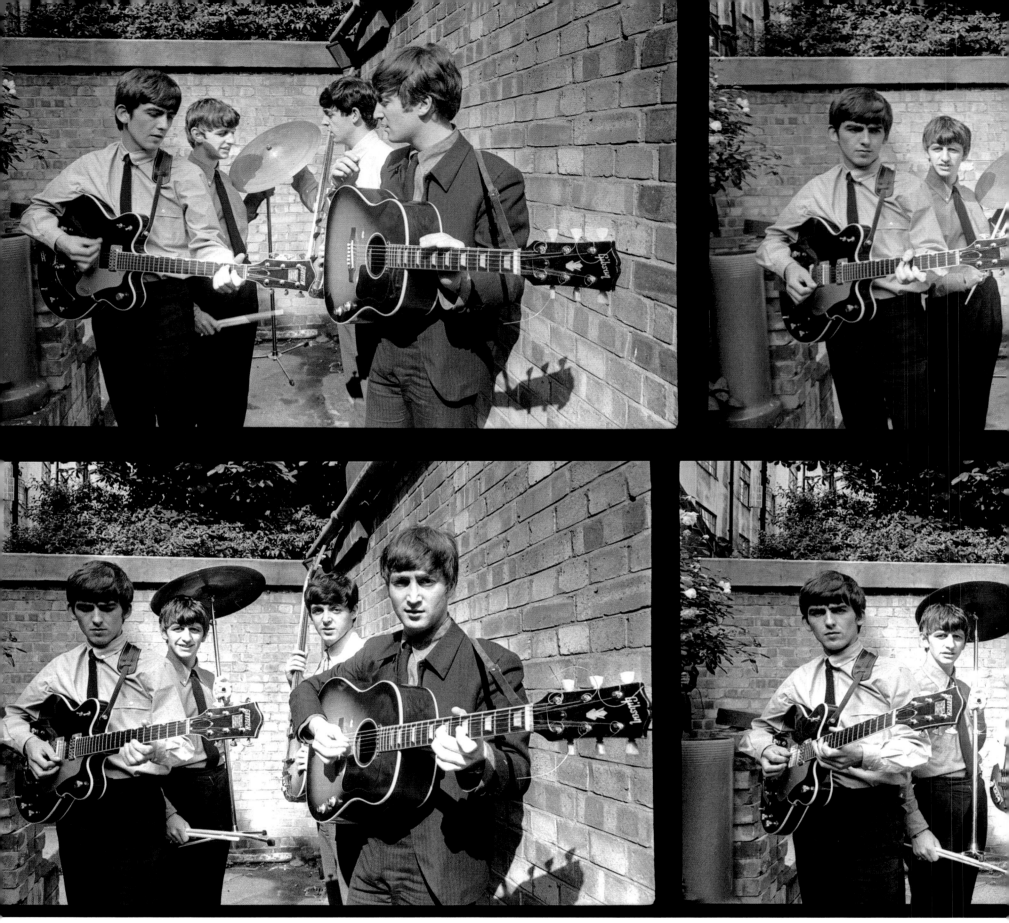

The Beatles at Abbey Road

anymore. The Beatles were making their film, *A Hard Day's Night*, when I photographed them a year after our first meeting.

When they arrived in the USA, there were 1,500 young girls screaming for them at the airport. Hundreds of newspaper reporters were poking fun at their "long hair", asking them if they had problems with dandruff. They didn't take The Beatles seriously and were very disrespectful. The Beatles to them were just a new circus-act in town. Only *Time Magazine* realised at that point what was happening. It wrote: "Olympian disdain masked simple ignor-

ance. The revolution had already been fought and won. The Beatles came, were seen, and conquered. If they could make it here, they could make it everywhere, and what they made was history."

American *Vogue* later called it a "Youthquake" — and the epicentre was Britain: the music, the fashion. I didn't realise at the time that I was part of that history. We were just young guys and girls hanging out together, thinking it was one big party. They were really very innocent and naive days. People got married at 21 or 22 and settled down. You were supposed to be a virgin when

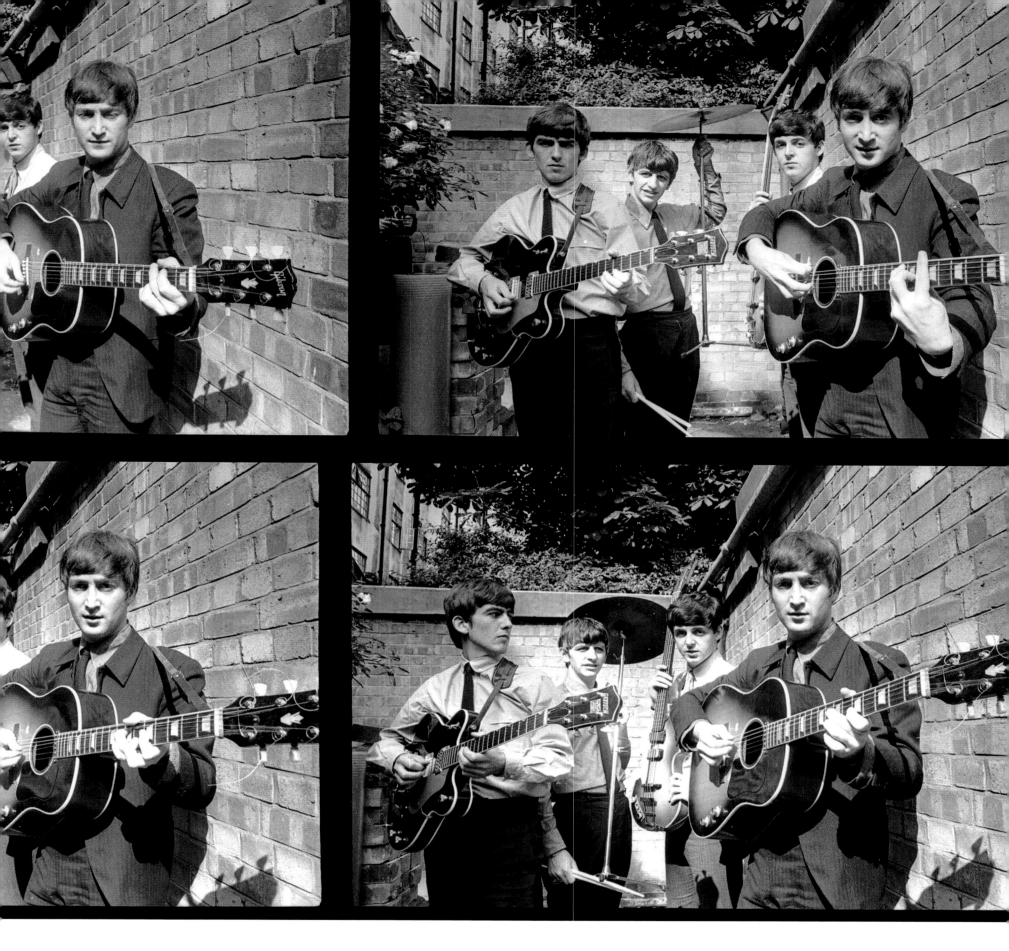

you wed. None of us had heard of drugs like cannabis or cocaine.

John and Paul were a great double act, not just on stage. Off stage they were clever young hustlers. John had the irony and Paul had the charm. They were nobody's fools. George was a brilliant musician, but quite shy. Ringo was new to the band in 1963 and deserves a lot of credit. Before The Beatles got their big break he had been a drummer with a more successful band in Liverpool and the truth is their music improved when he joined them. His drumming gave them a foundation that impressed the great producer Sir George Martin, who hadn't been very impressed when he first heard them without Ringo.

We stayed friends. I photographed Ringo's wedding to Barbara Bach, a Bond Girl and model. I photographed Paul and Linda McCartney when they formed Wings, and George, years later, when he'd become a major solo artist.

We all look back on those days and miss the camaraderie and romance. We were so young, immersed in the rollercoaster ride. We didn't realise that it would take over the rest of our lives ∎

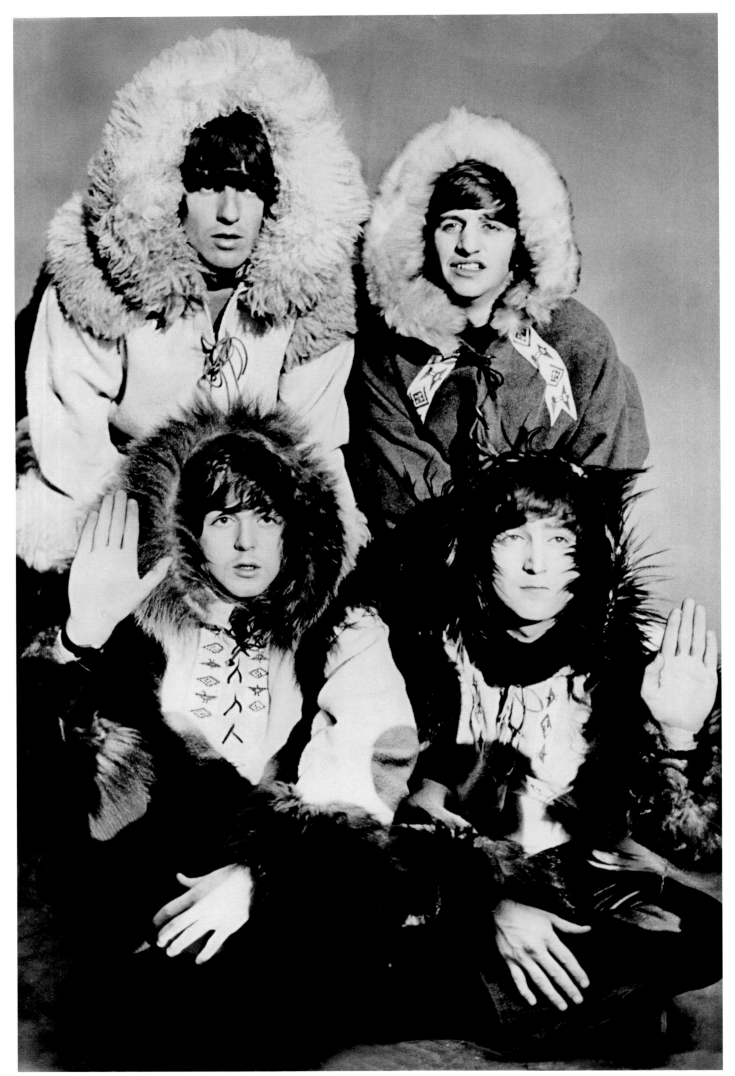

Dressed in Inuit costumes during rehearsals for *Another Christmas* at Hammersmith Odeon, 1964

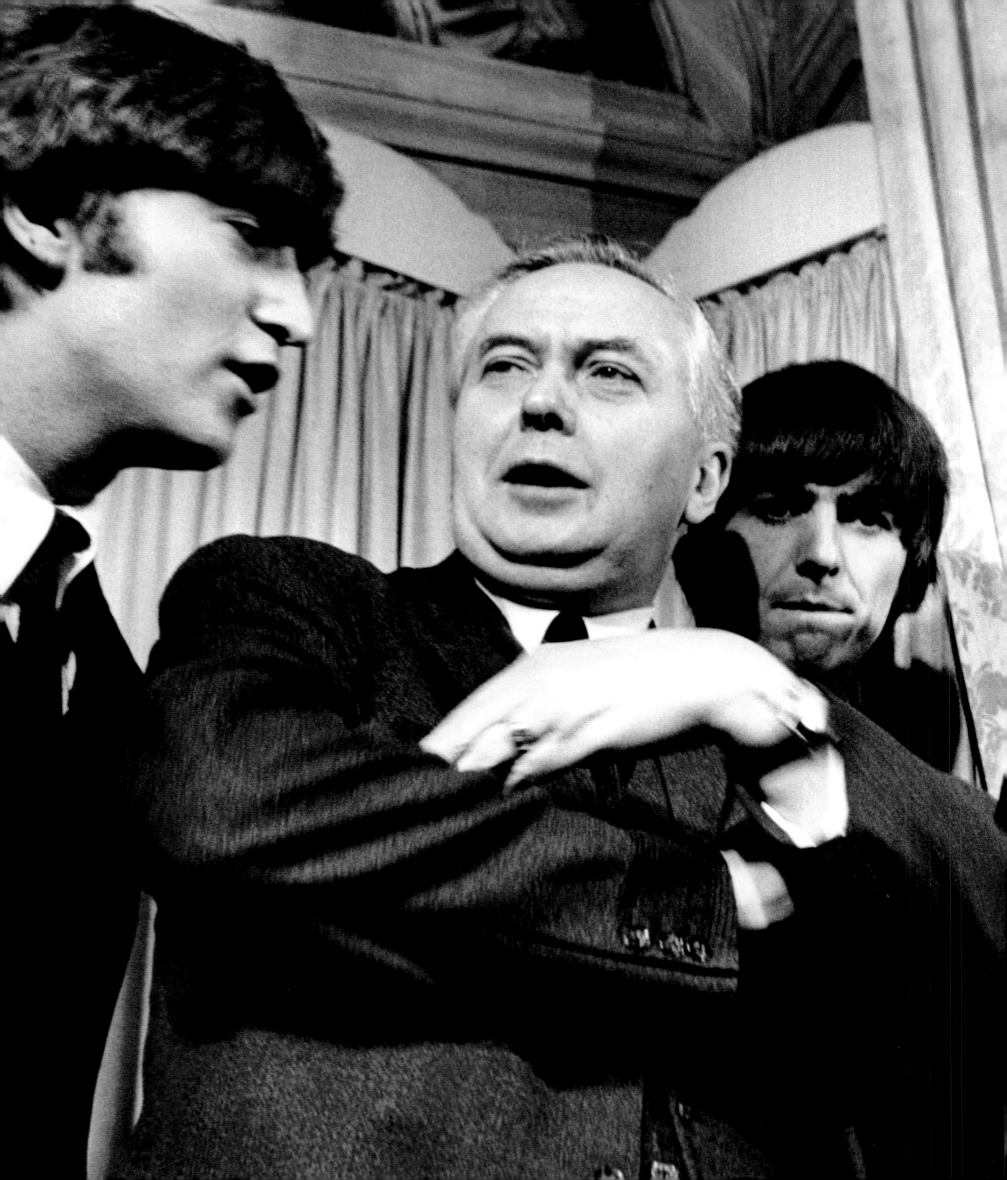

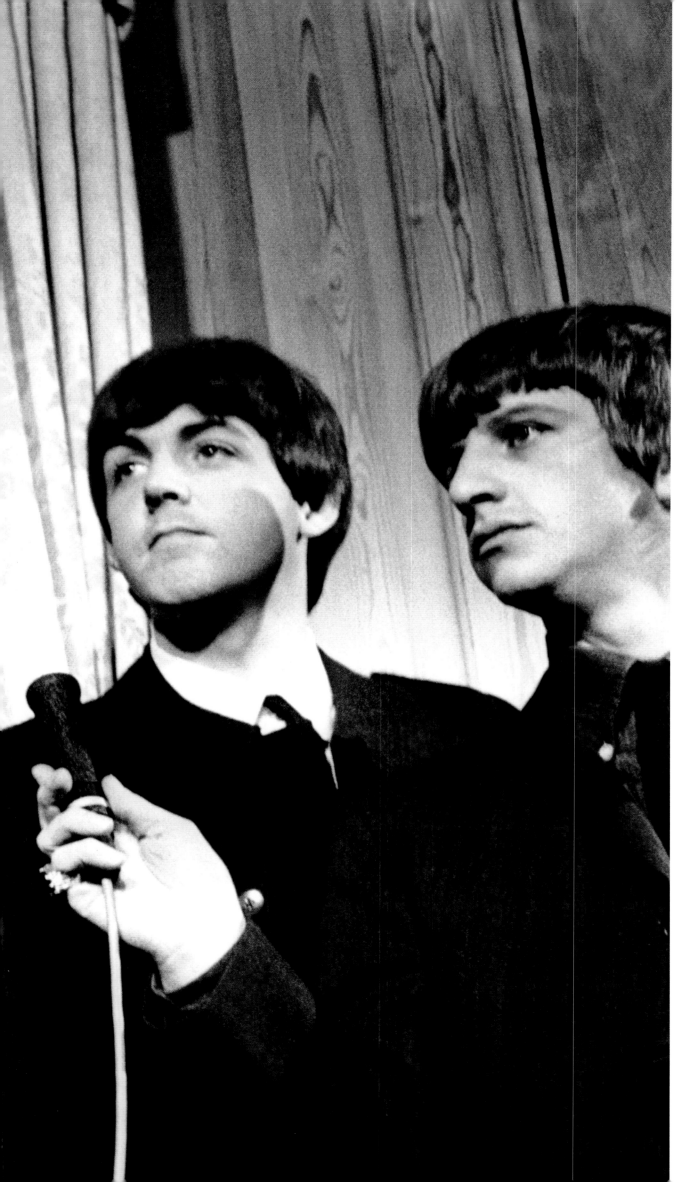

The Beatles meet British prime minister Harold Wilson. Within a year of their first hit, world leaders wanted to be seen with them

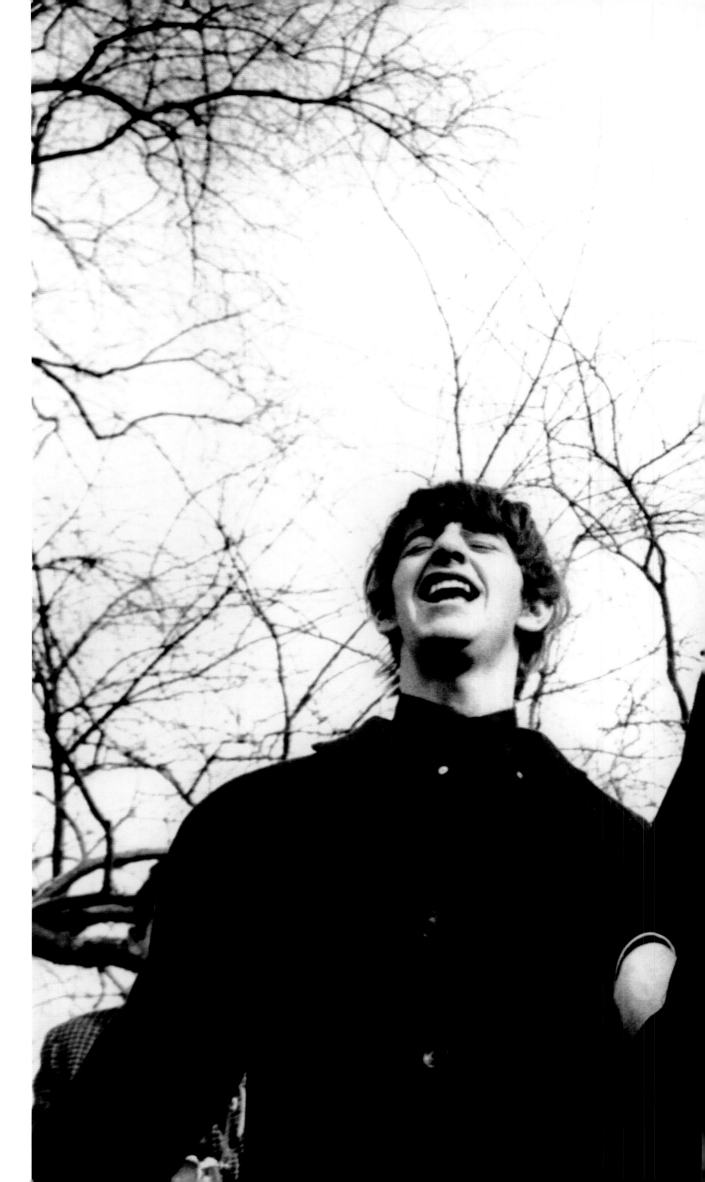

The Beatles (minus George Harrison) take a break from filming *A Hard Day's Night* in 1964

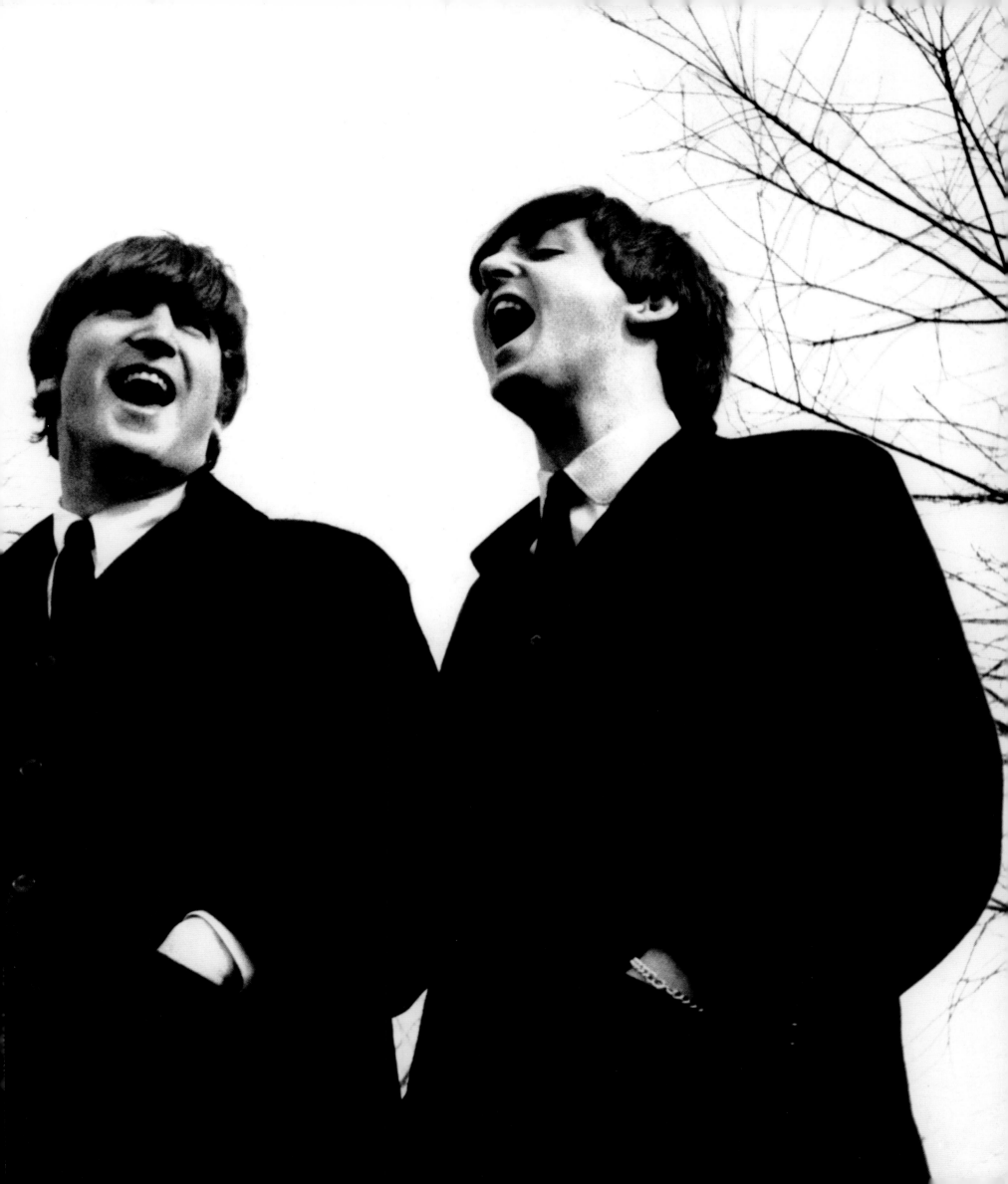

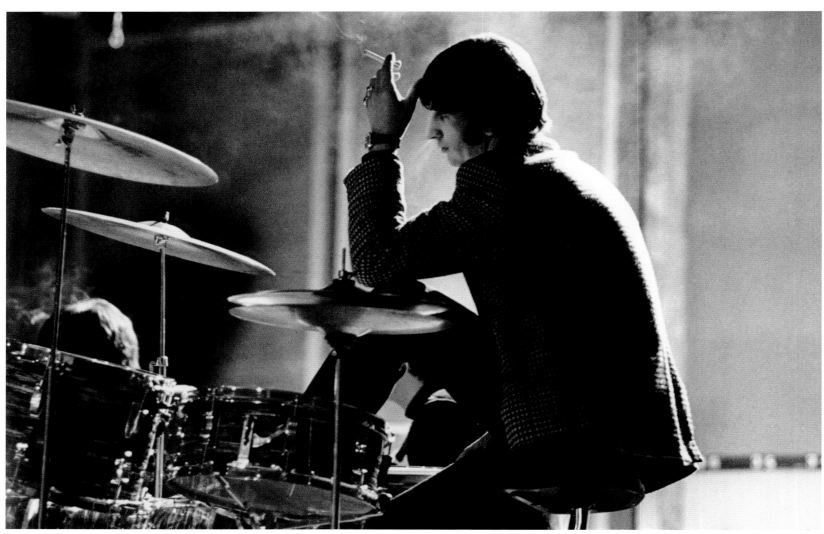

Ringo Starr takes a moment, 1964

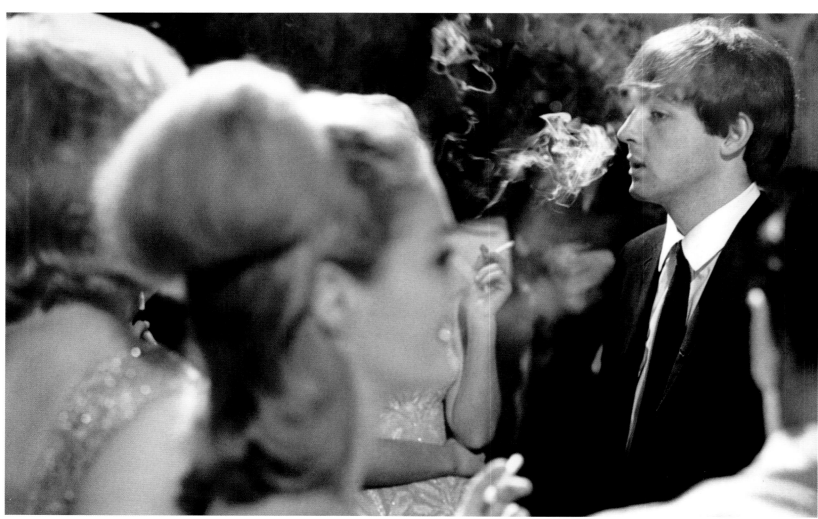

Paul McCartney taking time to unwind at a party

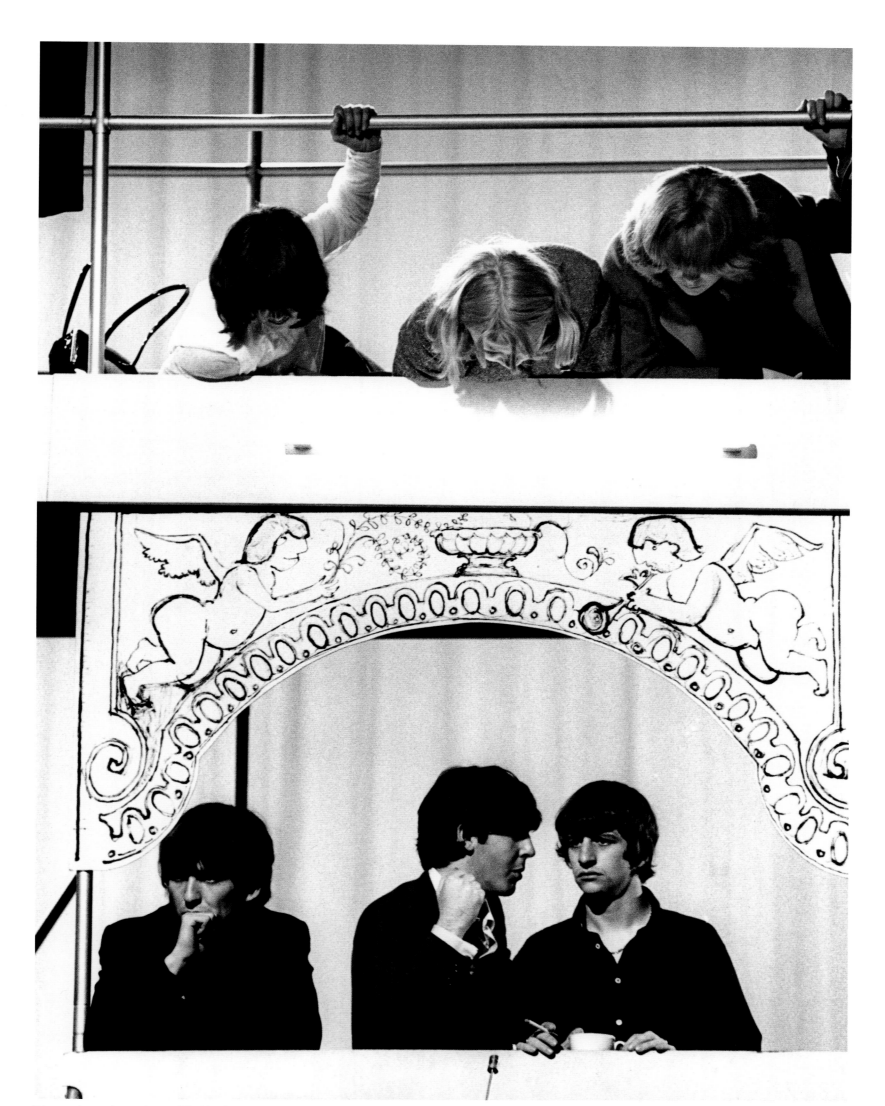

Women threw themselves at The Beatles wherever they went

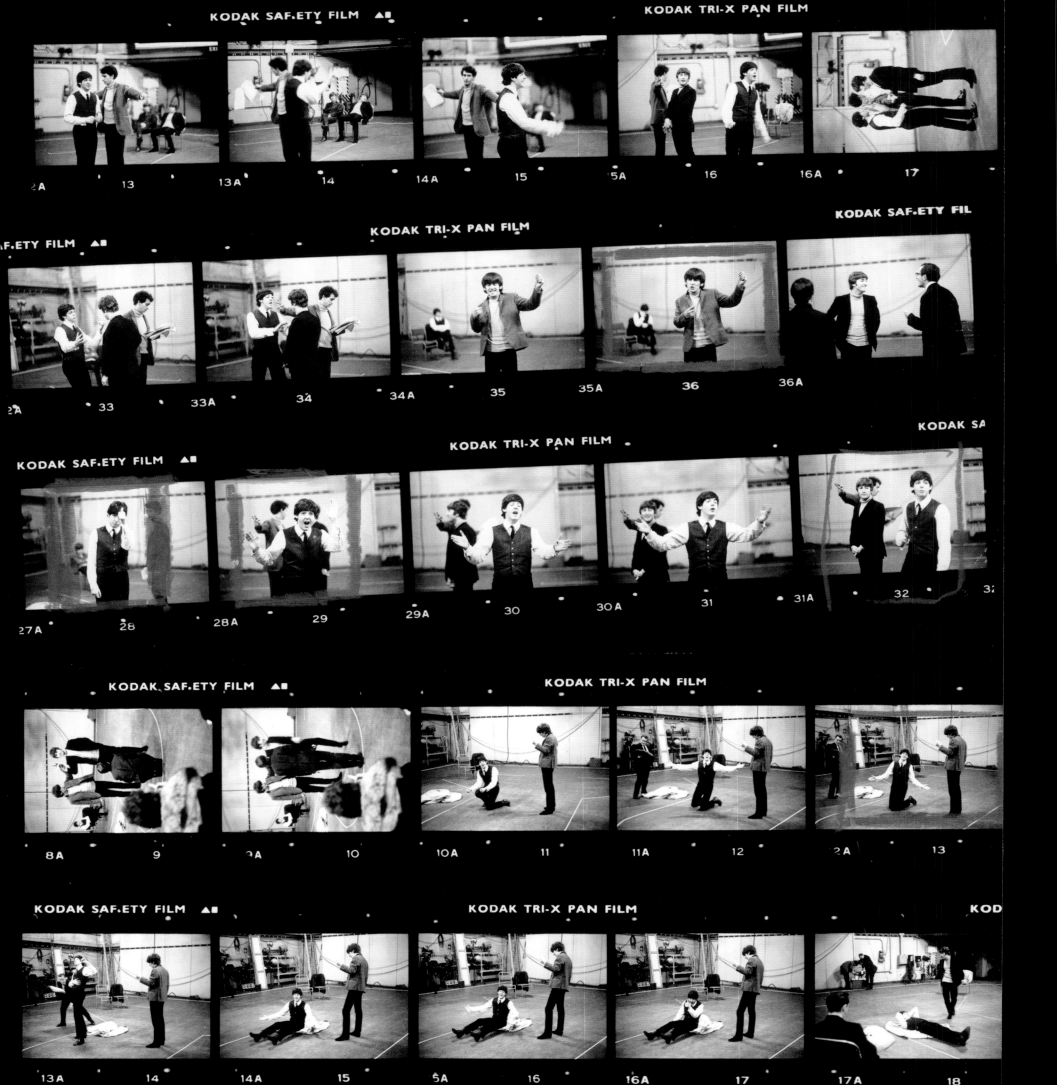

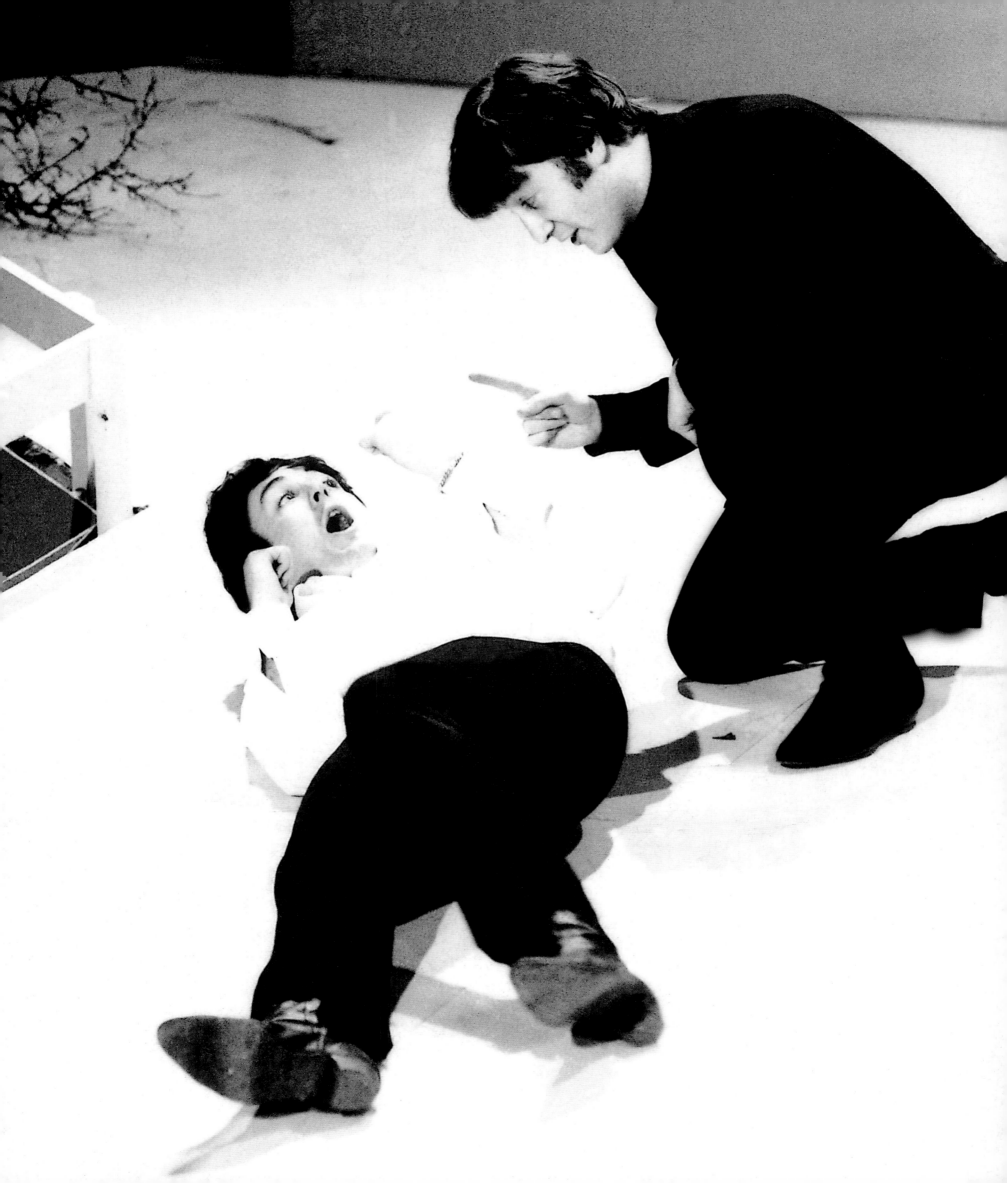

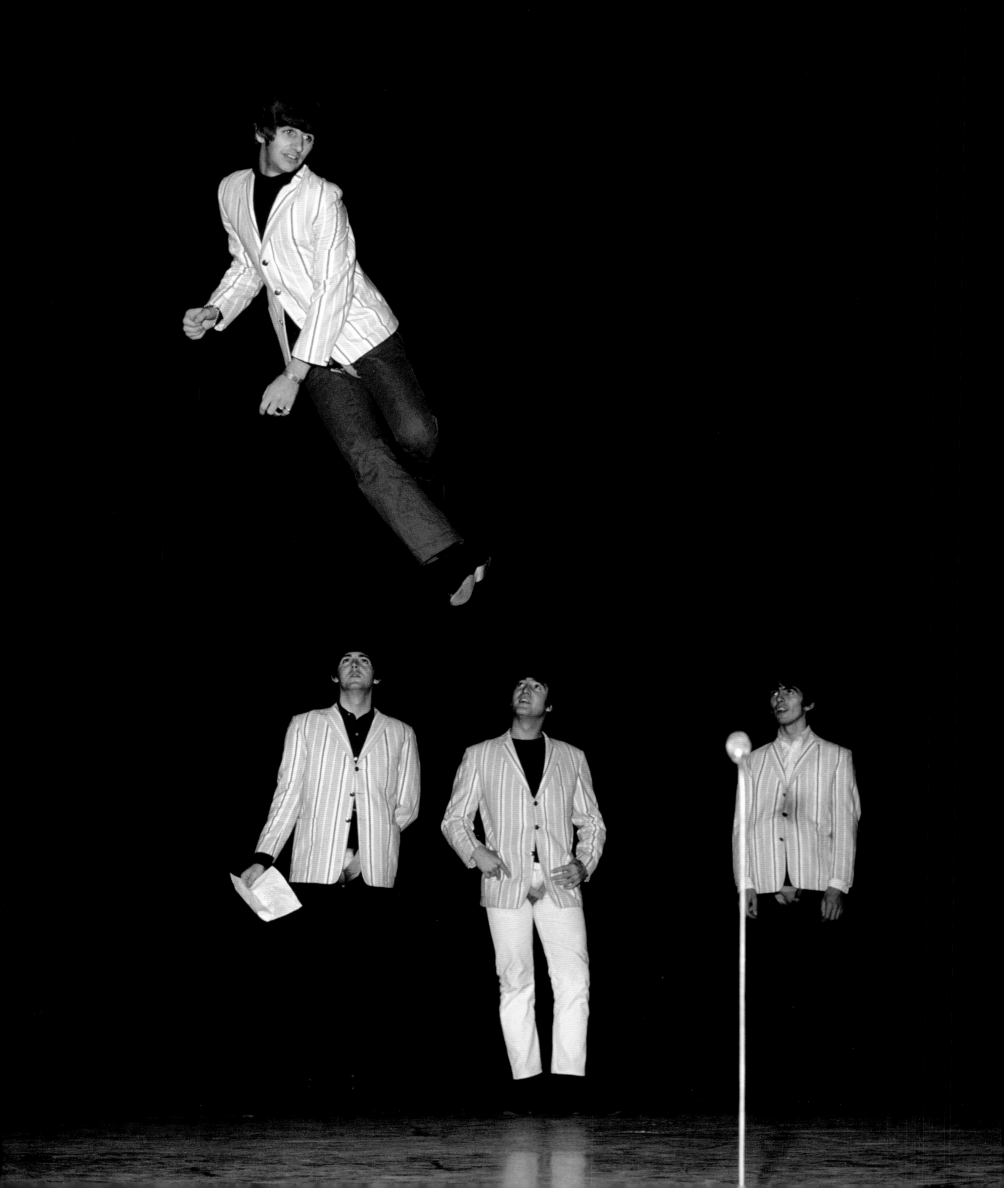

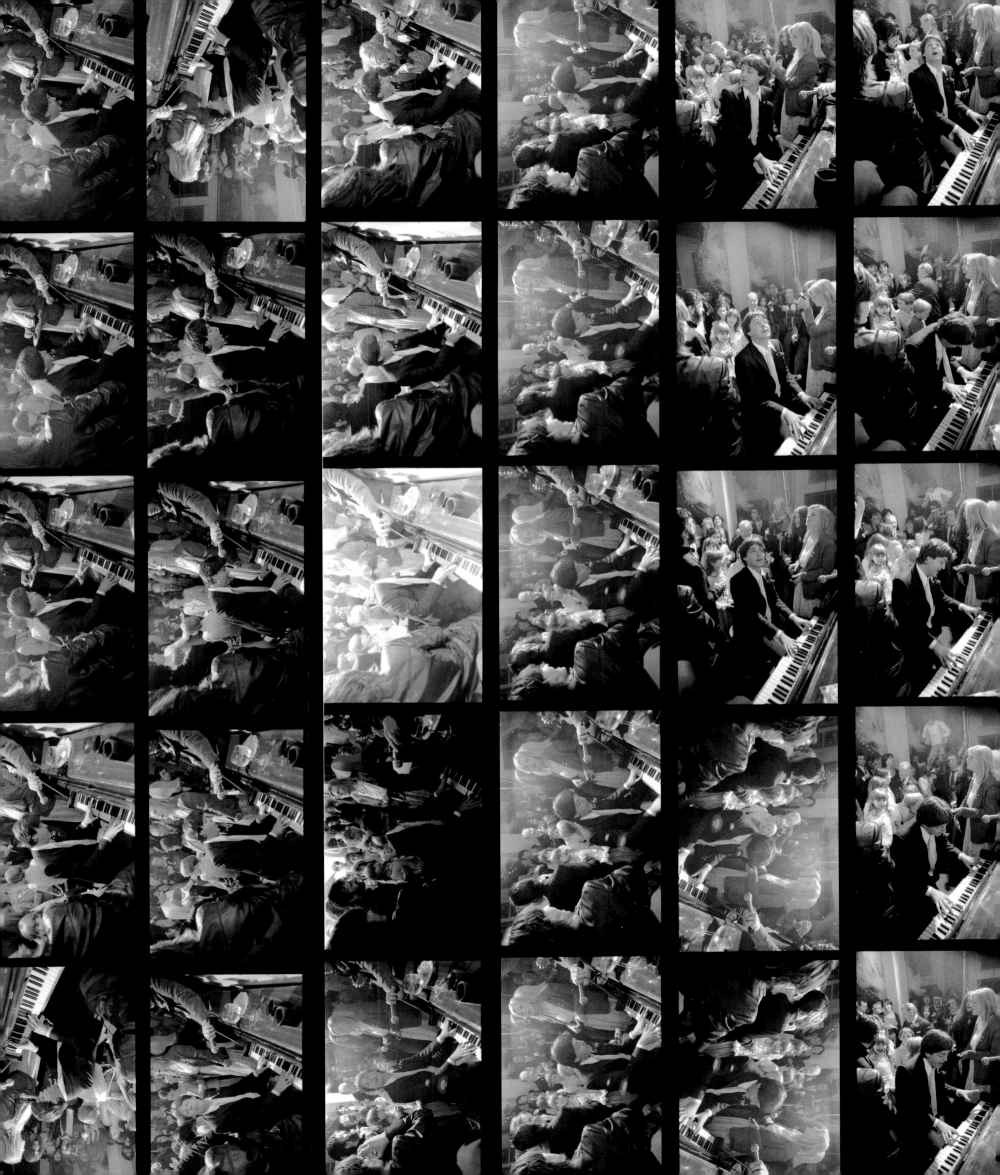

ILFORD FP4 PLUS

4

> *"Behind the scenes, Chuck wasn't always on his best behaviour. But once he was with the other musicians with a guitar in his hand, all the stresses and tedium just melted away"*

CHUCK BERRY

The film director Taylor Hackford made this very dynamic documentary feature called *Hail! Hail! Rock 'n' Roll* in 1986, which chronicled two concerts celebrating the great Chuck Berry's 60th birthday. I got to shoot Eric Clapton, Keith Richards, Julian Lennon (standing in for his dad) and Chuck on stage, in the studio and at Chuck's home during the filming.

There were two gigs in St Louis in October, but the rehearsals produced the most memorable images. It was an honour to be around them all. Eric and Keith I've known since we were all kids in London in the Sixties, trying to make it — and here we all were with one of our heroes.

Chuck had been there and done that at the very beginning, creating so much of the sounds that inspired these guys. In fact, The Stones's first record was a Chuck Berry song — 'Come On'. Keith hated it, so did the other Stones. I guess they just thought Chuck had done it and how could anyone top that?

Behind the scenes, Chuck wasn't always on his best behaviour. But once he was with the other musicians with a guitar in his hand, all the stresses and tedium you get filming a feature-length documentary just melted away.

It was such a privilege to be in the same house hanging out in private and then backstage with three of the greatest guitarists of all time — Keith, Eric and Chuck — all talking about their playing preferences, styles, swapping anecdotes and stories. It was a major event in rock 'n' roll history.

Keith toured with The Stones and The Everly Brothers, Bo Diddley and Little Richard in late 1963 (before The Stones made their big break-out). He has always said, it was his rock 'n' roll education hanging out backstage and watching talent like Chuck Berry perform ∎

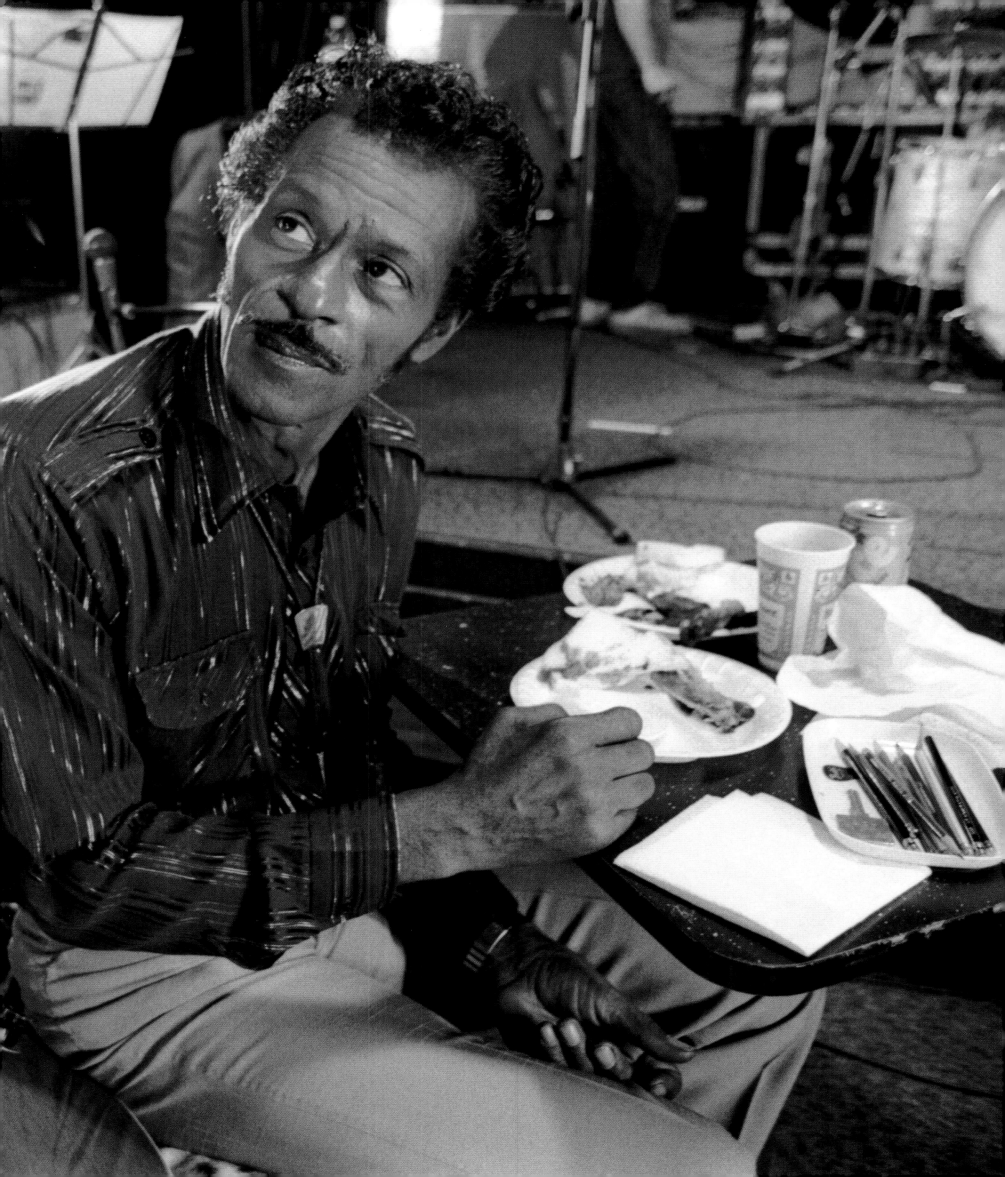

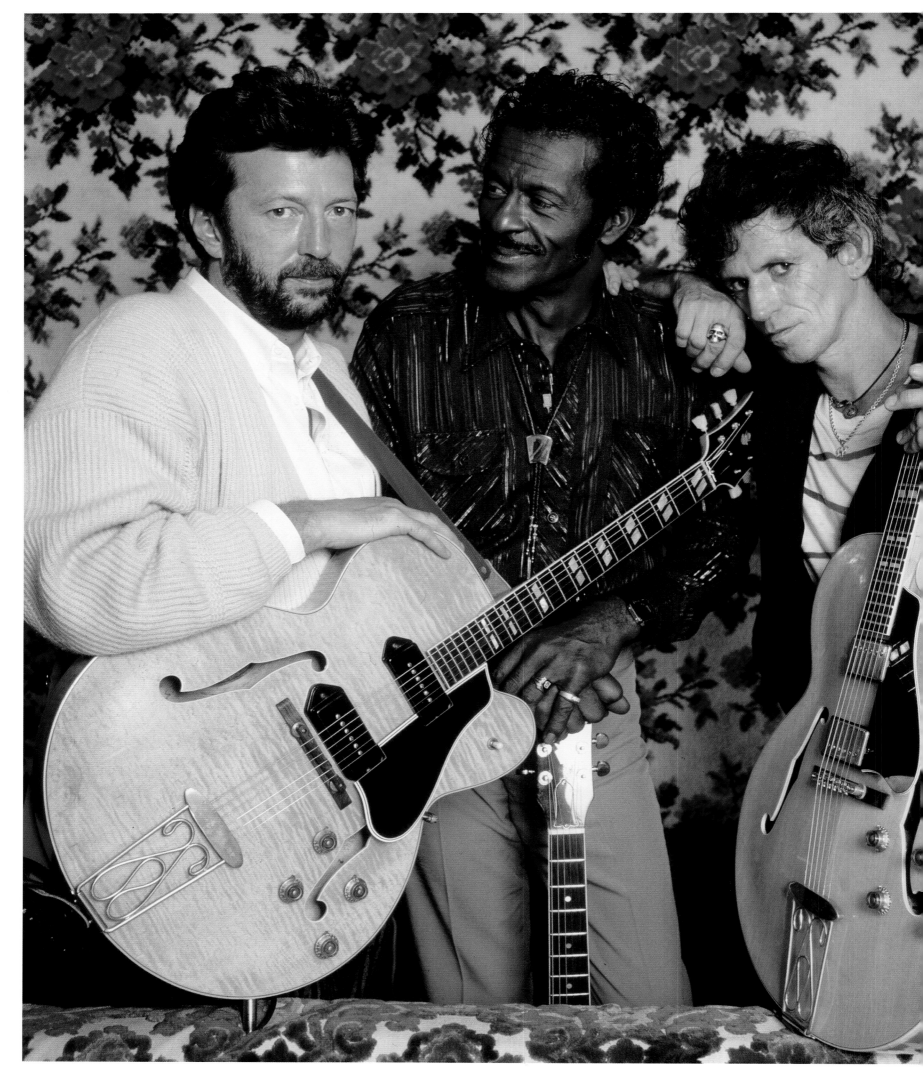

Eric Clapton, Chuck Berry, and Keith Richards. "I think it's the only time anyone got those three together," says Terry

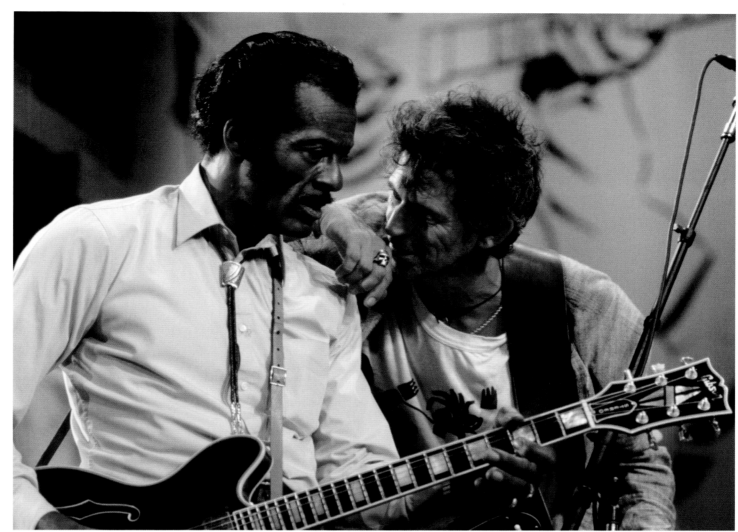

Chuck with Keith Richards, during filming of *Hail! Hail! Rock 'n' Roll*, 1986

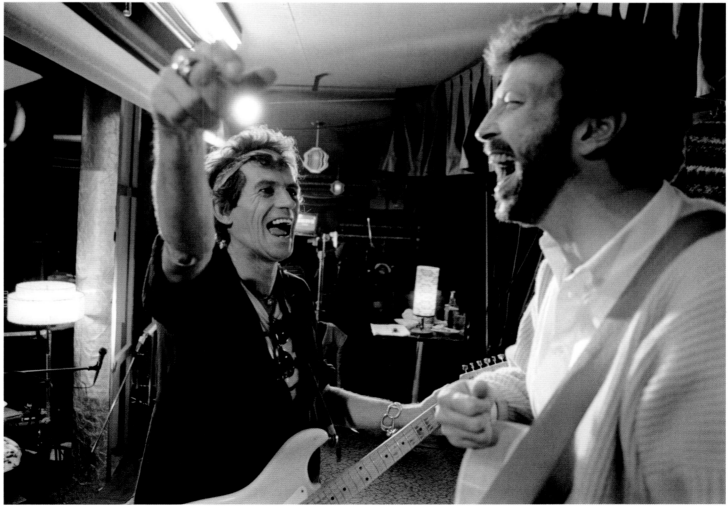

Keith, Eric and Chuck would swap anecdotes and stories. "It was a major event in rock 'n' roll history"

UNIVERSITY OF CHESTER, WARRINGTON CAMPUS

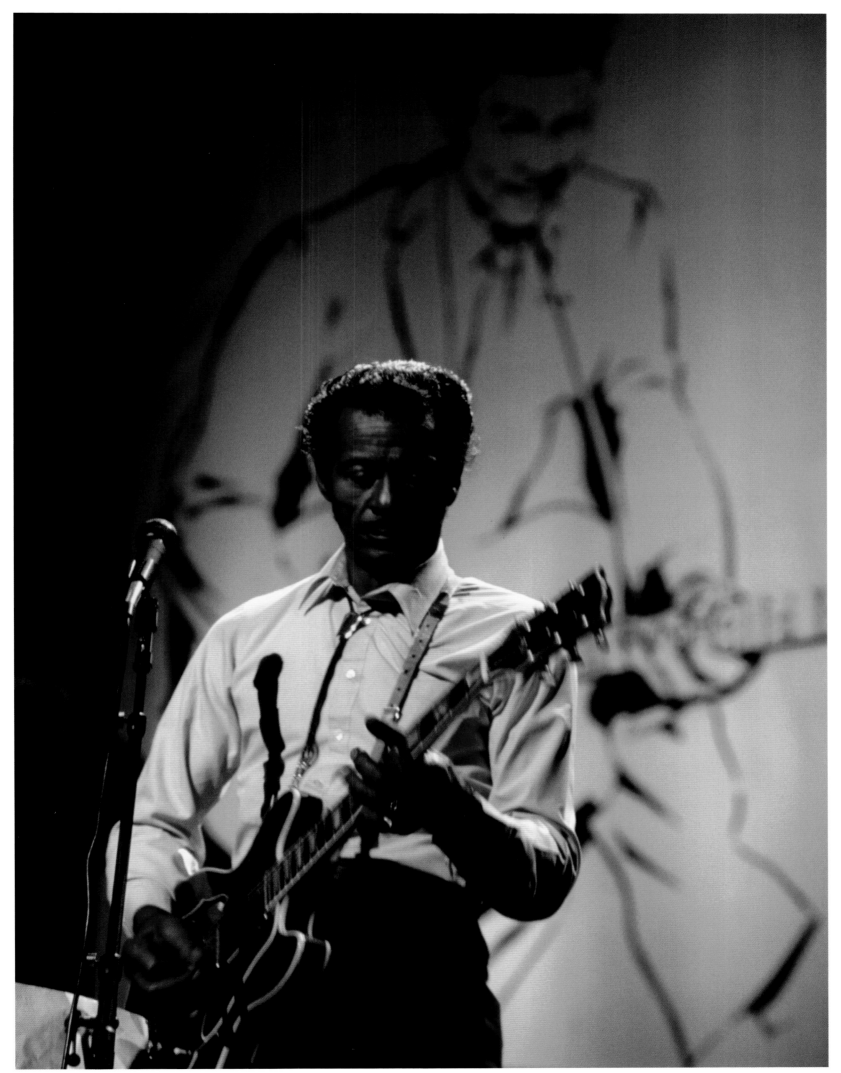

Terry remembers that there were two gigs in St Louis in October, but says the rehearsals produced the most memorable images

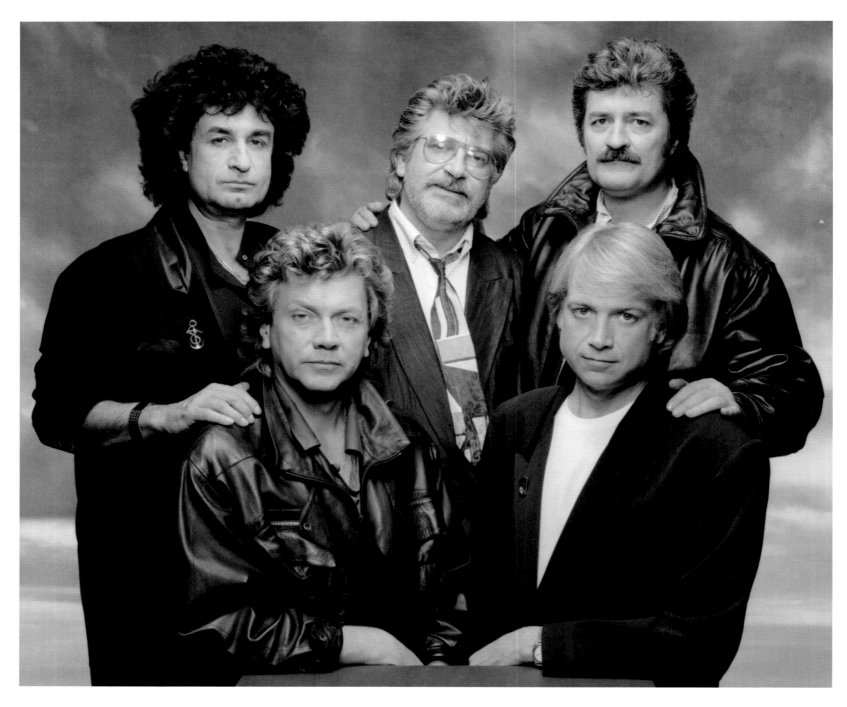

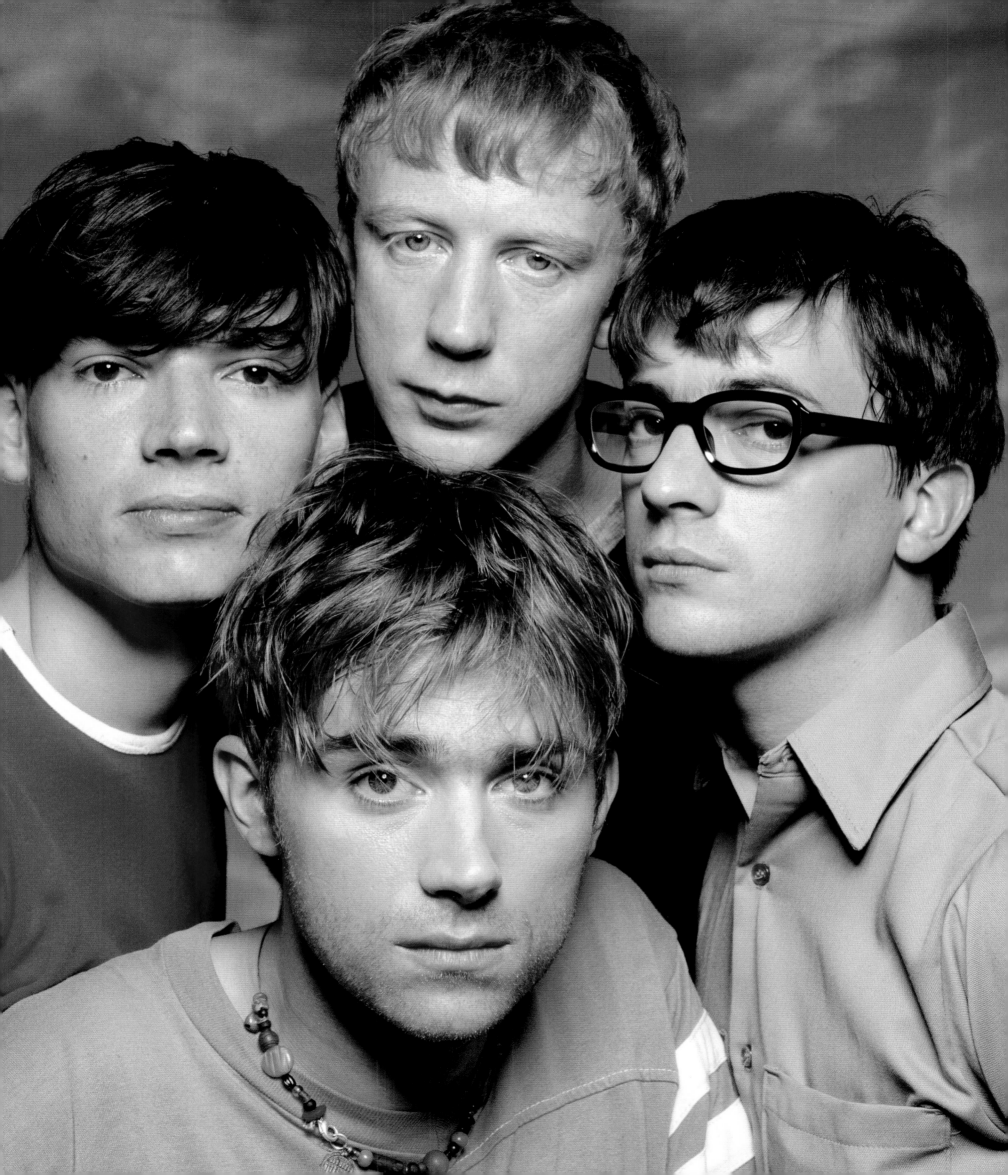

MARC BOLAN

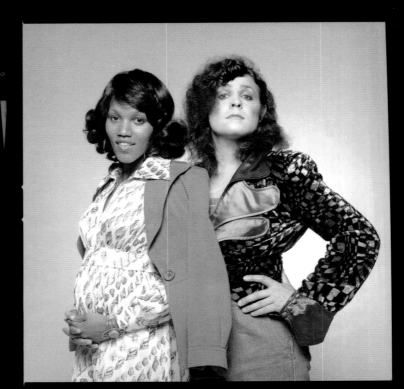
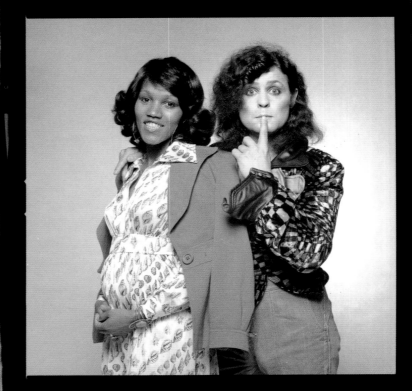
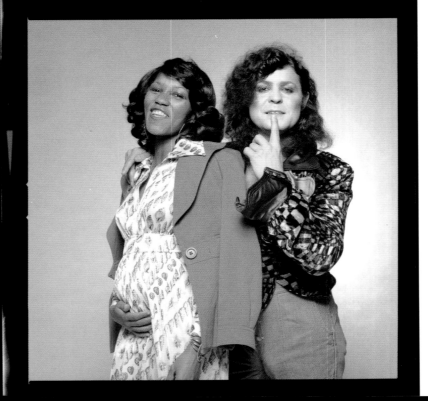
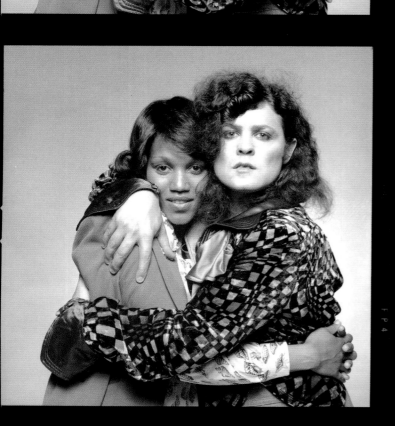

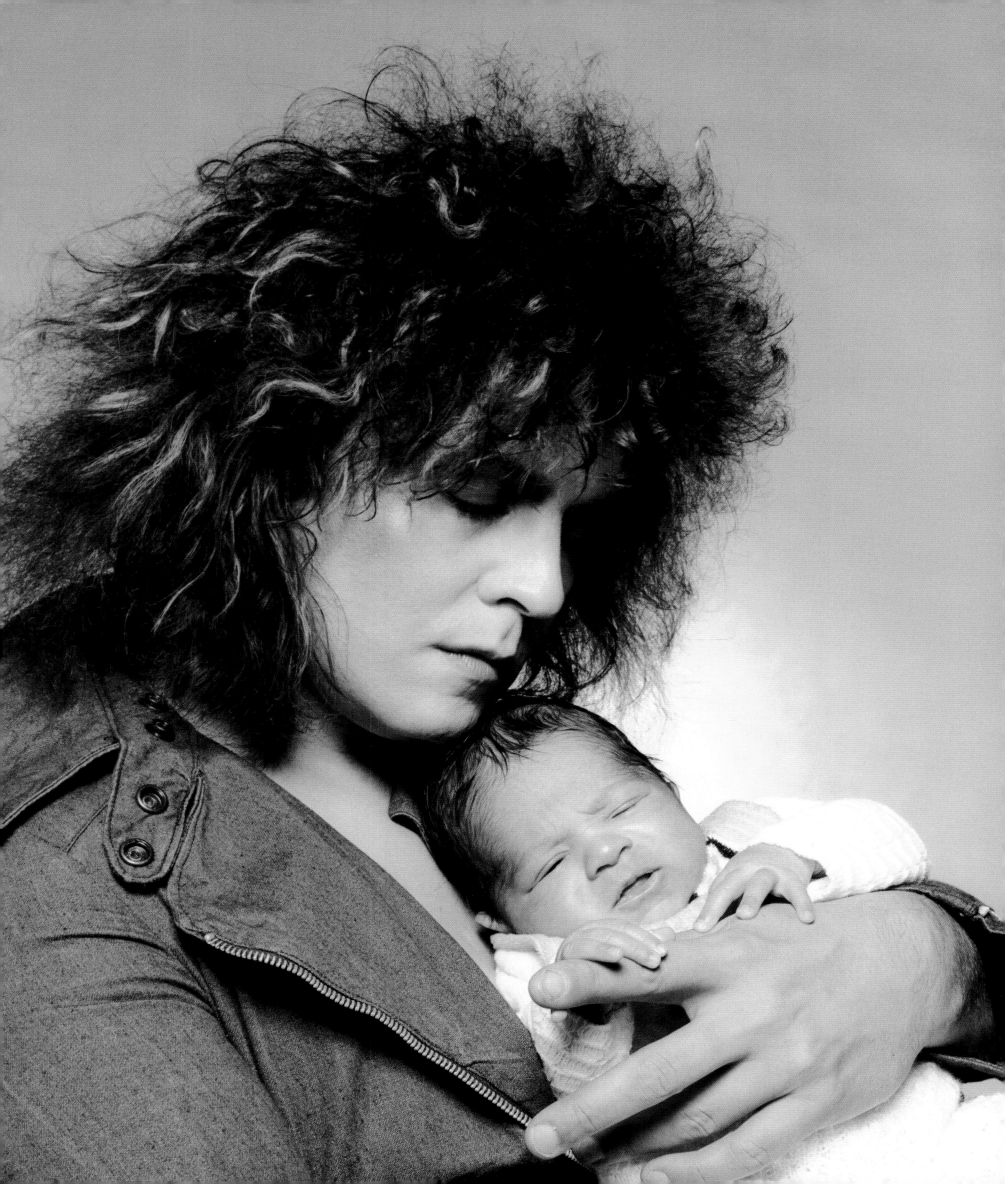

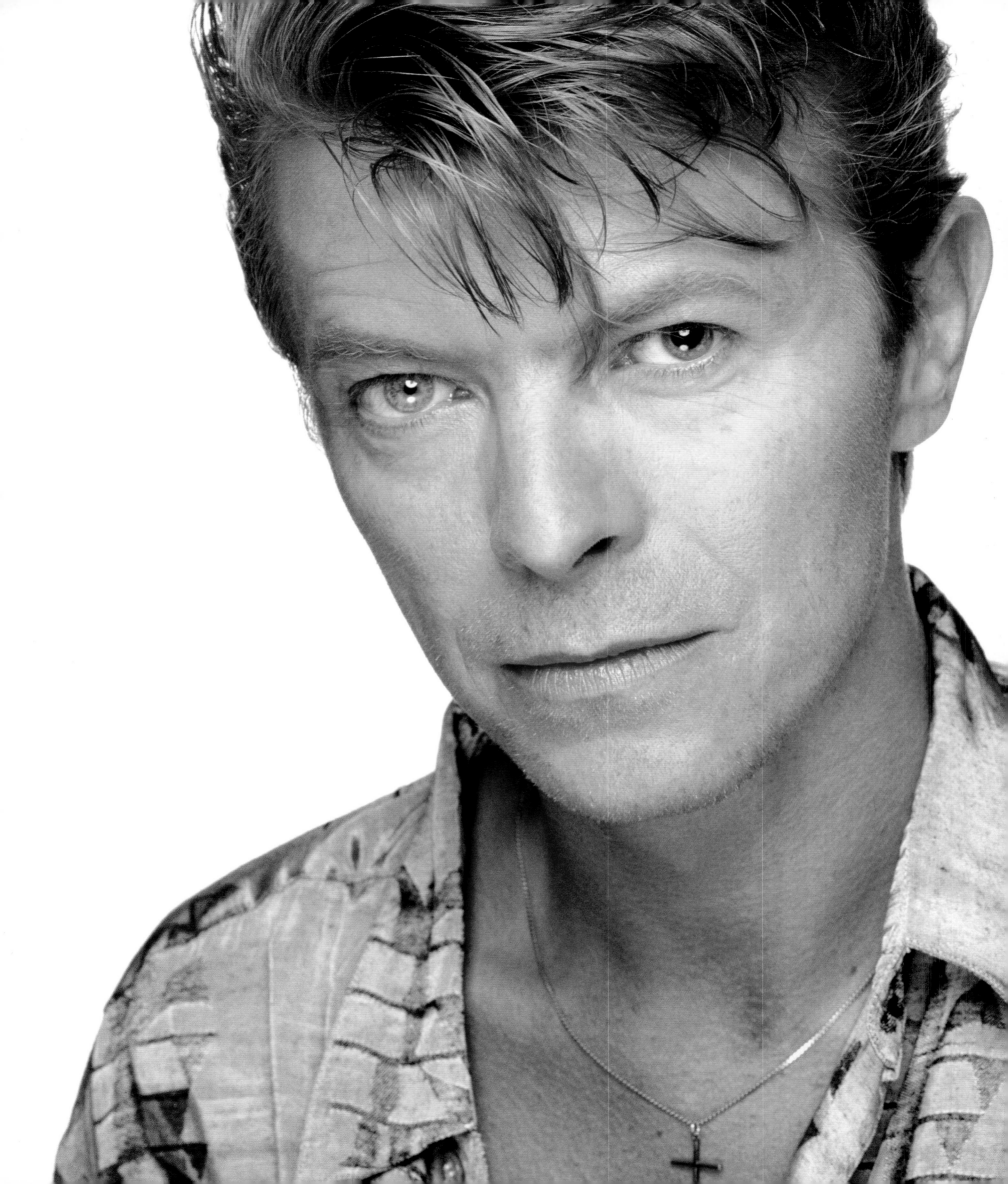

DAVID BOWIE

If I had to name the most talented, enigmatic and audacious star I ever photographed it would have to be David Bowie. A cerebral and searching soul who was — *is* — always looking to push the boundaries of his art. Even a simple portrait of the man generates questions and curiosity. He has a face the camera loves, but can't quite decipher. There's something serious and contemplative hidden away. I think David has a deep emotional curiosity about his identity, as if he's asking, "Who am I? What am I?"

I don't think he's found the answers yet. I don't think he wants to, because if he does he might stop asking questions, about himself, his art. He reminds me of the great jazz musicians, always looking to do something more with their talent, to take music to another level. He's a deeply private man on an intellectual journey, and I think it's the journey, not the destination, that motivates him.

David is an adventurer, an explorer. I don't know any other musician who has created so much more than just music and spectacle. His talent and charisma inform everything he does, as a singer, songwriter, actor, artist. He has a desire to create a meaningful dialogue, not just with an audience, but with himself.

So many musicians sit on their laurels, living off their past and the music that gave them fame. The truth is, fans don't want them to change direction. They want to hear the music they bought and played, over and over again. Many artists floundered with their fan base when they tried to do something new. David always chose his own direction. It was our choice if we wanted to follow or not — it's a testament to his talent that we did.

Back in the early days when he was creating that mesmerising character Ziggy Stardust, it wasn't just about the music and the performance, but the costume and the message. It was out of this world, out of our world.

Bowie had a brief burst of fame with 'Space Oddity' in 1969, seemed to disappear for a couple of years and then suddenly here

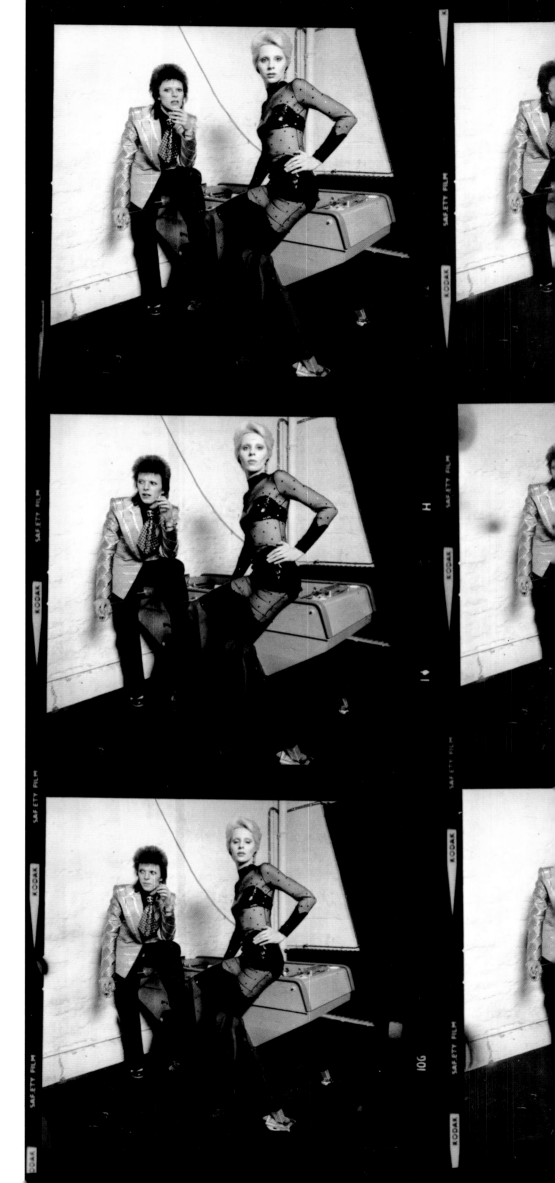

"Back in the early days when he was creating that mesmerising character Ziggy Stardust, it wasn't just about the music and the performance, but the costume and the message. It was out of this world, out of our world," says Terry

he was in front of us again, reinventing music with *Ziggy Stardust and the Spiders from Mars.*

This weird, androgynous alien character in its outlandish, otherwordly and almost gothic flamboyance, was merely the understudy to the music, but the effect was earth-shattering — it changed rock 'n' roll. Bowie was no longer a singer, musician. He was a cult.

David has always been a great creator. But you can't create without destroying. At the very point when he'd achieved, he would already be planning the next reincarnation of Bowie.

Ziggy started life in January 1972 in a tiny country town called Aylesbury, outside London. Nearly 18 months later, he had gone around the world. Bowie's last act as Ziggy was a TV special filmed in London for NBC in October 1973 behind closed doors at the Marquee Club.

A small invited audience of record company employees, band members' families and associates squeezed into the cramped Marquee and were treated to the last appearance of Bowie as Ziggy. For three days they filmed. Often, Bowie had to perform the same song over and over as camera angles were changed on a complicated set. The Marquee was never very big and they couldn't put several cameras on the floor to cover all the angles, so they had to keep stopping and moving the camera to record the same song again and again.

I remember how patiently Bowie worked, up to 10 hours a day in all that make-up and being squeezed into these uncomfortable costumes, which proves how seriously he took his art and how hard he worked to make it perfect.

In between takes he'd relax for a few minutes in his dressing room or mix with the audience and swap stories, answer questions, sign autographs. It must have been exhausting. I was able to get the most memorable shots, candid, backstage images and live perform-ance shots. Although I didn't realise it at the time, I was lucky enough

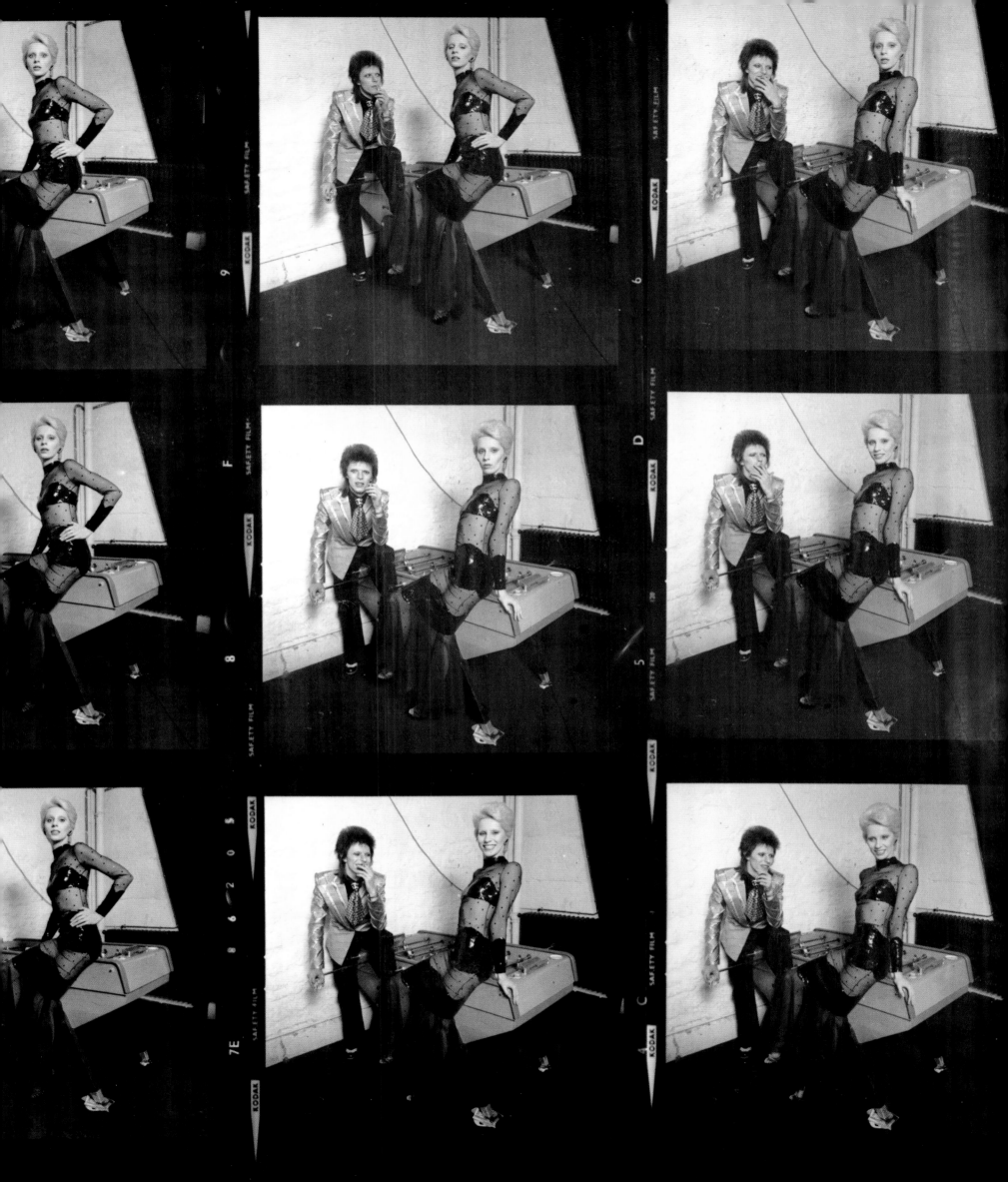

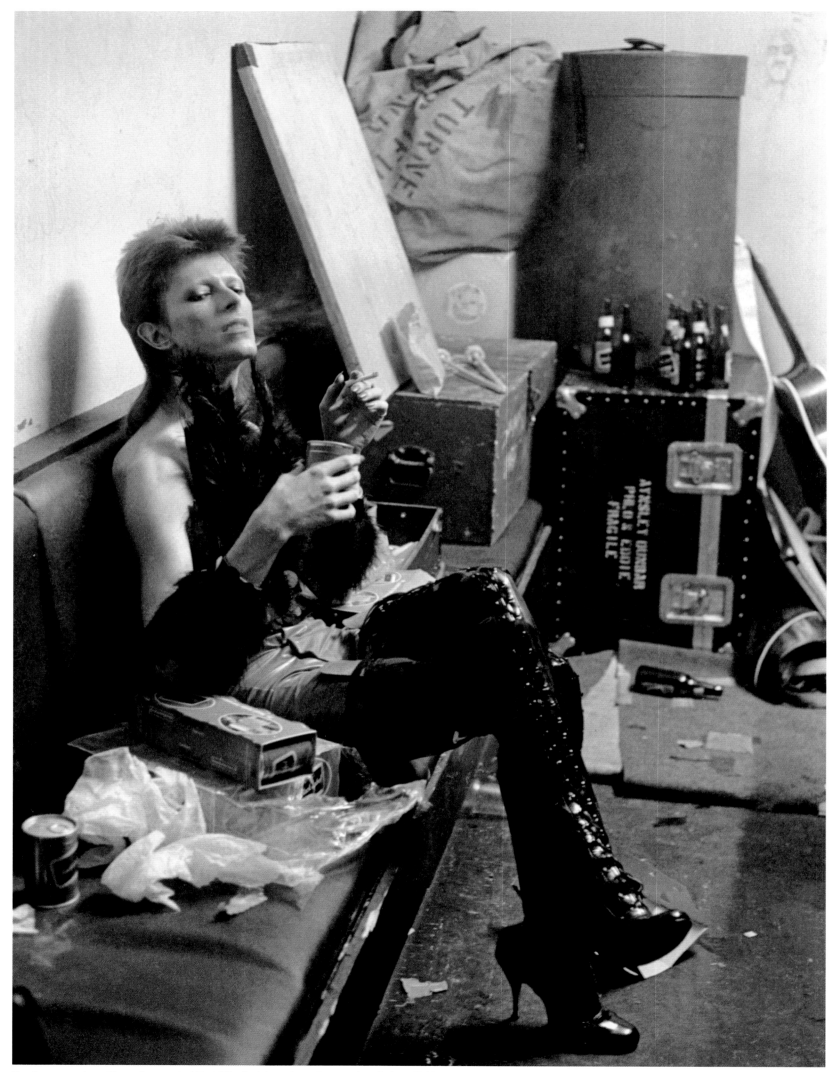

Bowie, remembers Terry, "respected that I had a job to do and wanted to do it well. He worked with you, not against you"

"Typical Bowie, he somehow managed to merge the music with art, literature and performance, drawing on William Burroughs and George Orwell for inspiration"

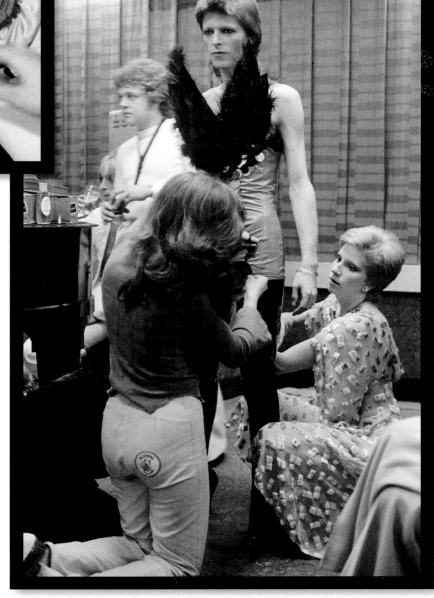

to be there witnessing a piece of cultural history.

I'd been there with David and his then-wife Angie in the early days of Ziggy, when they were refining the character. I'd done some studio shoots with them. That was what I always enjoyed about David: on stage or in the studio or even casually, he respected that I had a job to do and wanted to do it well. He worked with you, not against you.

Of course, most of the time it just came naturally to him — he is a born performer, a born creator.

He buried Ziggy that night and then suddenly he was back — this time it was the *Diamond Dogs* era. Less than a year after he'd laid Ziggy to rest he had a new character, new music, new fashion, new art, a whole new persona.

Typical Bowie, he somehow managed to merge the music with art, literature and performance, drawing on William Burroughs and George Orwell for inspiration. Around this time, the artist Guy Peellaert was commissioned to paint Bowie as half-man half-dog, but needed images to work from. I photographed David in the man poses and later a dog for the hindquarters. Guy painted a composite of my photographs and the album duly came out.

At the same time I put David, in full costume, and the dog together in the studio — it was a huge great dane, quite docile and sweet, but still, a hulking great thing. It was supposed to just sit at

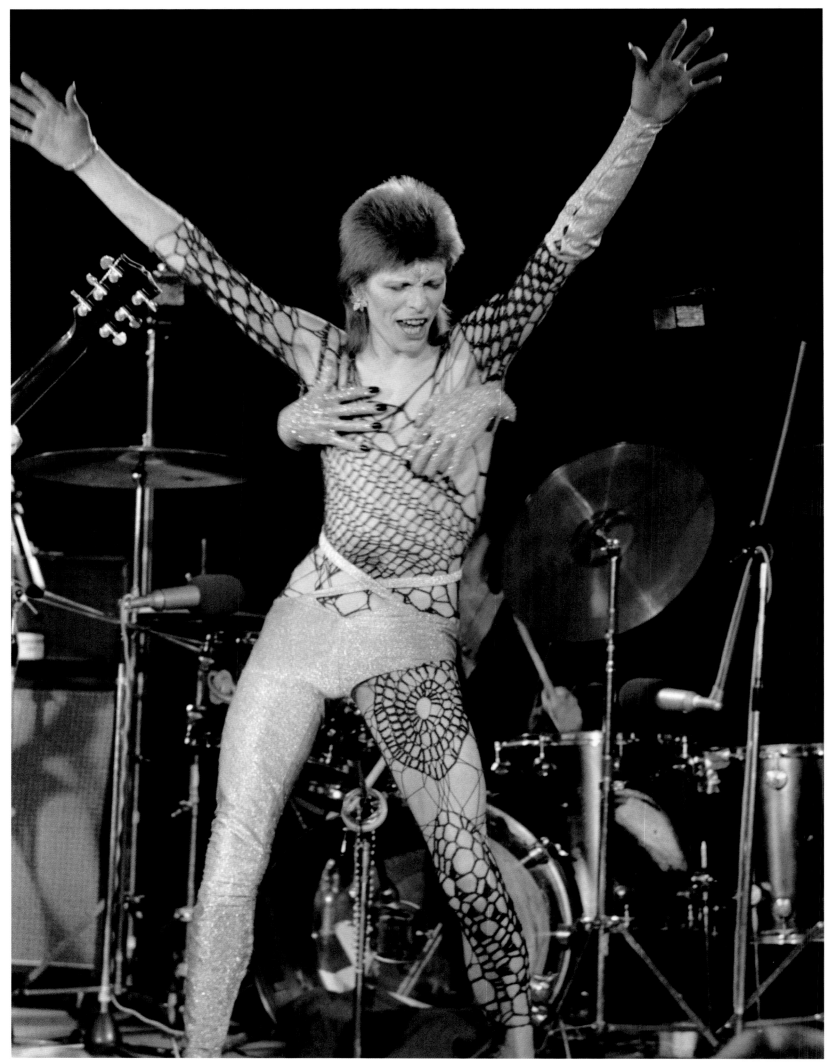

"I never really felt like a rock singer or a rock star or whatever," David Bowie said about his Ziggy Stardust period

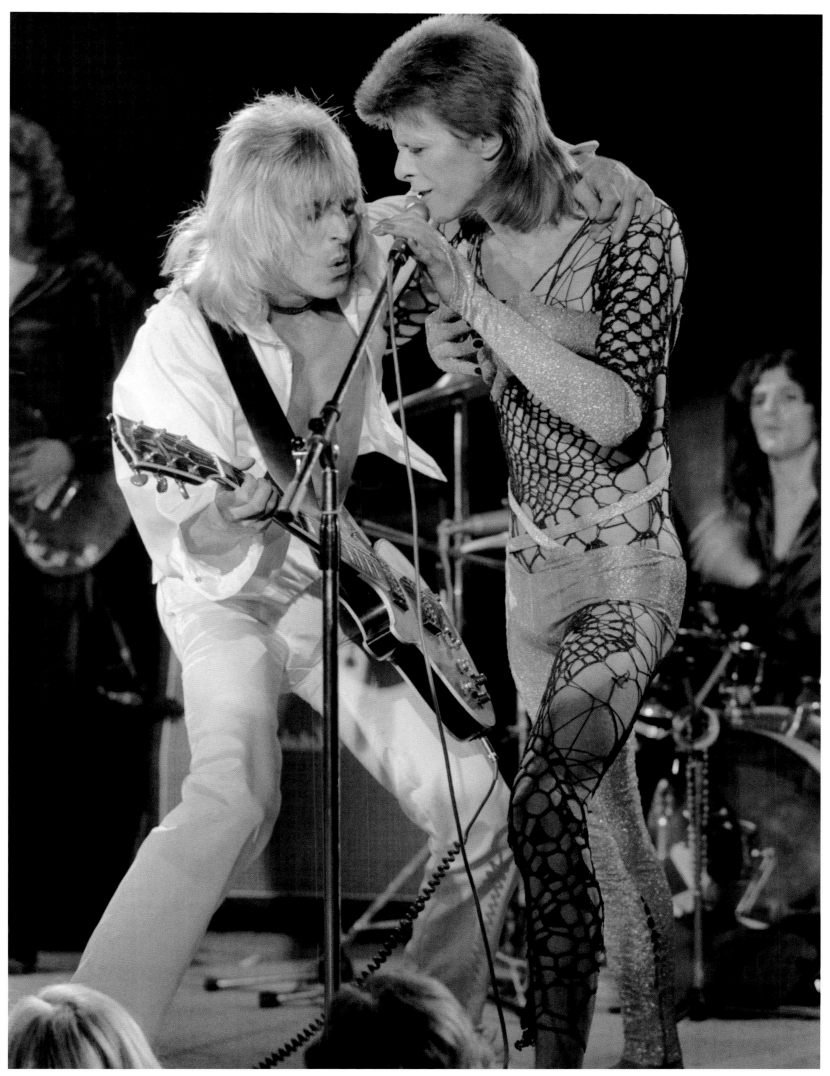

David Bowie and guitarist Mick Ronson rocking the stage in 1973

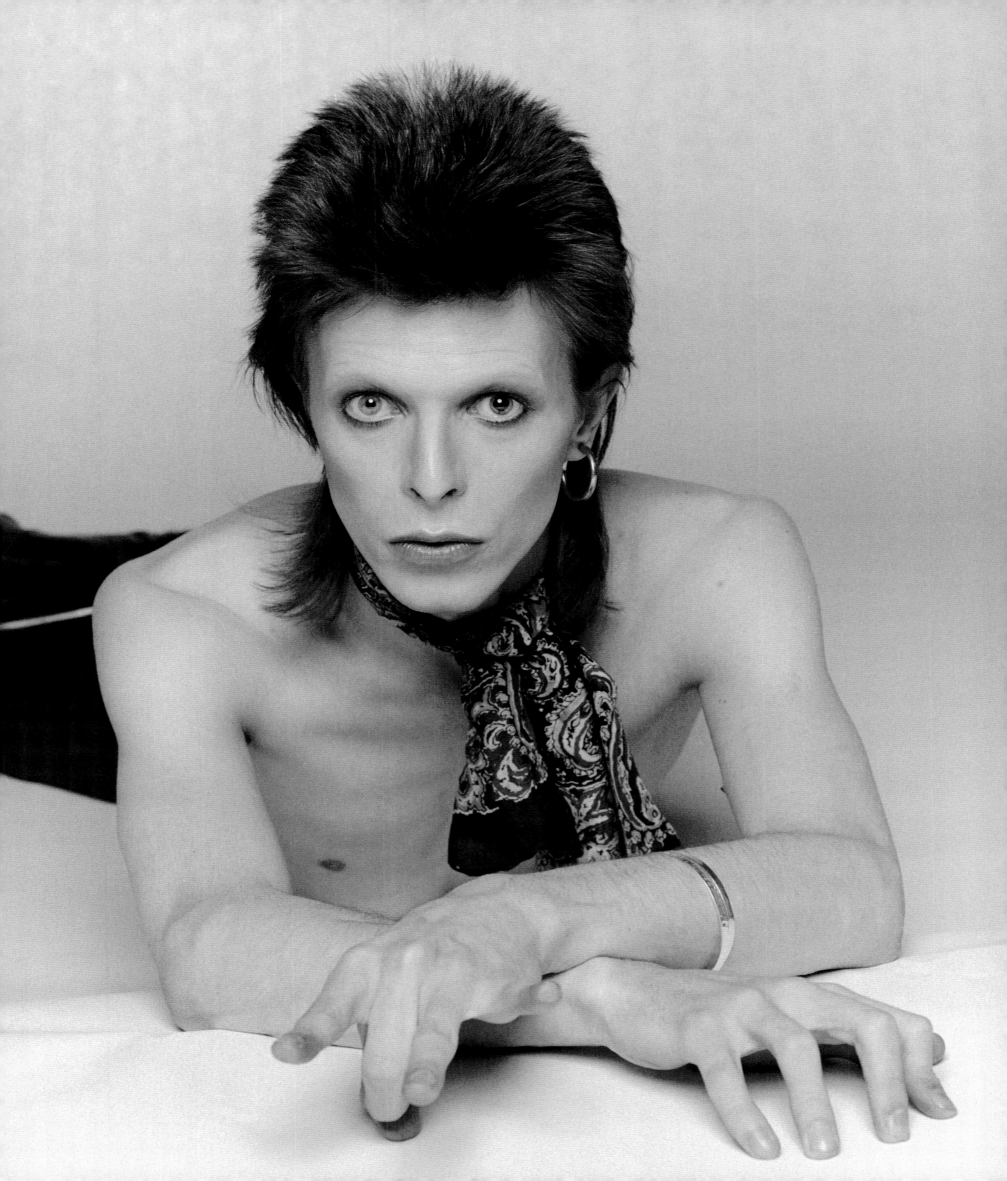

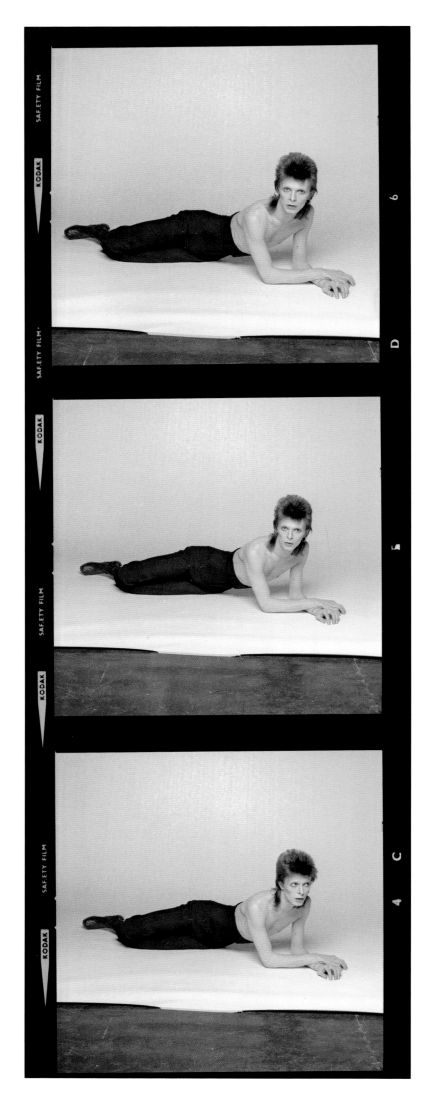

Terry O'Neill photographed
Bowie for the cover of his
1974 *Diamond Dogs* album

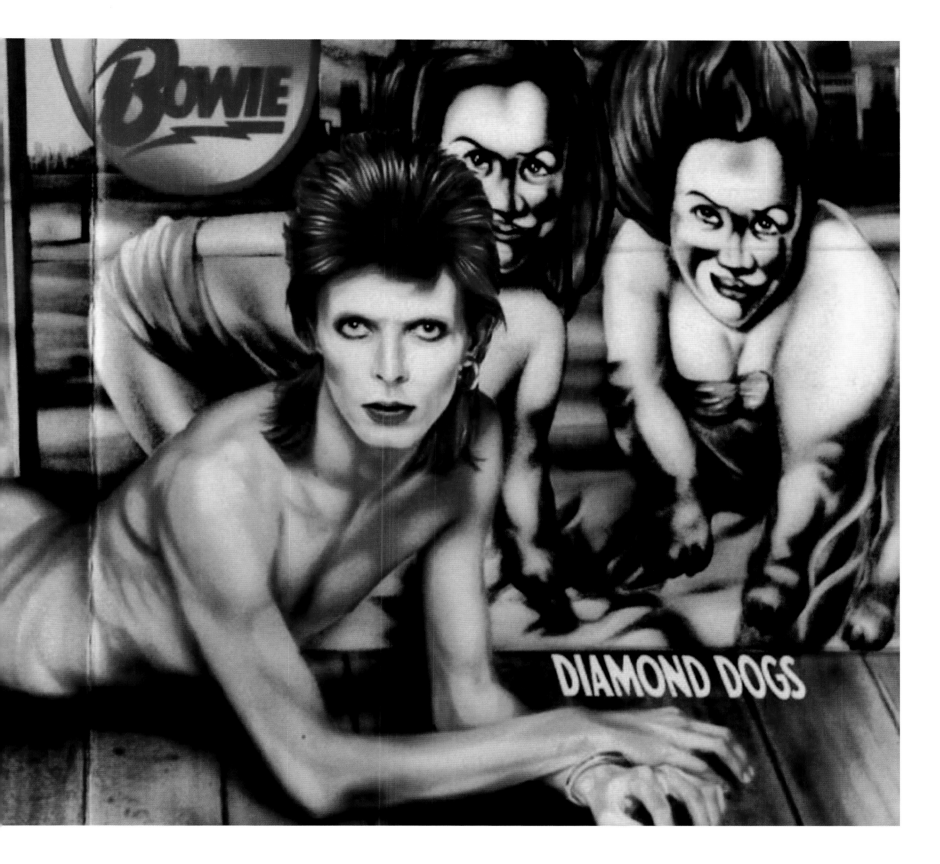

David's feet obediently and I thought it would make a great publicity shot for the *Diamond Dogs* tour, but the strobe lights going off spooked the animal — suddenly it leapt up on his hind legs, barking loud enough to wake the devil. Everybody scattered, as if there were a wild boar on the rampage in the studio — except me and David. I was behind the camera and a photographer always feels remote and disconnected looking through the lens. David didn't move a muscle.

People speculate that he was on something at the time. The truth is I think he was so into the role that he wasn't the least bit surprised — and he knew instinctively this would be a great shot. And it was. Another accident, another immortal image.

I don't know why, but it was always the same with David. I was in Los Angeles shooting him in his new persona, the Thin White Duke, on stage and in the studio, with him in a mustard-coloured suit, which has since become this cult-fashion shot. He's got a cigarette in his mouth and he's holding a pair of scissors. I didn't ask him to. He just saw them on the floor, picked them up and I thought — why change it? Hang on to them.

I'd known Elizabeth Taylor since the early 1960s and saw her regularly. I knew she fancied him for a movie she was making and she asked me to bring him to lunch. It was 1975 or '76.

He was hours late, she wasn't amused. But they knew I wanted to get some great shots of their first meeting and they both cuddled and kissed for 10 minutes before she suddenly announced the meeting was over. He never did get that part in her movie. You don't keep the biggest star in the world waiting — unless you're David Bowie ■

"Less than a year after Bowie had laid Ziggy to rest he had a new character, new music, new fashion, new art, a whole new persona," says Terry

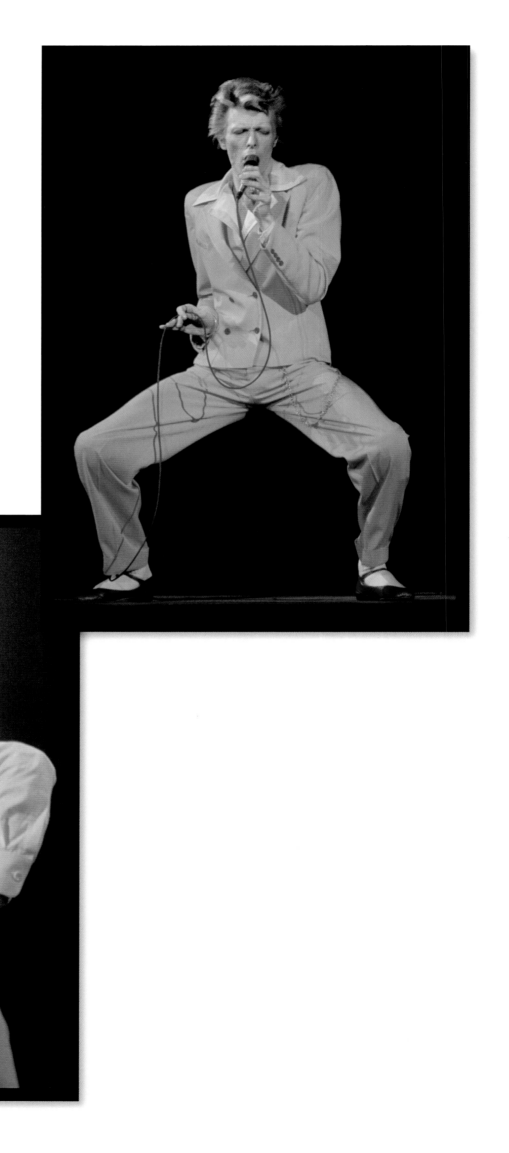

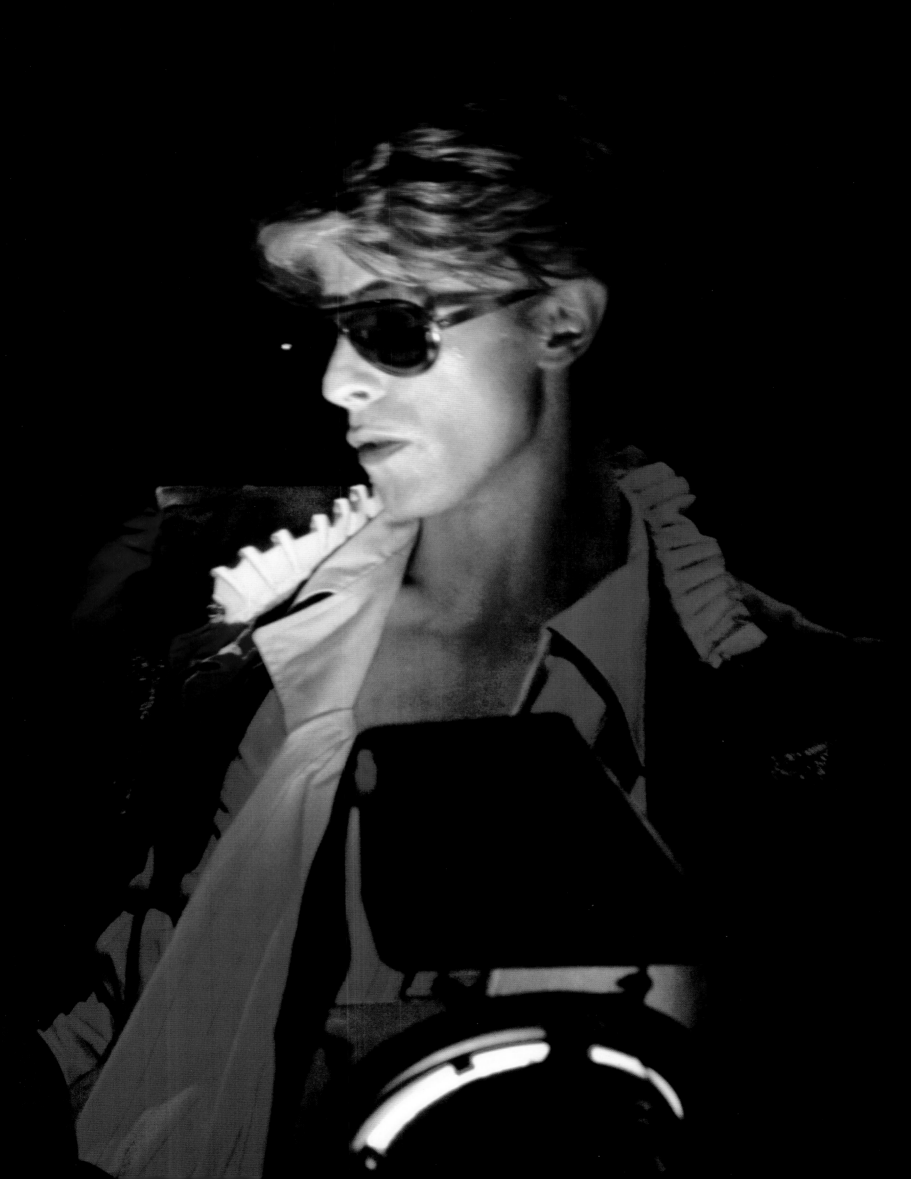

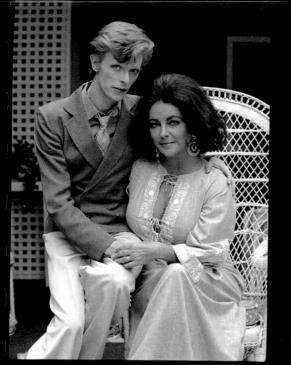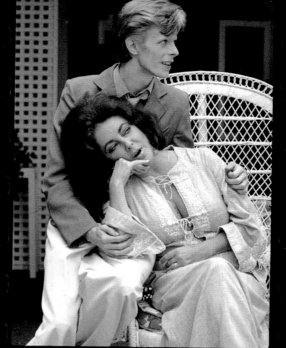

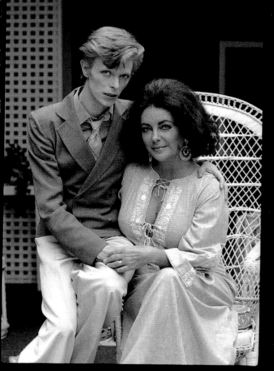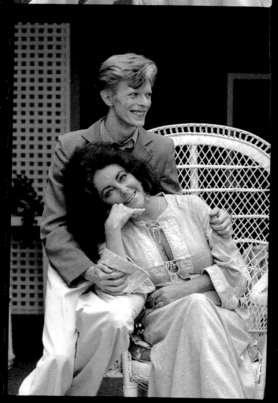

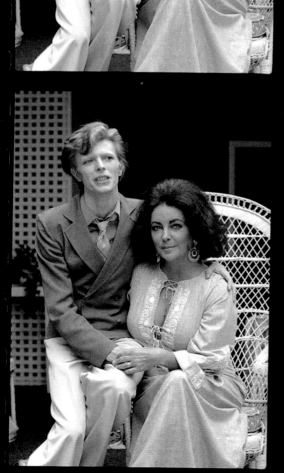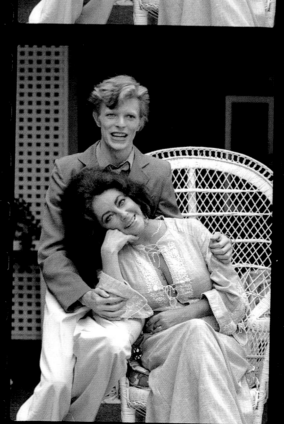

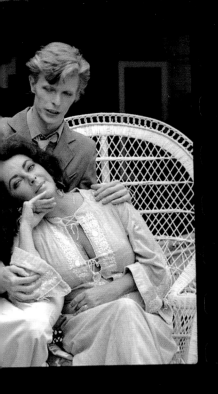
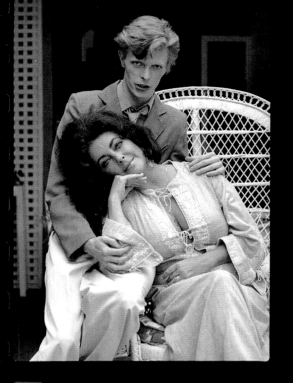
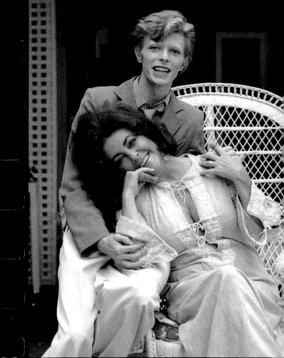
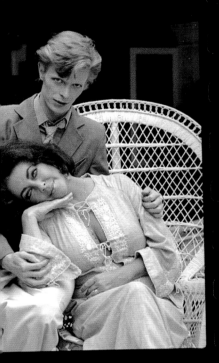
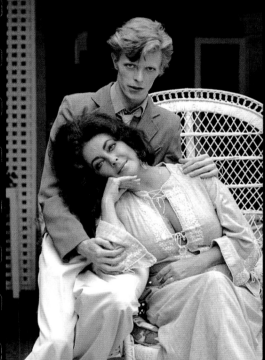
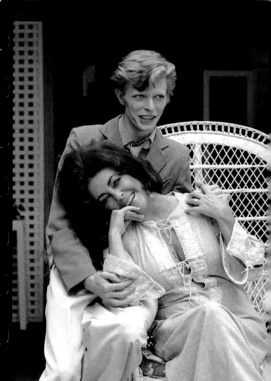
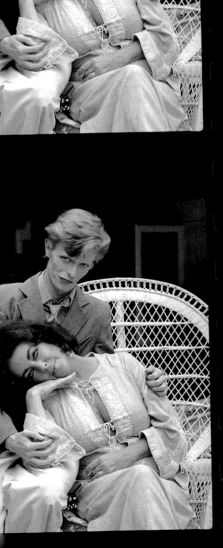
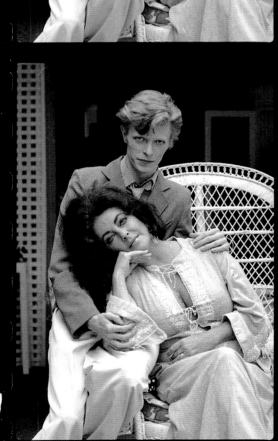
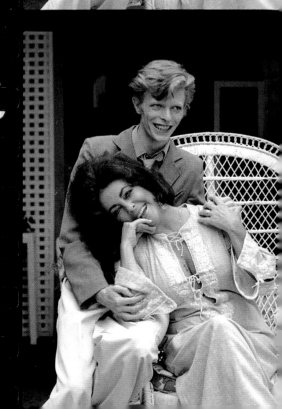

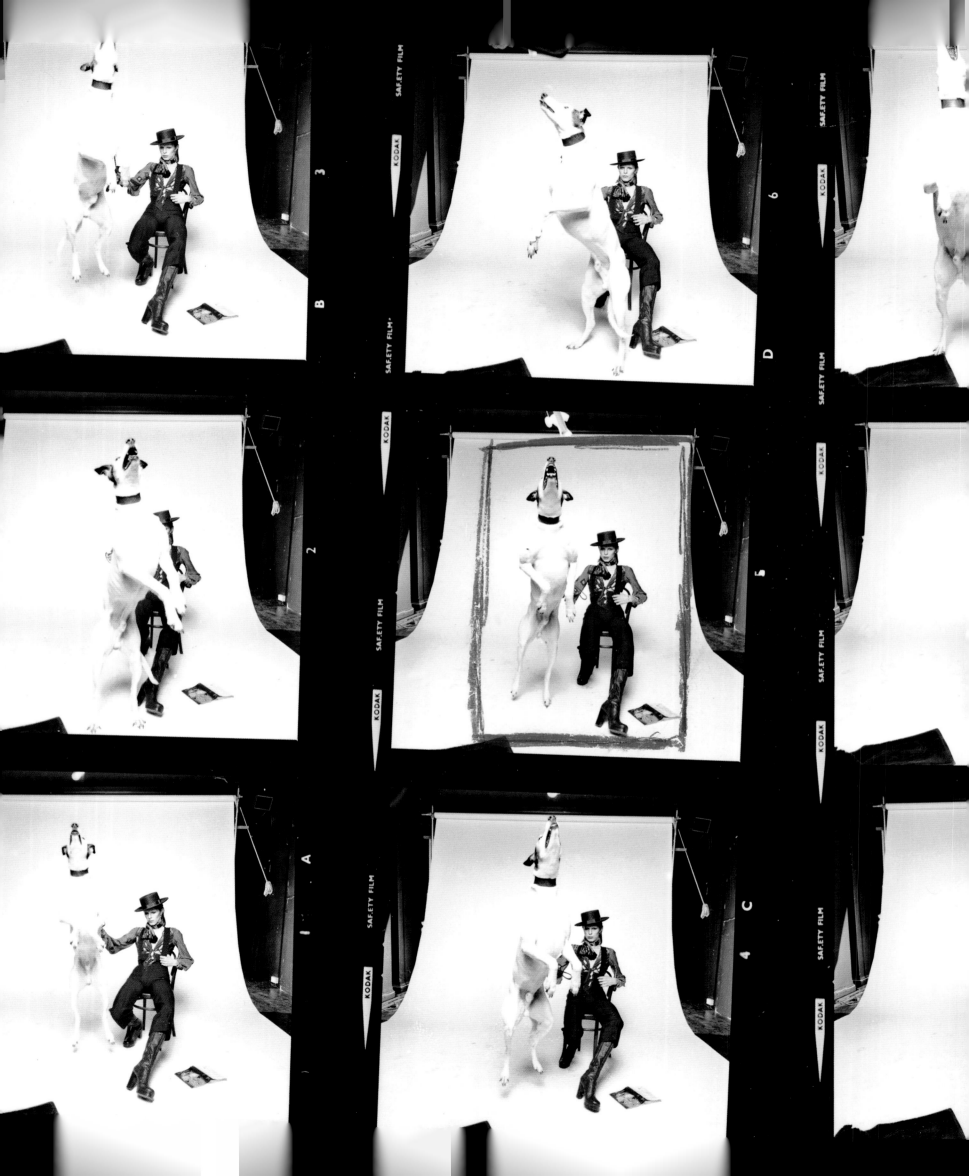

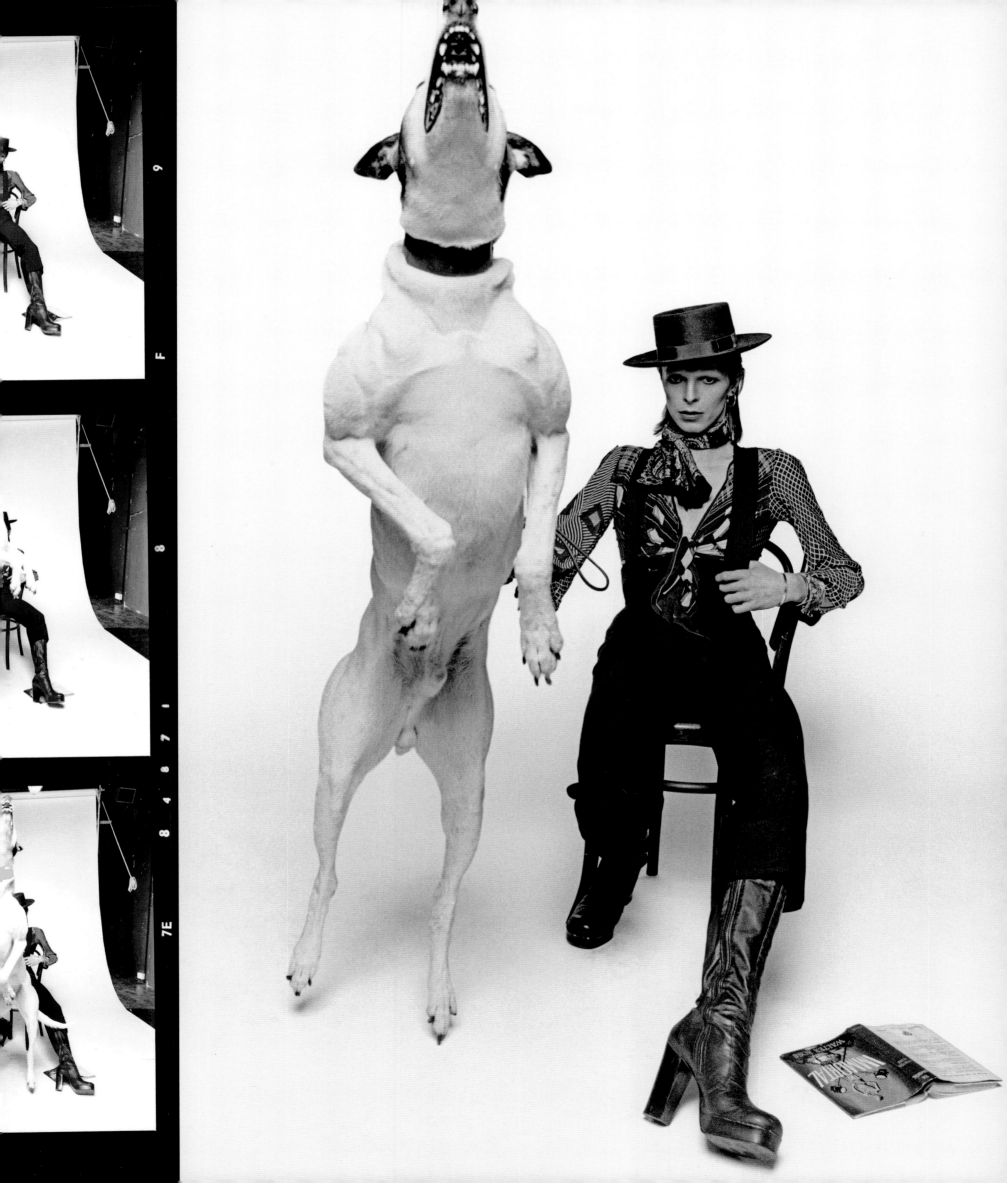

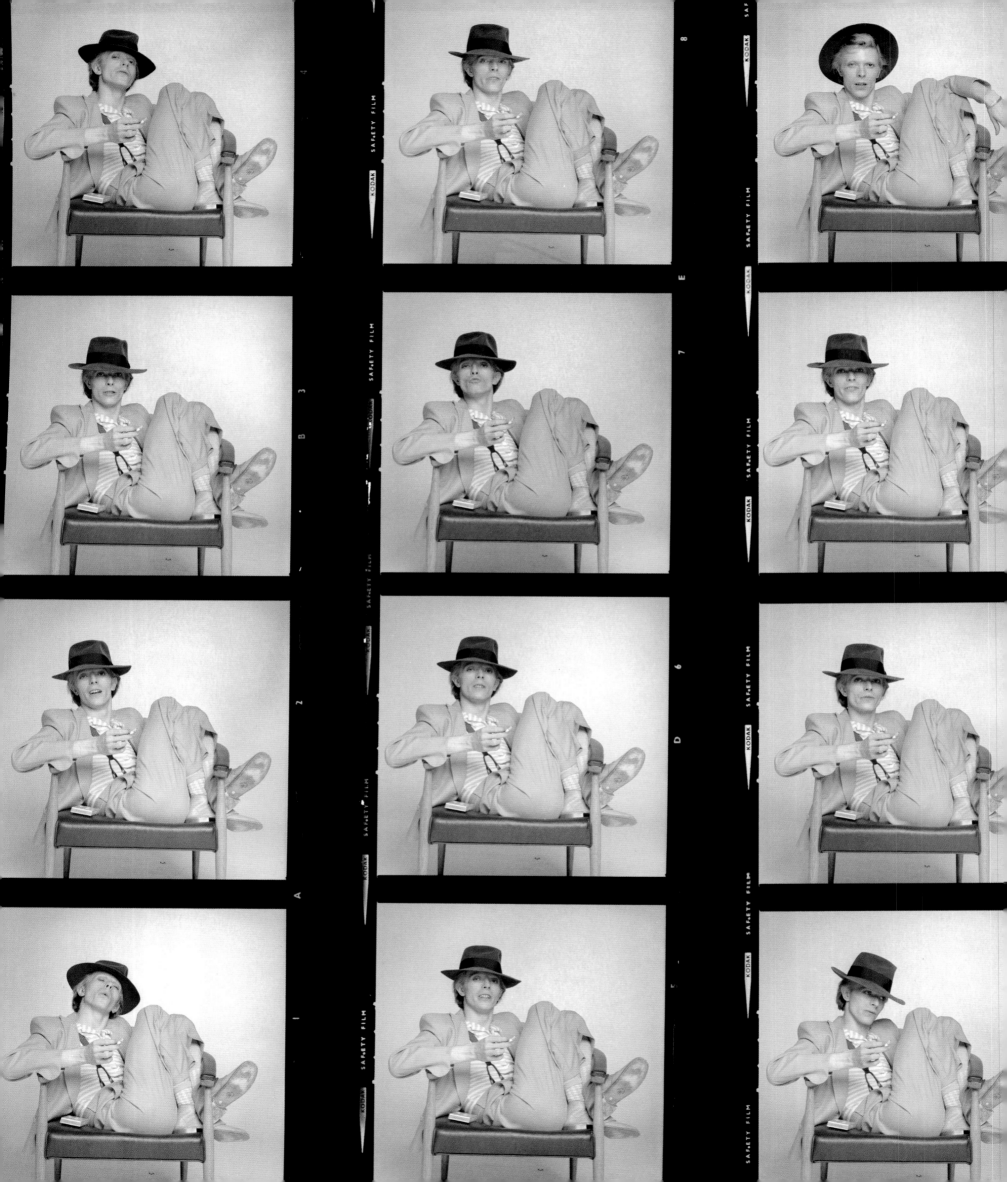

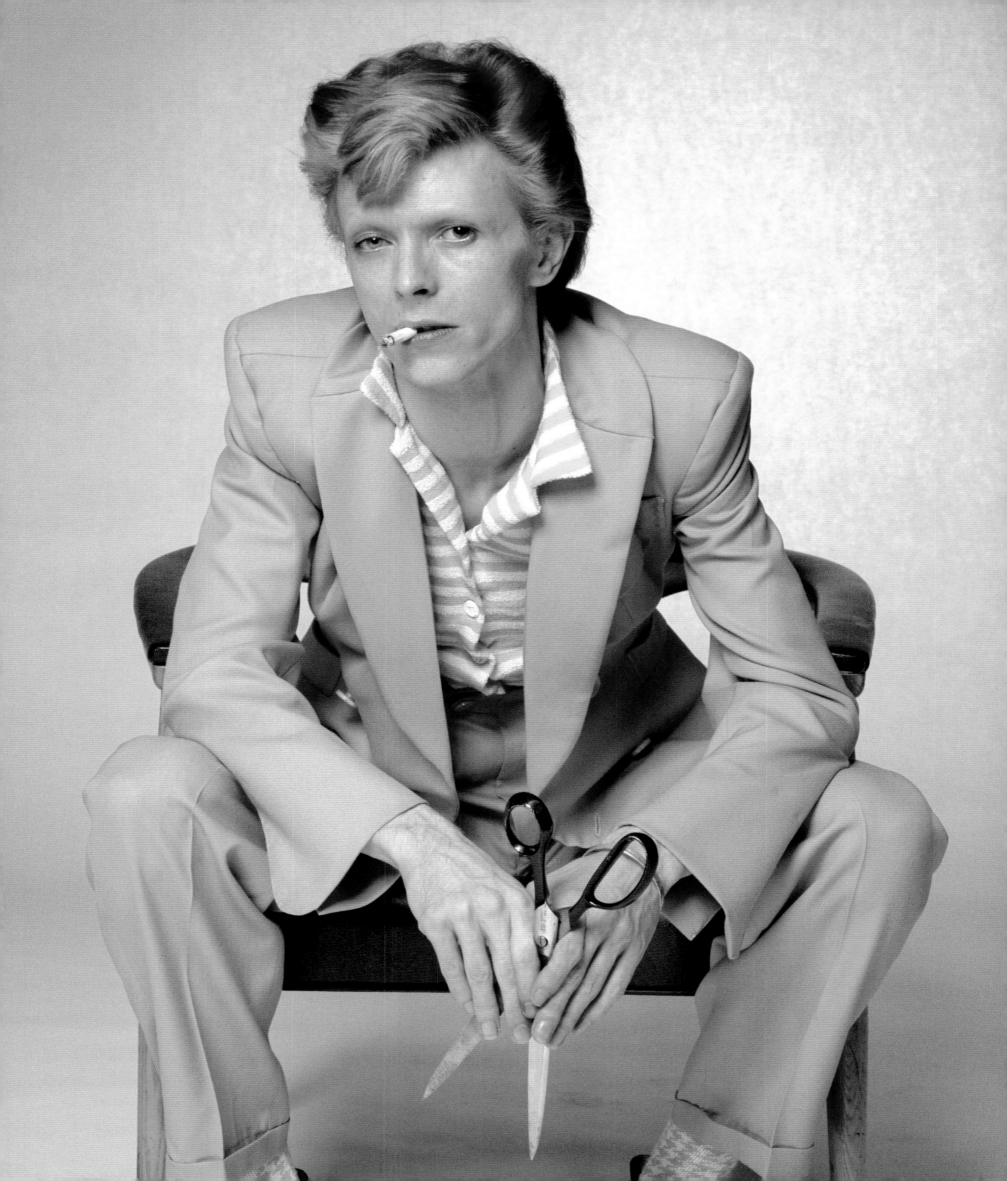

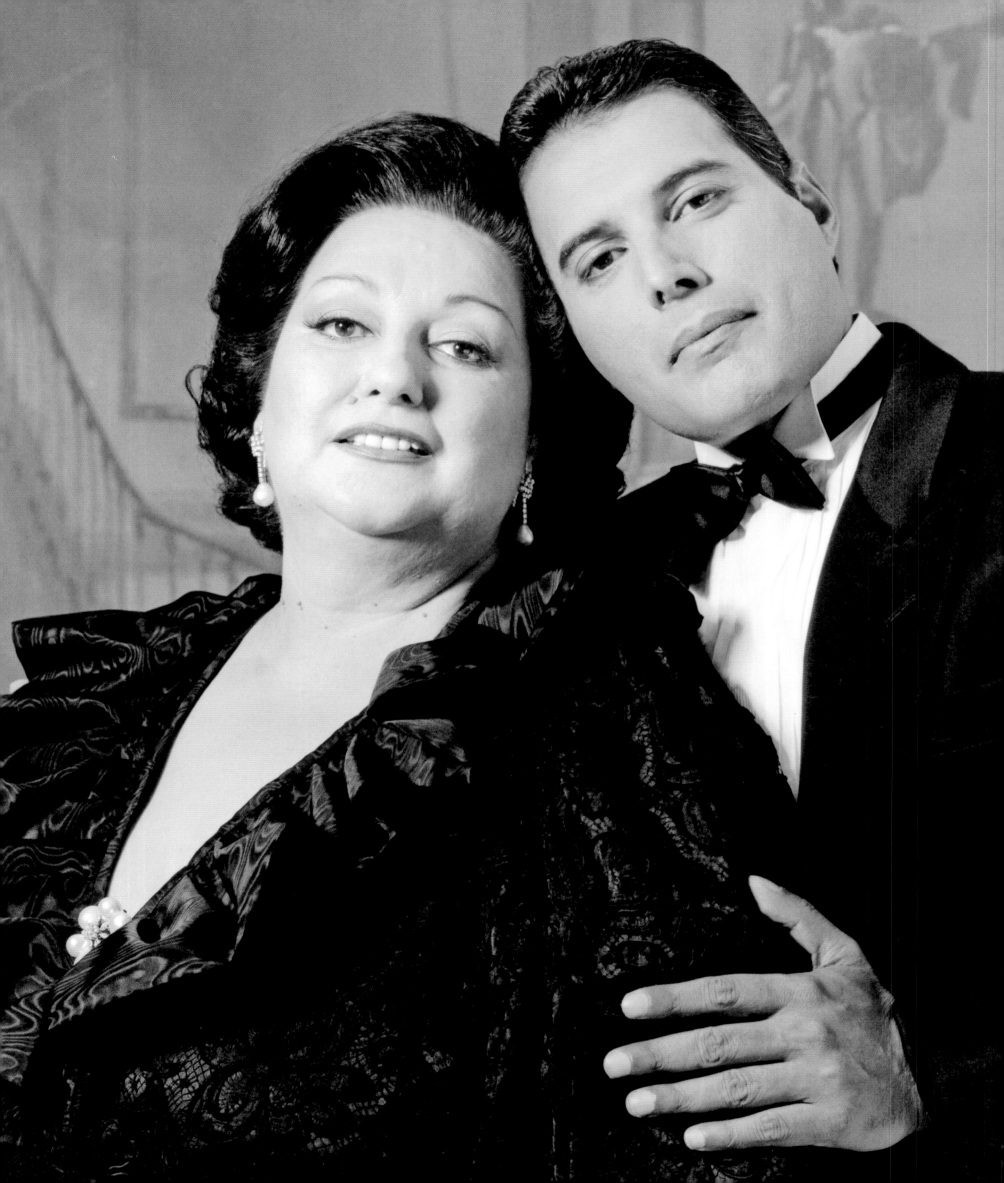

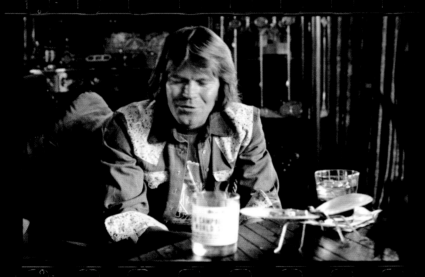

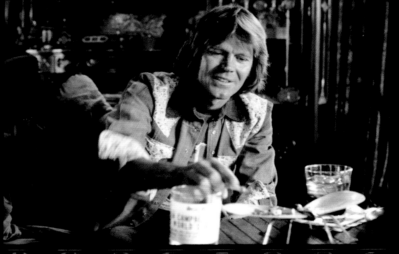

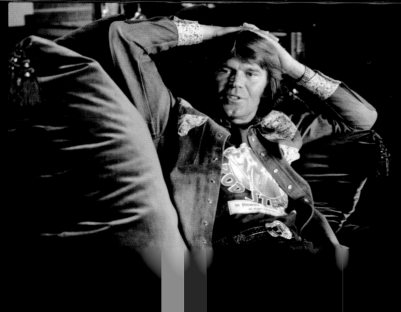

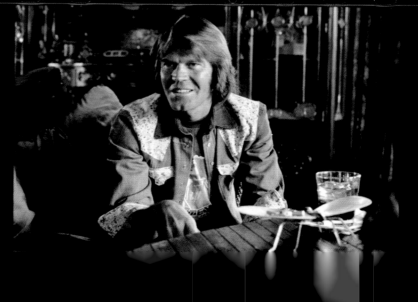

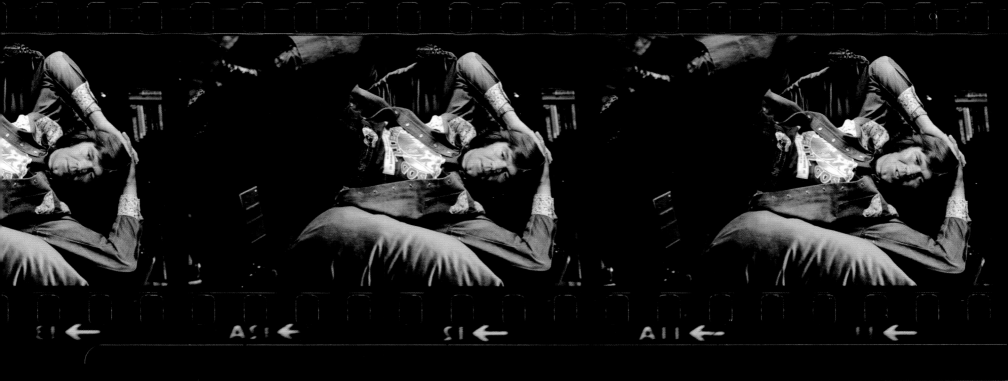

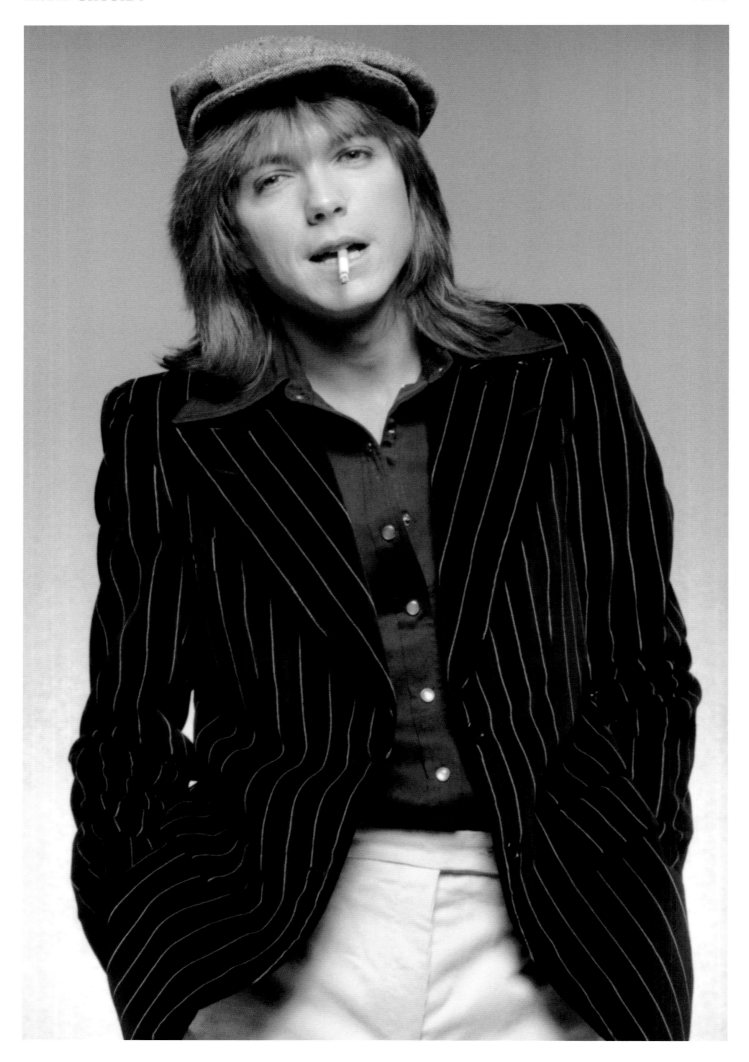

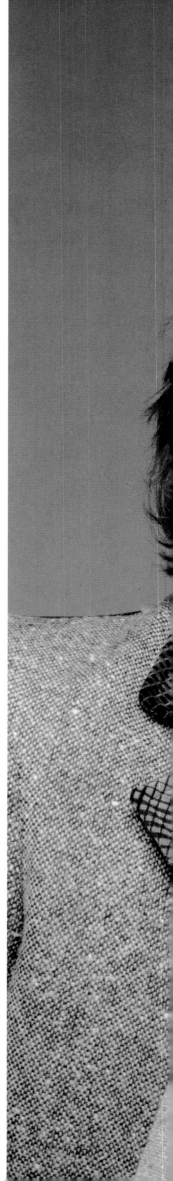

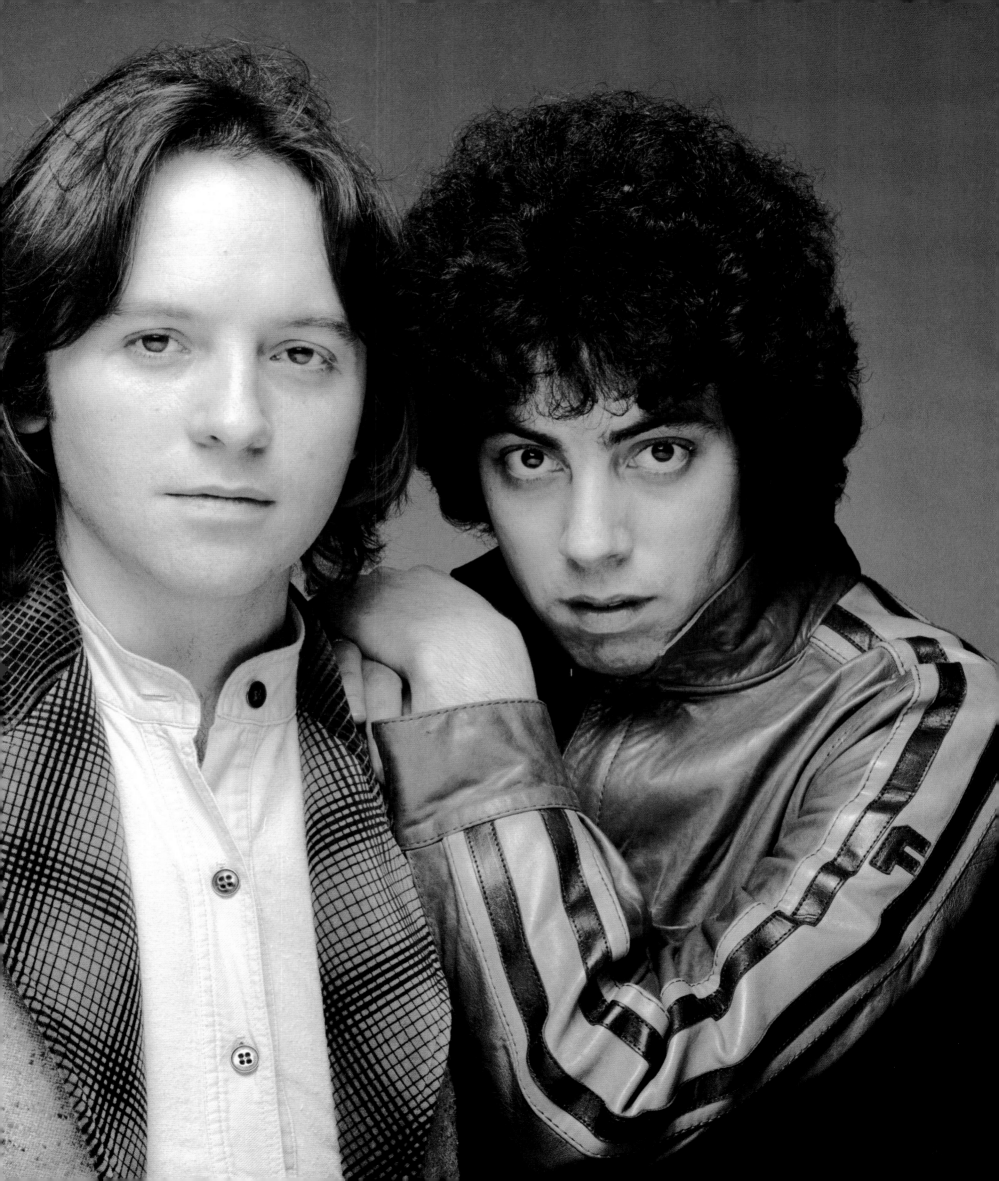

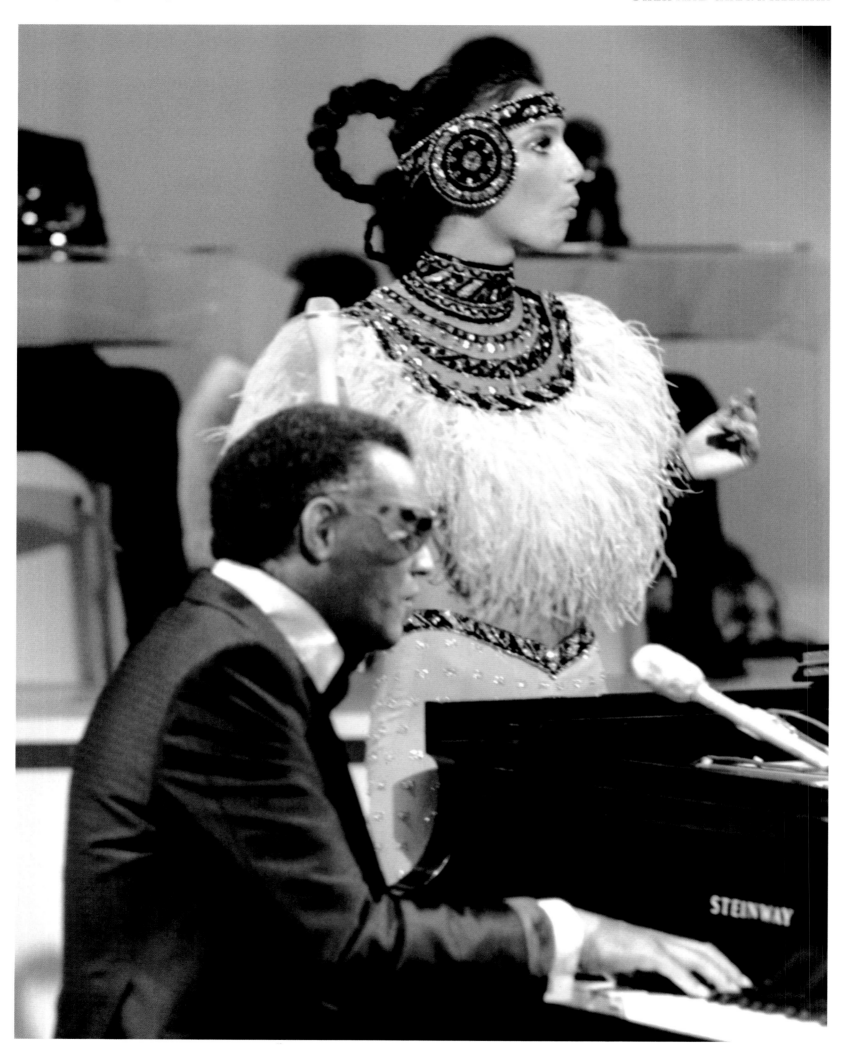

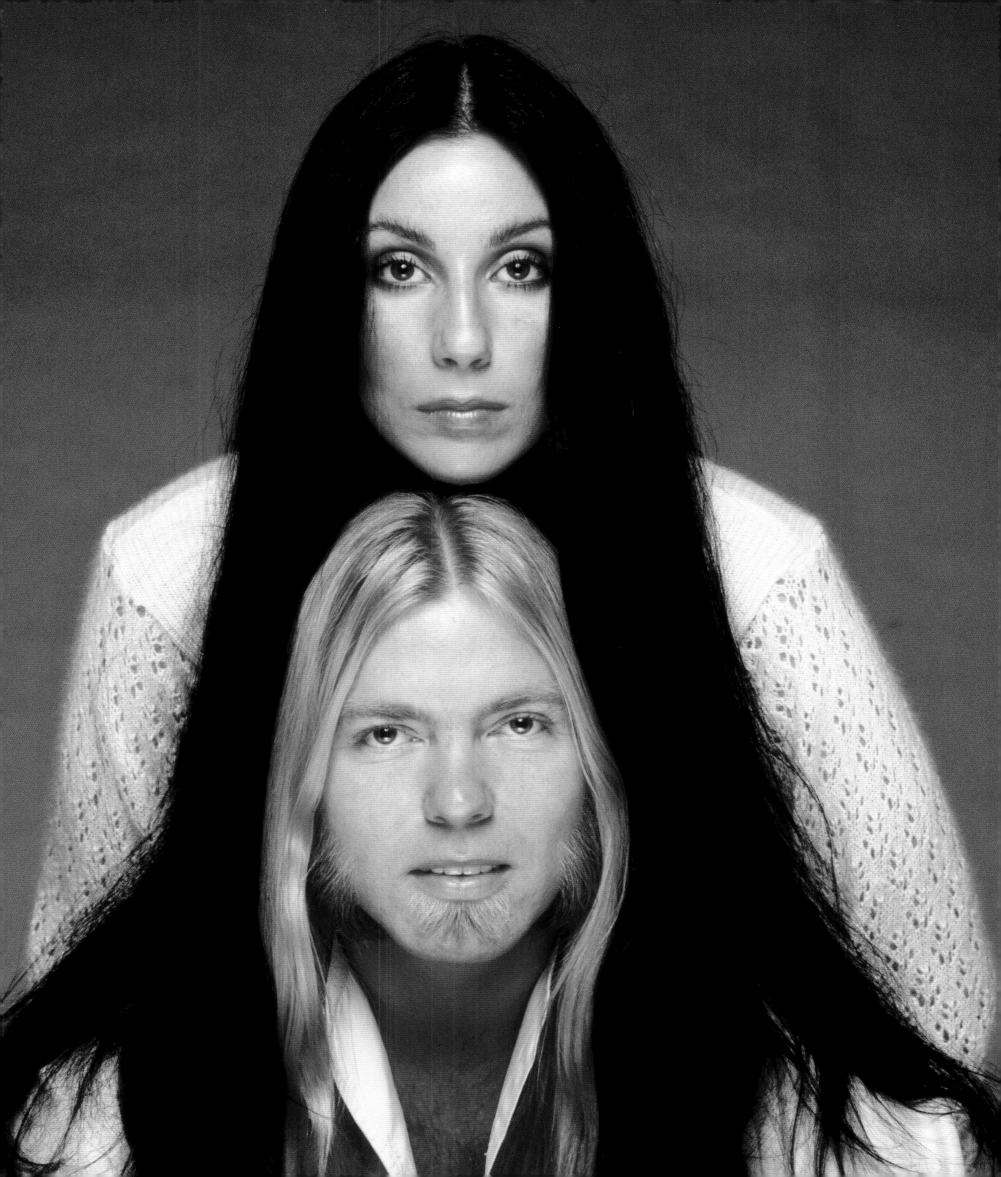

ERIC CLAPTON

If there's one photograph that sums up the man, it has to be this one. Eric, eyes closed, ears tuned, lost in the sounds he's making with his Fender — a musician totally immersed in his art. That's Eric Clapton. The dedication, the concentration, the constant attention to detail. Every note is important to him. That's what makes him one of the greatest guitarists of all time, along with Hendrix and Keith Richards.

Eric has always been a man who is uncompromising. It's not about the fame or the money, it isn't even about the audience, although he always draws an educated and appreciative crowd, wherever he is in the world.

I don't think he would care if 10 or 10,000 people turned up to hear him play, because really, he plays for himself. He'd play to a brick wall just to get the best out of his guitar. So often on tour, he'll get away from the crowds and turn up at a little blues club if he hears there are good musicians playing and ask, respectfully, if he can jam with them.

Eric tunes out on stage. He's often said that if he had to worry whether the guy in the front row was enjoying the music, it would be a distraction — he'd rather listen to his music and concentrate on searching for quality. He's always been like this — in the Sixties when he was a 16-year-old kid starting out with The Yardbirds, he was so determined to improve that he'd quit a band if he thought they were becoming too commercial or putting popularity and fame before the music he loves.

The other thing about Eric is that it was never about just playing the best, or with the best. He wanted, and still wants, to contribute, to add, to take it to another level. He could just sit back and be the best blues guitarist in the world; he could just sit back and enjoy his fame and wealth. Instead, he goes in search of more. A tour drains him emotionally and intellectually, because of the investment he makes, not in energy and stamina, but in the intellectual pursuit.

It's inspiring to watch someone like Eric, who always feels there's room to improve, that they can never be good enough. I've always believed true artists are their own worst critics — they are

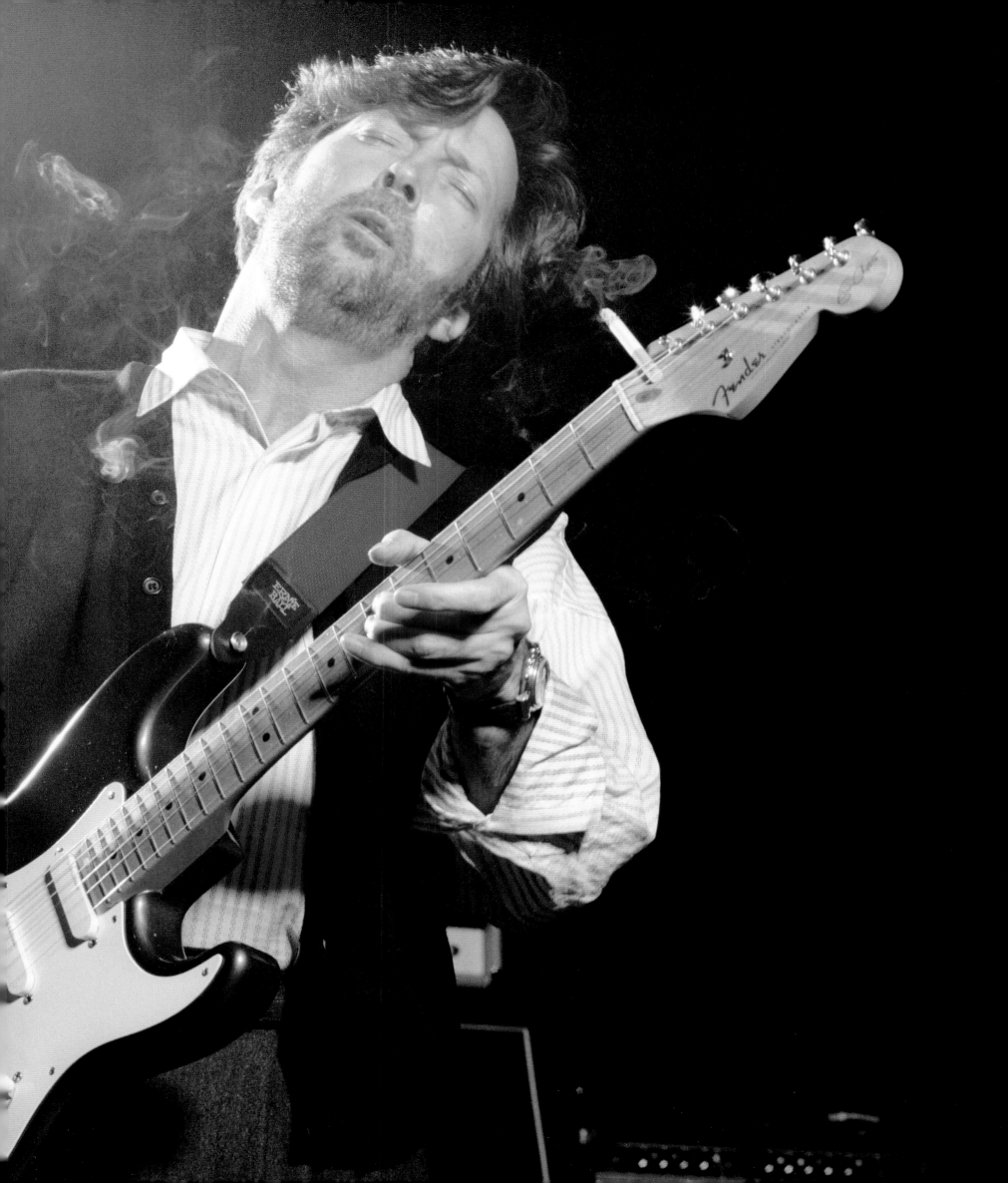

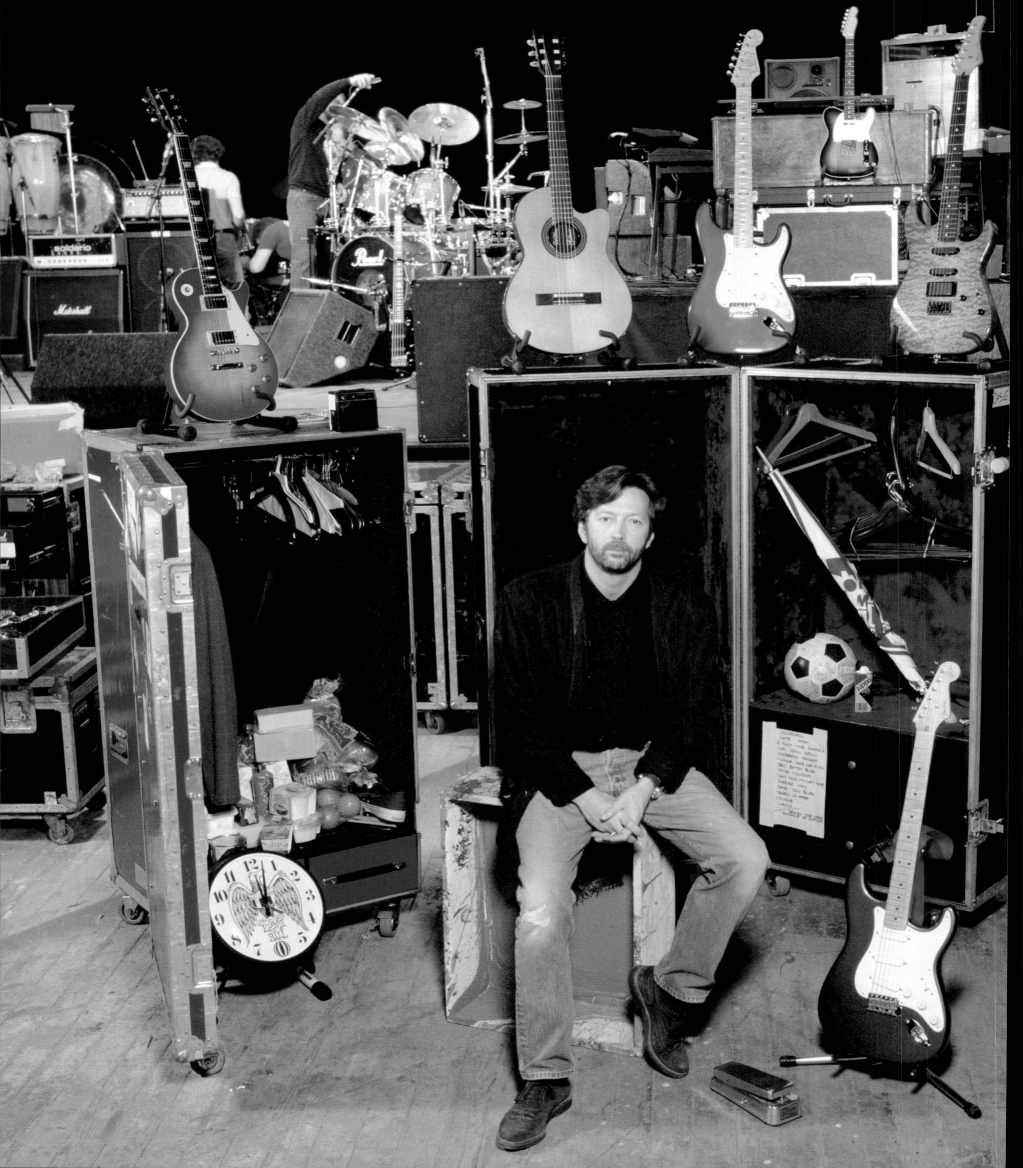

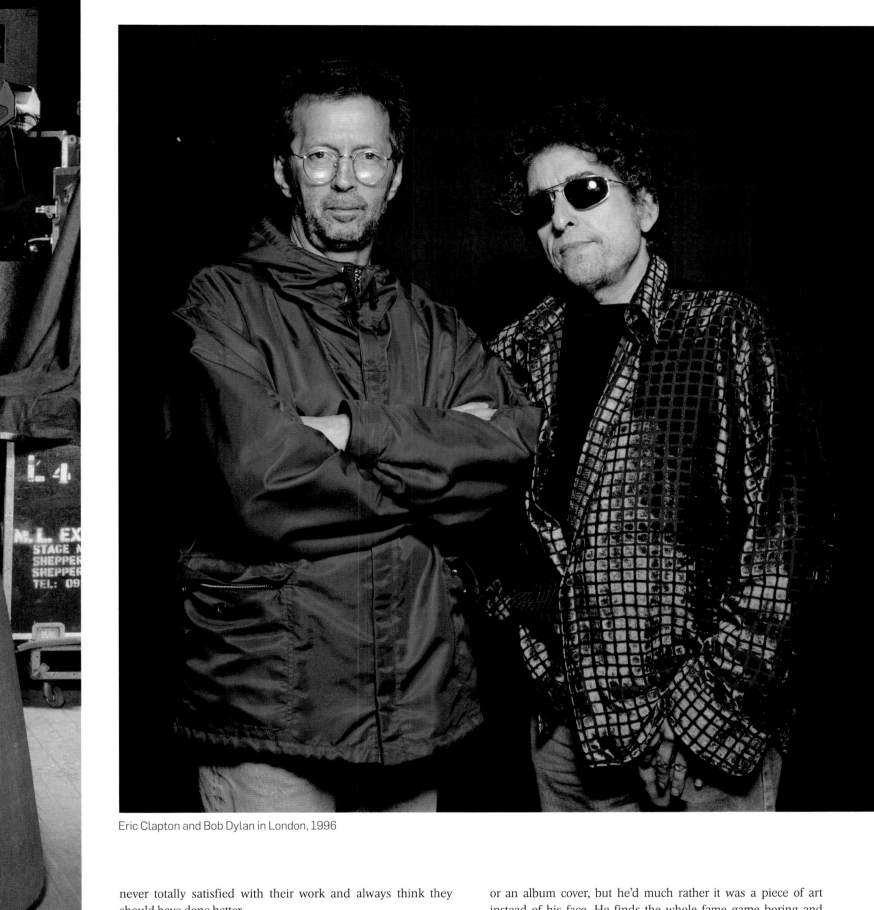

Eric Clapton and Bob Dylan in London, 1996

never totally satisfied with their work and always think they should have done better.

That's what drives Eric, 50 years after he first picked up a guitar, he's still trying to get better when the world already regards him as the best. He would probably hate me for saying this because he's such a private and modest man. He's far more at home talking about football or motor racing than himself and rarely gives interviews, as he doesn't like talking about himself. He doesn't even like putting his portrait on an album or a poster. I remember someone wanting to put my photographs on T-shirts and out of courtesy I asked Eric if it was okay. He just said, I'd rather you didn't. He knows that he has to have his image on his biography

or an album cover, but he'd much rather it was a piece of art instead of his face. He finds the whole fame game boring and avoids it as much as he can.

A few years ago, I did a photoshoot with him in rehearsal at a London concert. Knowing Eric as I do, I knew he'd hate having to pose, so I put him among all his guitars — you'd be surprised how many he can get through in a gig, they are beloved tools and each has a specific role to play in his hands.

It's strange to think that when I was so busy chronicling the 1960s, Eric and I both frequented the same clubs, but we never really met until much later. He was great friends with my pal George Harrison (they married the same girl, my friend the

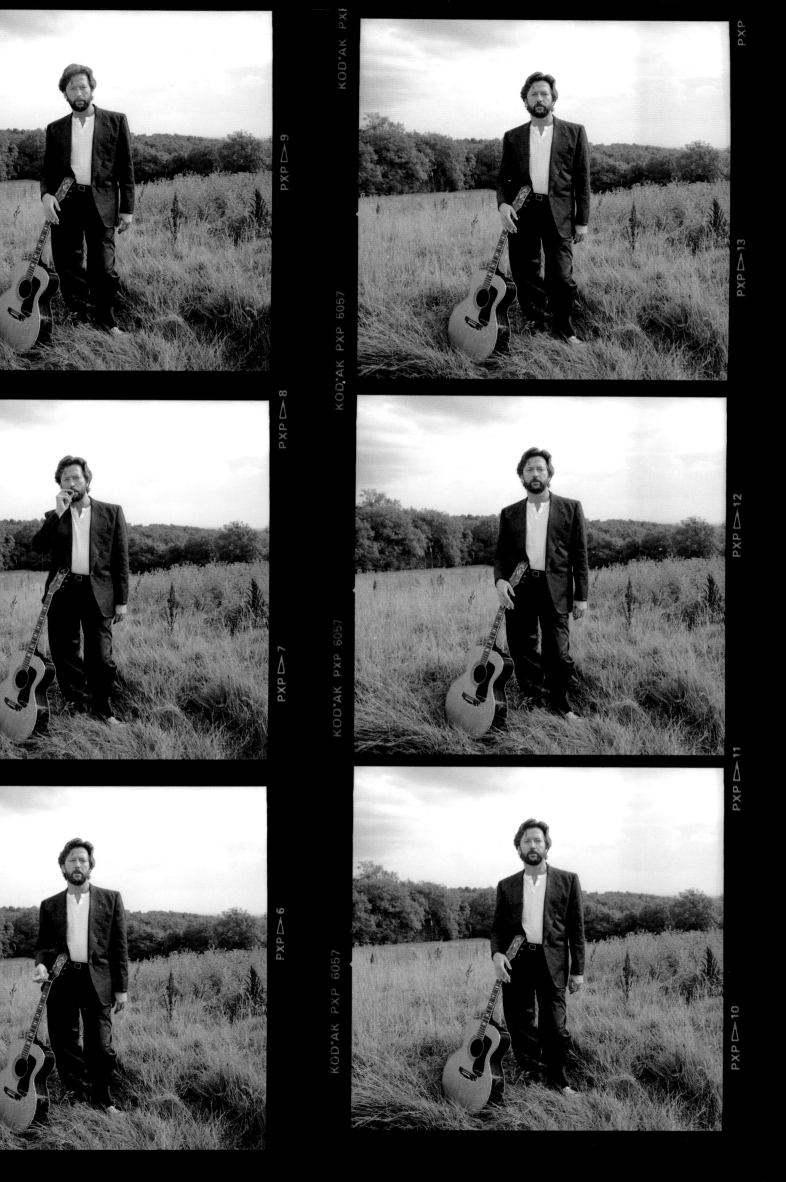

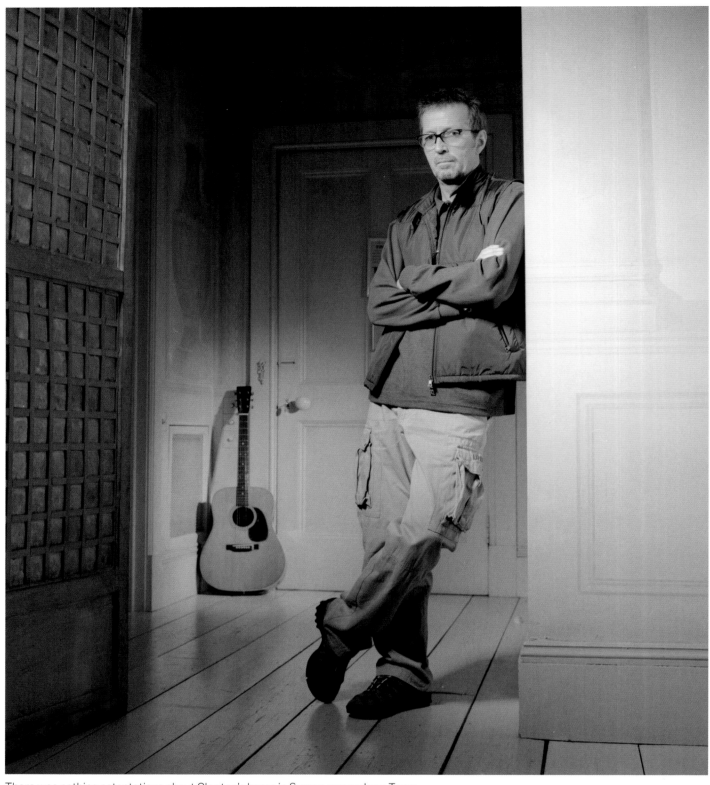

There was nothing ostentatious about Clapton's home in Surrey, remembers Terry

Sixties supermodel Pattie Boyd, who married Eric after her divorce from George). They all remained firm friends, even through the haze of the drug days, yet my path didn't cross with Eric until the 1980s.

I was asked to photograph him at his home in Surrey. At a time when rock stars had their big stately home estates, Eric's was comfortable, nothing ostentatious — other than his collection of cars, which he loves, like his guitars. I took him into the fields behind the house, and the shoot was over in minutes. You couldn't take a bad shot of him. Eric is a hugely charismatic man.

But there's a quietude about him that is compelling — he is a commanding yet simple man. He doesn't need to shout about himself, he just lets the music speak for him.

Bob Dylan is another just like him. There was a day when Eric and Dylan were on the same bill and I was backstage at the gig with Eric. I just knew this was a perfect moment. I'd photographed Eric, Chuck Berry and Keith Richards all together in the 1980s, three of the greatest of all time in one shot. I think it's the only time anyone got those three together.

Here was another chance. Clapton and Dylan, the wise old gurus of rock 'n' roll, perhaps the two most original artists of their age. I couldn't let it pass. Dylan's another hugely private man who hates the camera, so getting them together was a serious moment for me. After decades photographing the greats, opportunity and luck could still present itself and I could still get excited to be behind a camera. Another chance of a lifetime ∎

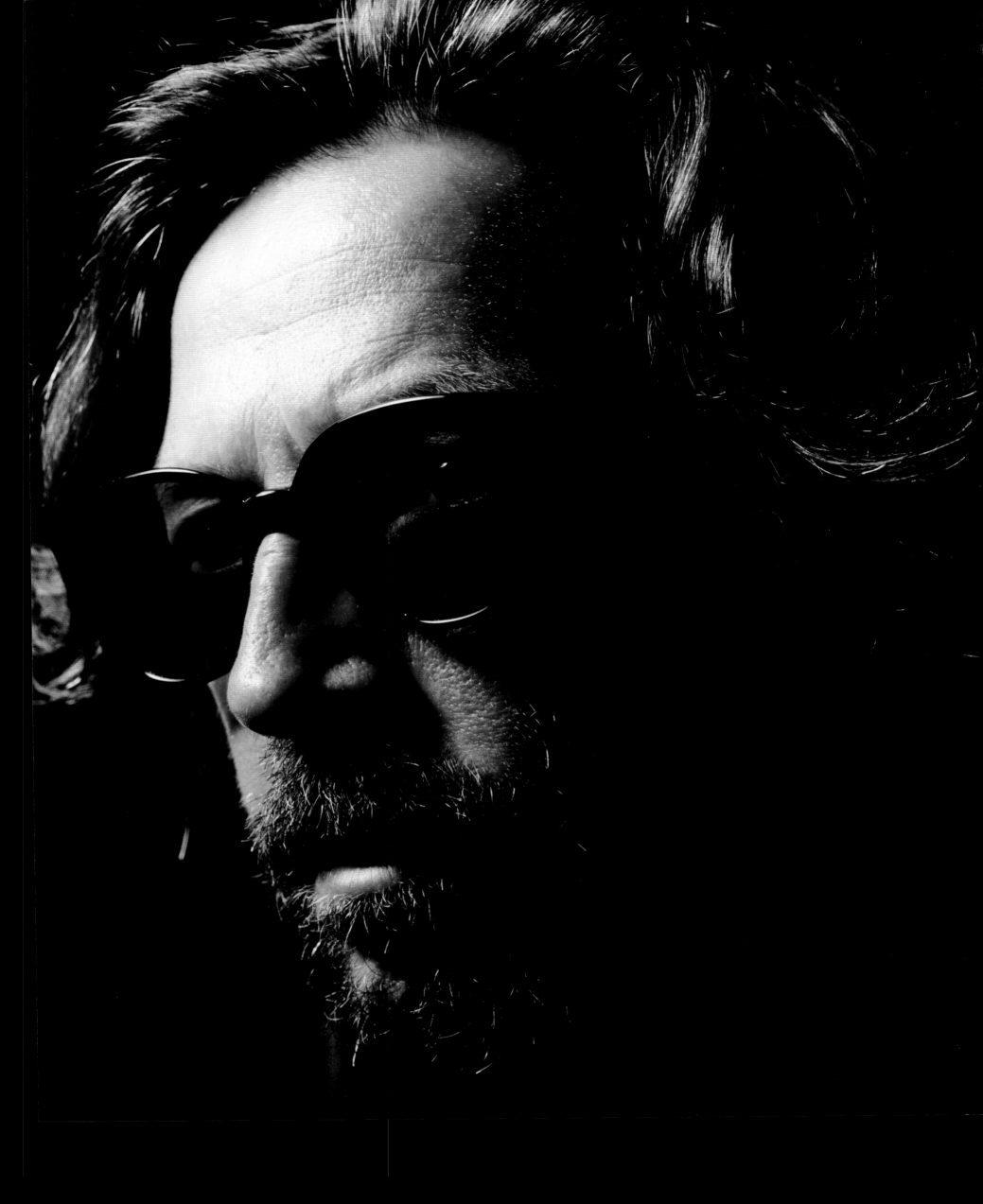

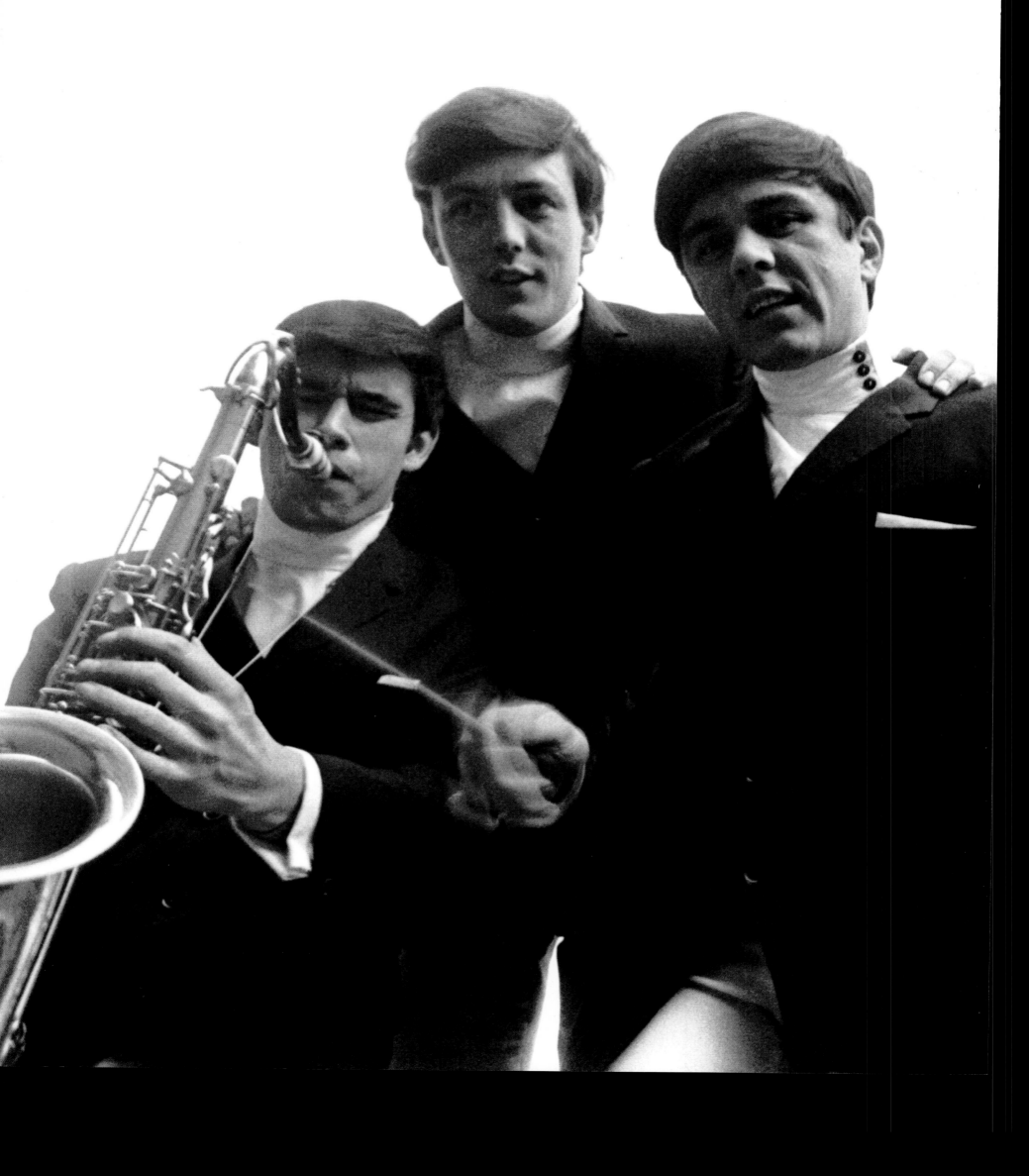

KODAK SAFETY FILM

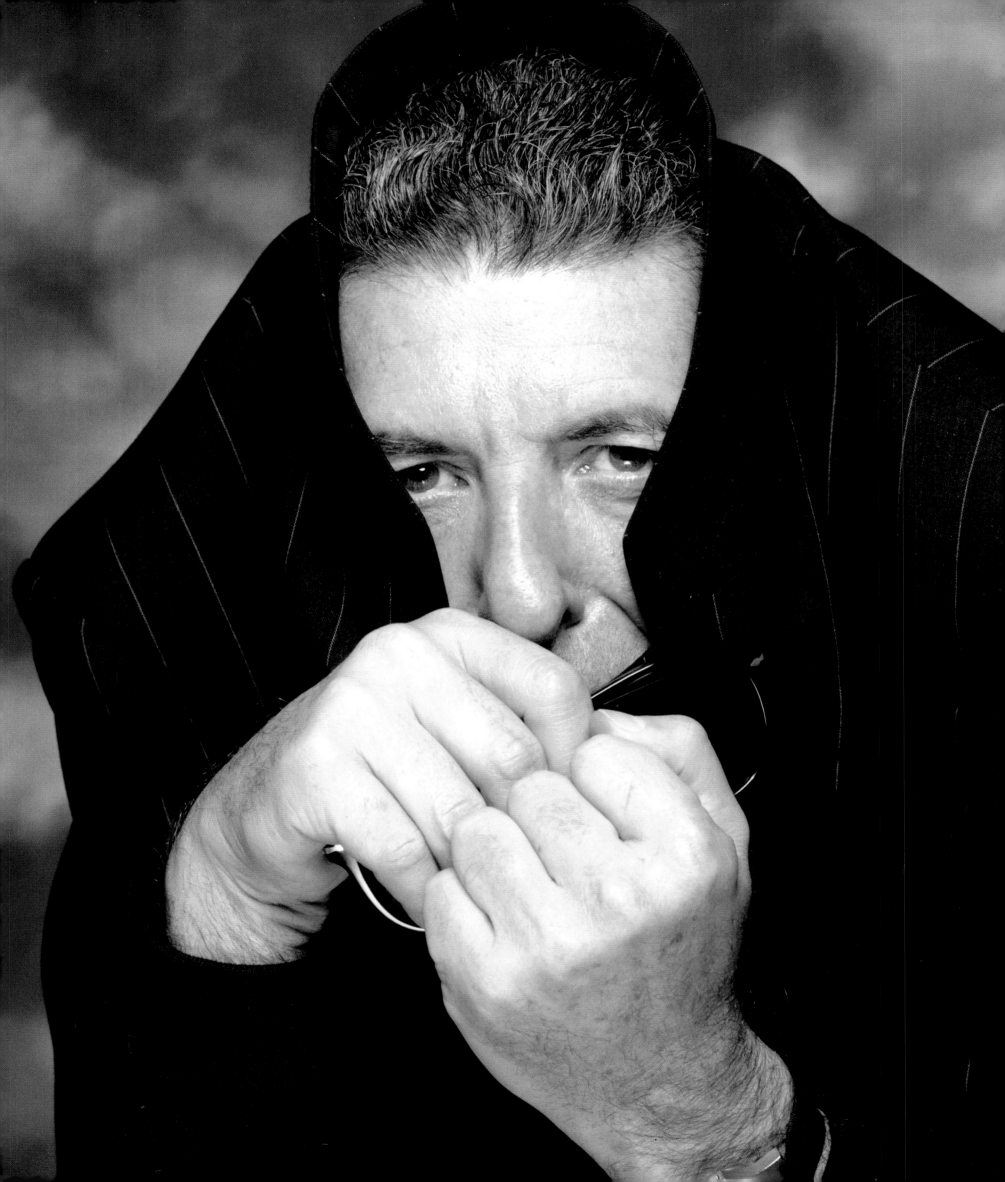

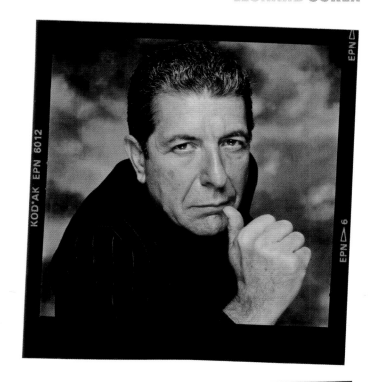

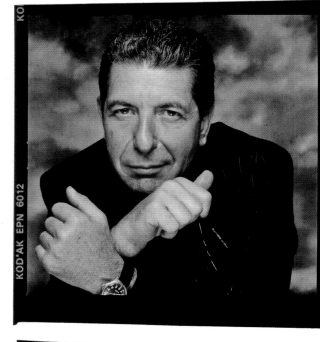

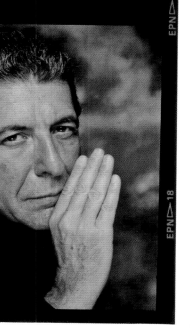

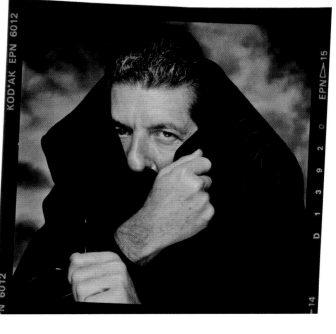

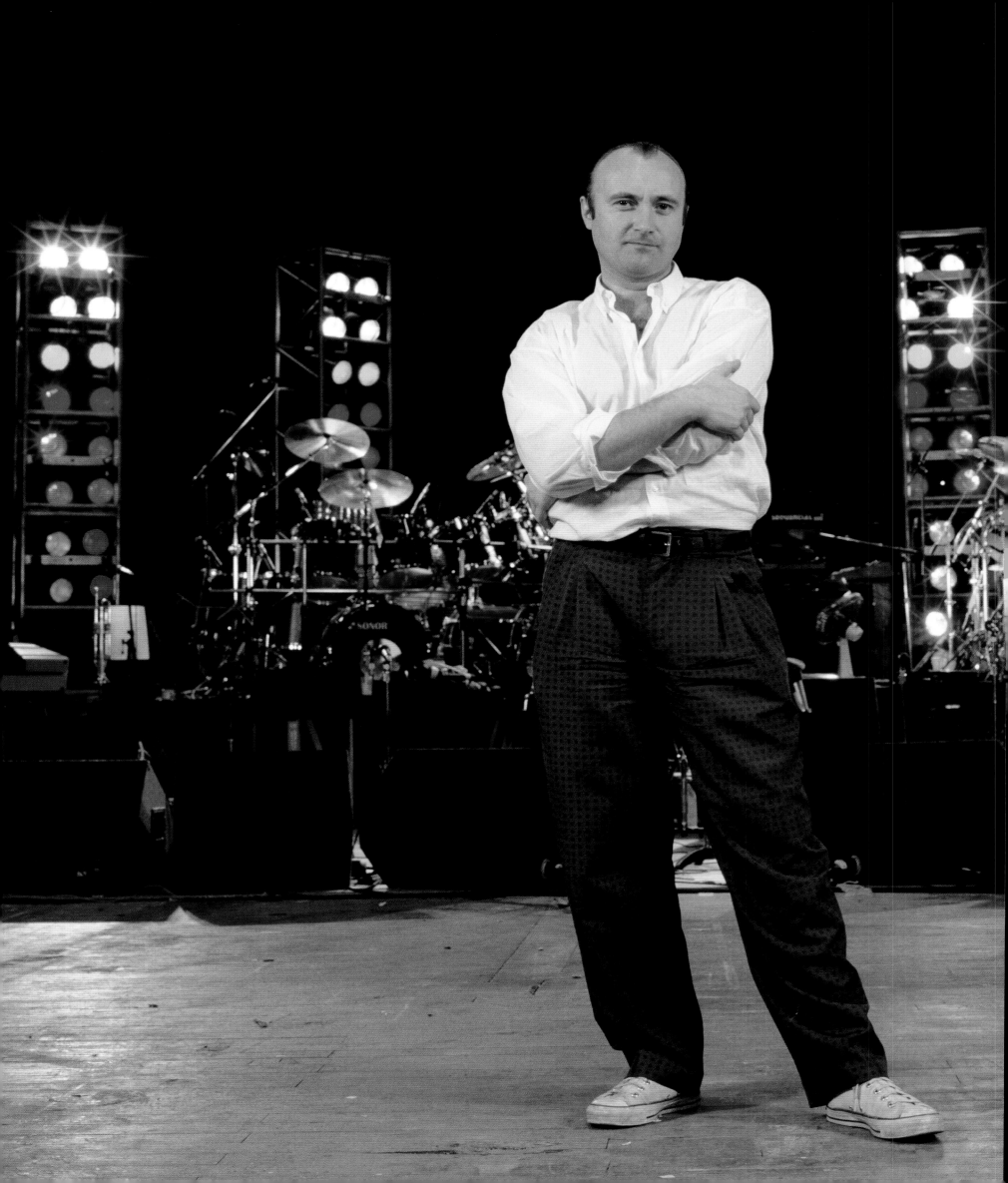

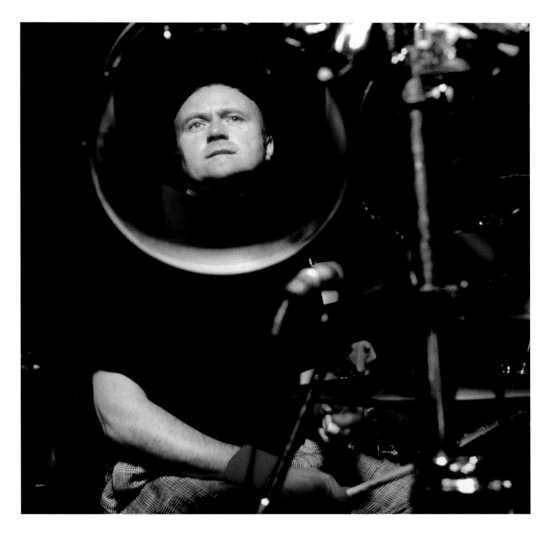

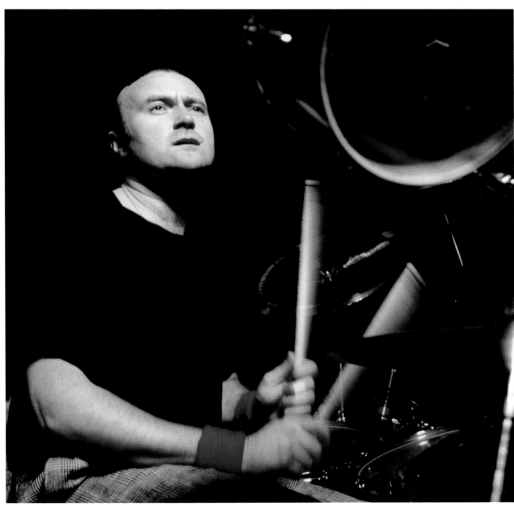

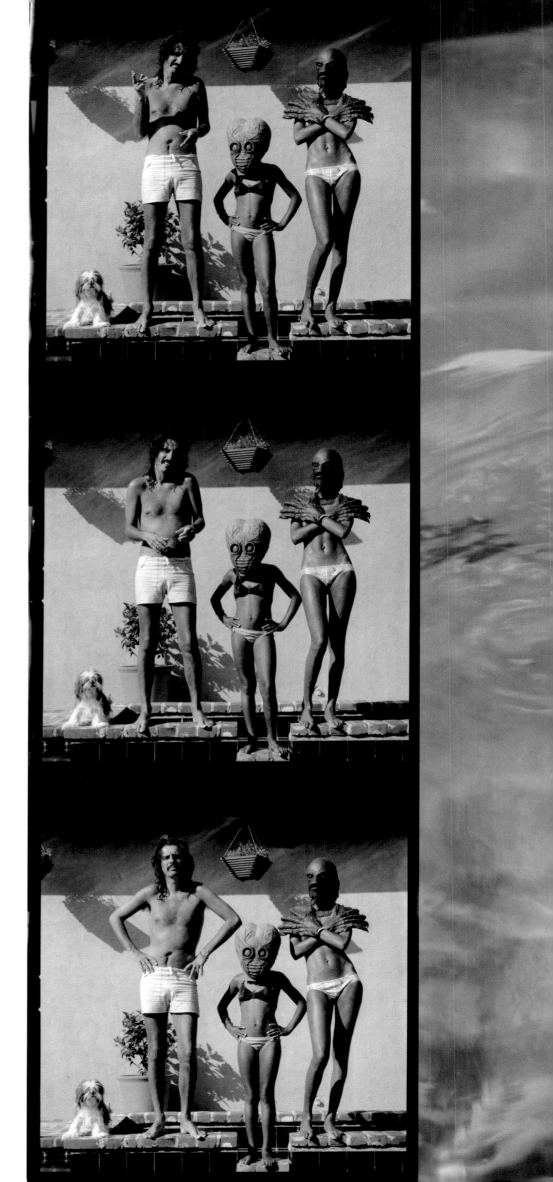

> *"You'd think Alice was some crazed monster who ate babies for breakfast, but in real life he was completely the opposite to that 'shock-rocker' who used guillotines, fake blood and vampires on stage"*

ALICE COOPER

Don't laugh! Seriously. Alice Cooper (real name Vincent) has to be one of the most charming gentlemen I've ever had the pleasure to photograph. You'd think he was some crazed monster who ate babies for breakfast, but in real life he was, and is, completely the opposite to that "shock-rocker" who used guillotines, fake blood and vampires on stage and wore horror-story make-up. By 1975, he had dealt with his demons (drink and drugs), and a funny, intelligent sweetheart had emerged.

He was bringing out an album, *Welcome to My Nightmare* — a typical Alice Cooper gothic-rock title — and I wanted to do something different. I wanted to write his story in photographs, his battle with drink, drugs and how it could have killed him. I wanted to illustrate "his nightmare".

He immediately grasped the idea. I photographed him out-of-his-head lying on a bed of empty booze bottles. I took him to a graveyard to capture how it might have ended if he hadn't got control of his drinking. In between, I spent days with him at his home in Los Angeles. He was full of fun and surprises.

One day, he and his wife and little girl emerged by the pool, all wearing masks from that old 1954 black-and-white horror movie *Creature from the Black Lagoon*, which had just been re-released in 3D. He was reading Peter Benchley's novel *Jaws* at the time and the movie had opened, which was another wonderful opportunity to clown around. He was floating in his pool reading the book when his wife pushed this plastic inflatable shark up behind him. We had so many laughs together.

I feel sorry for photographers today working with rock stars and actors. They are manipulated and controlled by management and every image is carefully styled and doctored to sustain the "brand". I was so lucky. I had freedom to be honest, to have fun, to capture character and personality and reality ∎

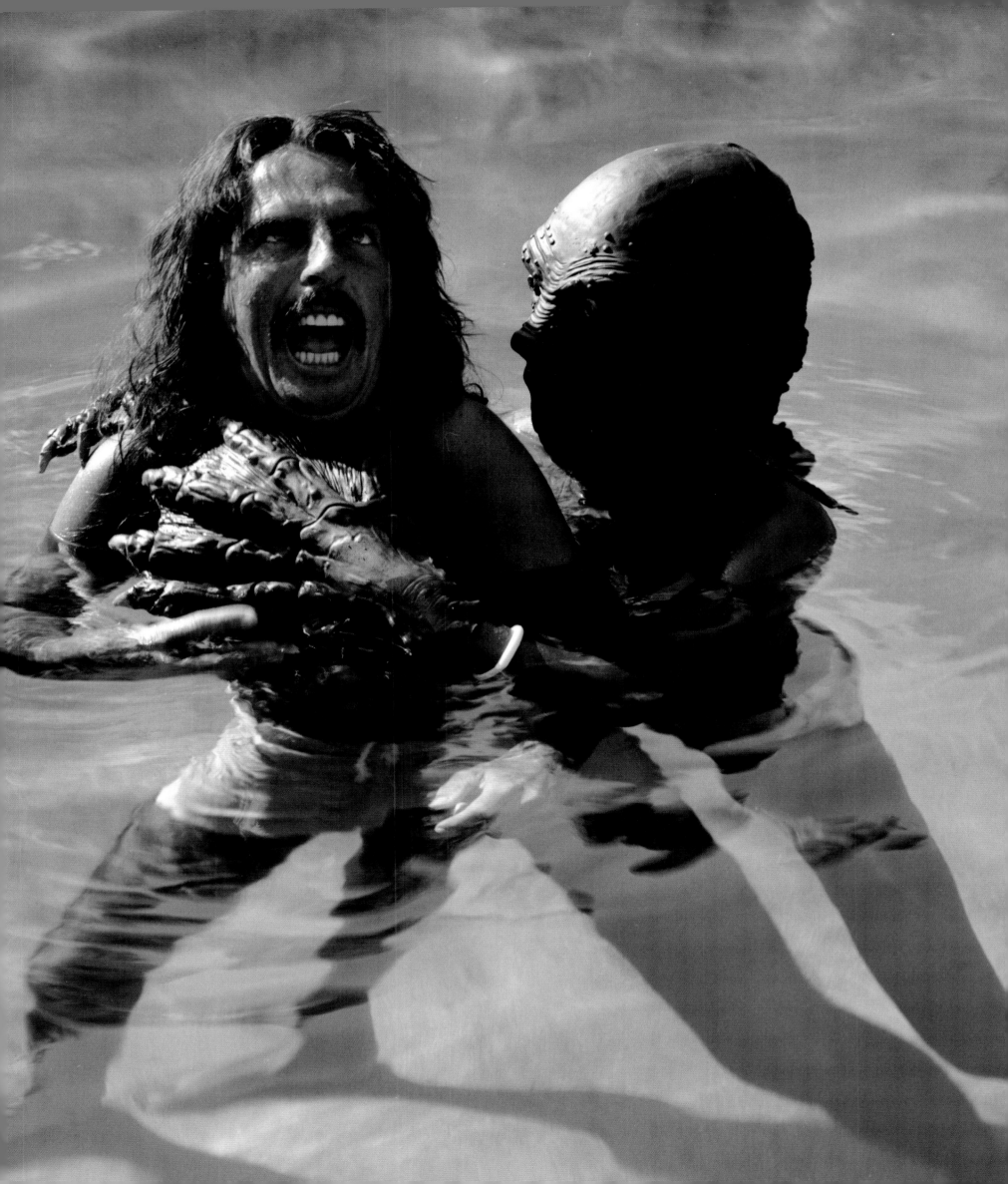

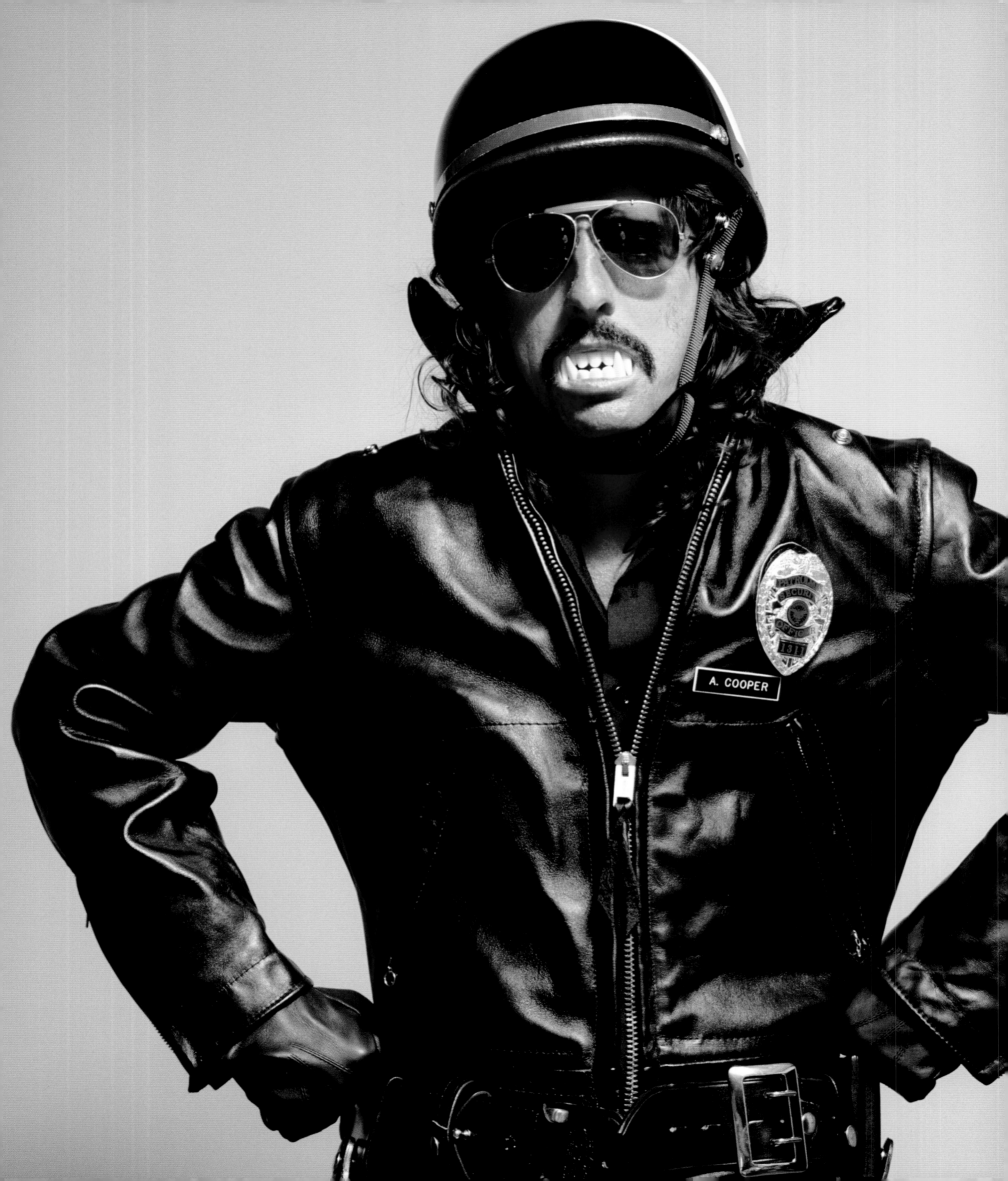

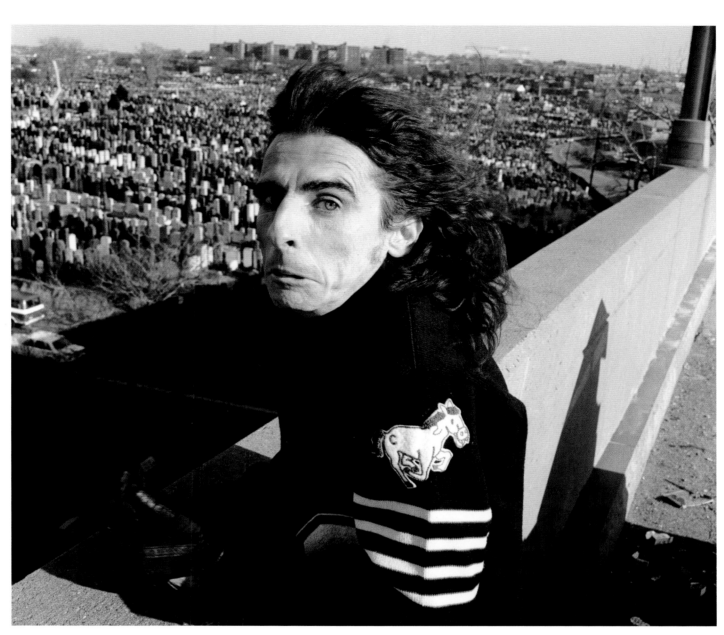

Alice Cooper helped to shape the sound and look of heavy metal and is said to have introduced horror imagery to rock 'n' roll

With the album, *Welcome to My Nightmare*, "I wanted to do something different," says Terry. "I wanted to write Alice's story in photographs, his battle with drink, drugs and how it could have killed him. I wanted to illustrate his nightmare"

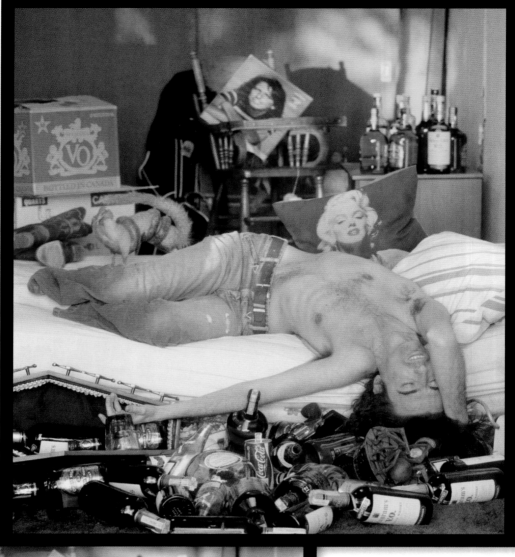

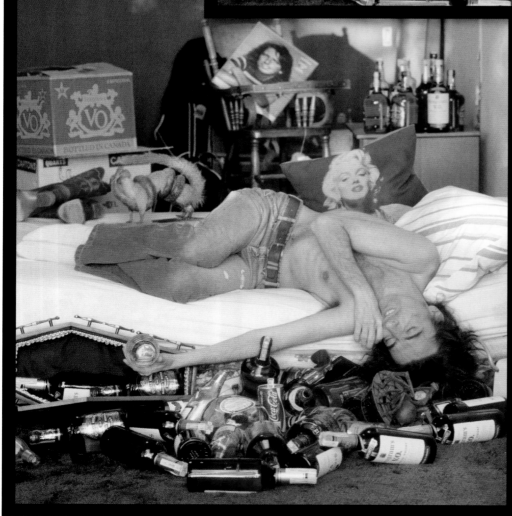

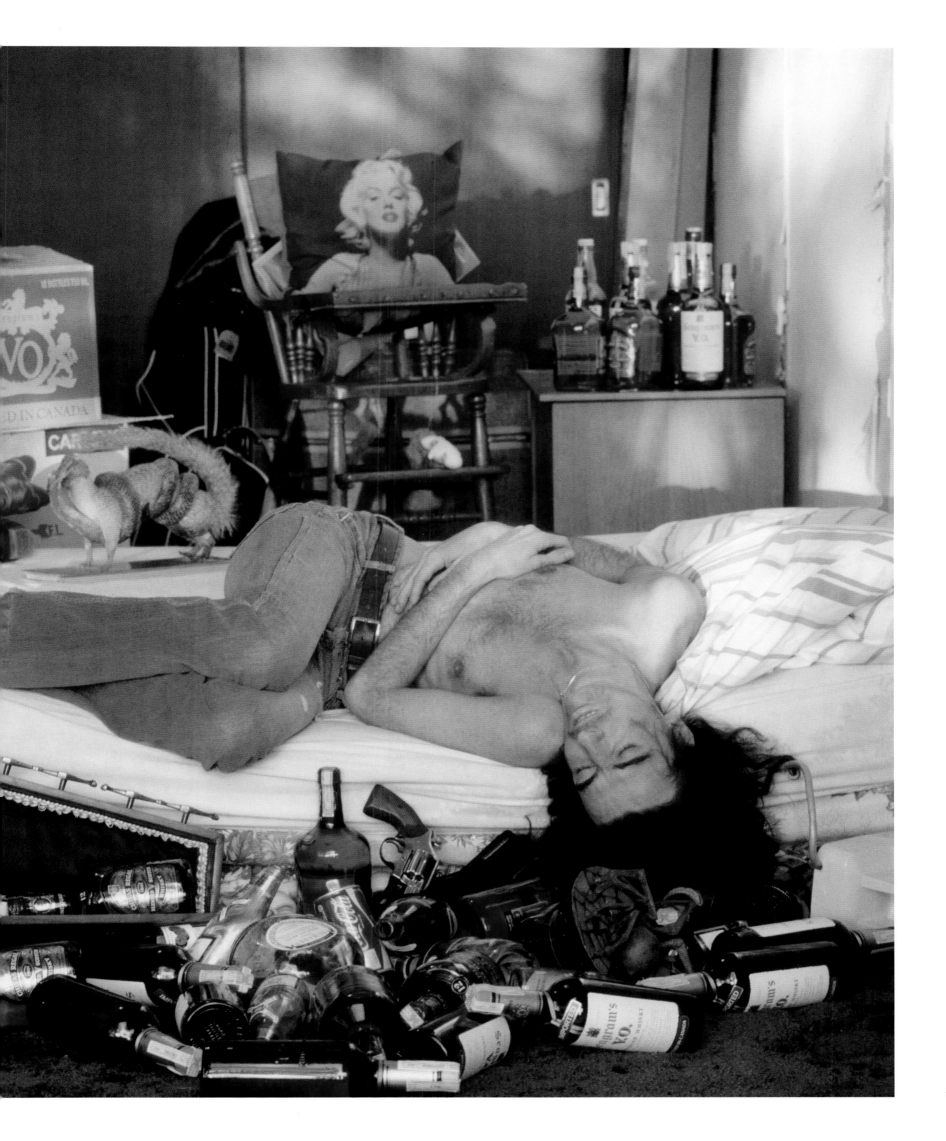

Alice Cooper, playing up for the
camera at home in Los Angeles.
"I had freedom to be honest, to have
fun, to capture character and
personality and reality," says Terry

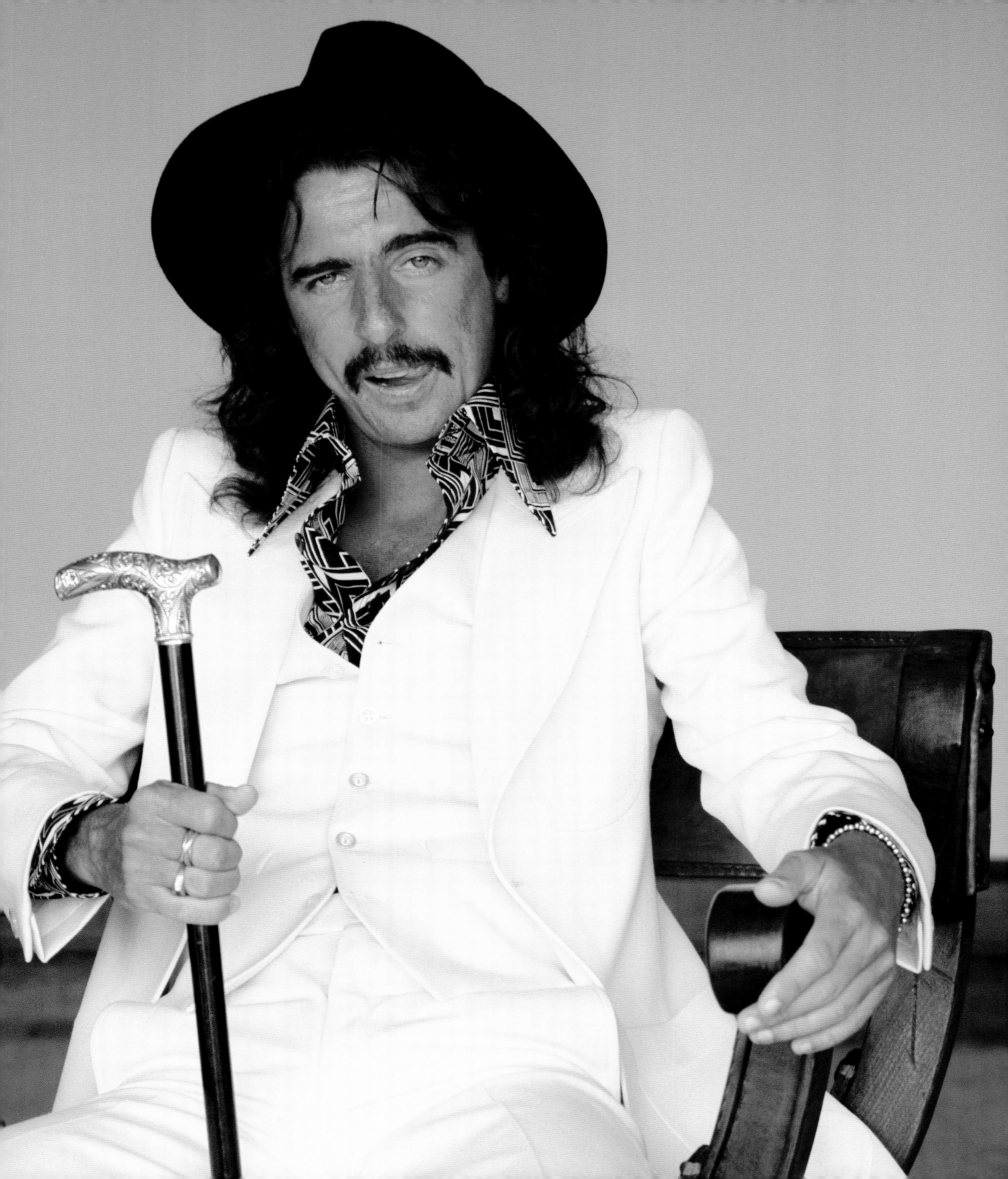

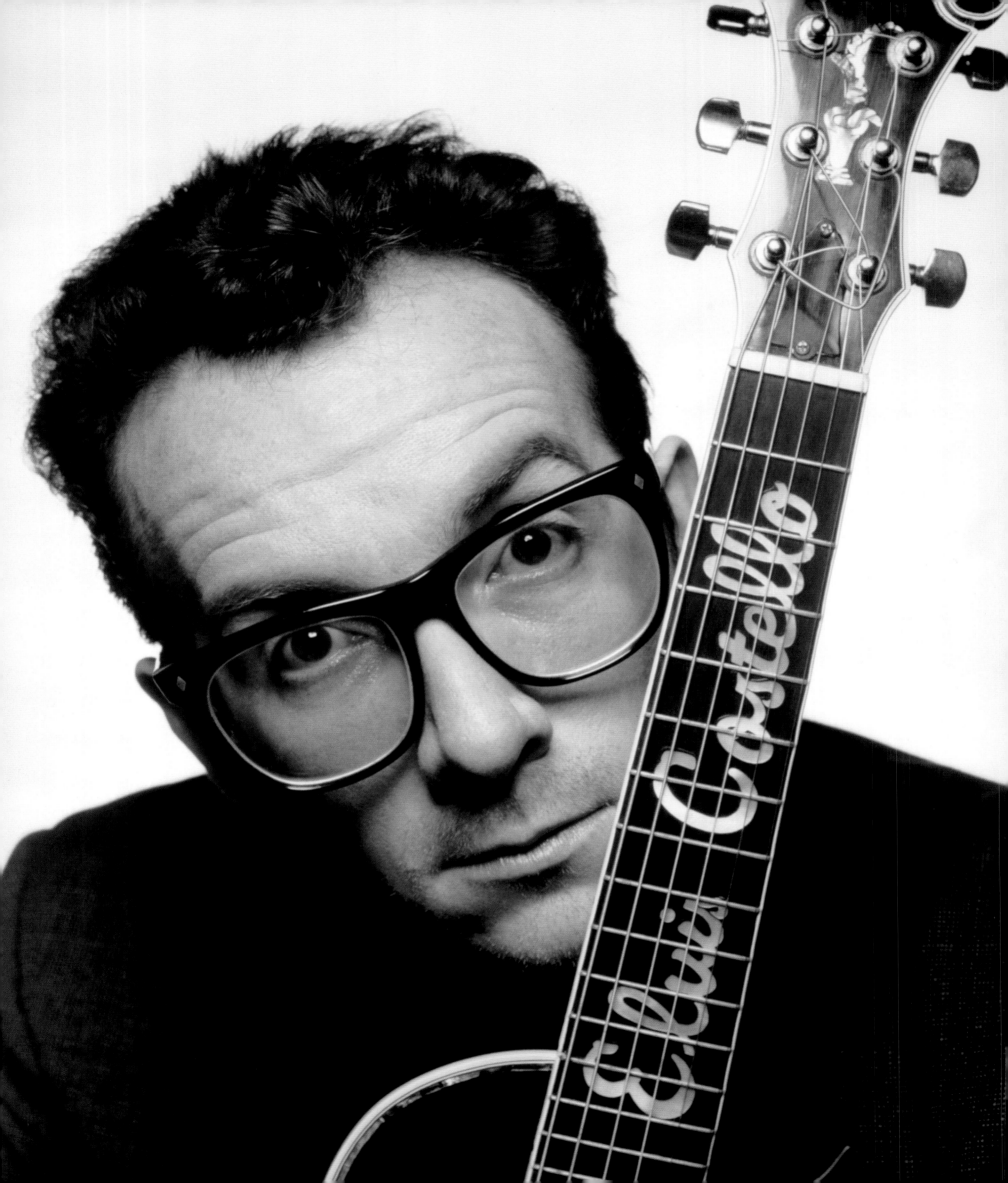

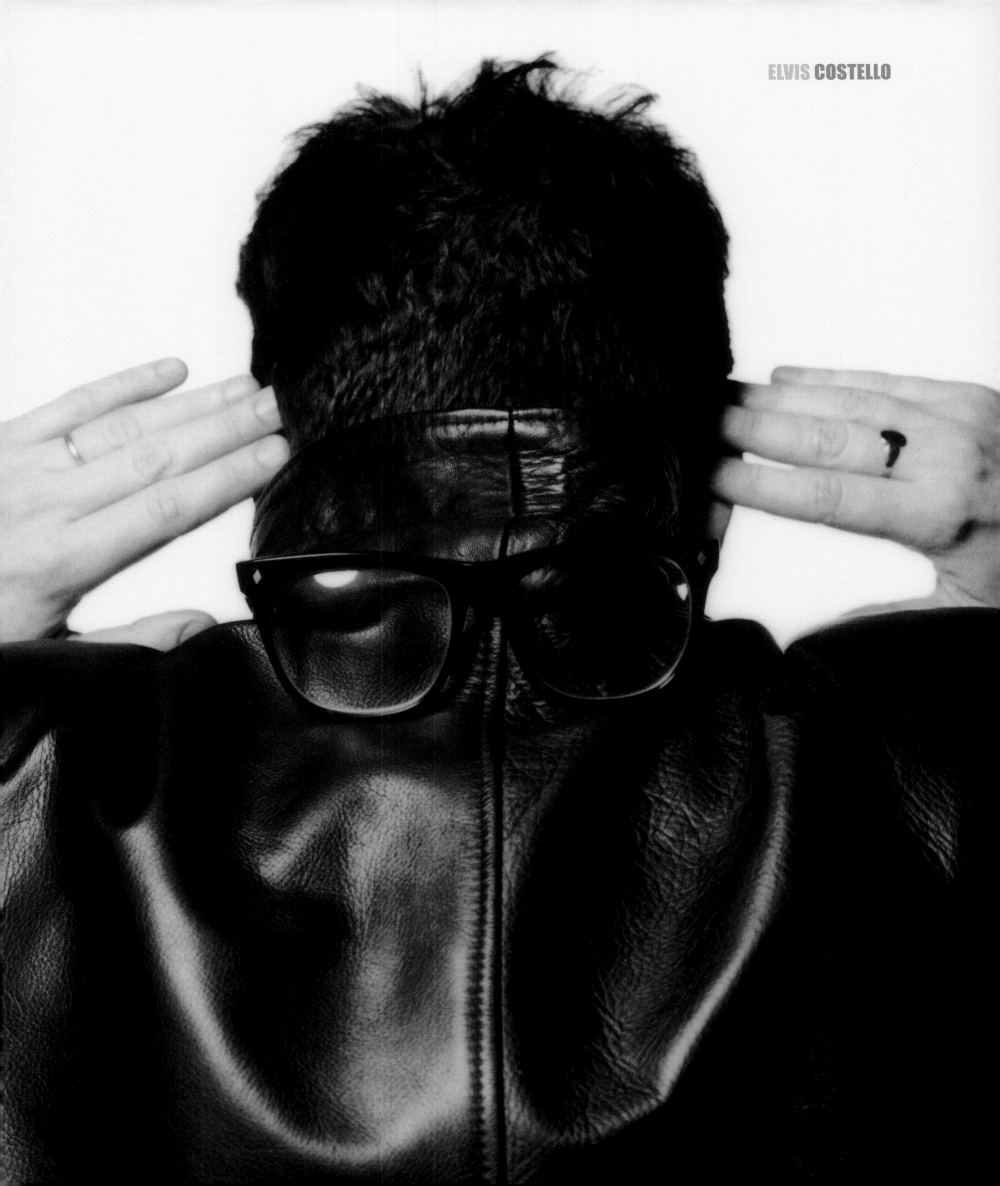

ELVIS COSTELLO

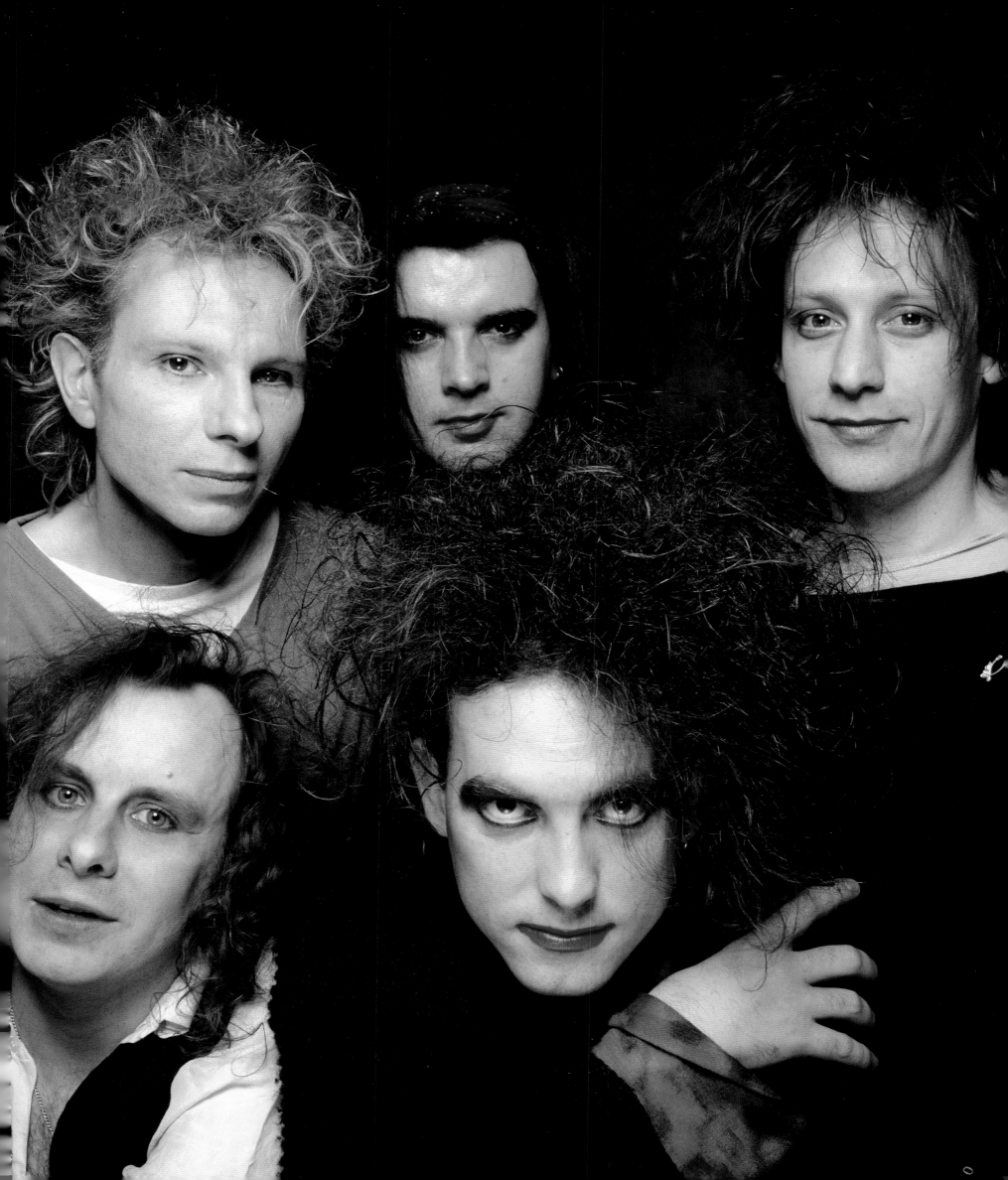

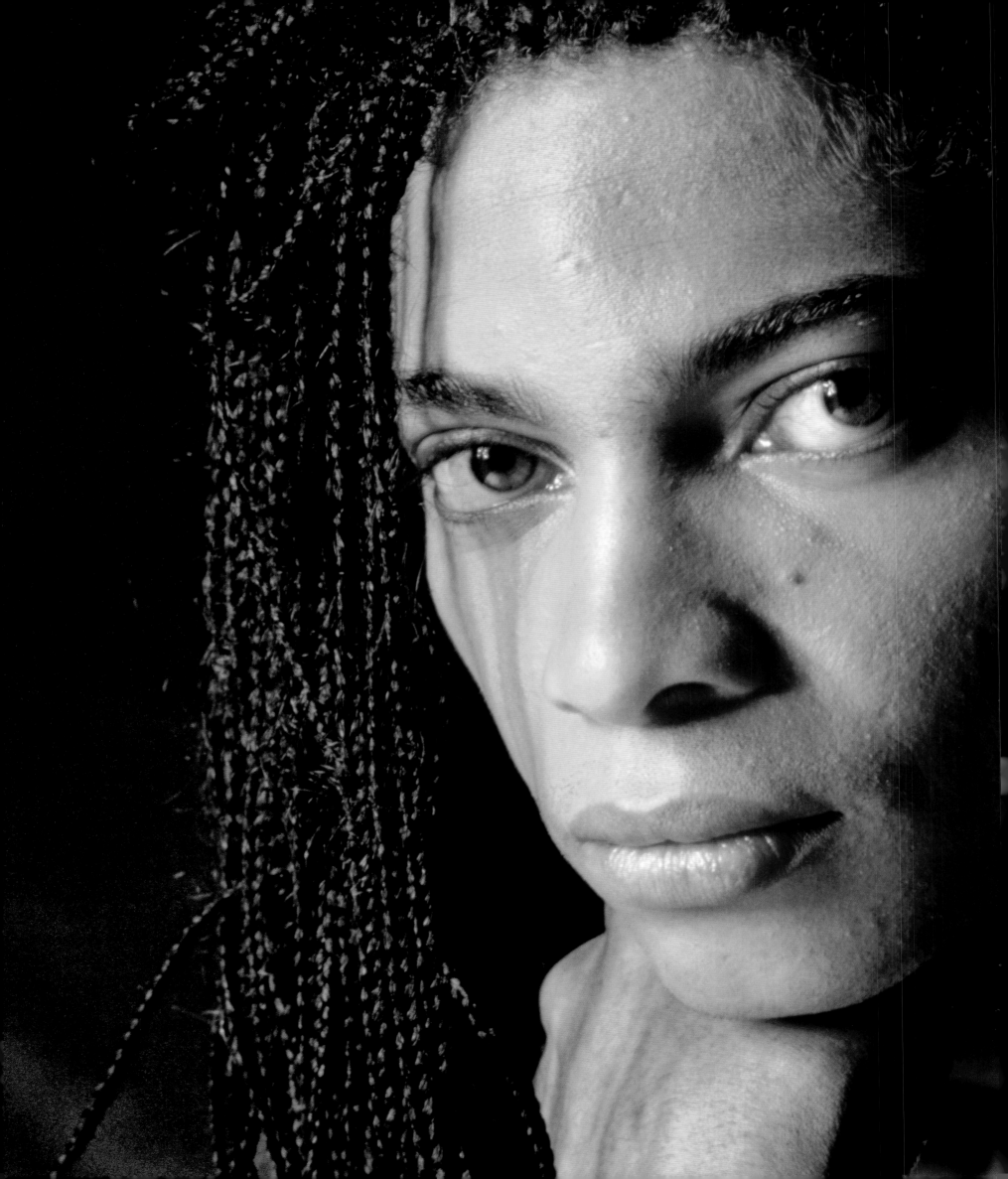

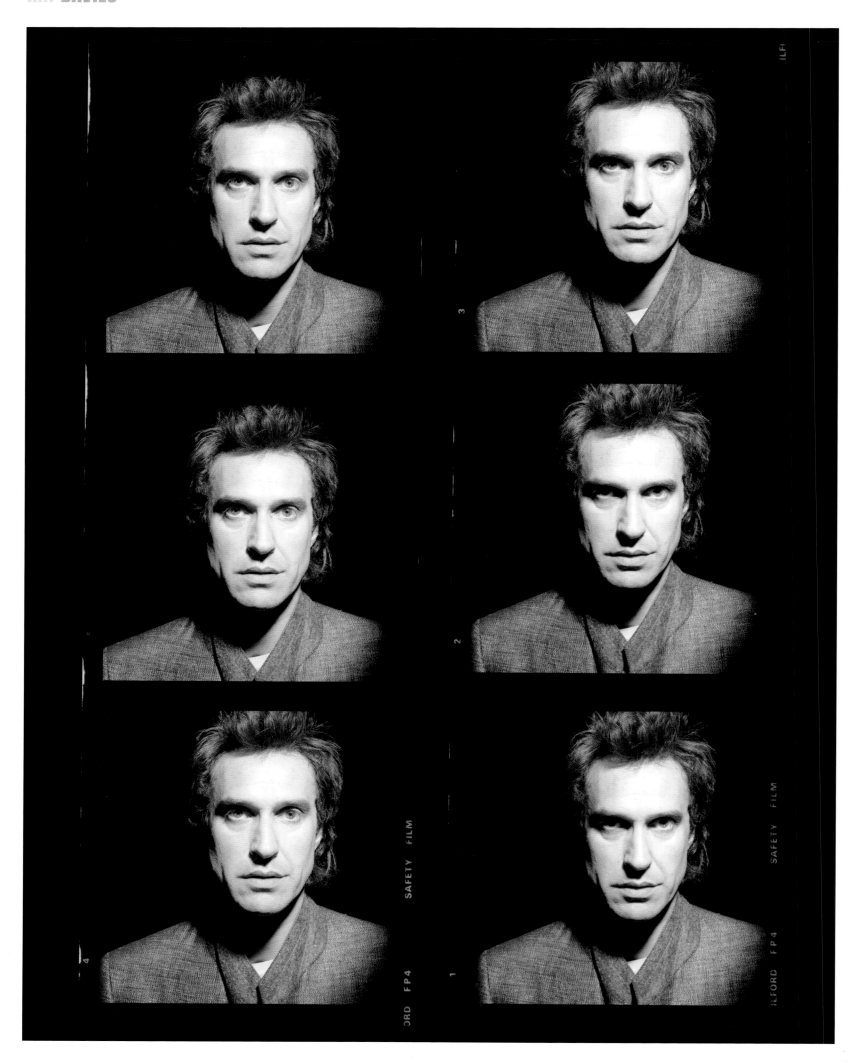

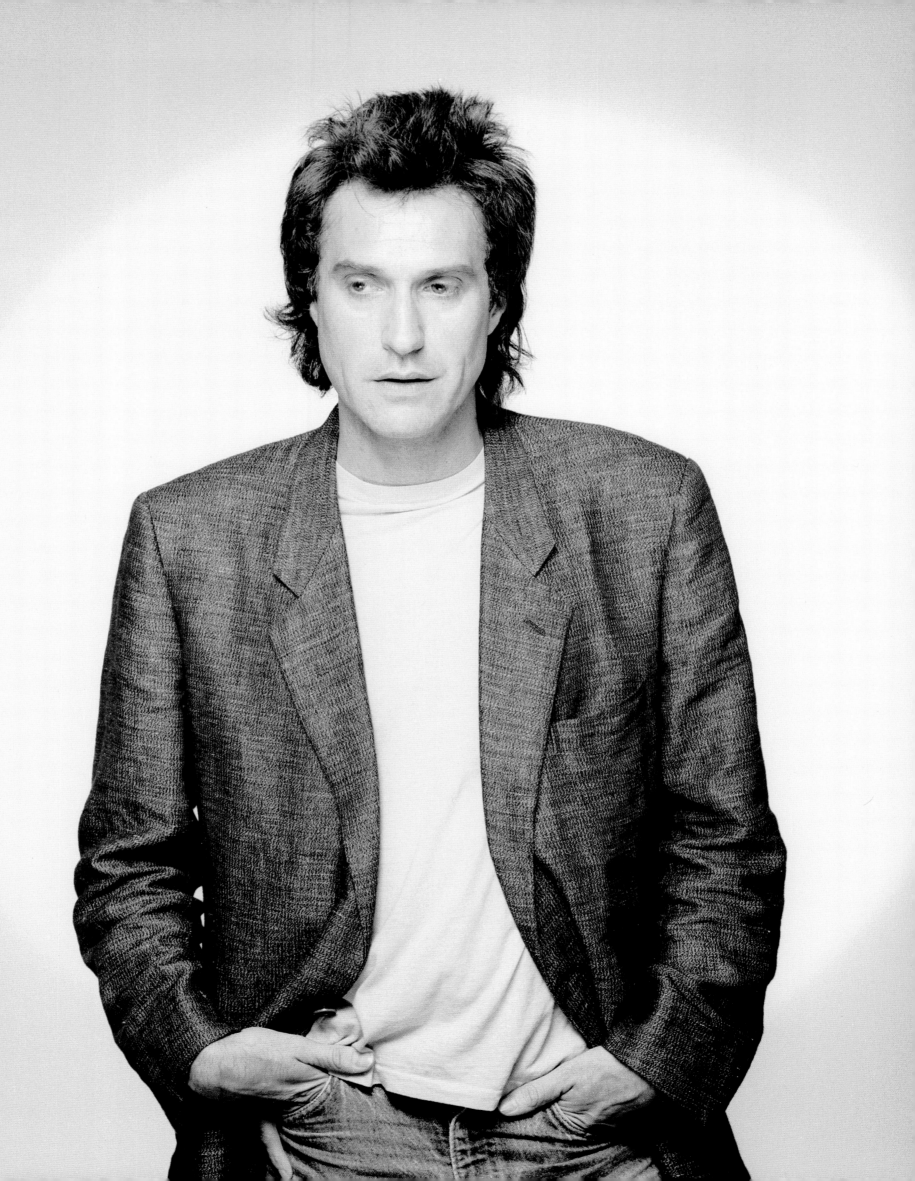

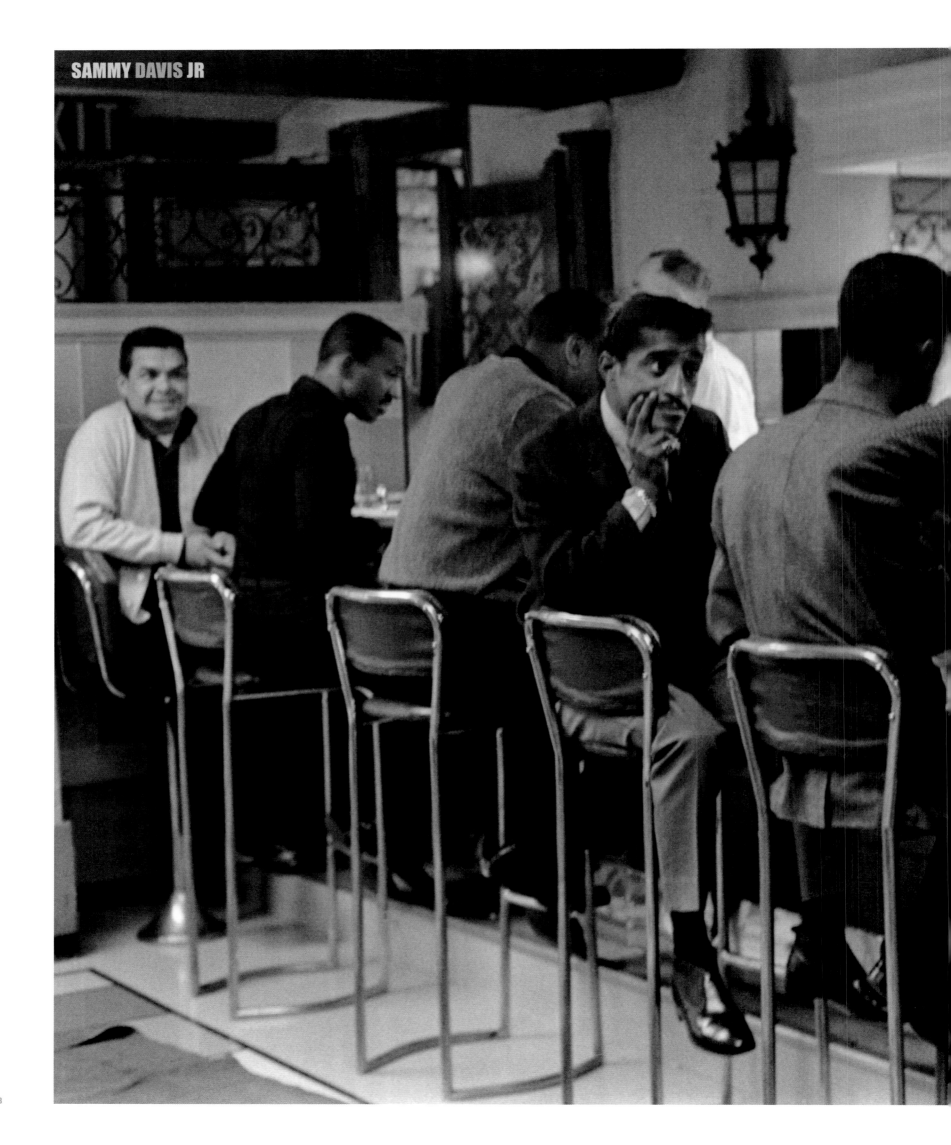

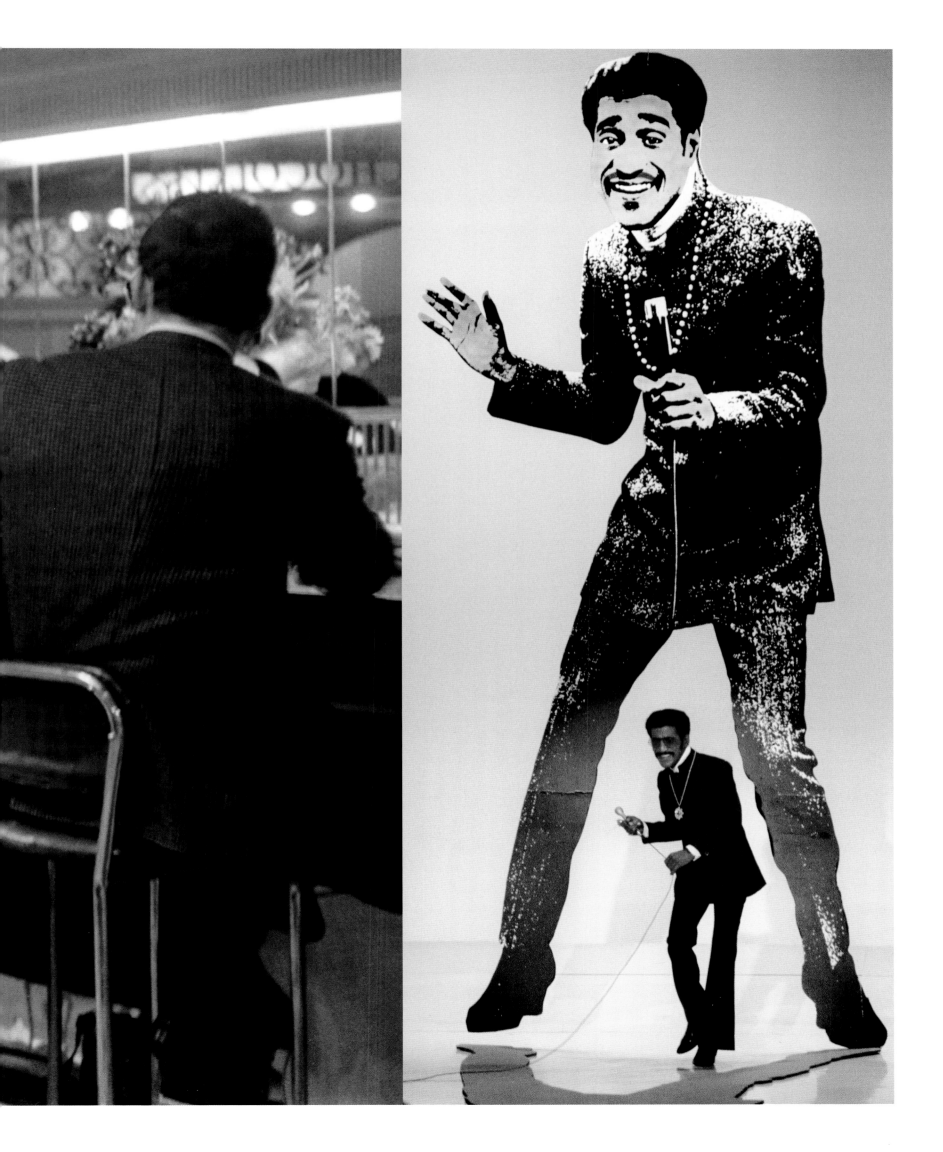

ADAM FAITH

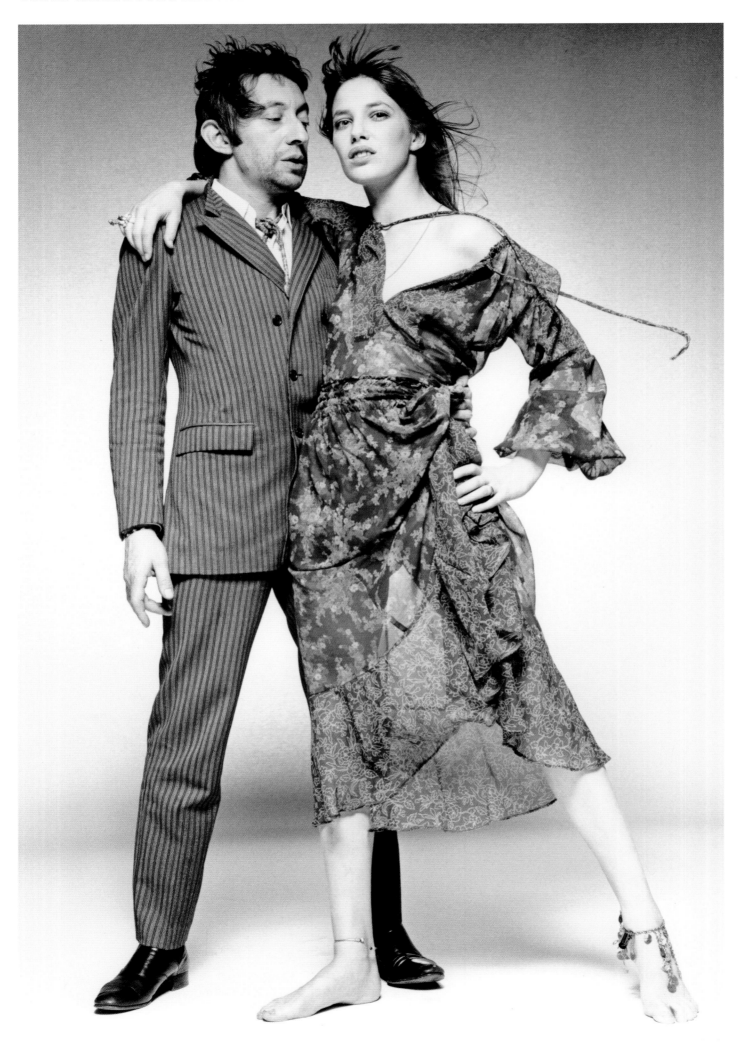

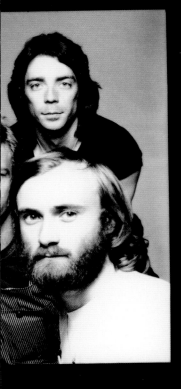
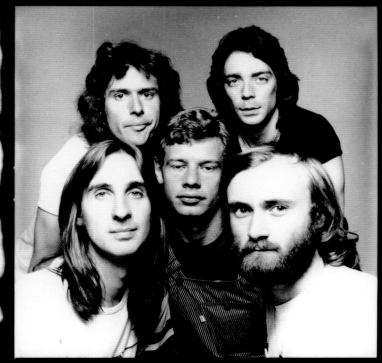
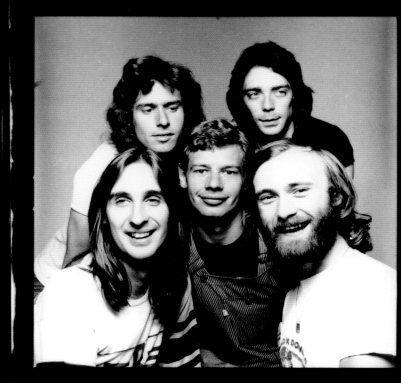

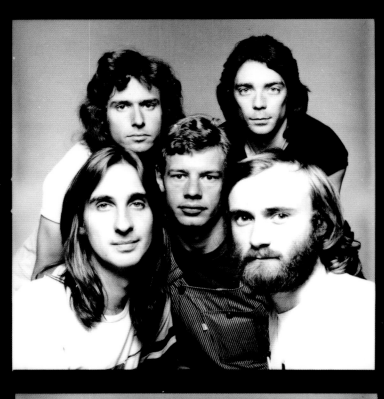
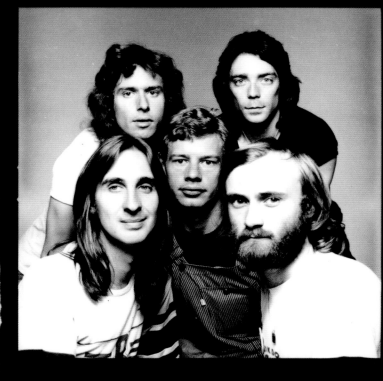
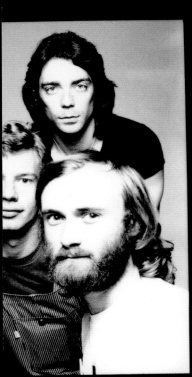
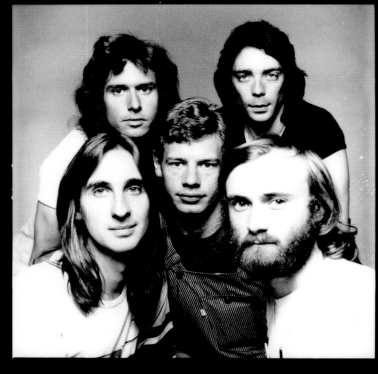
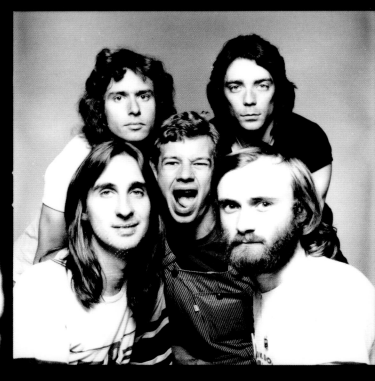

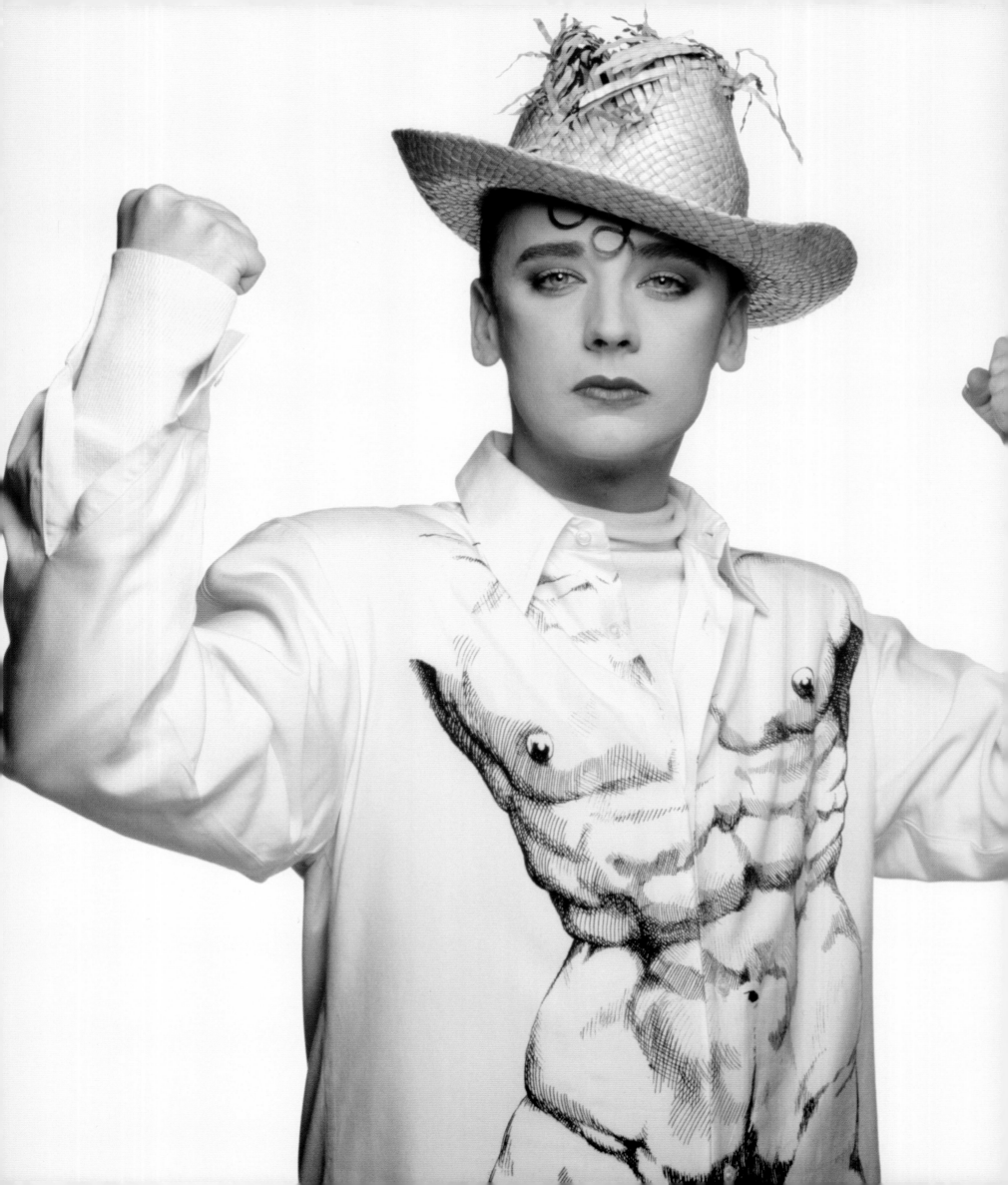

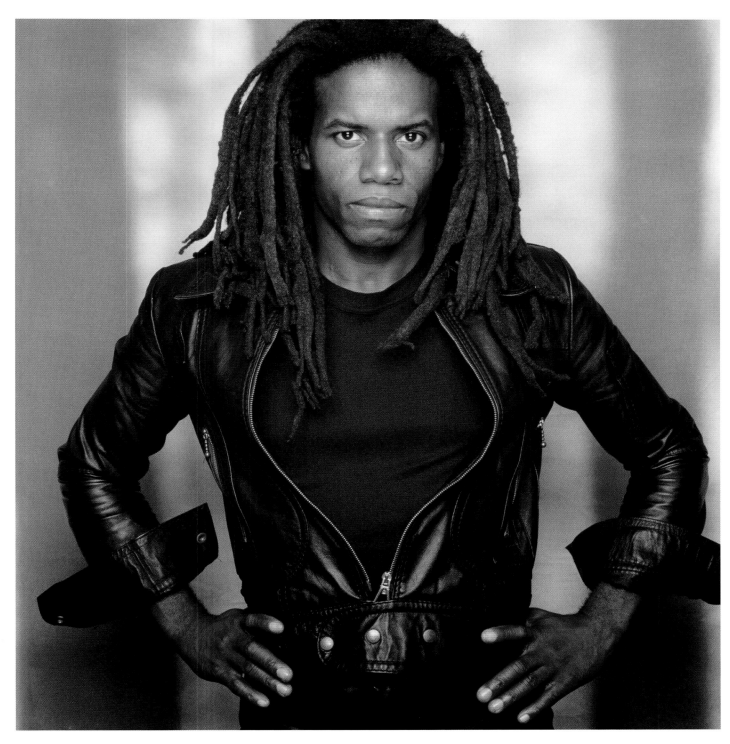

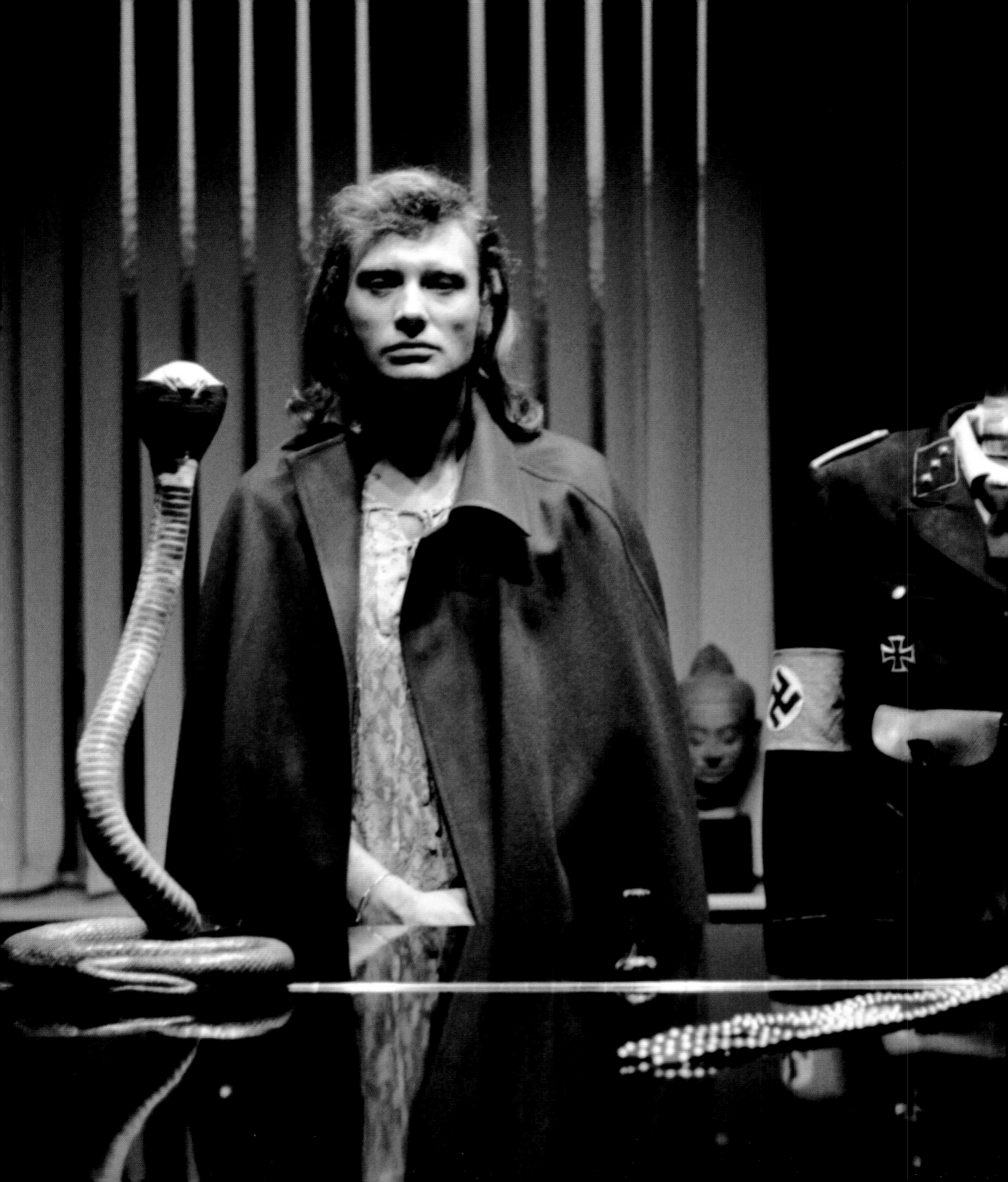

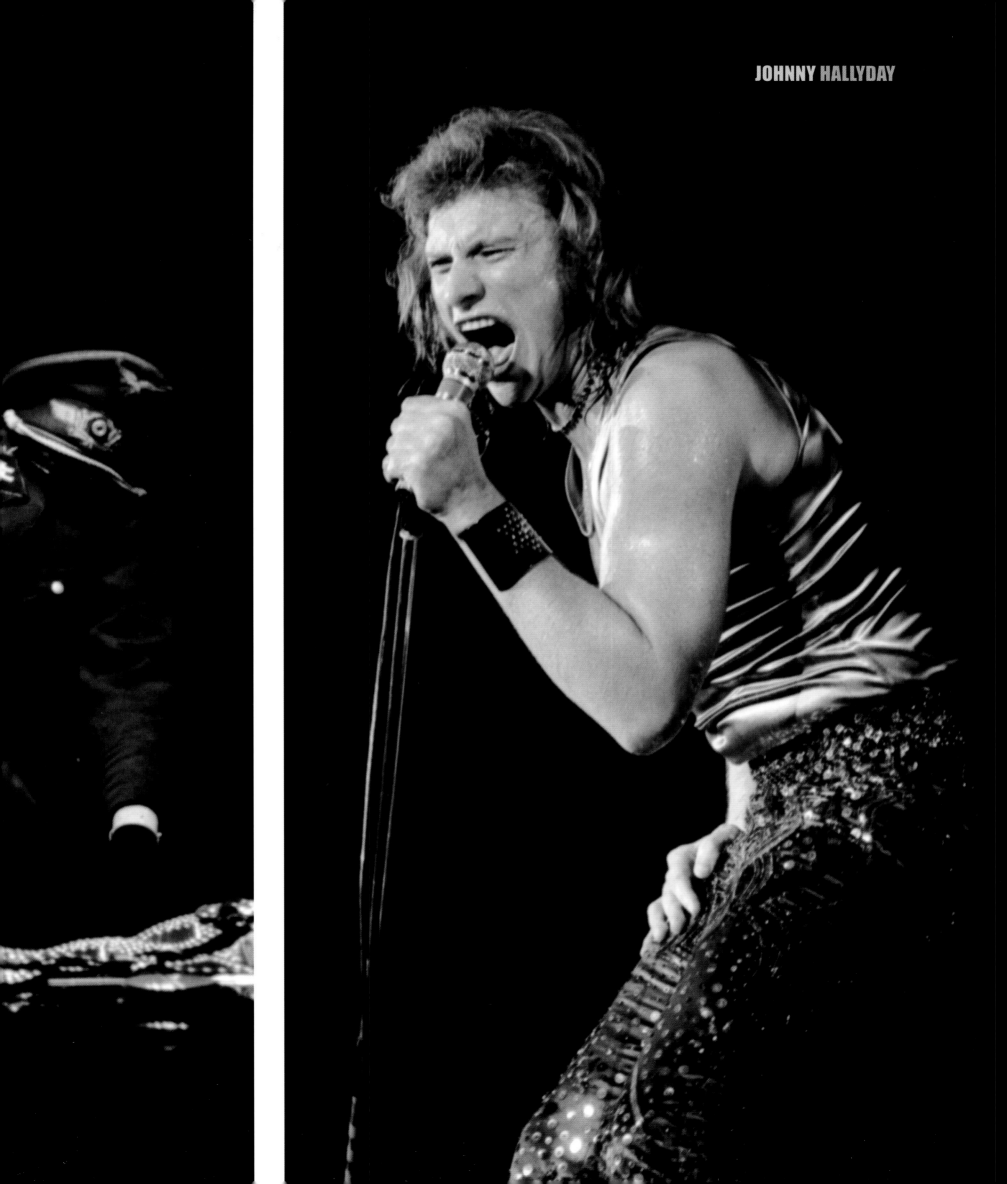

JOHNNY HALLYDAY

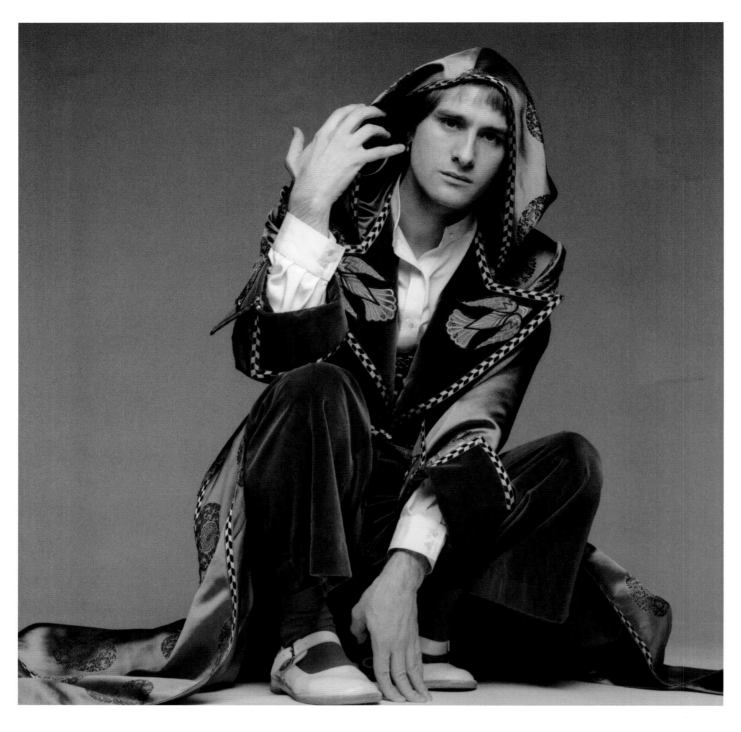

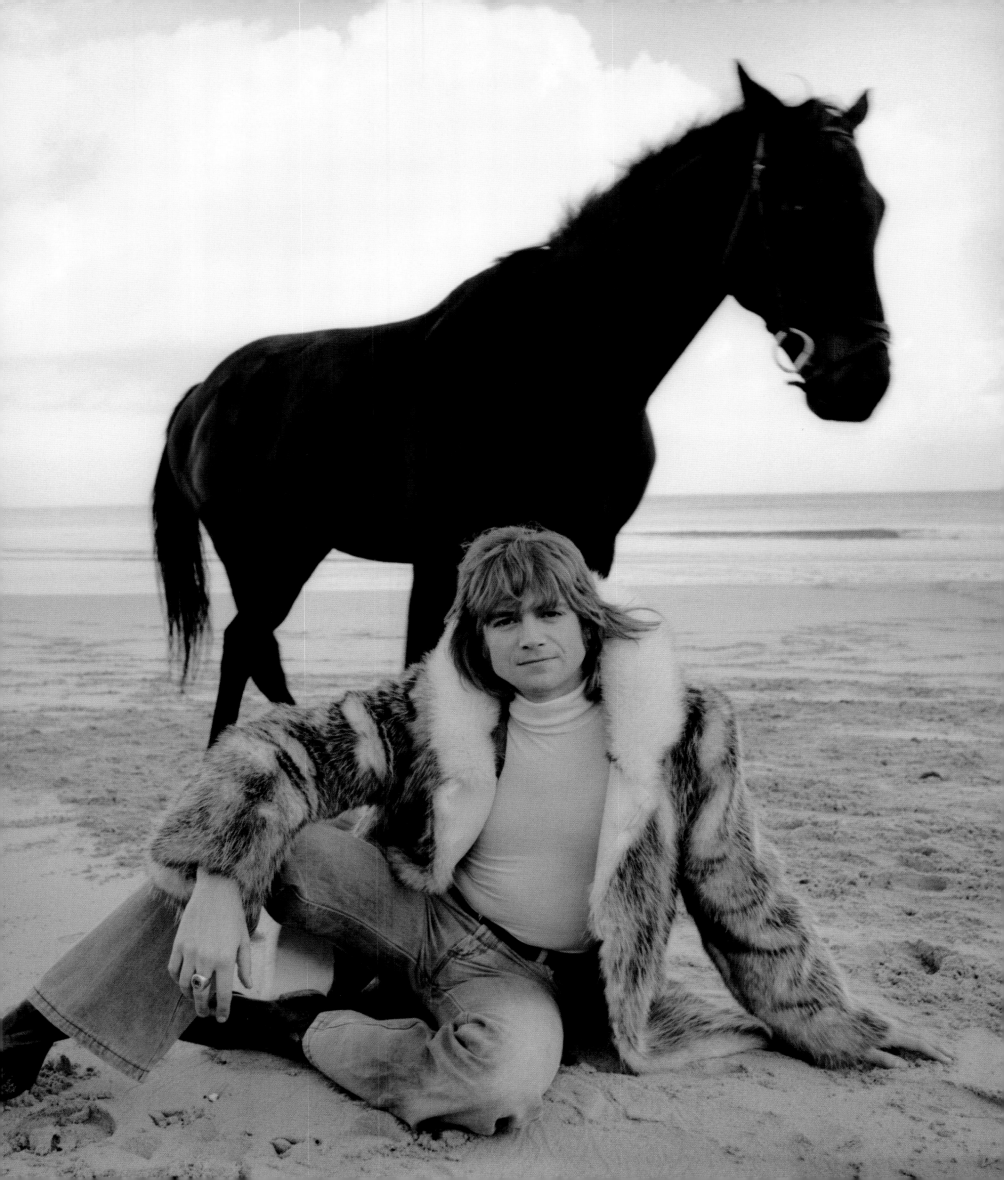

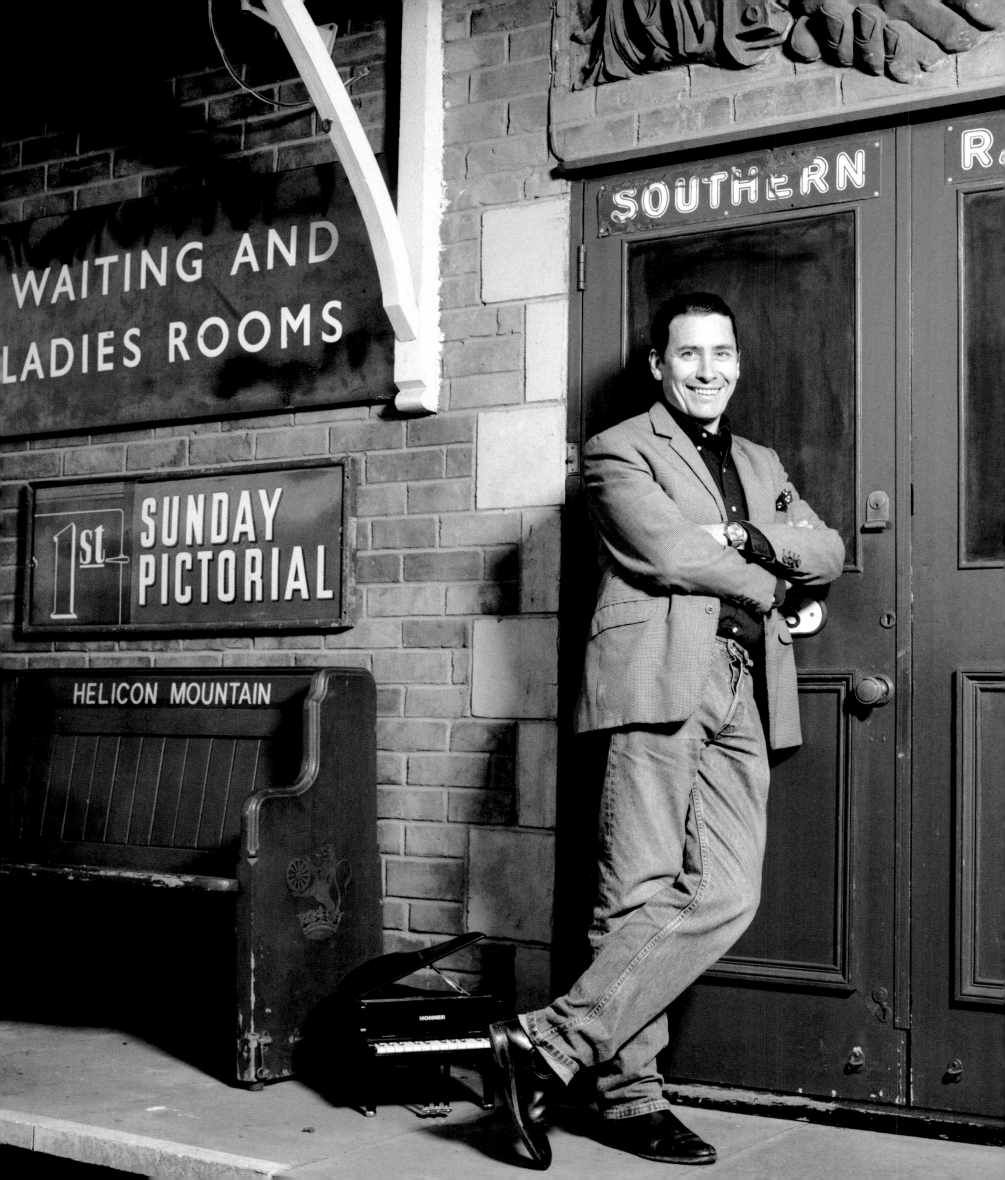

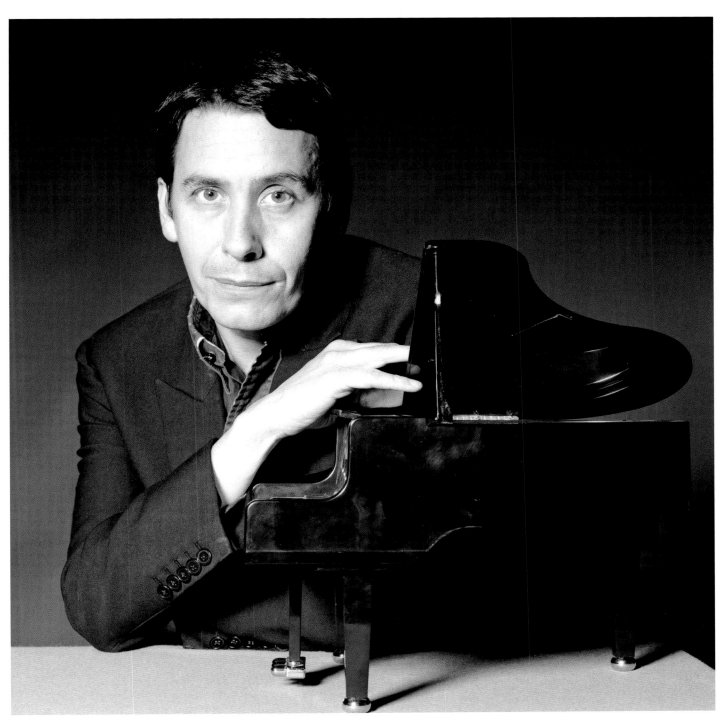

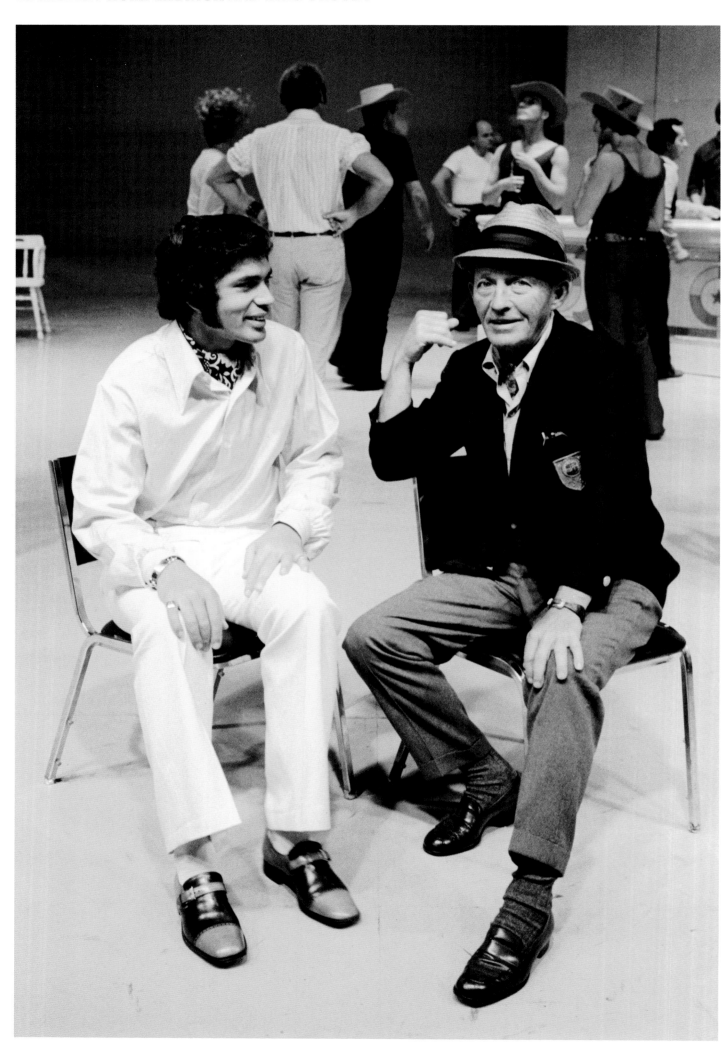

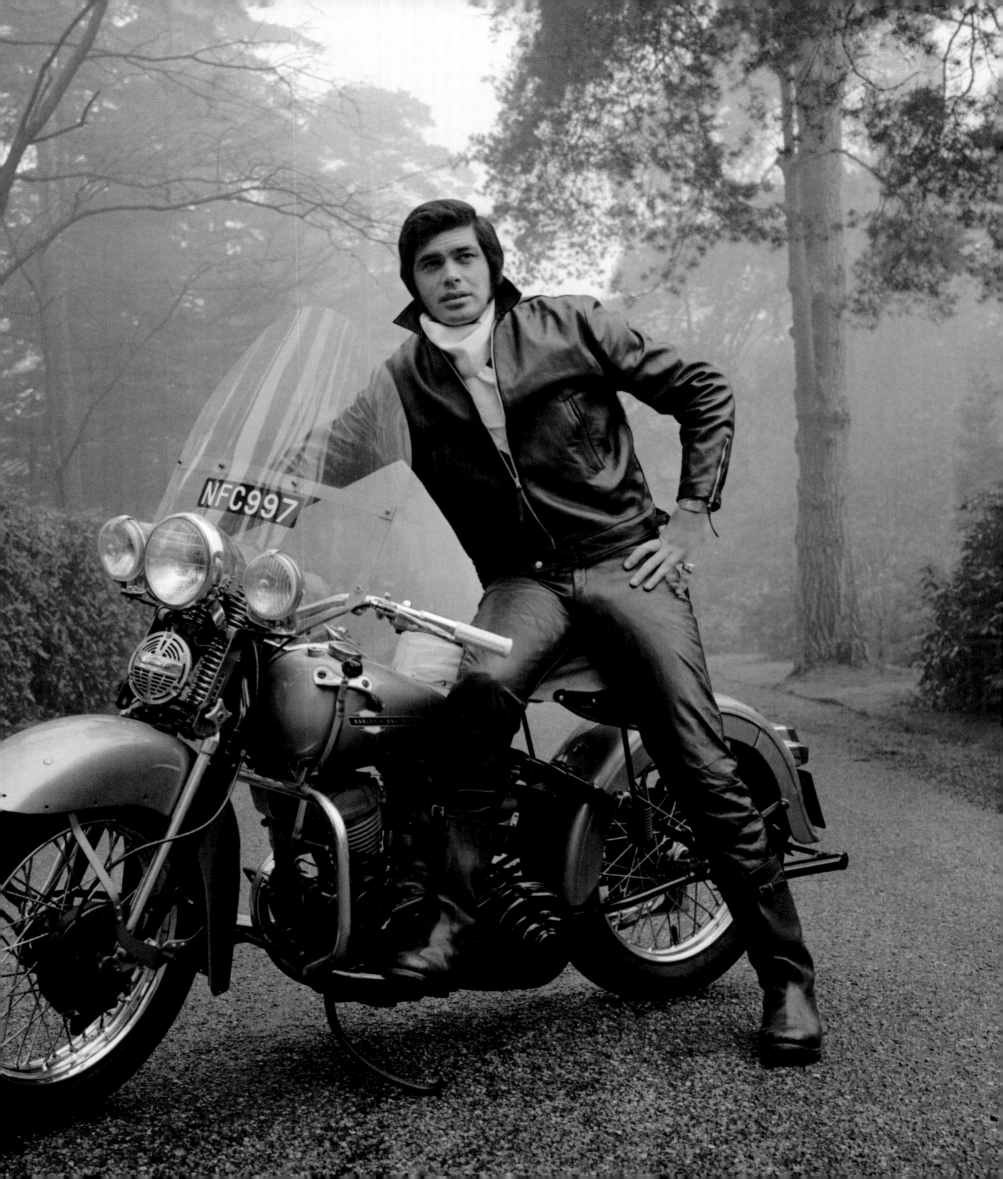

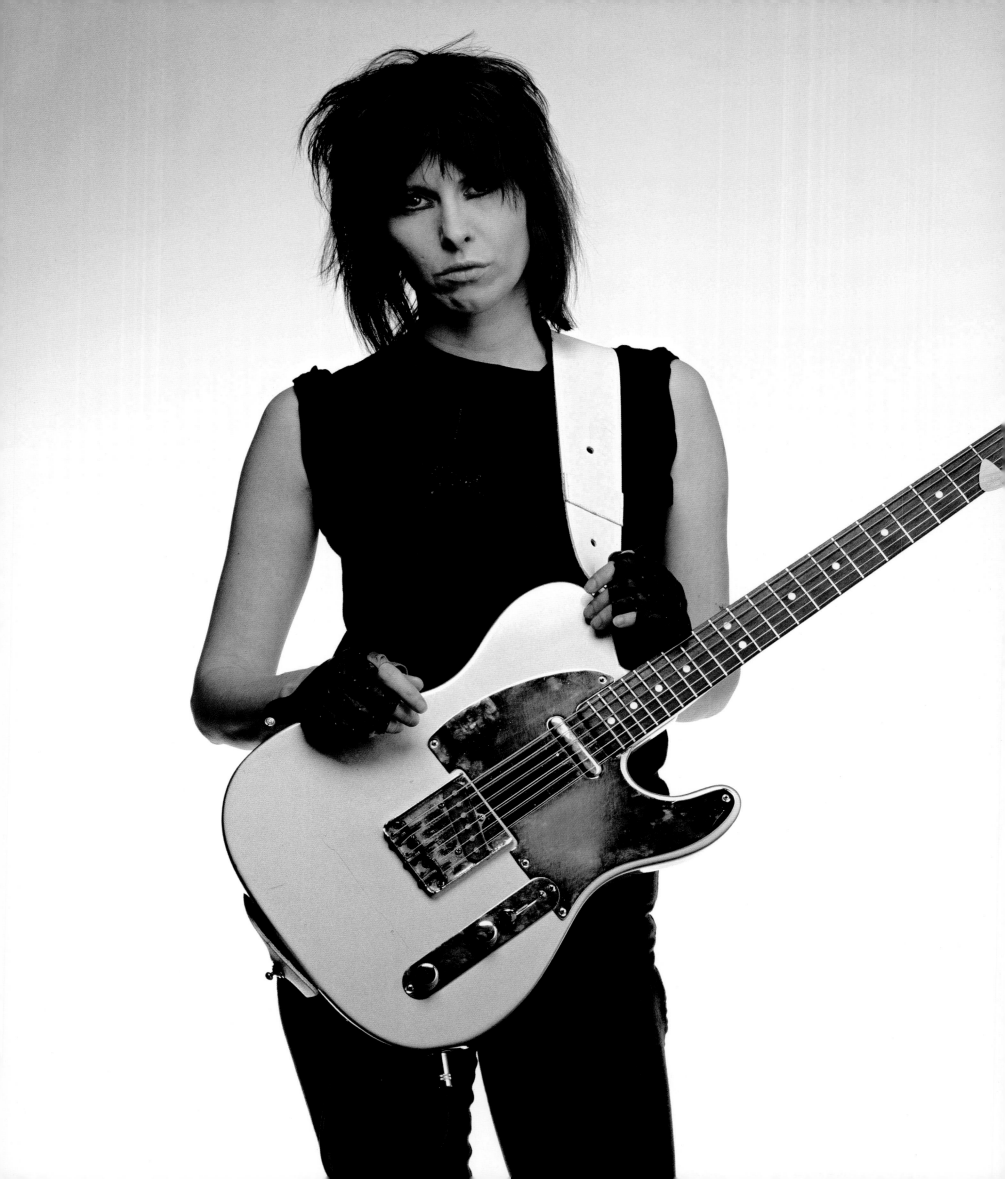

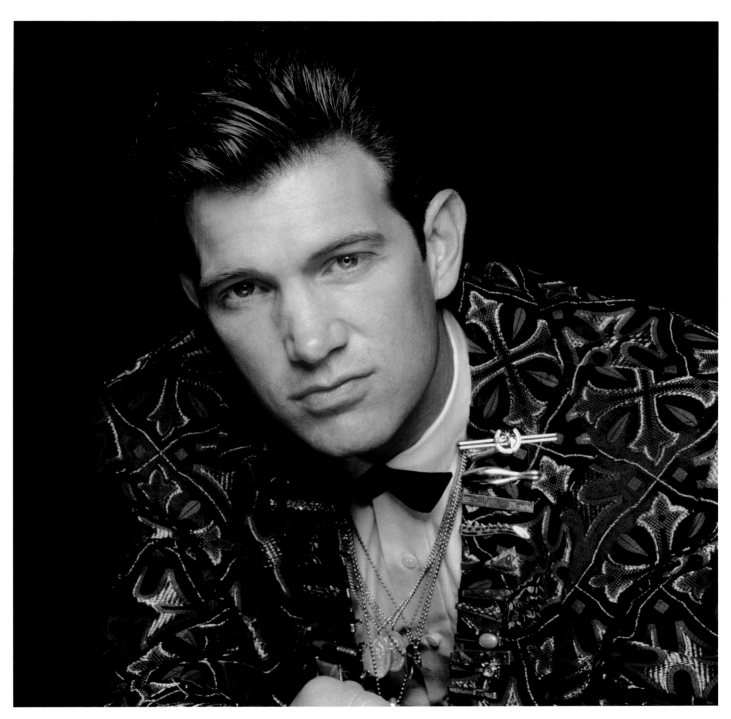

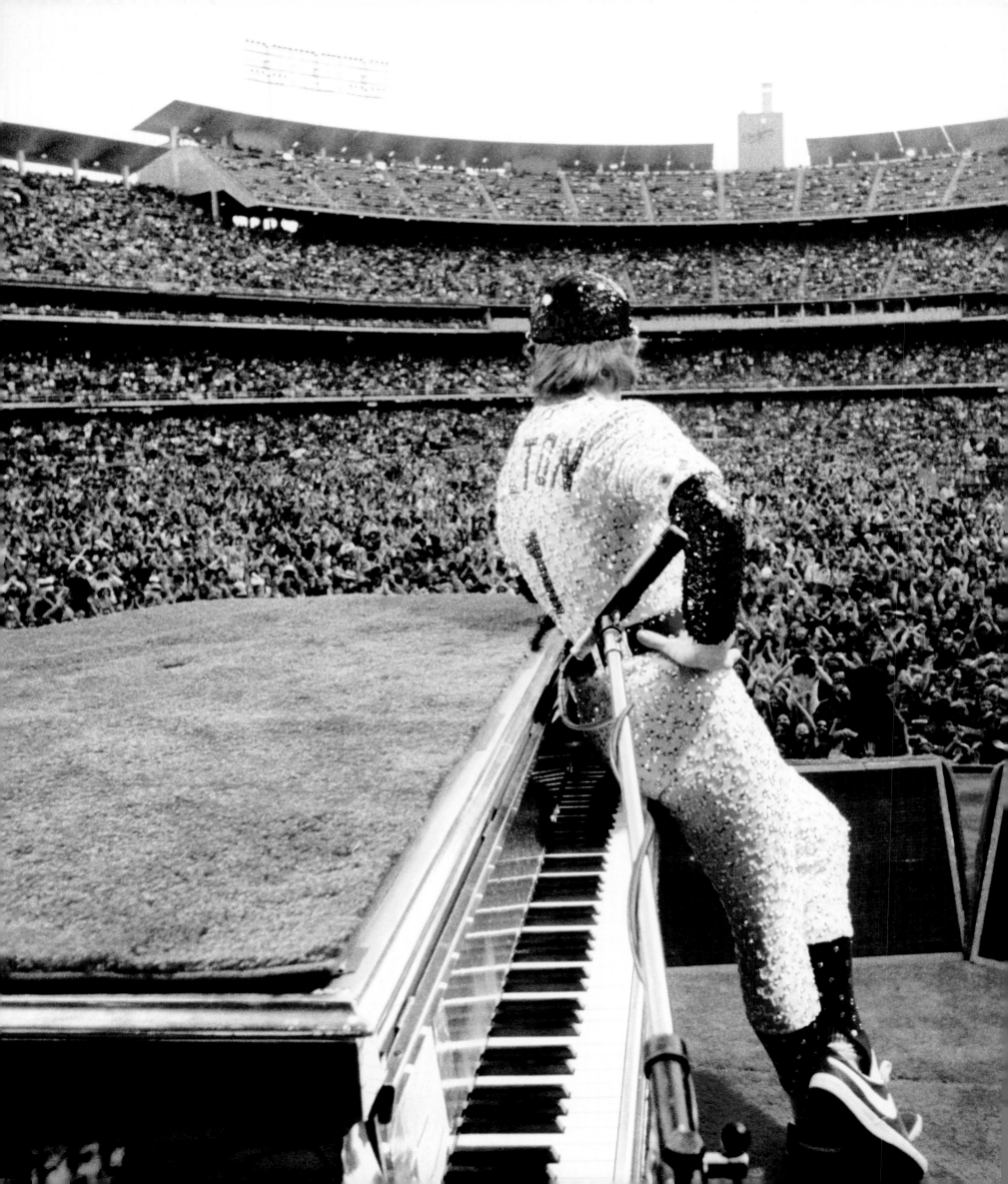

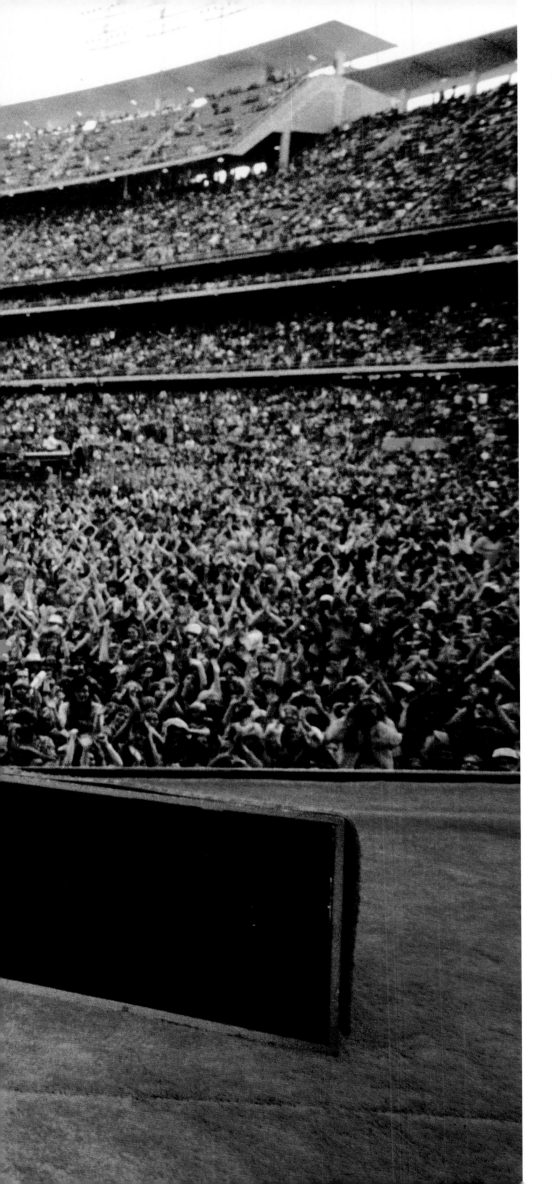

"It was obvious Elton was going to be a huge star. I photographed him fooling around, leaping up an down on the piano while he played"

ELTON JOHN

There are only a few people in show business that I'd call a genius. It's too easily applied to mediocrity, like the word "brilliant". It just gets thrown around in exaggeration. Frank Sinatra was a genius, Bowie is another. Elton John will, in my opinion, be regarded one day in the same breath as Beethoven.

As a composer, his legacy will be a catalogue of music that will last for generations. Like Bowie and Sinatra, people will be listening to Elton and appreciating his music 100 years from now.

Elton's music defines a generation, as did Bob Dylan's. Elton has been playing and composing and singing for 50 years. I read recently that he's played more than 3,000 concerts in 75 countries. But he isn't just a musician and a singer: his compositions have sold more than 300 million records, he wrote the biggest-selling single of all time, he's won Oscars, Grammys and every award under the sun. But he's also a man who gives back in other ways. He has raised nearly $250million for charity. Elton has made a difference to people's lives all over the world. He often asks for one of my prints to sell at his charity auctions. I never say no to Elton. I sign them, and he auctions them for crazy money, like $150,000. It makes me feel proud that I can help him.

I first heard his amazing rock 'n' roll voice on the radio way back in 1970. He'd just joined up with the lyricist Bernie Taupin, a great storyteller. Before that he'd been a piano player in pubs and clubs, and before that, he'd studied his music at the Royal Academy of Music. He'd won a scholarship when he was just 11.

When I heard that voice on the radio I'd thought, "There must be an amazing new American talent in town," and I went in search of him and found this young guy in a studio banging away at his piano. It was obvious he was going to be a huge star. I photographed him fooling around doing his Jerry Lee Lewis impersonation, leaping up and down on the piano while he played.

For the next 50 years we were friends. I photographed him everywhere. He was always a performer. It wasn't just the music, it wasn't just the song, Elton wanted to electrify and amuse and

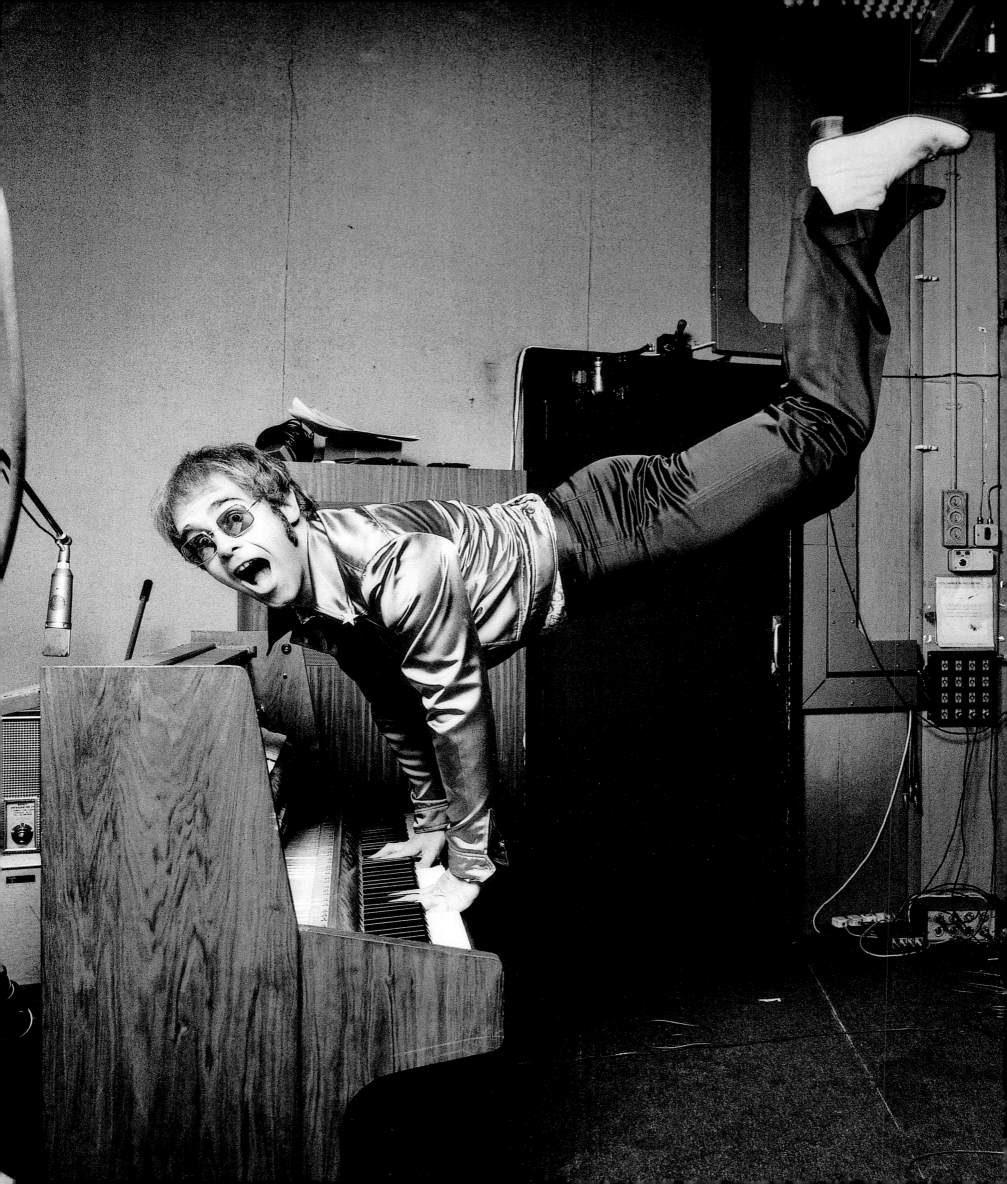

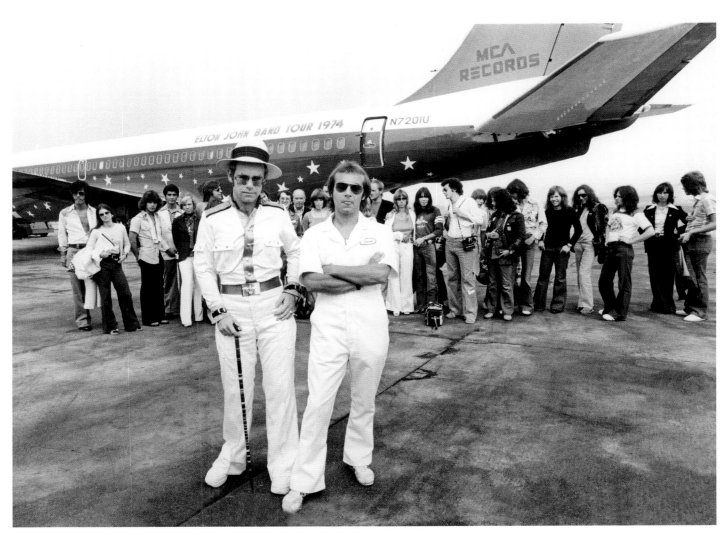

Swept off his feet by the power of music (left) in London, 1972; and in white during his 1975 tour (above)

tease, he wanted his audience to become totally immersed in spectacle. His costumes became a hallmark — eccentric, outrageous, comical clothes that cost thousands of dollars to tailor. His songs just seemed to sync with the times and the mood. That perhaps was his genius, an instinct for what an audience wanted to hear next, a vision of what he could make them want to hear next. He captured the mood, the times, the emotional needs of fans. He never stood still or sat on his laurels.

I was with him on his world tour in 1975. He did over 150 concerts in three years between 1974 and 1976 — he was on stage performing every nine days for three years — it must have taken incredible energy, stamina and drive, because in that time he also wrote and recorded four albums, 14 hit singles and starred in a movie, *Tommy* (1975). When you add up the travelling time, organisation and rehearsals, you wonder if he ever got any sleep.

On that world tour he had his own private jet, which he travelled on from continent to continent and, being pals, I was with him. At Wembley Stadium before the gig we all played football; at the Los Angeles Dodgers Stadium we hung out with his friends the actor Cary Grant and the tennis player Billie Jean King. Elton kept rushing on and off stage changing costumes; he'd play for hours, he'd be exhausted, but everywhere he went he had 75,000 people jumping up and down.

I'll never forget those two concerts at the Dodgers. They were among the greatest rock 'n' roll gigs of all time — they've made documentaries about them. In the footage you can see me

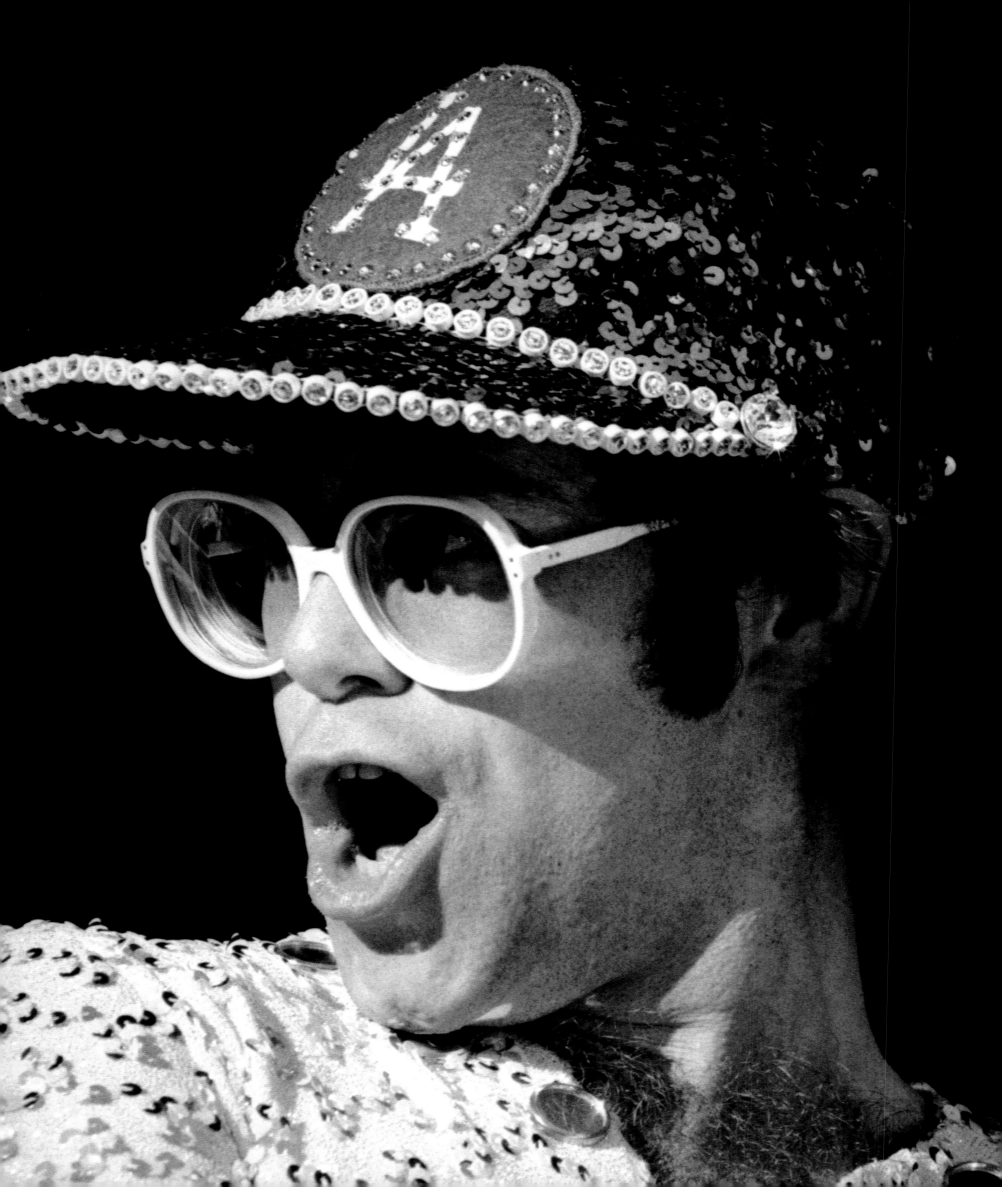

"At one point, Elton stopped playing, hushed the crowd and said, 'The guy rushing around the stage is Terry O'Neill,' and then picked up the music again"

hopping around backstage behind the musicians, taking pictures. At one point, Elton stopped playing, hushed the crowd and said, "The guy rushing around the stage is Terry O'Neill," and then picked up the music again.

Elton is a guy who broke down barriers. He was one of the first superstars to openly admit being gay when it wasn't fashionable and might have wrecked a career. He was the first rock 'n' roll star to perform behind the Iron Curtain in the old Soviet Union.

Of course we all know now that Elton was kept going on this killer schedule in the 1970s with the help of drugs — and they nearly killed him. During the Dodgers gigs there was a suicide attempt, yet he was back on stage after a couple of hours.

I think that is what drives his charity work now into research to find a cure for AIDS. He's been one of the loudest and most successful voices in demolishing the bigotry that surrounds it. I think he feels so incredibly lucky that he didn't succumb to drugs that he is driven to give that gift of life to others now. Billionaires ask him to perform privately for him — he charges them crazy money, like half a million dollars for half an hour, on condition they give the money to his charity.

Of course Elton's famous, he's an iconic musician with world-wide recognition, but I believe in decades to come his reputation will surpass mere fame, celebrity and notoriety. He'll be happy if he's remembered as a great rock 'n' roll man with a big heart and he'd probably be embarrassed to hear me say this, but I think in time people will appreciate that there was greatness in him and his art. He's one of those rare people I've felt incredibly proud and privileged to have known as a pal and to have worked with through the highs and lows ■

Elton stands tall as the Pinball
Wizard, during filming for the 1975
film *Tommy*, based on The Who's
1969 rock-opera album

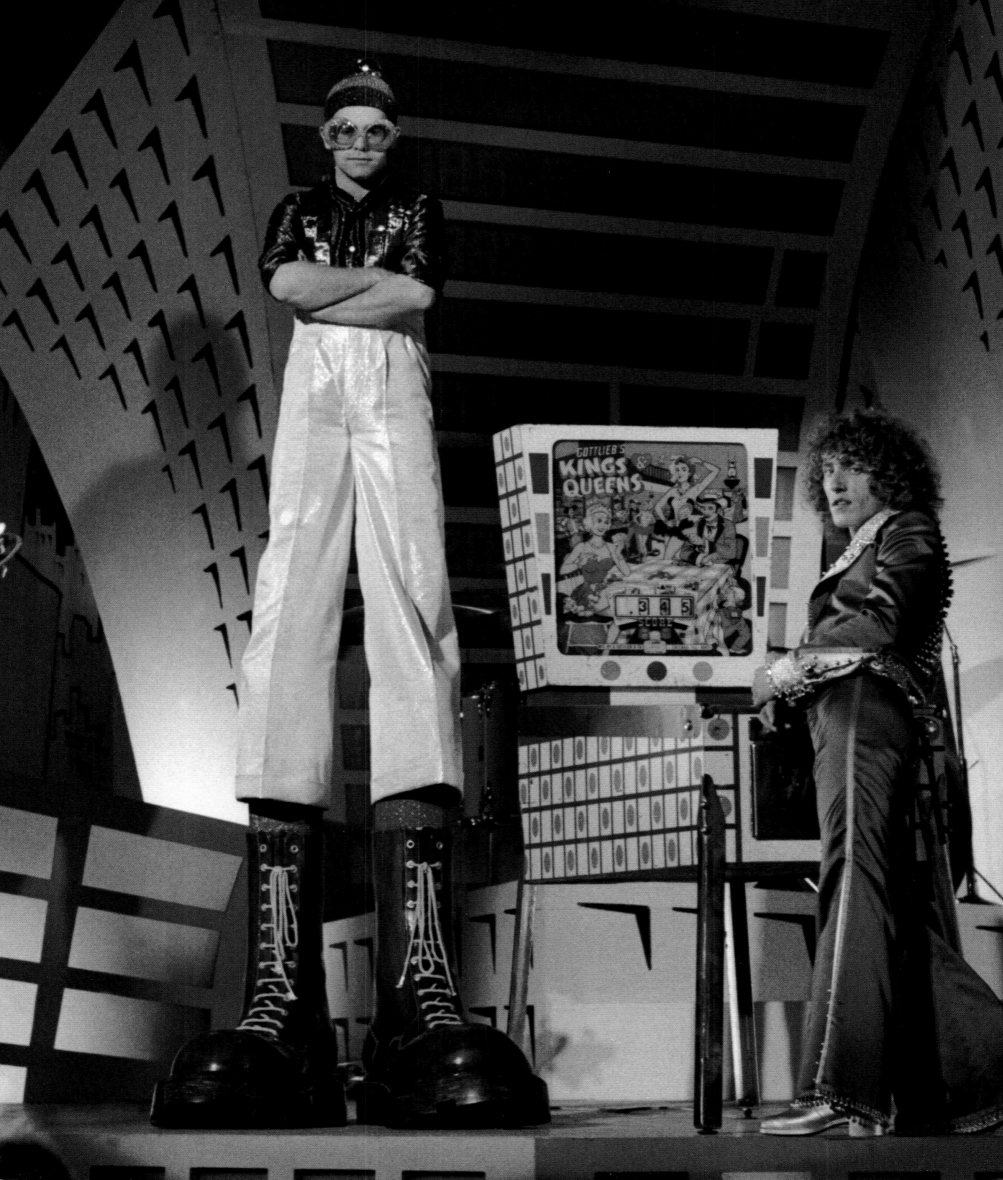

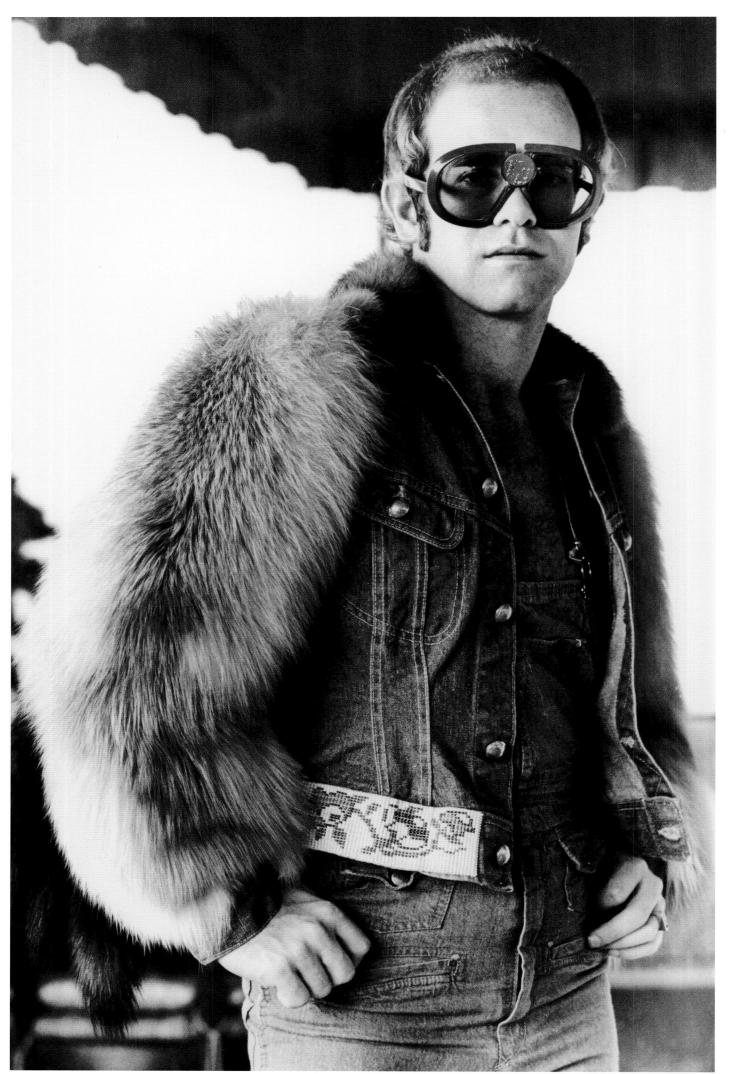

Elton in the Seventies, in Cannes, sporting furs and large sunglasses

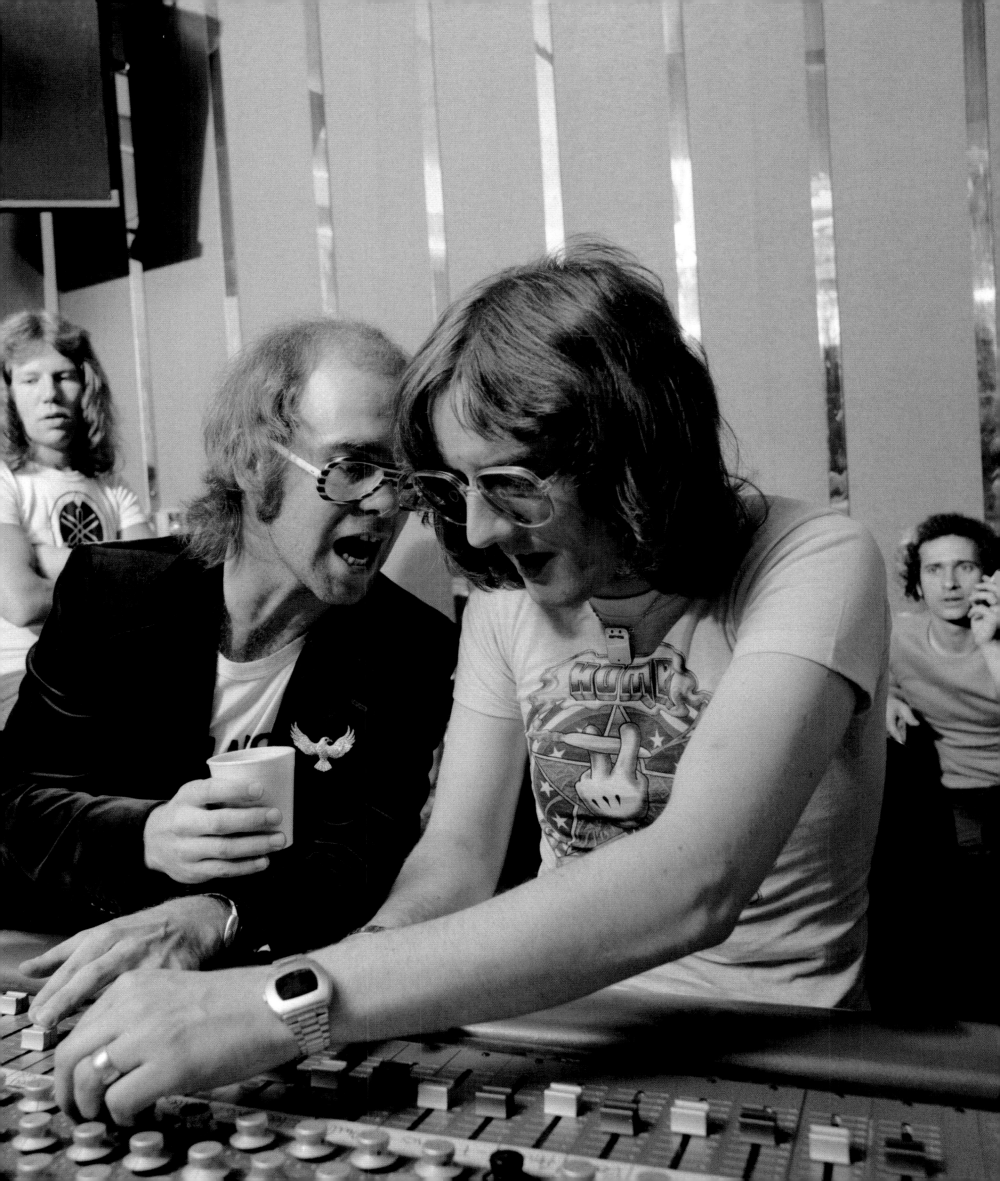

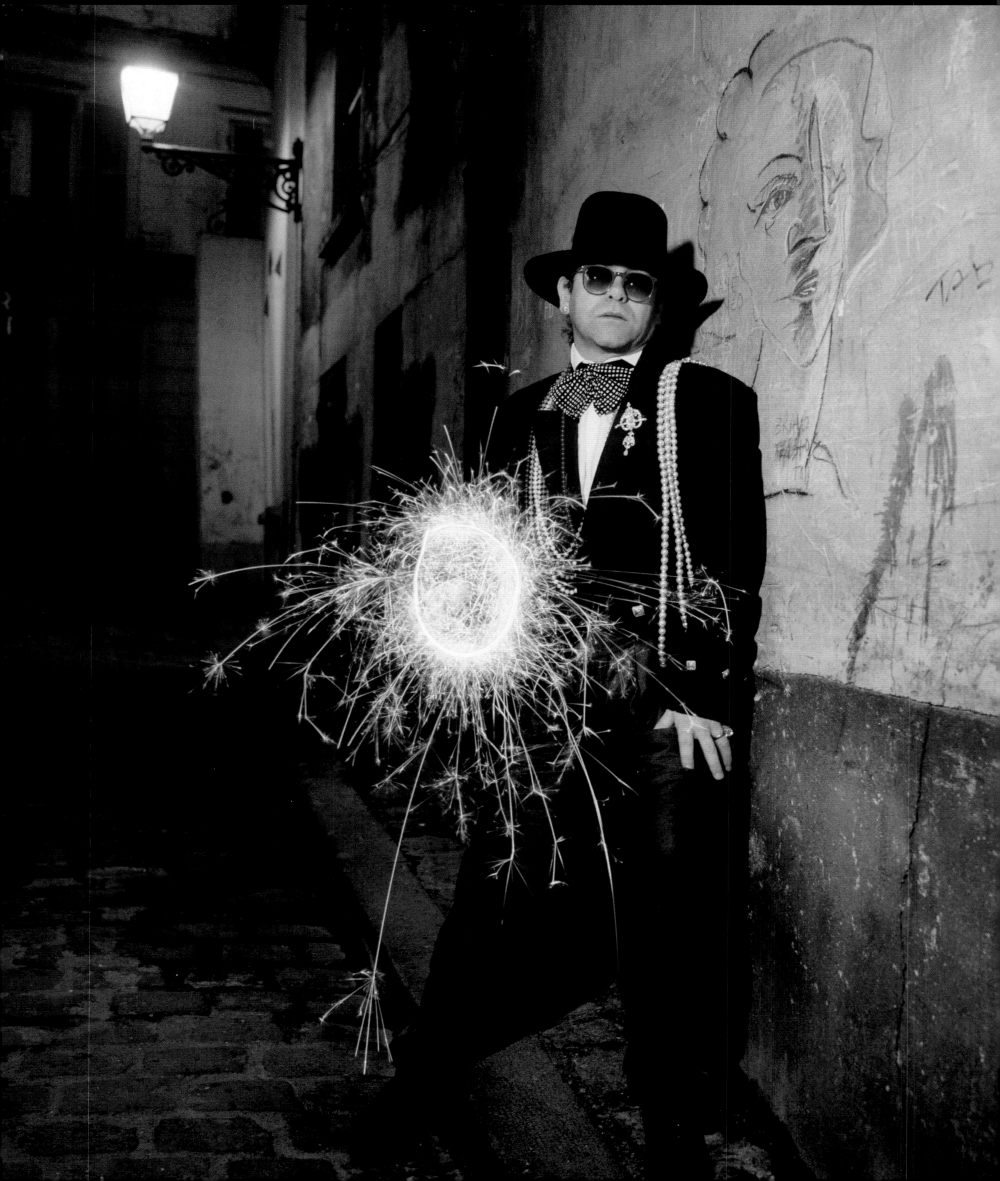

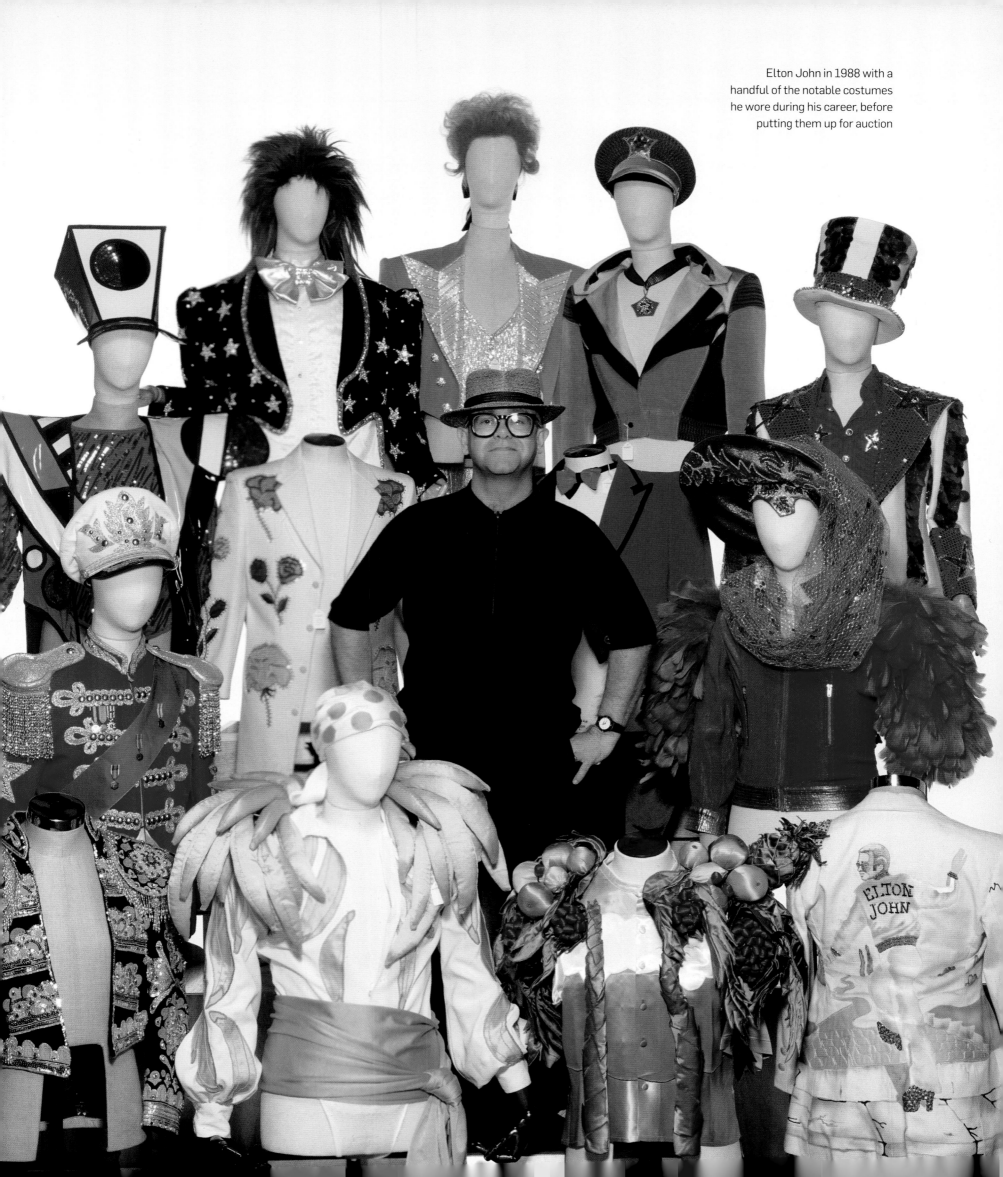

Elton John in 1988 with a handful of the notable costumes he wore during his career, before putting them up for auction

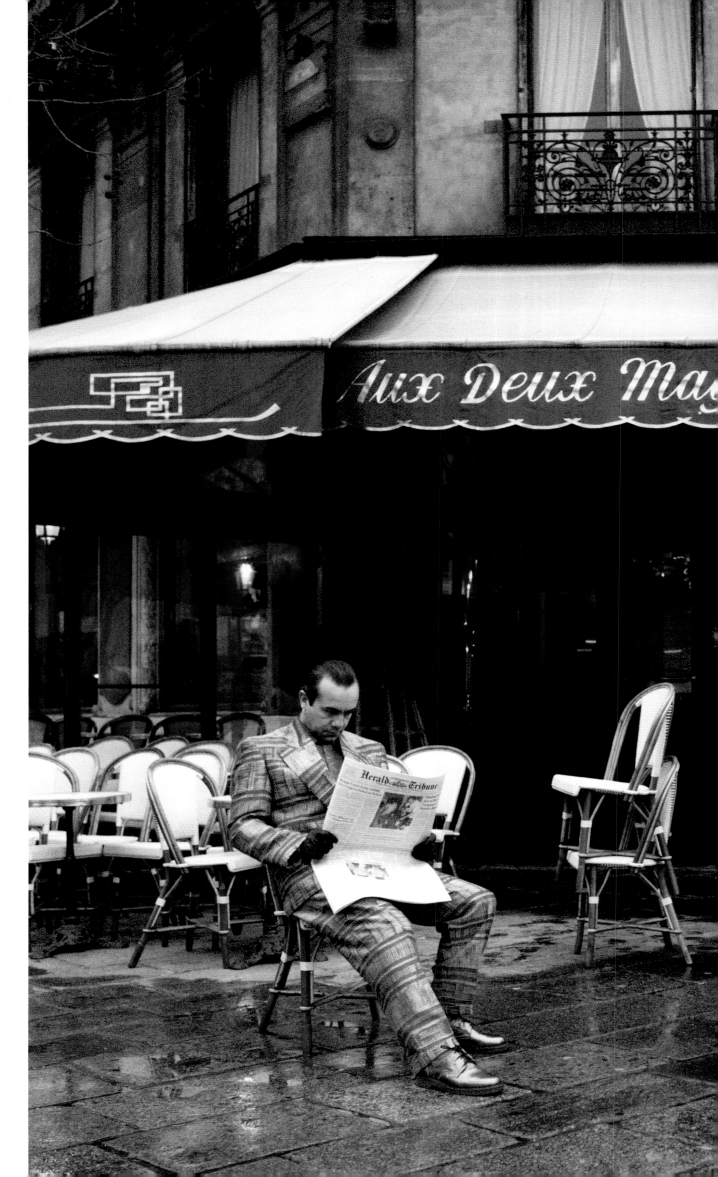

Elton and the lyricist Bernie Taupin
outside the famous Paris café,
Aux Deux Magots, 1980

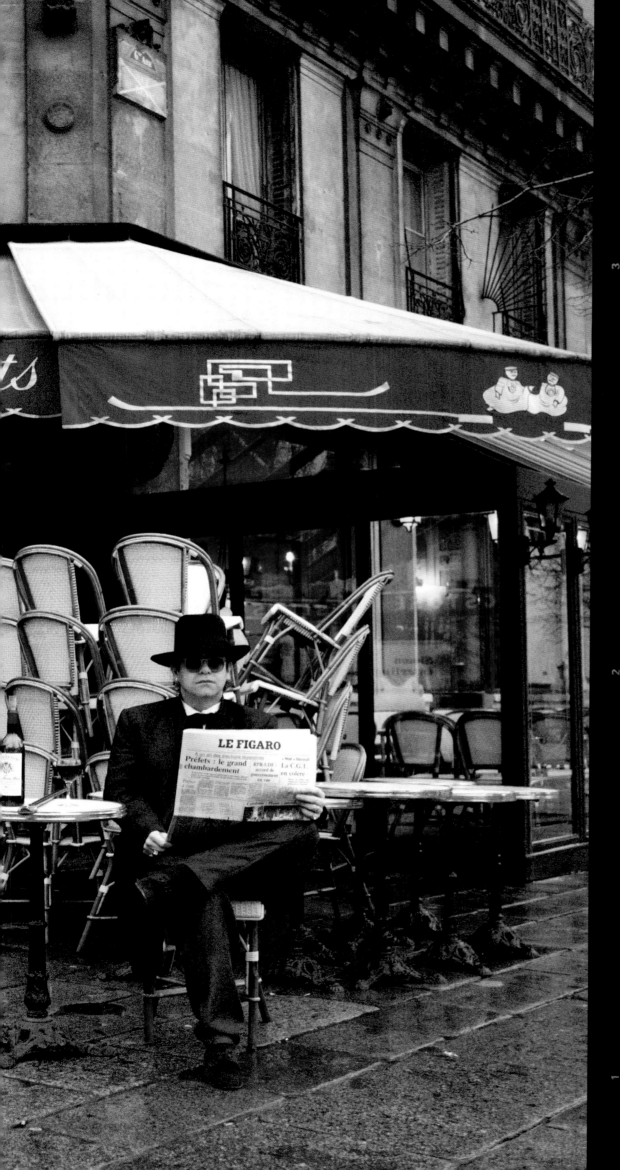

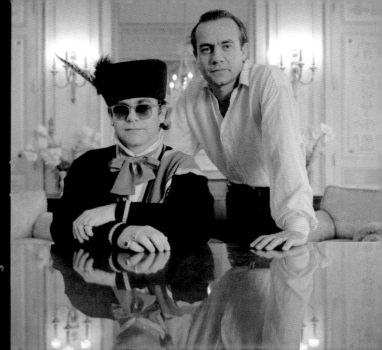

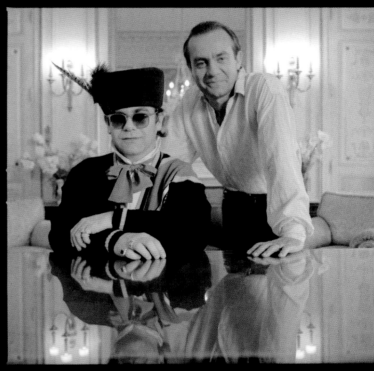

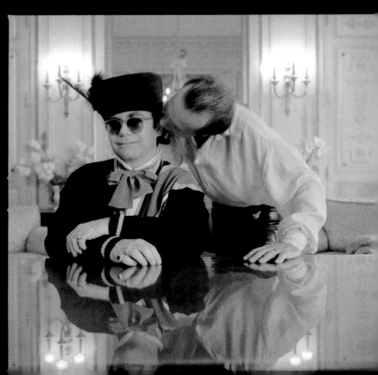

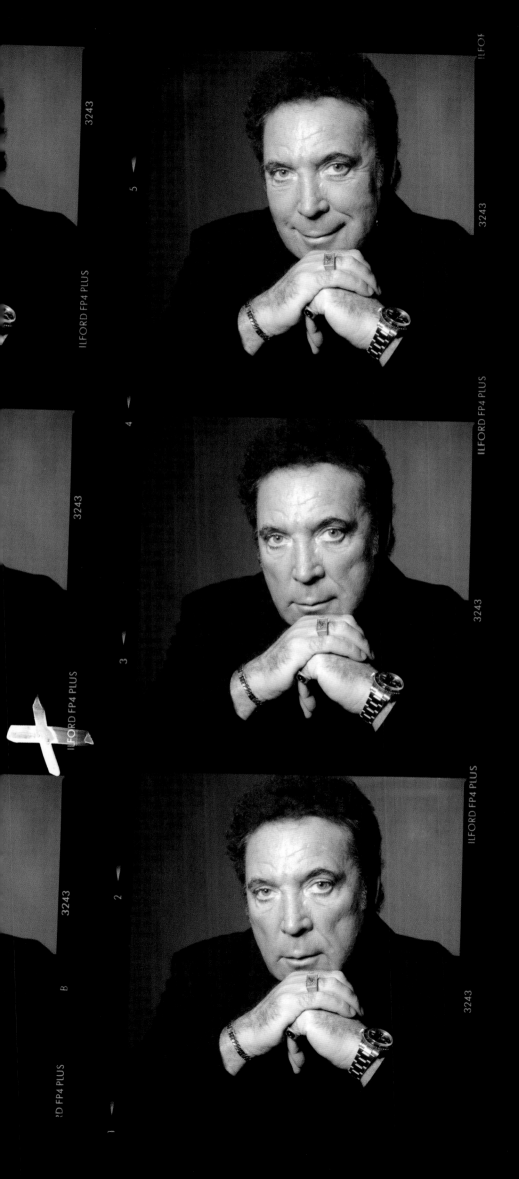

"Elvis would come backstage and watch Tom perform. Not a lot of people know this, but Elvis's manager banned him from singing with Tom, because Tom's voice was so superior"

TOM JONES

The first time I heard Tom Jones sing I was in Las Vegas in the Riviera Club. I couldn't believe that Britain had produced such an incredible talent. Music was still dominated by bands like The Rolling Stones and The Doors or Elvis and Sinatra. Tom was something in between — a real rock 'n' roll singer who could croon a ballad or blast the roof off a theatre. He bridged this gap between the kids who wanted the emerging psychedelic and glam-rock sound and the older people who were into our jazz and rhythm and blues. He could do it all.

He was mesmerising, an overpowering masculine presence — and women were going crazy for him. I think this was the first time I ever experienced women's overtly sexual hysteria. Up to then, they'd screamed and cried and grabbed at their idols to get a piece of hair or rip a scarf off a Beatle or a Stone, but here women were actually throwing their bras and panties and room keys onto the stage.

Tom lapped it up. He was the first British star to crack America. Of course bands like The Beatles and The Rolling Stones had made it, but a single act? It wasn't just Vegas, but his network television specials, which glued millions in front of their sets.

Tom was good friends with Elvis, who would come backstage and watch him perform. Not a lot of people know this, but Elvis's manager banned him from singing with Tom, because Tom's voice was so superior.

I took Tom back to his roots in a little coal-mining town in Wales. Now he was the big star in the white Rolls-Royce, with the big Cuban cigar, standing outside the little worker's terrace he'd been born in. It's still one of my favourite photographs ∎

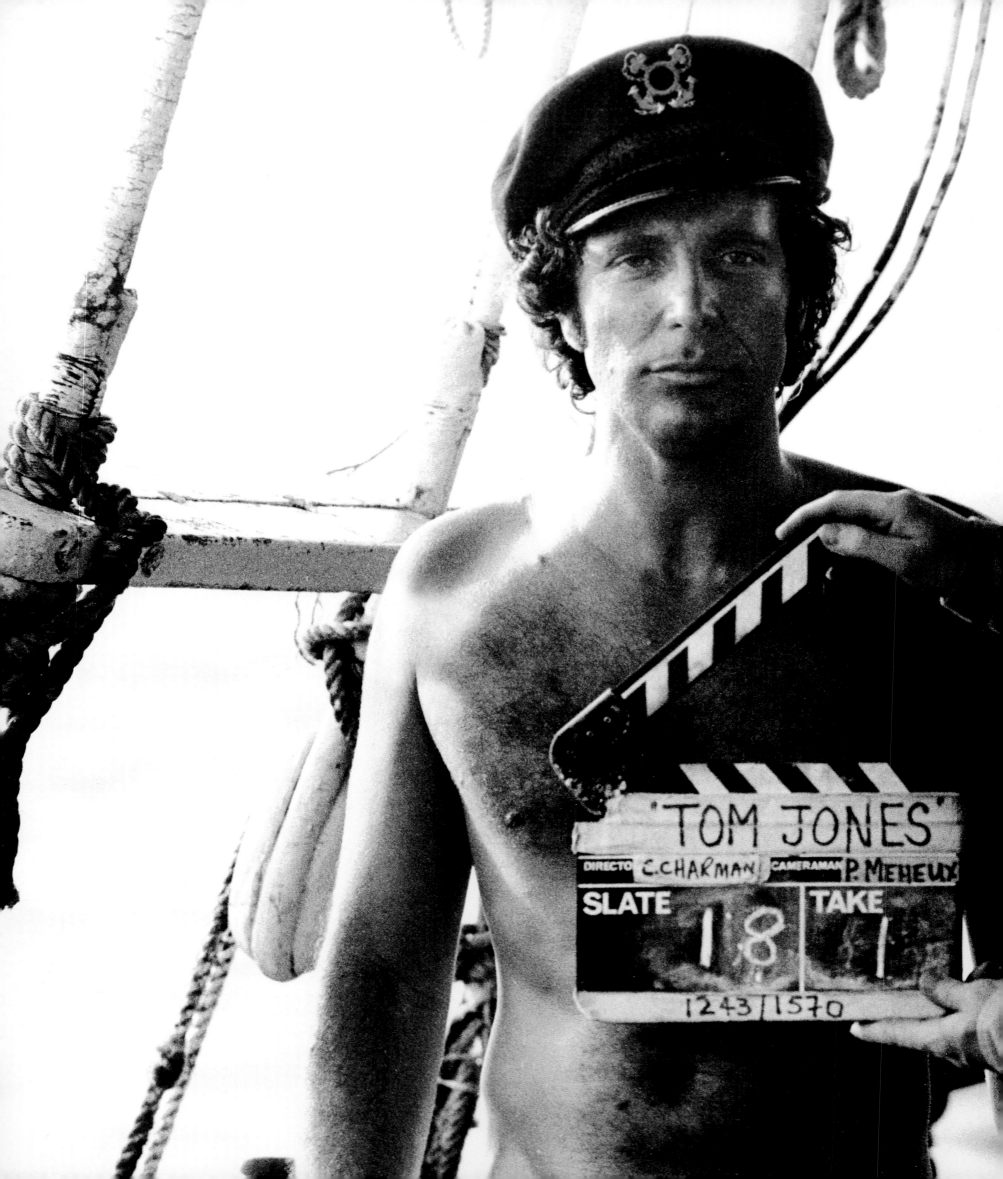

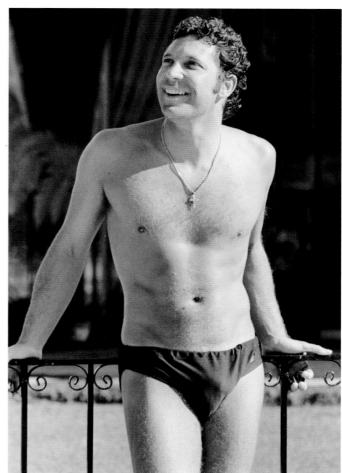

Shirtless between takes (left);
and wearing only swimming
trunks (above), around 1968.
"Women were actually throwing
their bras and panties and room
keys onto the stage," says Terry

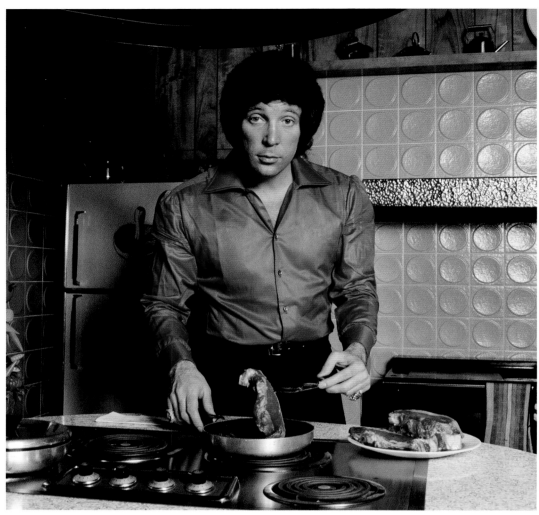

The singer cooking steak at his home near Weybridge, England

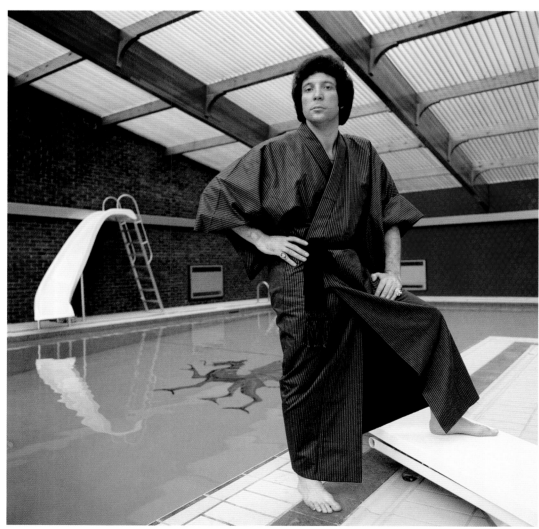

Posing by the edge of the pool at home

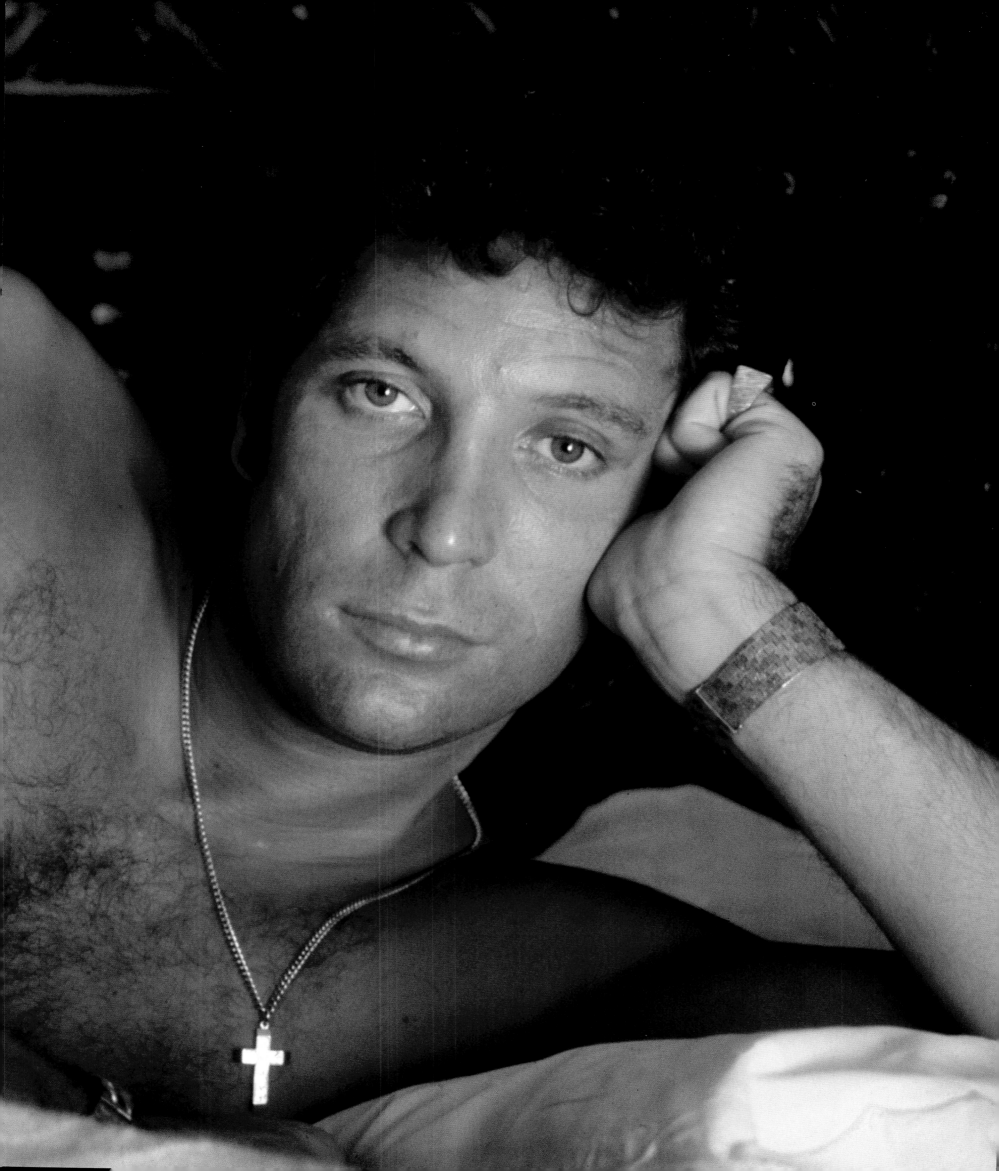

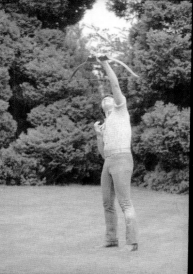
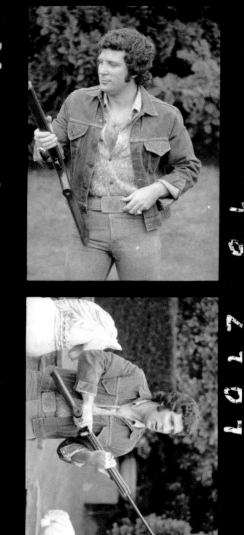

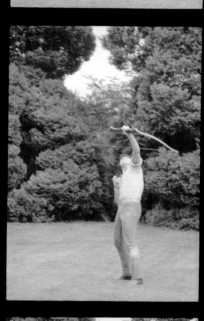

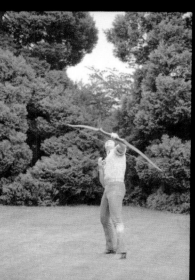
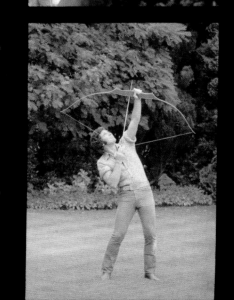
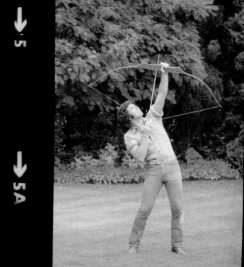
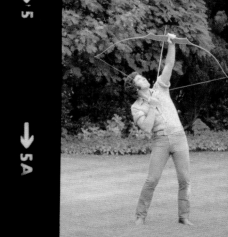

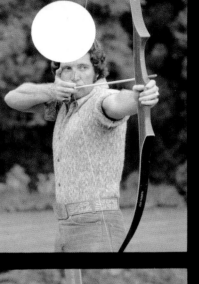
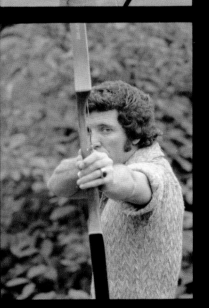

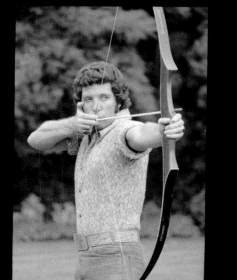

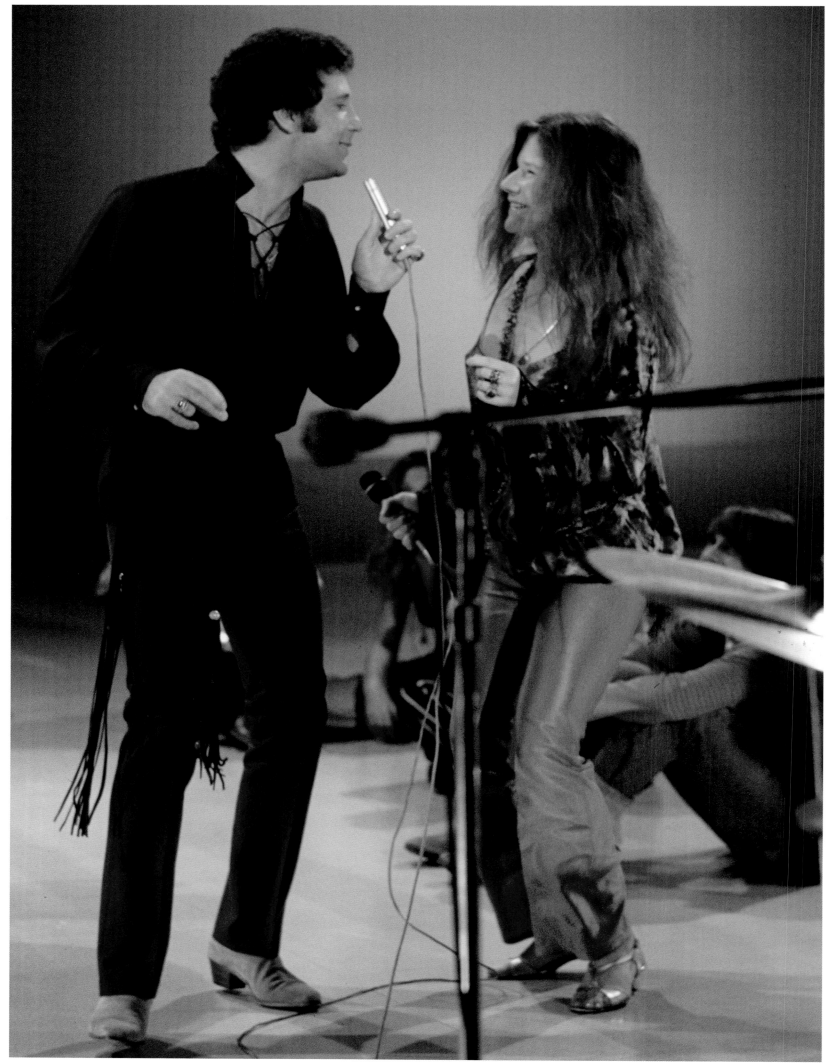

Tom and Janis Joplin on *This is Tom Jones*, 1969

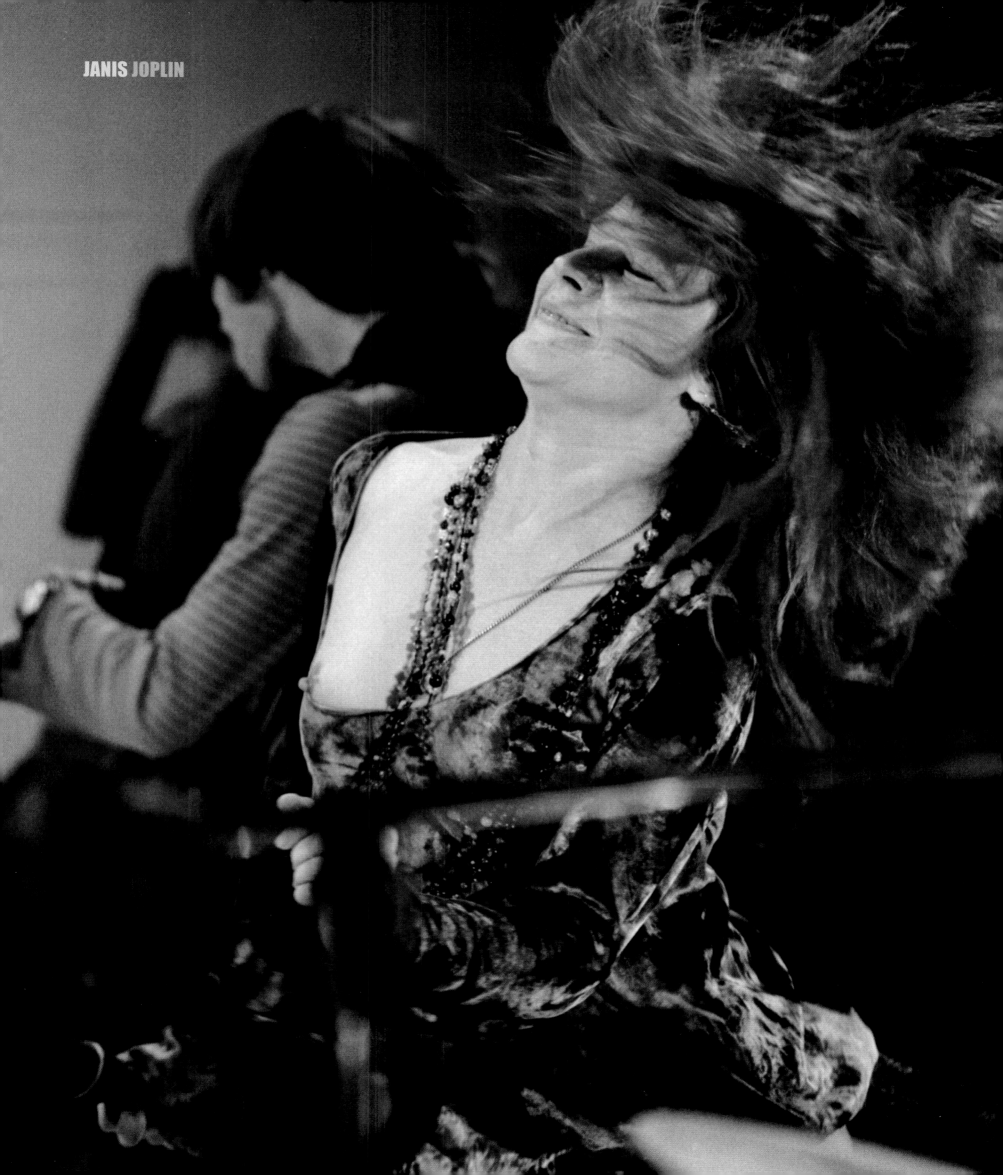

JANIS JOPLIN

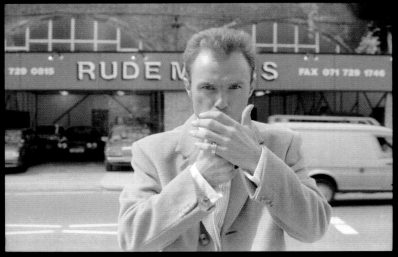

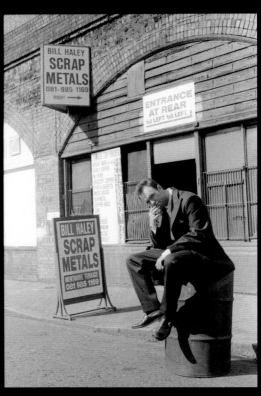
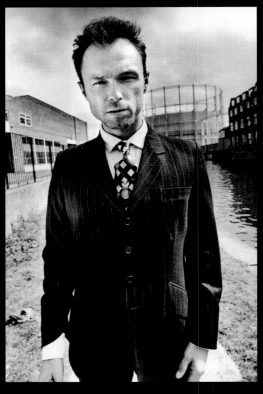

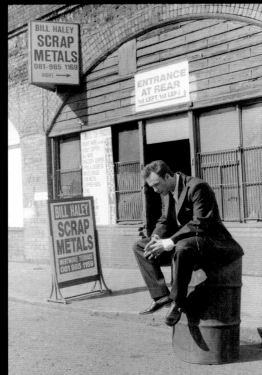
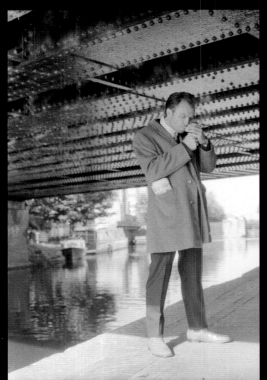

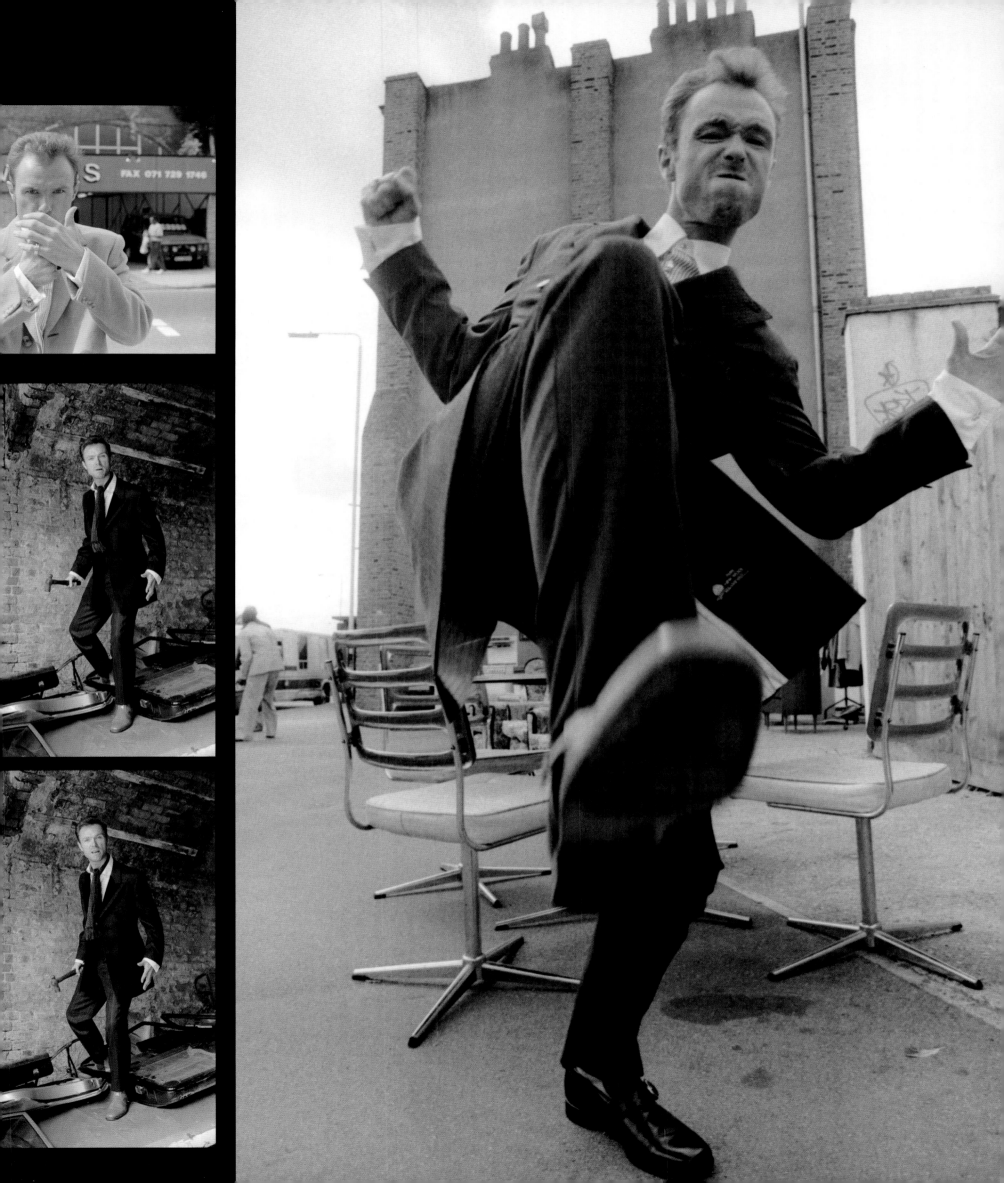

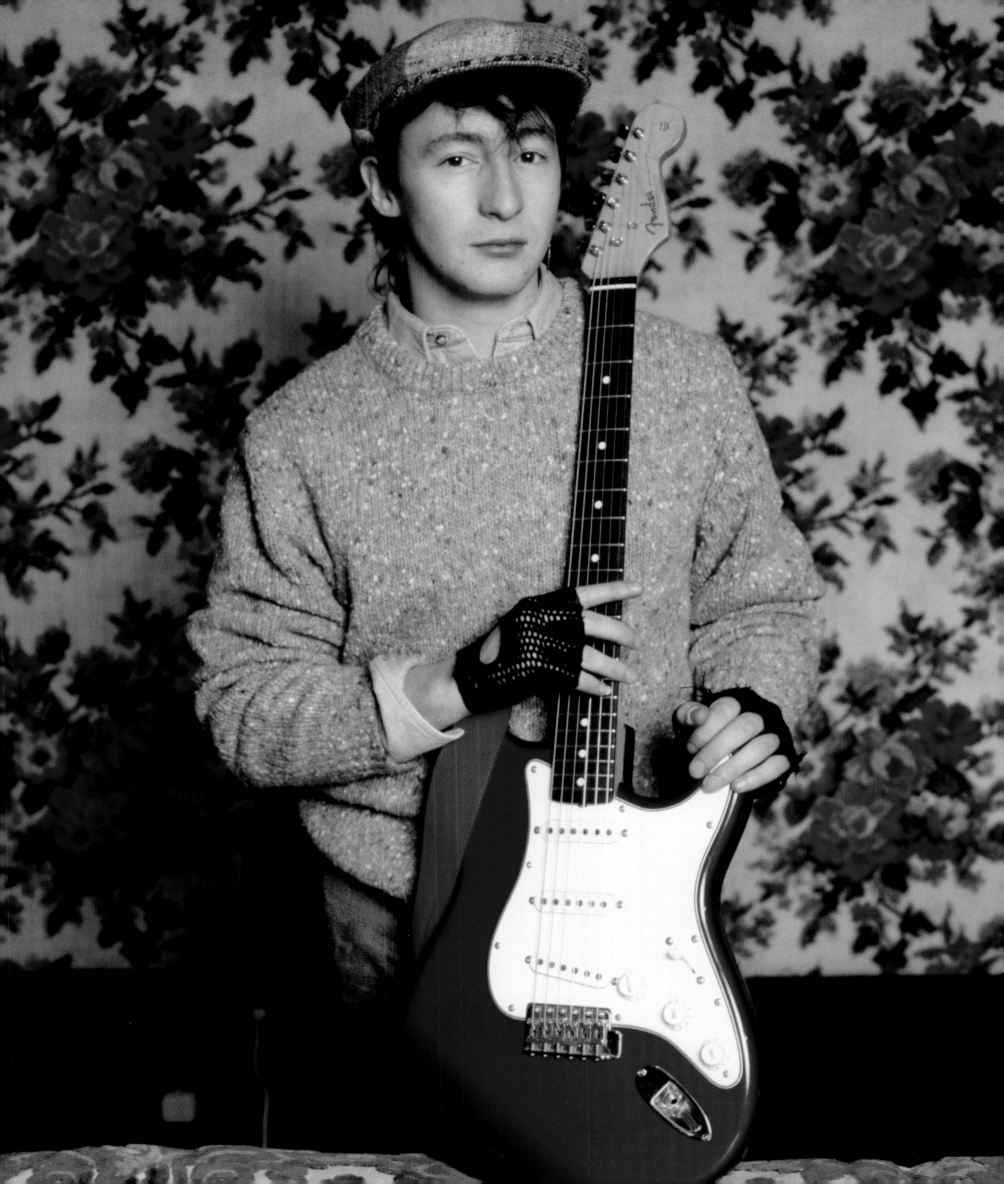

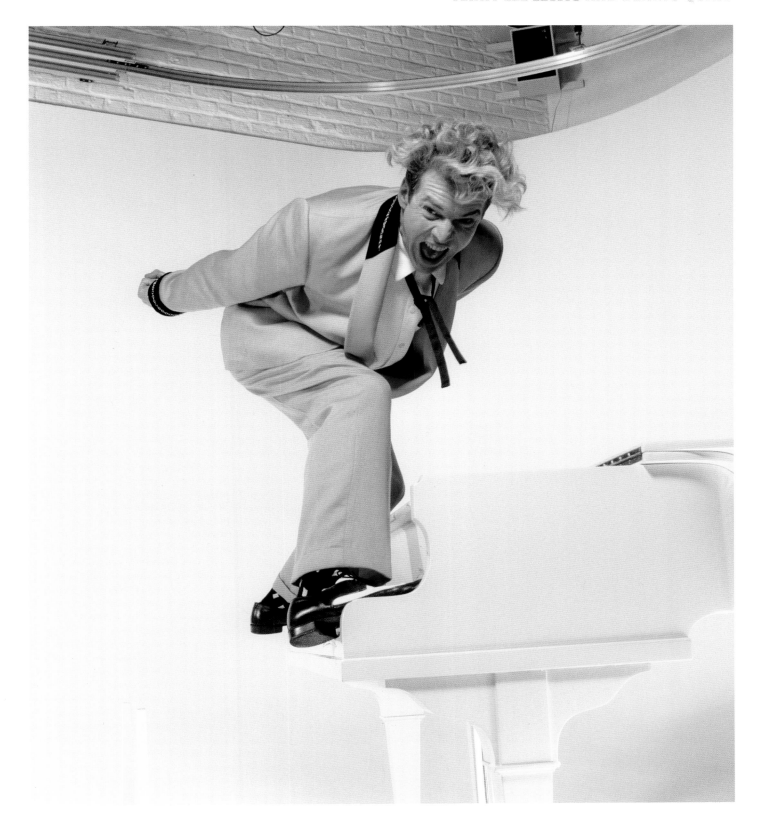

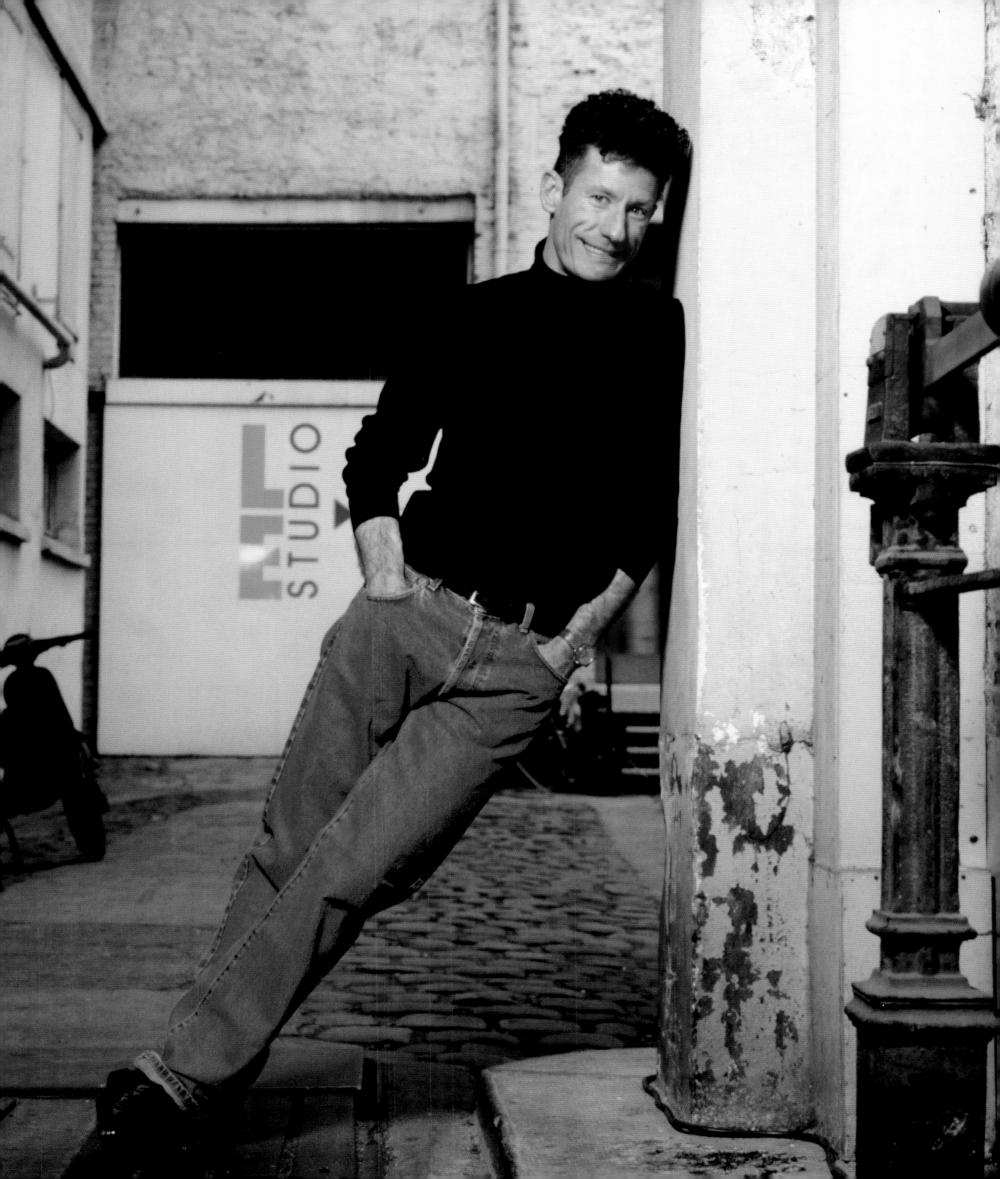

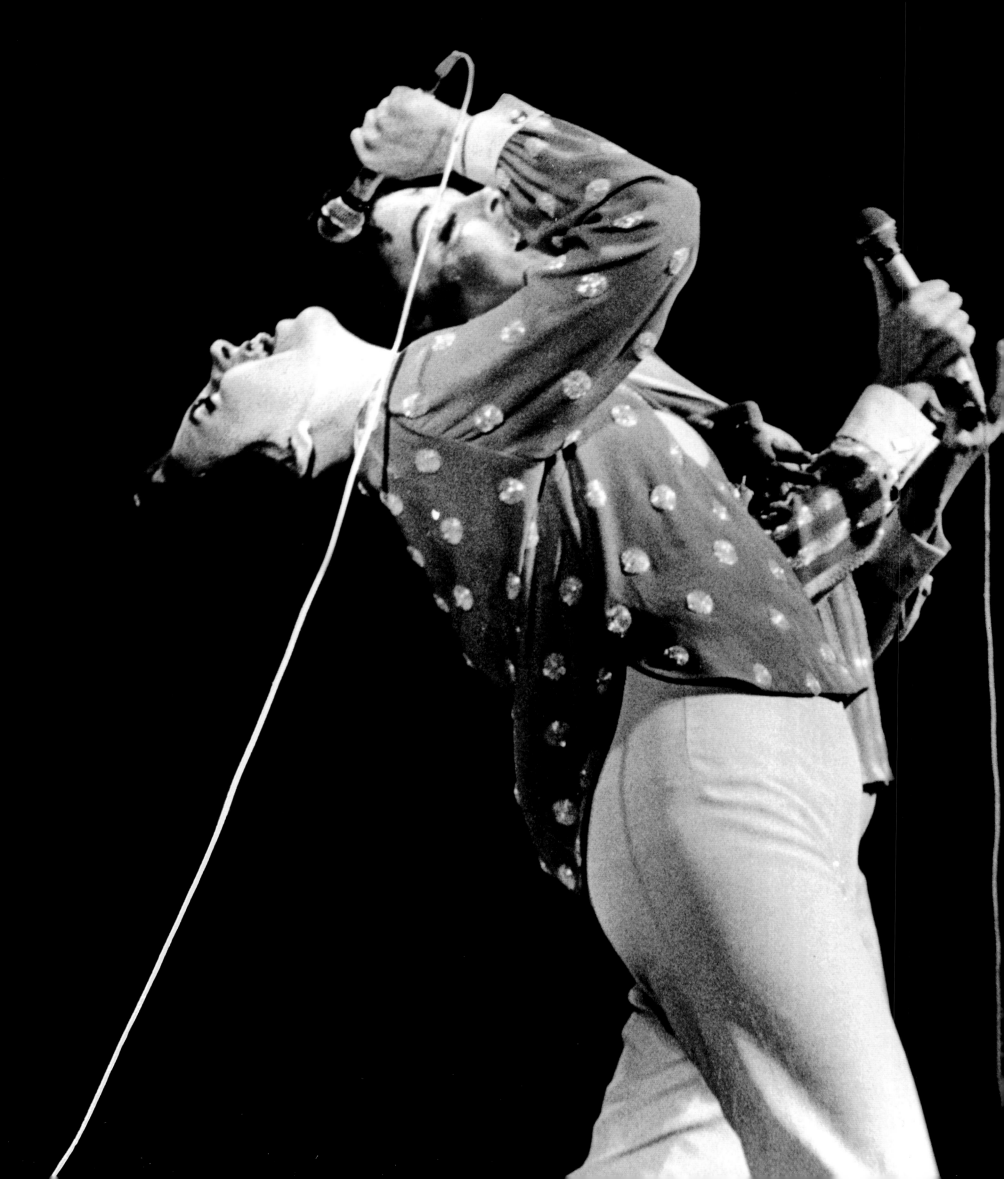

"I was there to photograph her daughter, an 18-year-old kid called Liza Minnelli that nobody had ever heard of"

LIZA MINNELLI

In November 1964, I got a call inviting me to a house in Belgravia to photograph this young girl who was supposed to be a sensational singer. I didn't give it a lot of thought — in those days I was hurtling around from job to job. For two years, I'd been on this merry-go-round photographing emerging young talent, like The Beatles and The Stones, so another young singer from America didn't really register.

I knocked on the door and when it opened my jaw dropped. Standing in front of me was the great Judy Garland. You have to remember that, as a jazz drummer myself, this was a revelation. Here was one of the great musical talents of our generation and a major film star inviting me in. She was performing at the London Palladium and I was there to photograph her daughter, an 18-year-old kid called Liza Minnelli, who nobody had ever heard of and who would be duetting with her mother.

Judy fussed around this shy little girl making sure she looked great for the camera. Then suddenly Judy said, "Why don't you come and photograph the show and do an album cover?"

They were sensational. That shy little girl came alive on stage — a powerful presence and voice, just like her mother. A year later that little girl was a Broadway star, then the youngest ever to win a Tony Award. We worked together a lot after that. I even photographed her wedding ■

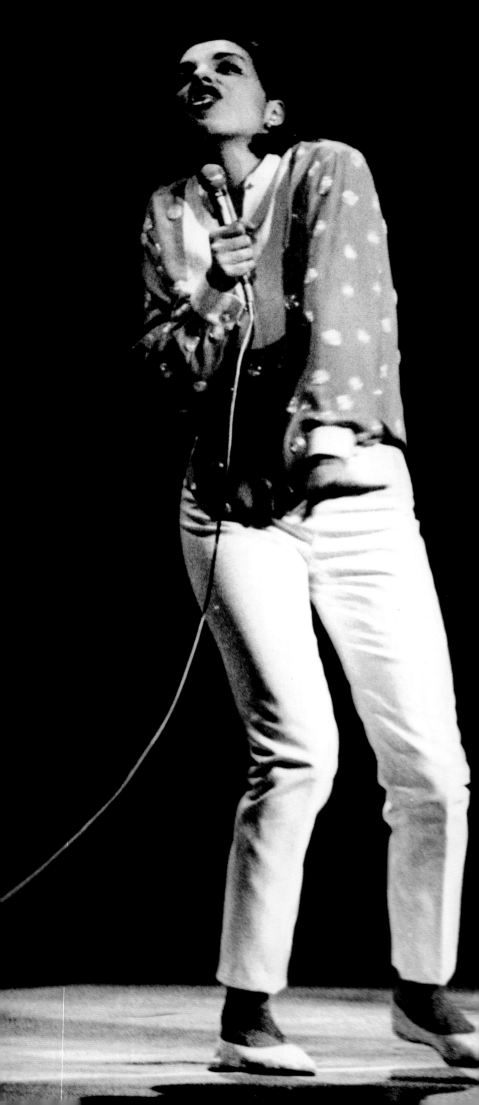

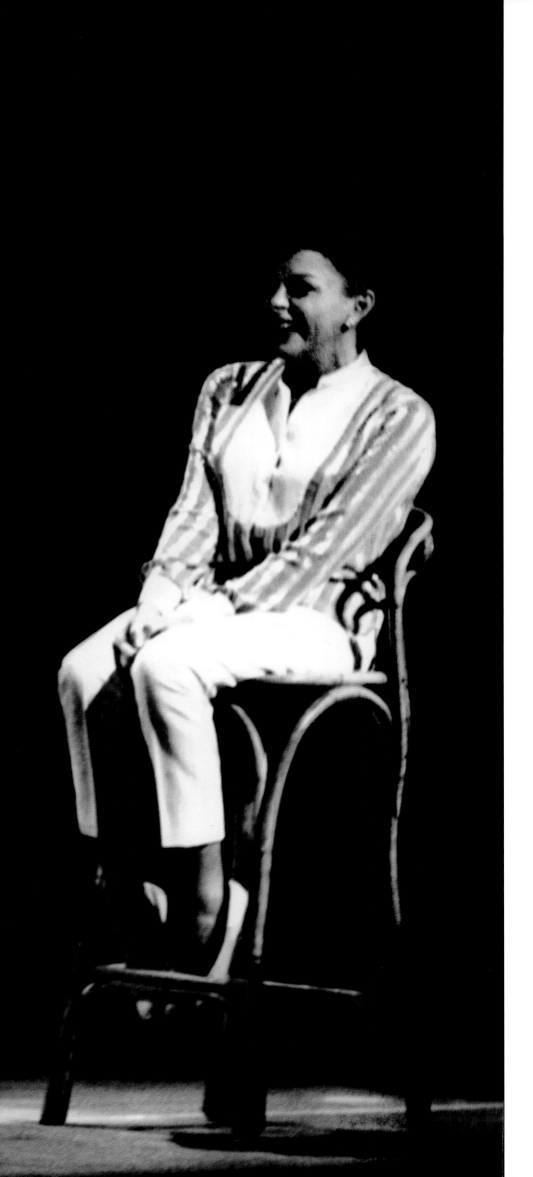

Liza Minnelli in concert with her
mother Judy Garland at the London
Palladium in November, 1964

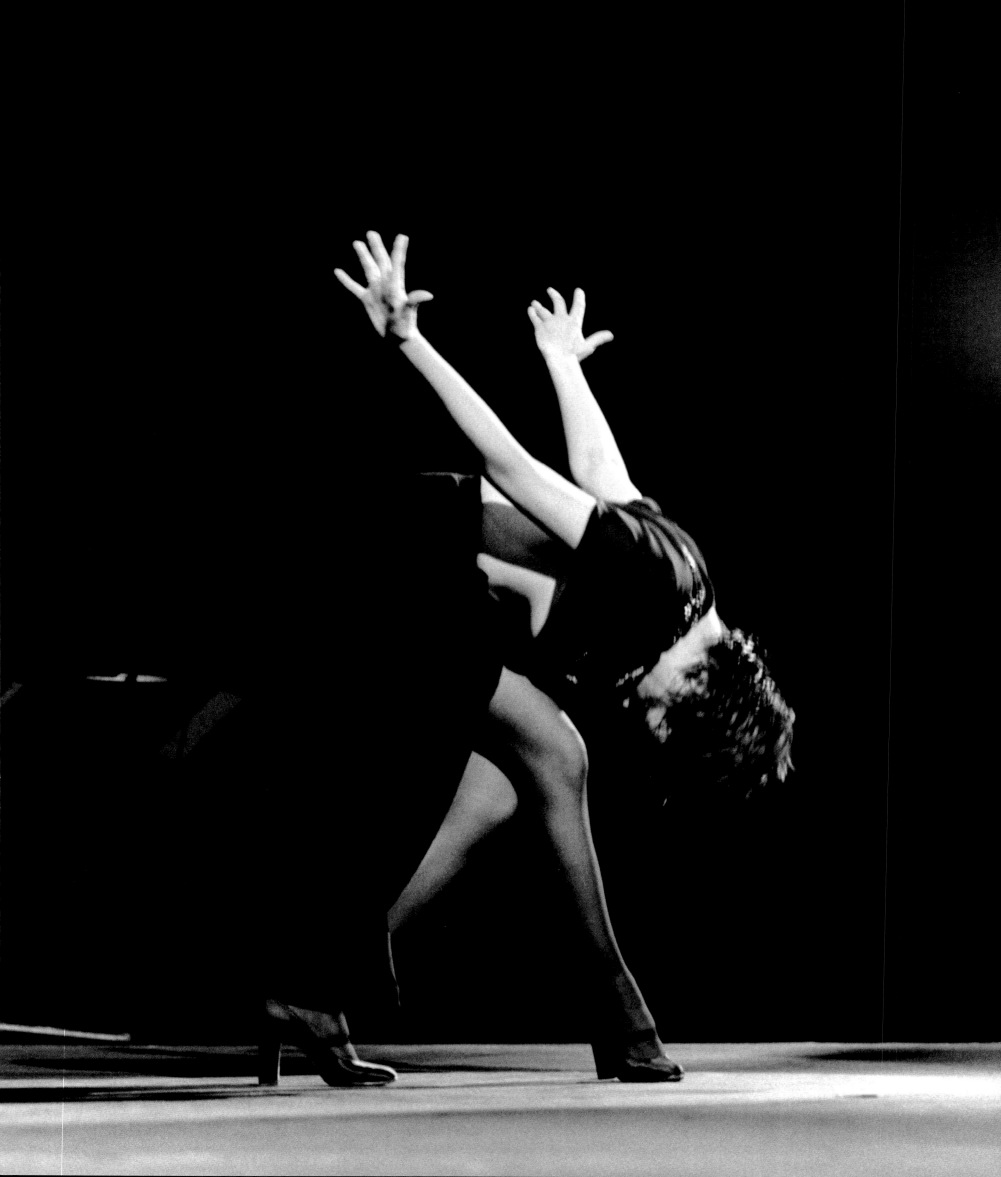

Liza finding time to unwind backstage

Liza was a "shy little girl, who really came alive on stage". She had a "powerful presence and voice, just like her mother," says Terry

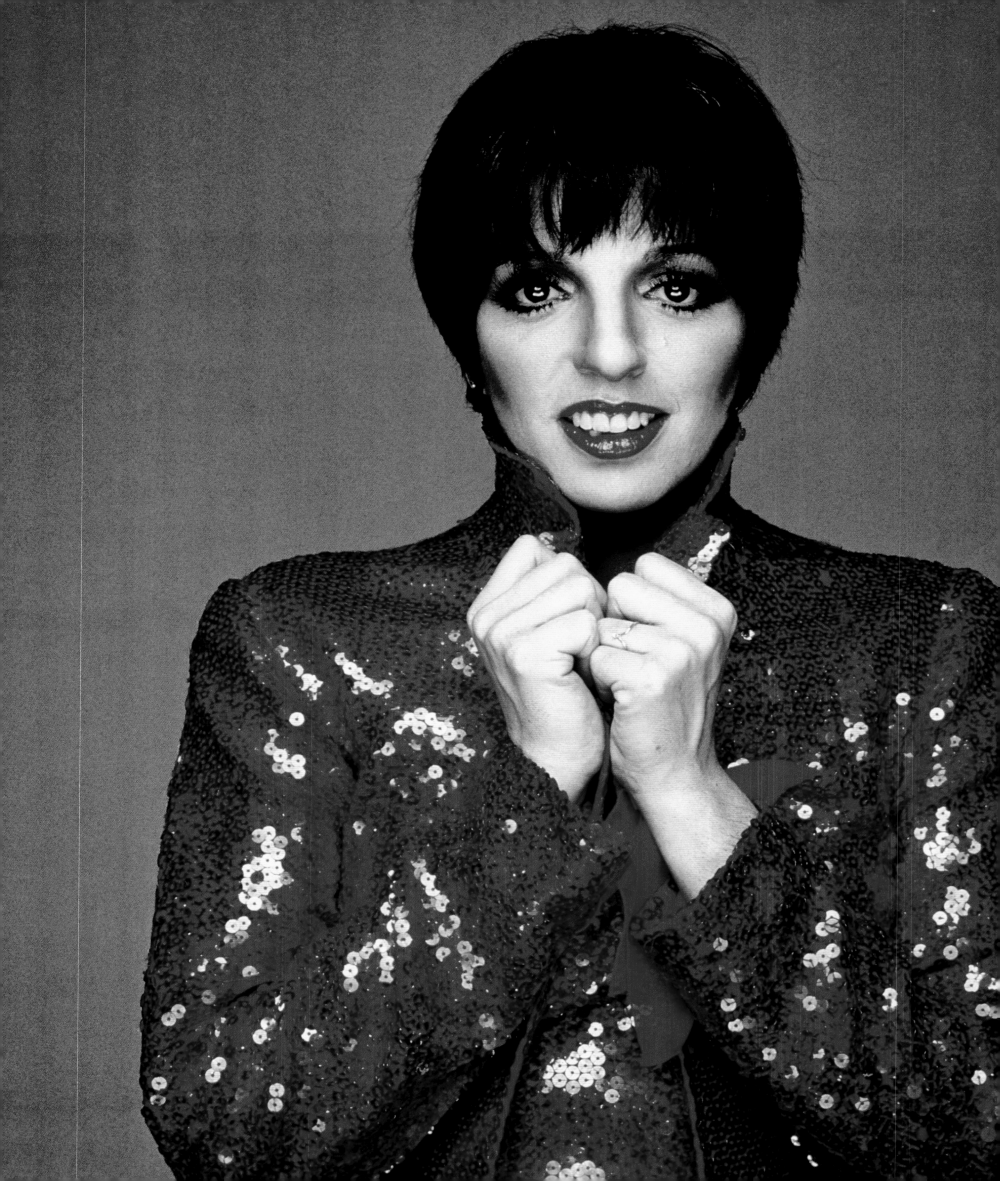

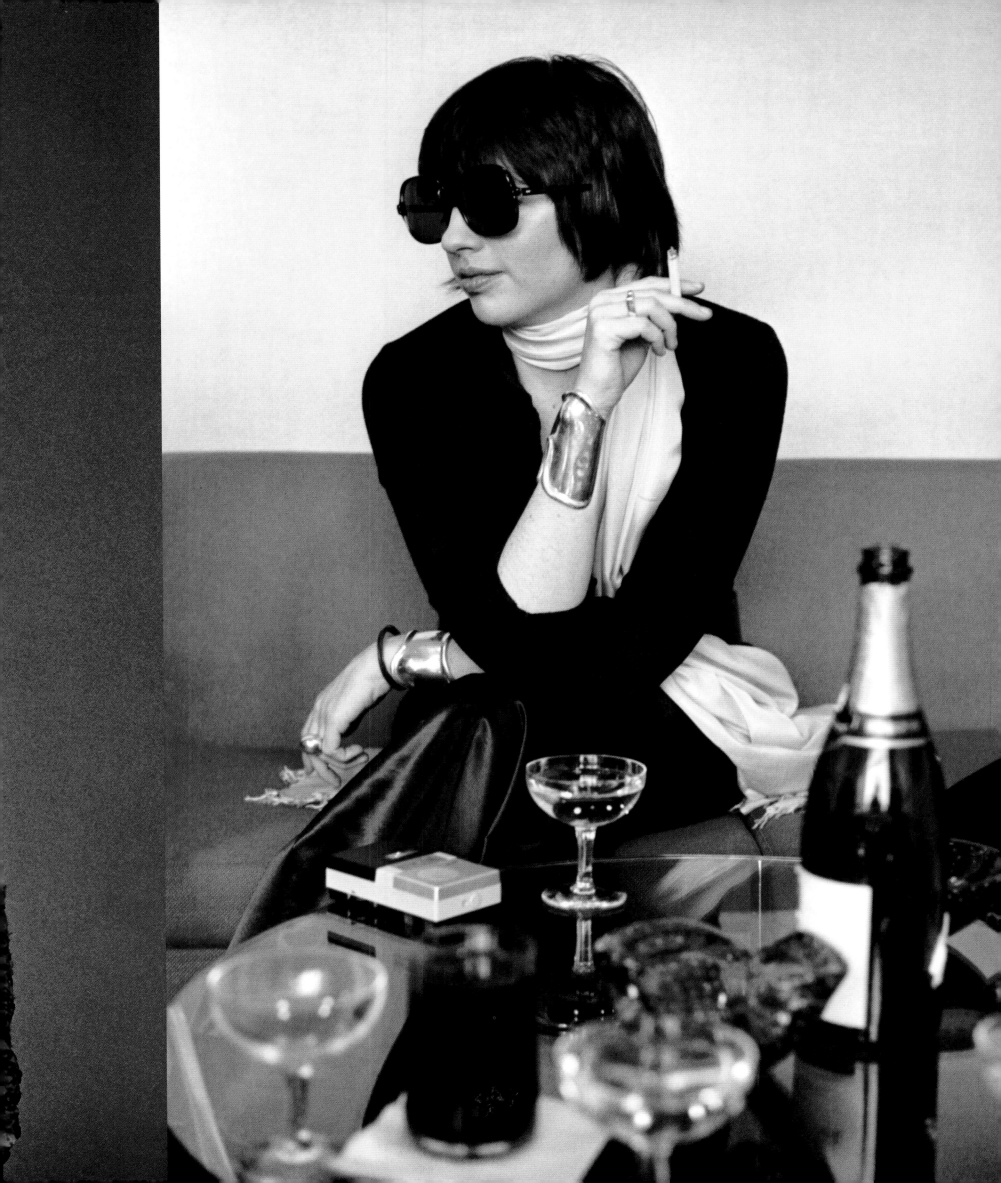

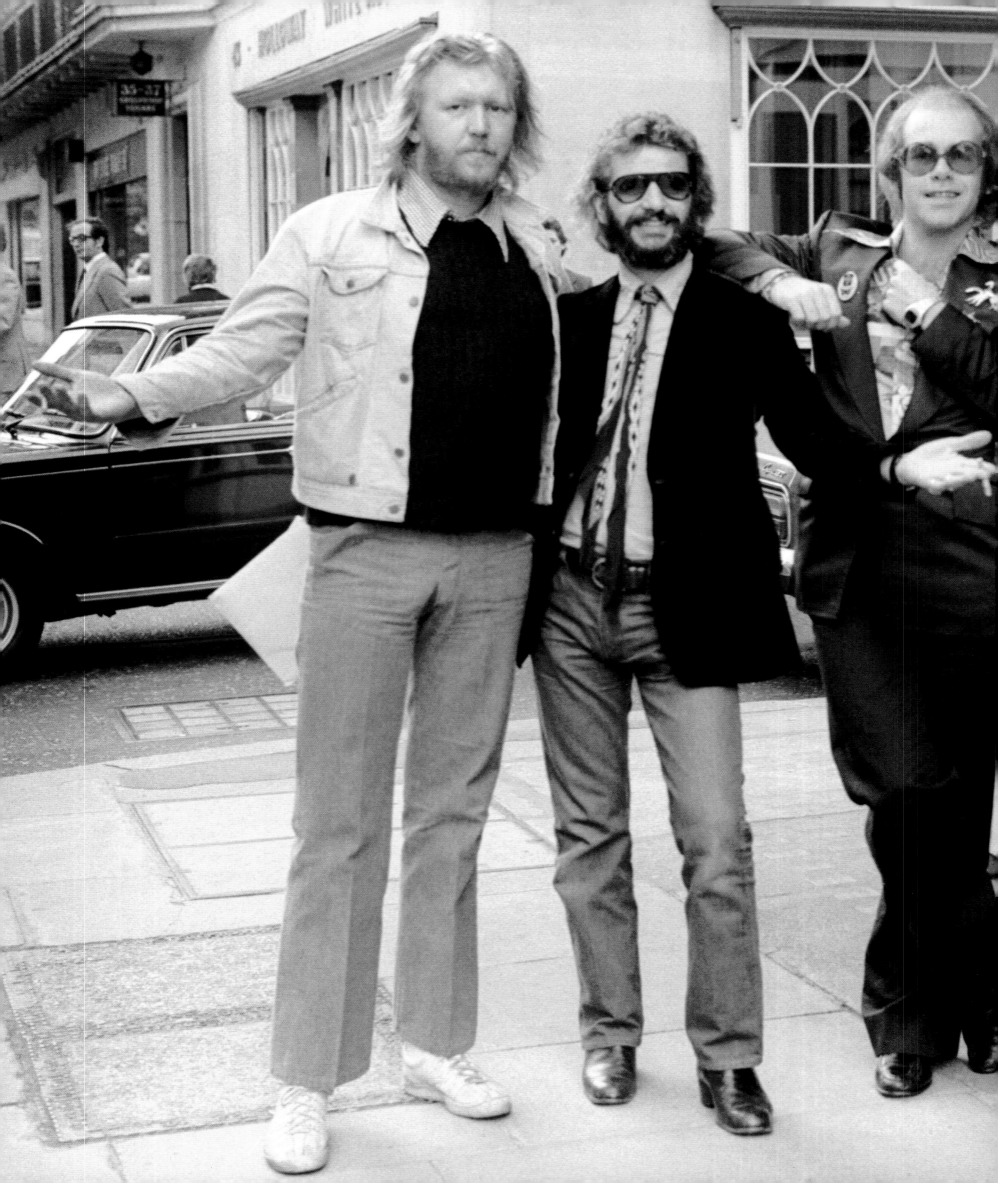

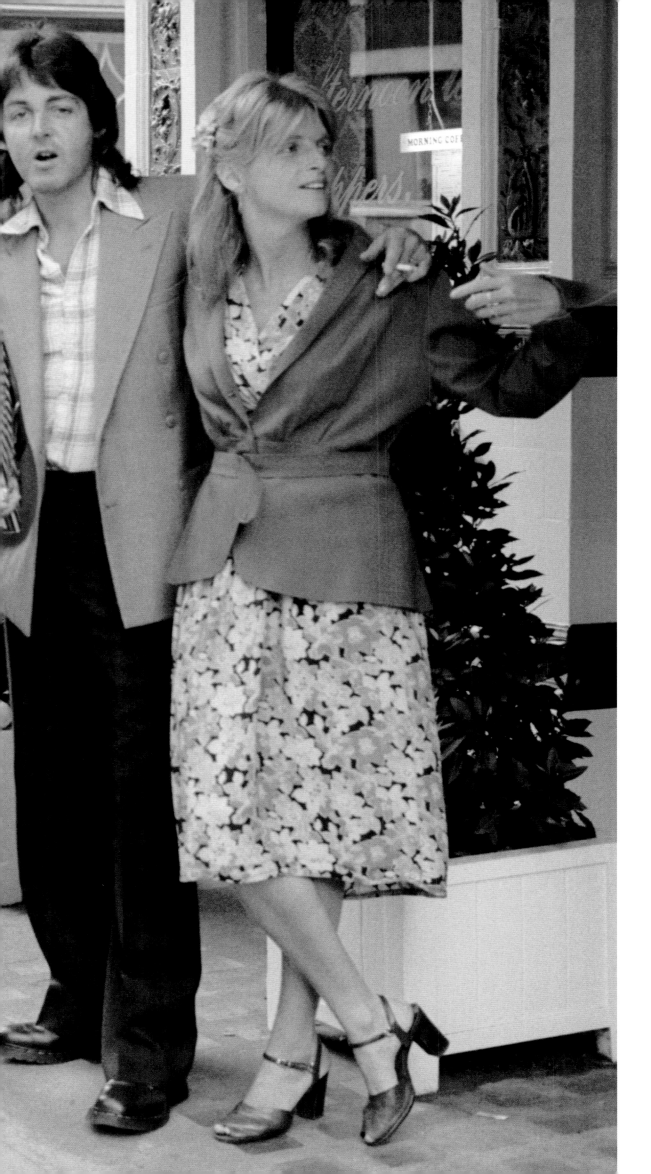

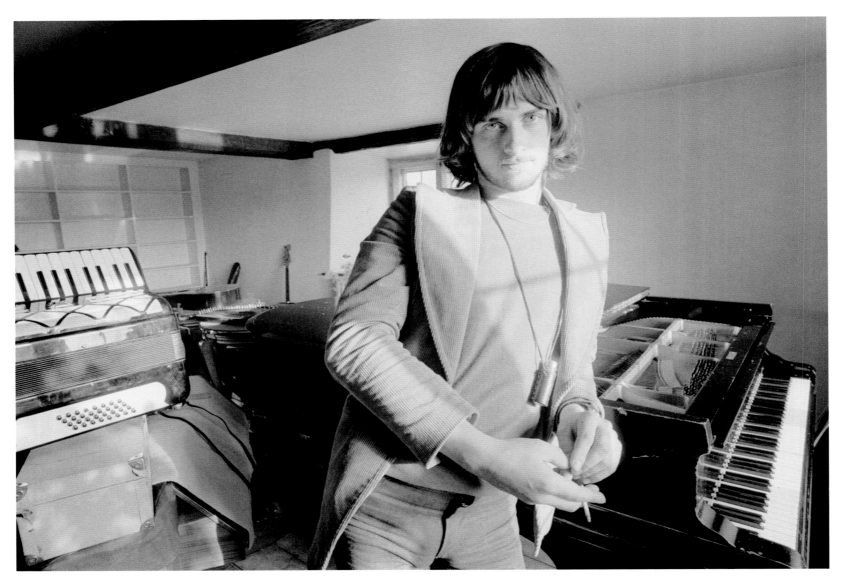

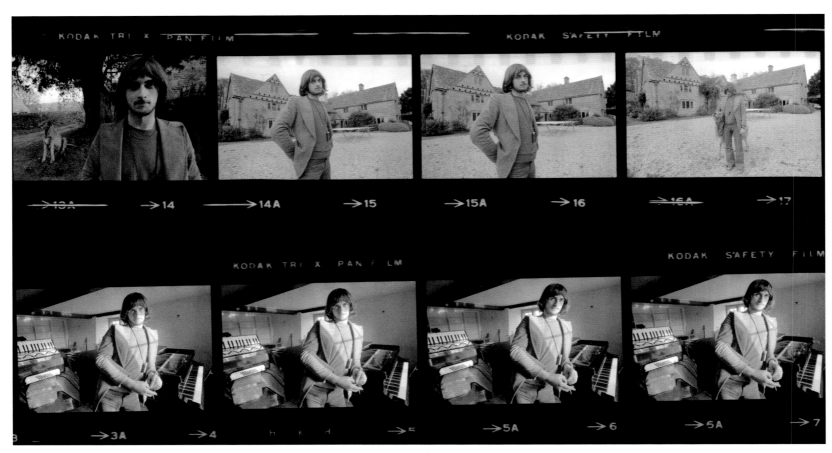

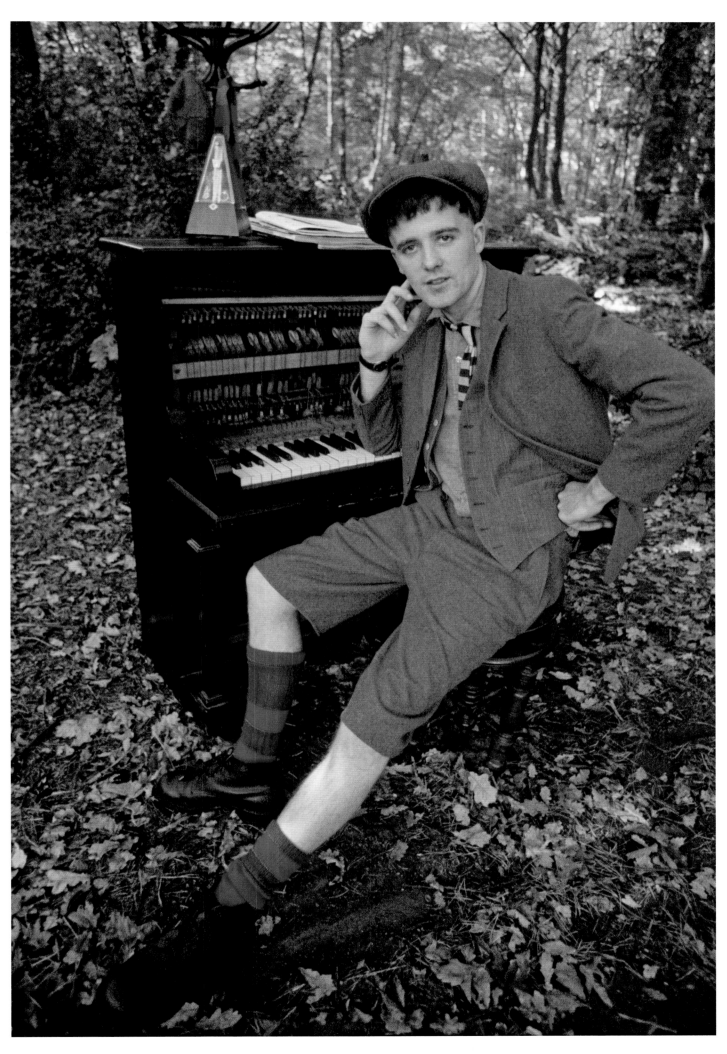

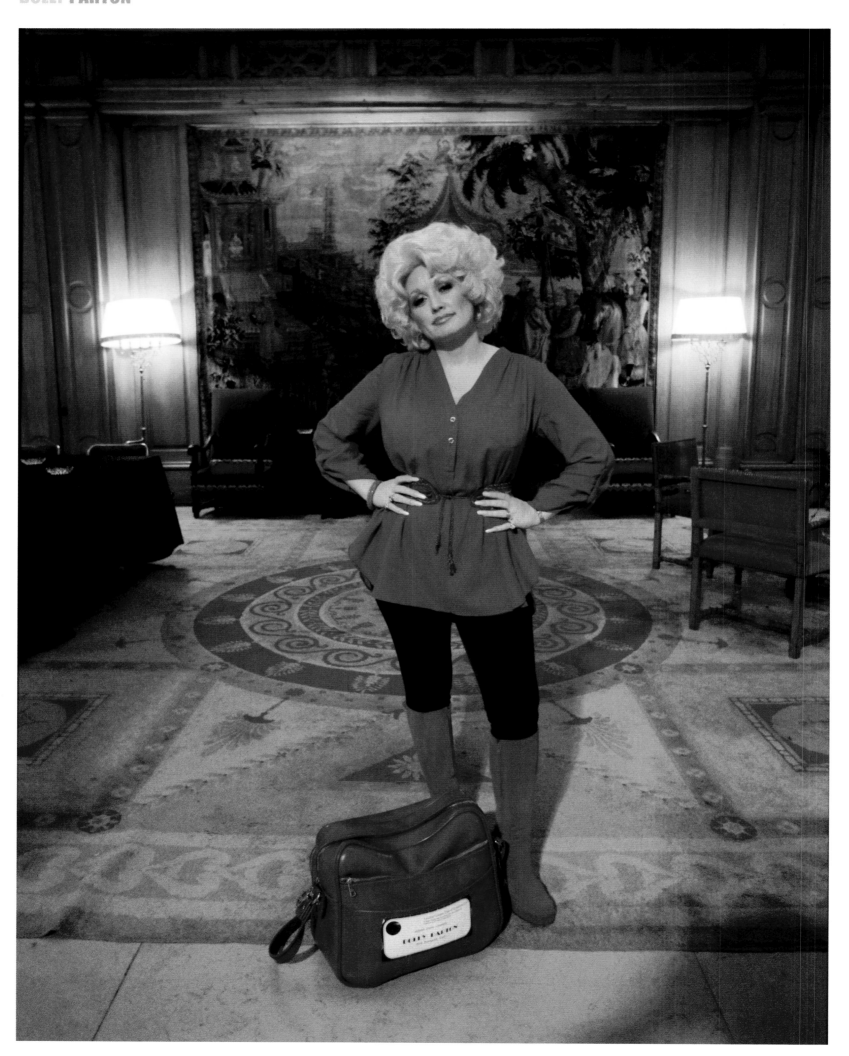

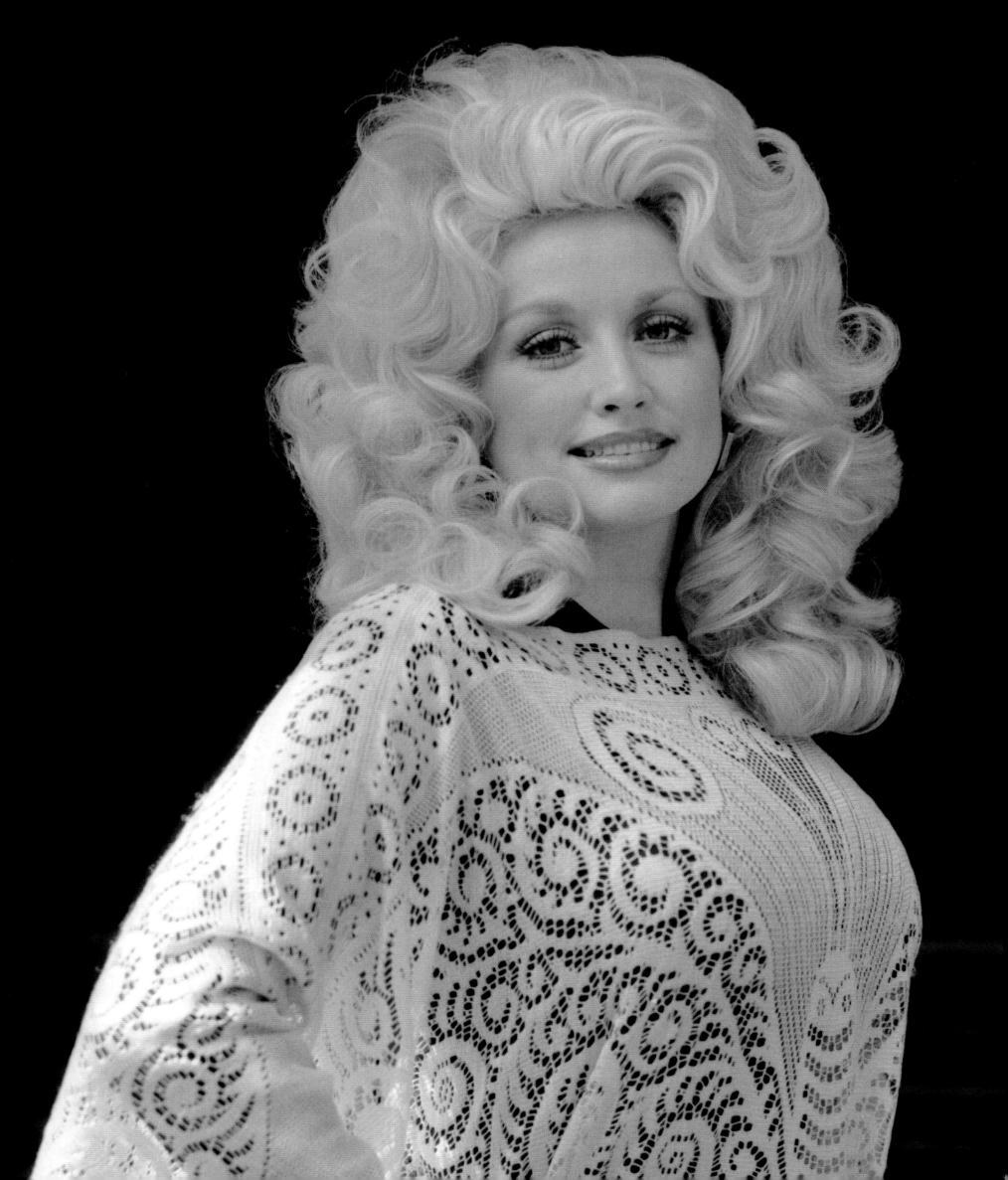

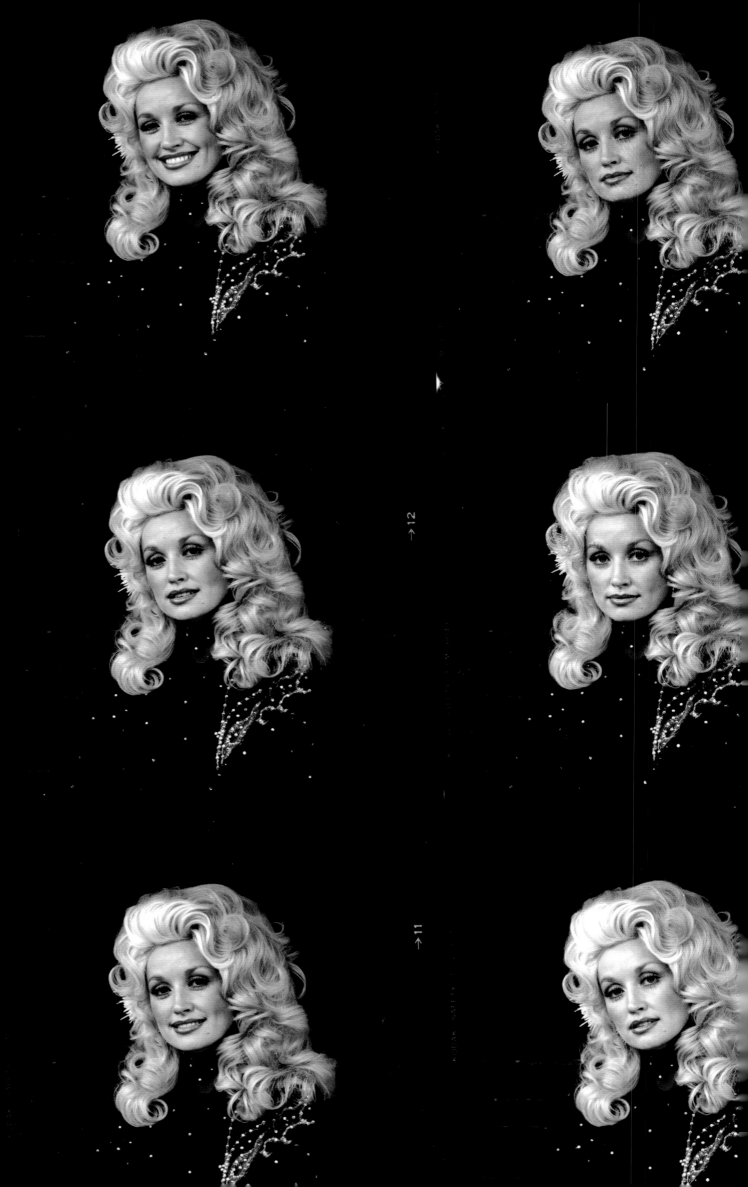

→12

→11

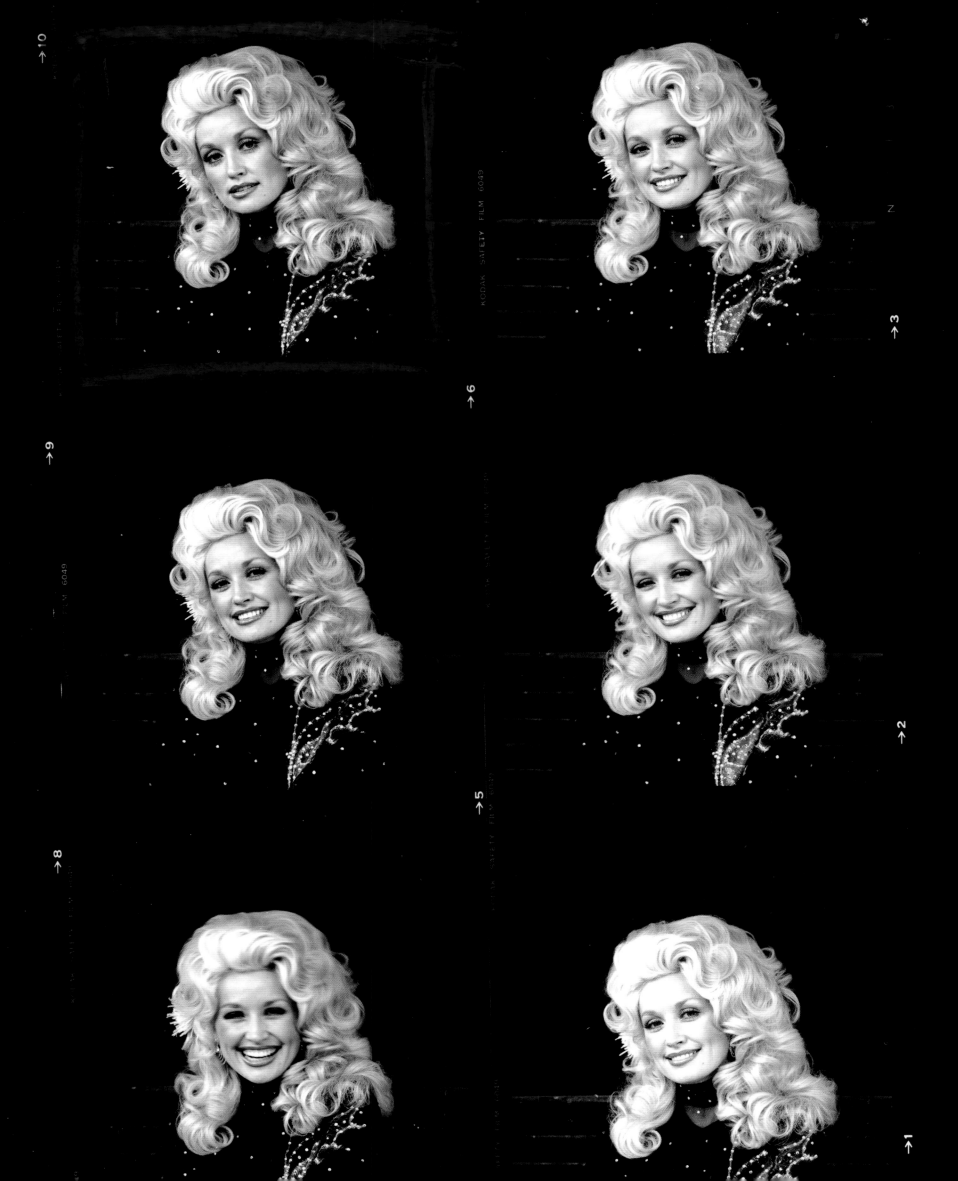

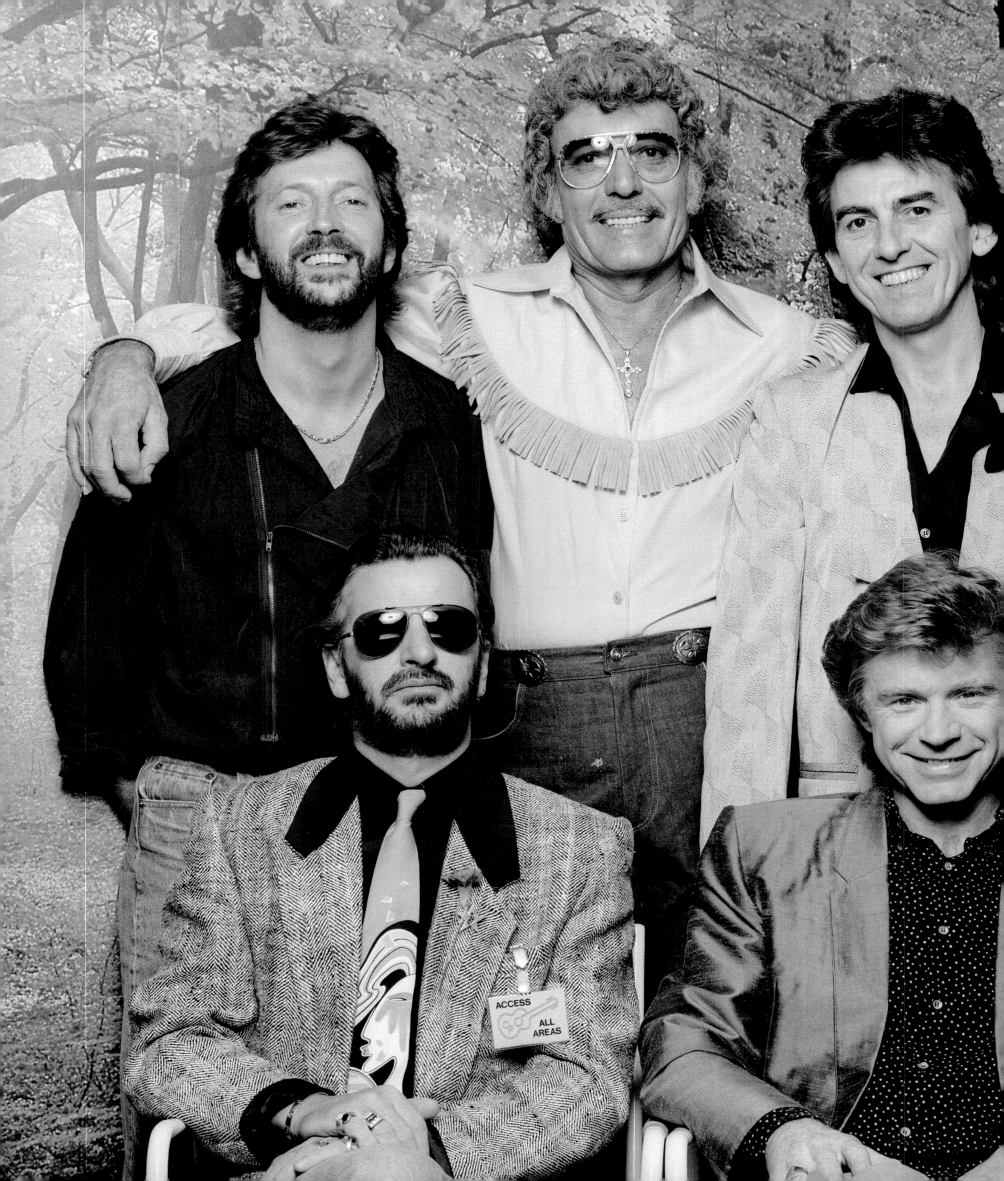

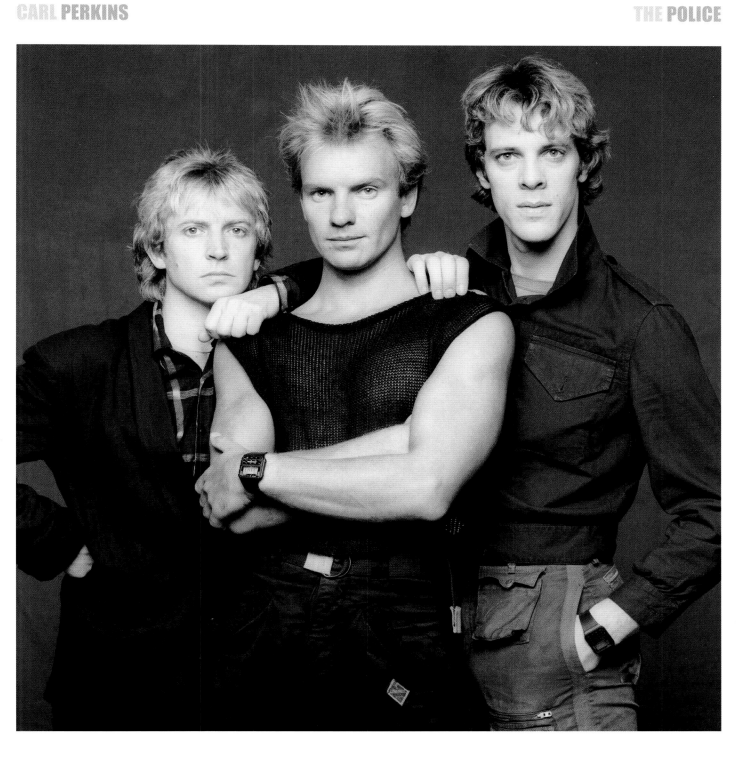

Recording the television
programme *Blue Suede Shoes*,
spotlighting veteran rockabilly
songwriter and guitarist
Carl Perkins. From left to
right: (back row) Eric Clapton,
Carl Perkins, George Harrison;
(front row) Ringo Starr,
Dave Edmunds, 1985.

Elvis on stage the opening night of his comeback show at Caesar's Palace Hotel in Las Vegas, 1971. "Tom Jones fixed a great vantage point where I could shoot him performing," remembers Terry

ELVIS PRESLEY

There are a few people I never got to photograph — Marilyn Monroe was one. And there were a few people who, when luck gave me a tiny window of opportunity, I knew I'd have to act fast. Elvis was one of those.

I was in Las Vegas with my pal Tom Jones, in 1971. He had been headlining since 1967. Tom was so huge in America he almost gave up recording songs — he was in such demand in concert.

His television specials were broadcast on both sides of the Atlantic and featured big-name stars as part of the show, like Bing Crosby, Raquel Welch and even John Wayne. Fame does that for you. When you are at the top of your game everyone wants to be in the spotlight alongside you. Some hope the stardust will rub off and rejuvenate a career, others like to spread their wings, like Raquel. She was one of the hottest movie stars of her day, but she was also a good cabaret singer and dancer and loved the stage.

Elvis was the other big-draw Vegas attraction and I discovered he and Tom had become great friends. Tom and Elvis spent a lot of time hanging out, often duetting together into the early hours of the morning in their hotel suites.

Women would throw their hotel room keys on stage for both of them. They were crazy for Tom and Elvis.

Tom asked me if I had ever photographed Elvis and I said no. He asked if I wanted to. You can guess the answer. In those days nobody got close to The King. But Tom just whisked me backstage and introduced us — the next thing I know, I'm photographing him. I didn't have long because he was due on stage, so I grabbed a few portraits. Then Tom fixed a great vantage point where I could shoot Elvis performing. I never got another chance ∎

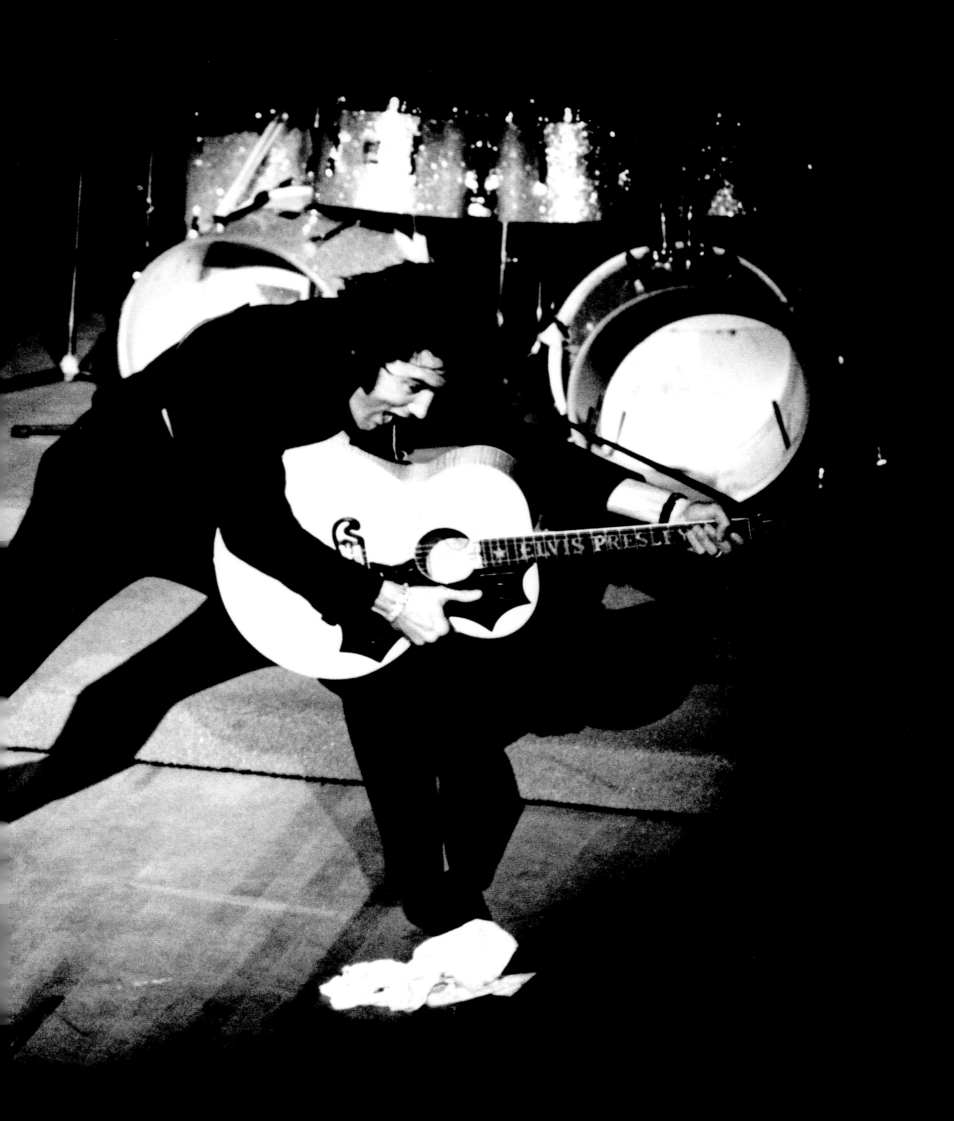

"Tom Jones asked me if I had ever photographed Elvis and I said no. He asked if I wanted to. In those days nobody got close to The King"

"Tom just whisked me backstage and introduced us — the next thing I know, I'm photographing Elvis. I didn't have long because he was due on stage, so I grabbed a few portraits," says Terry

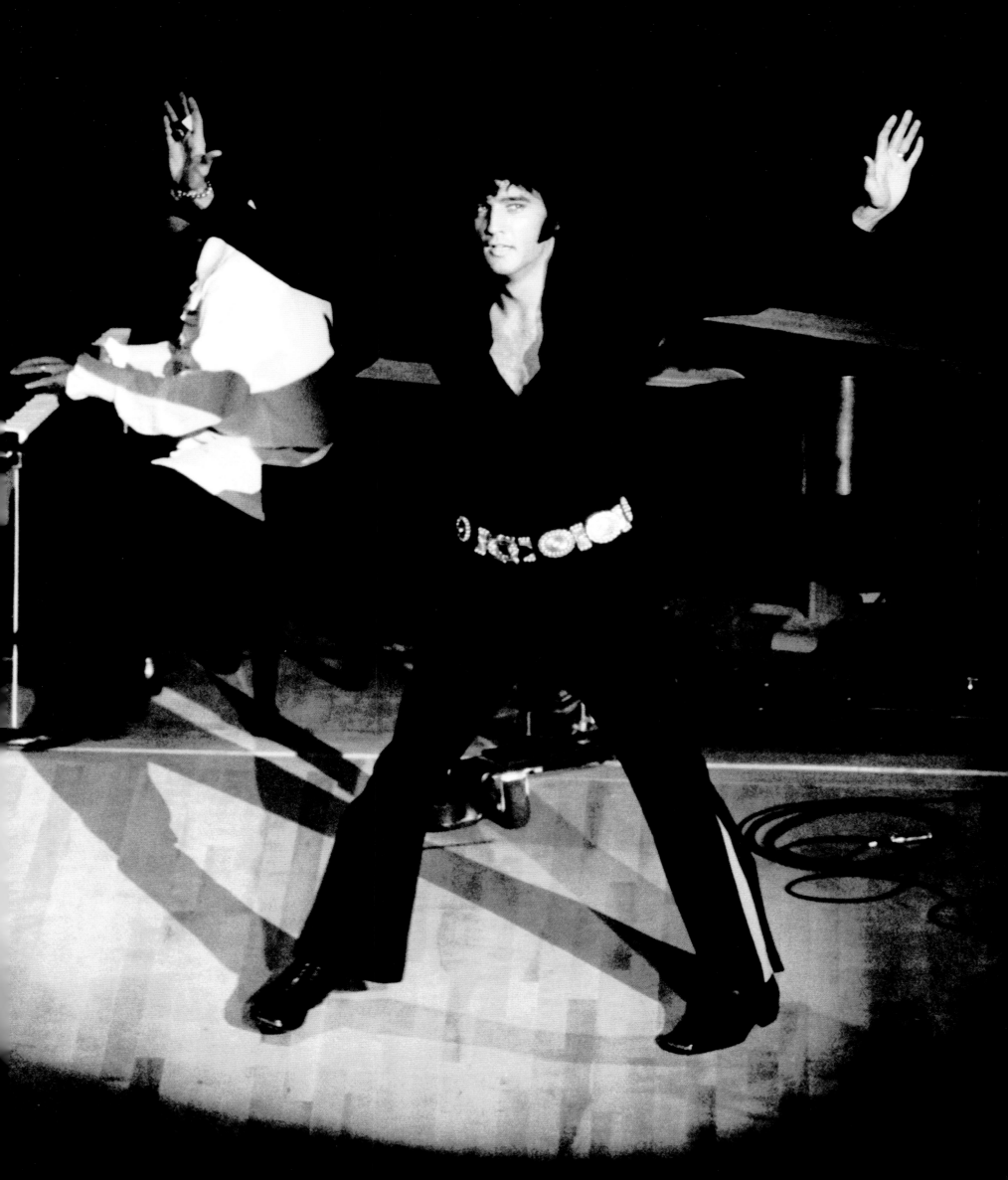

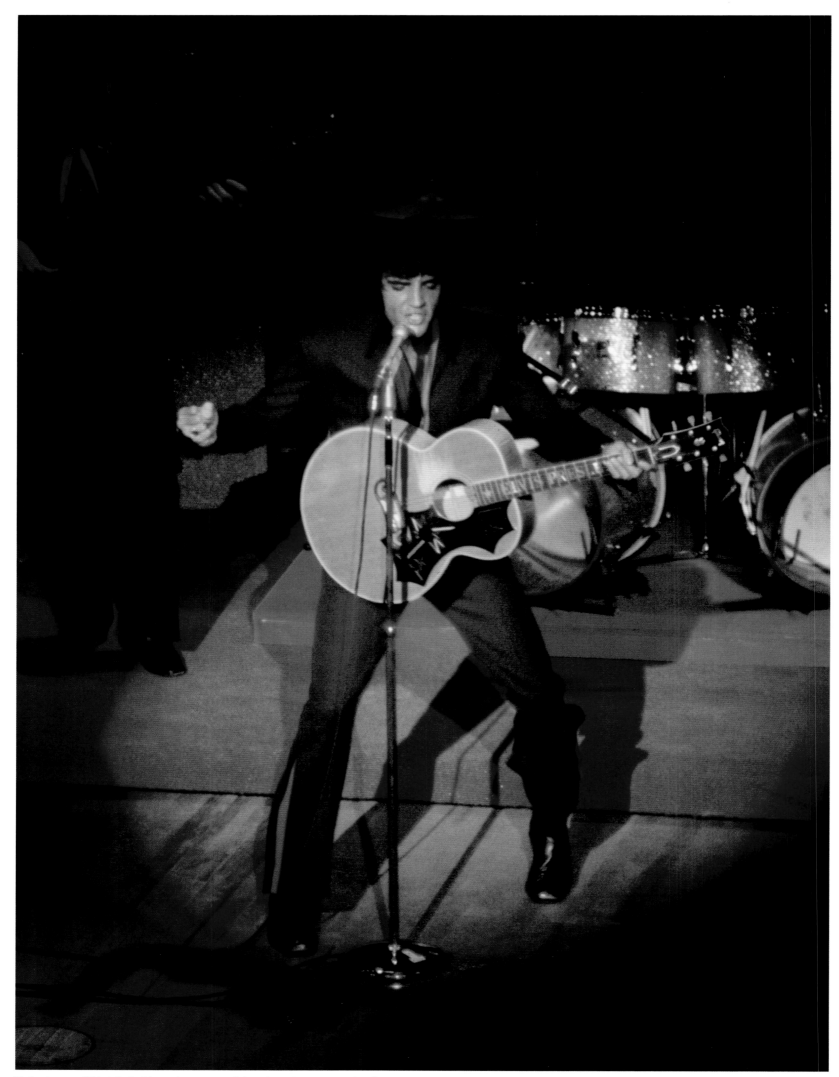

Elvis shows off his inimitable style on stage (above); and – a close-up before the show captures a moment of calm (right)

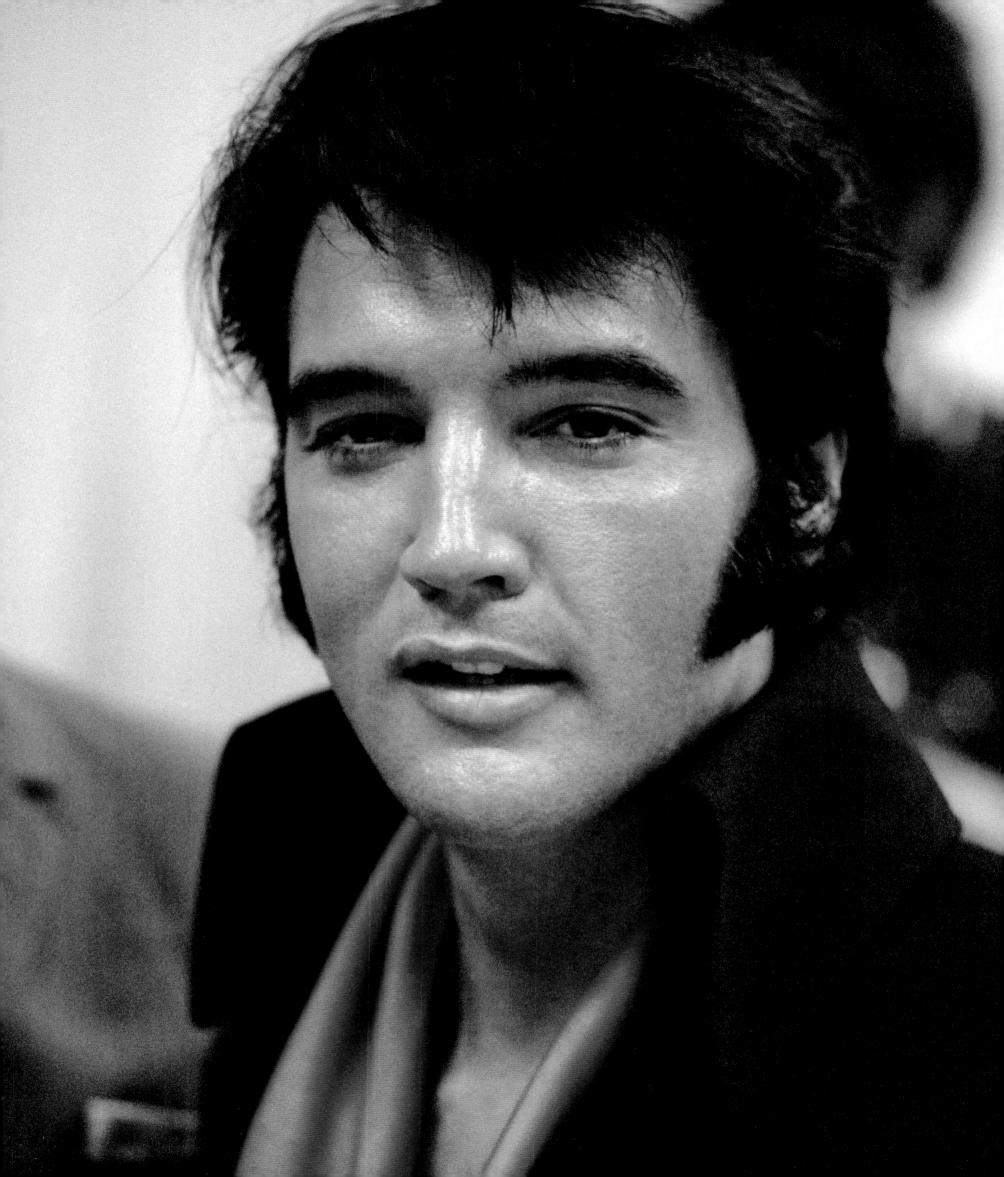

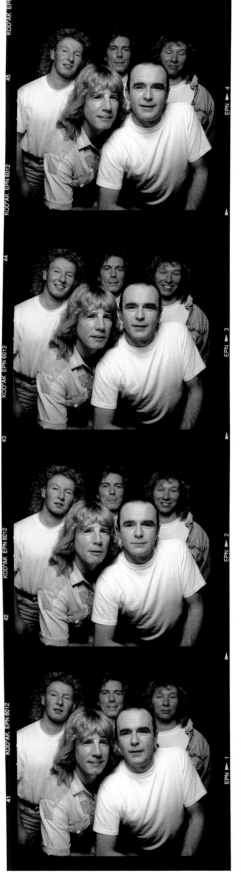

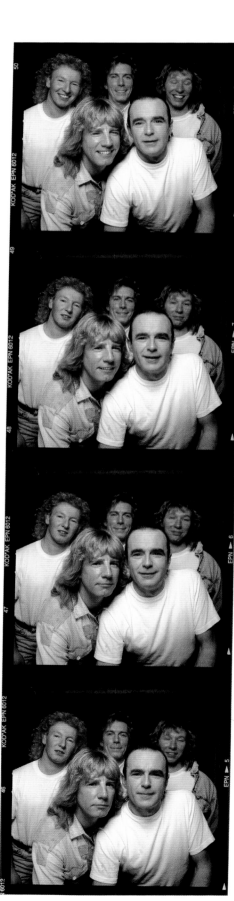

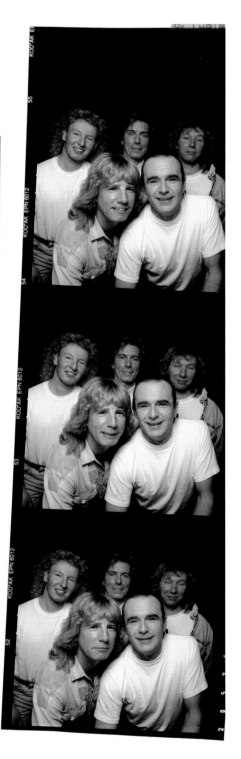

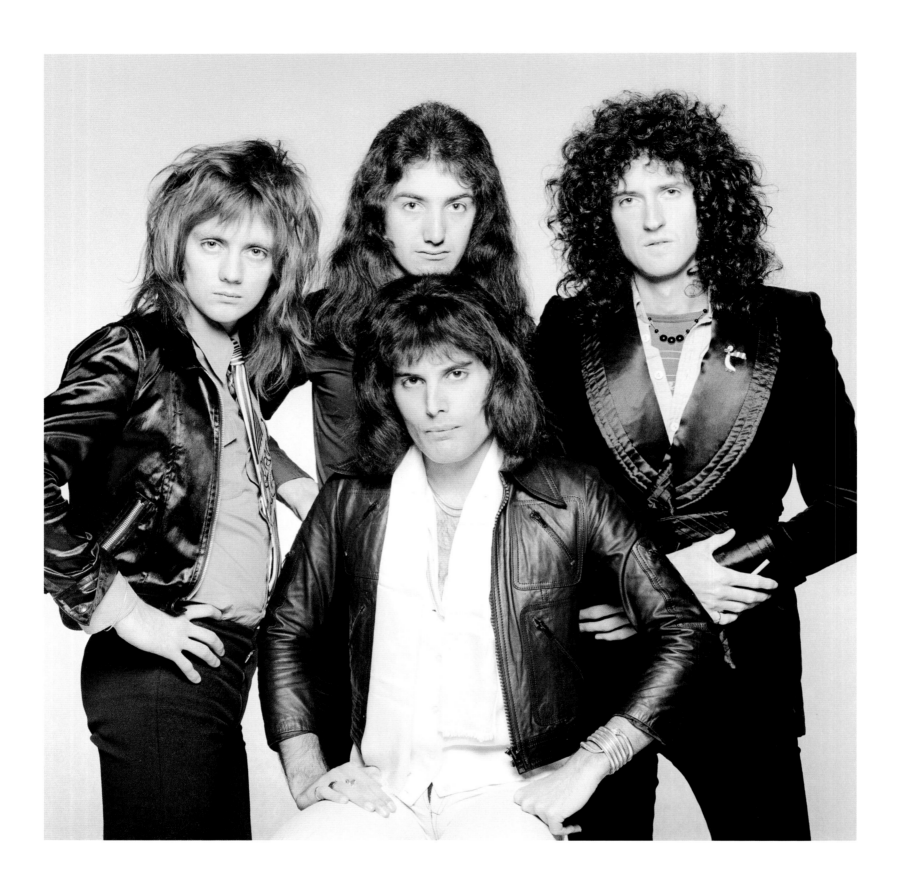

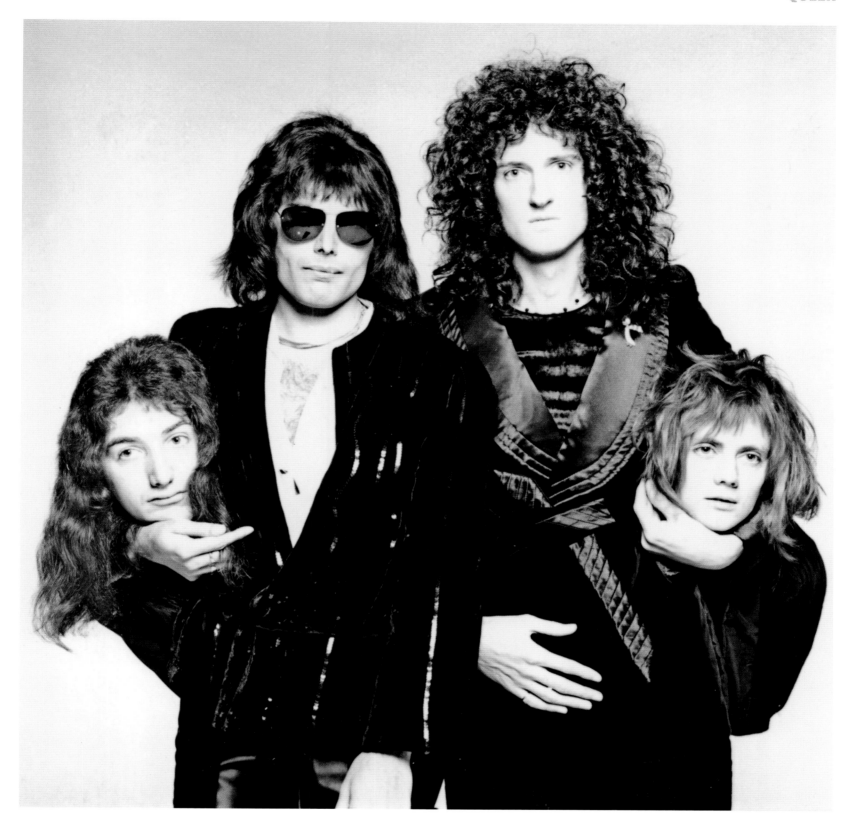

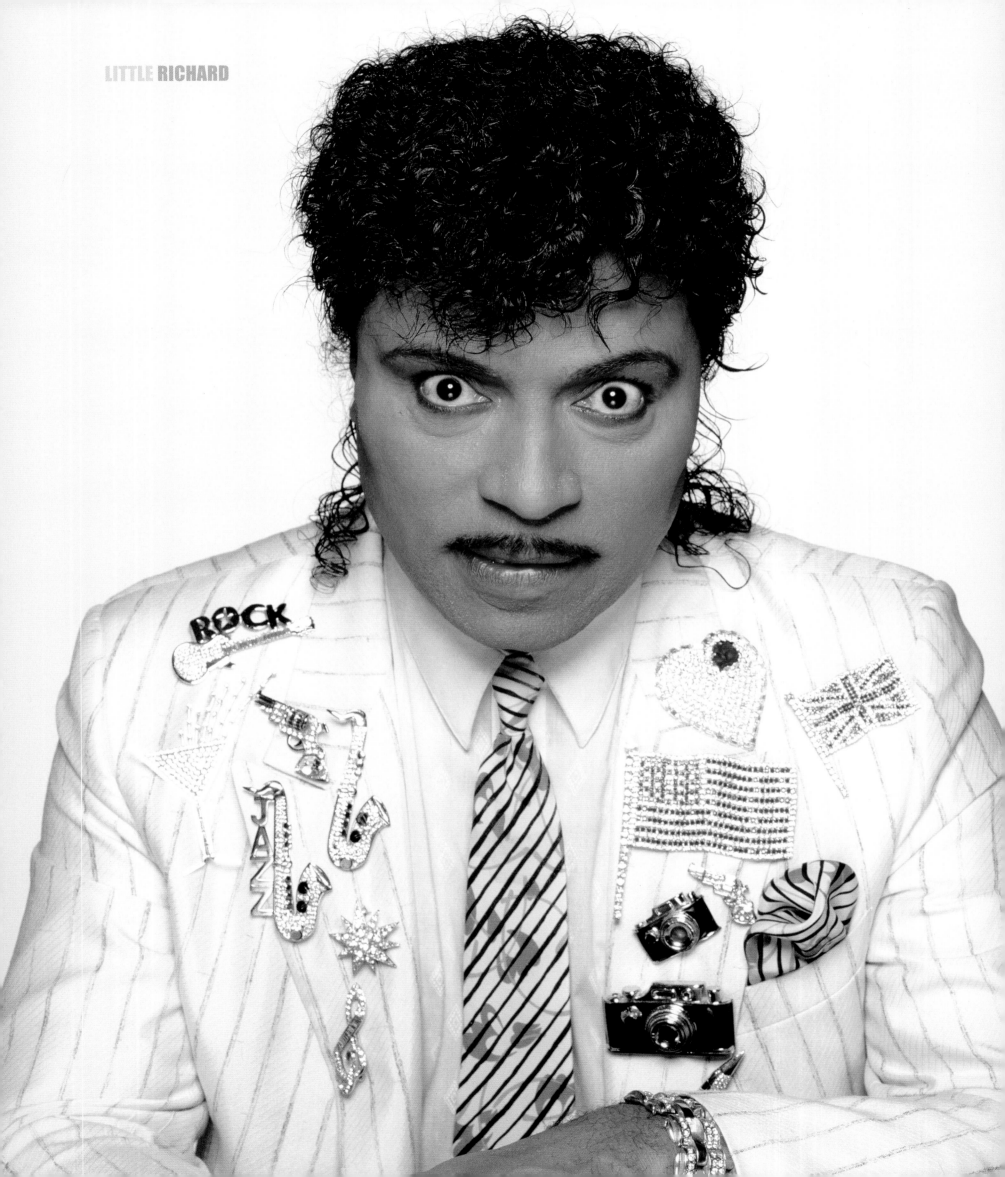

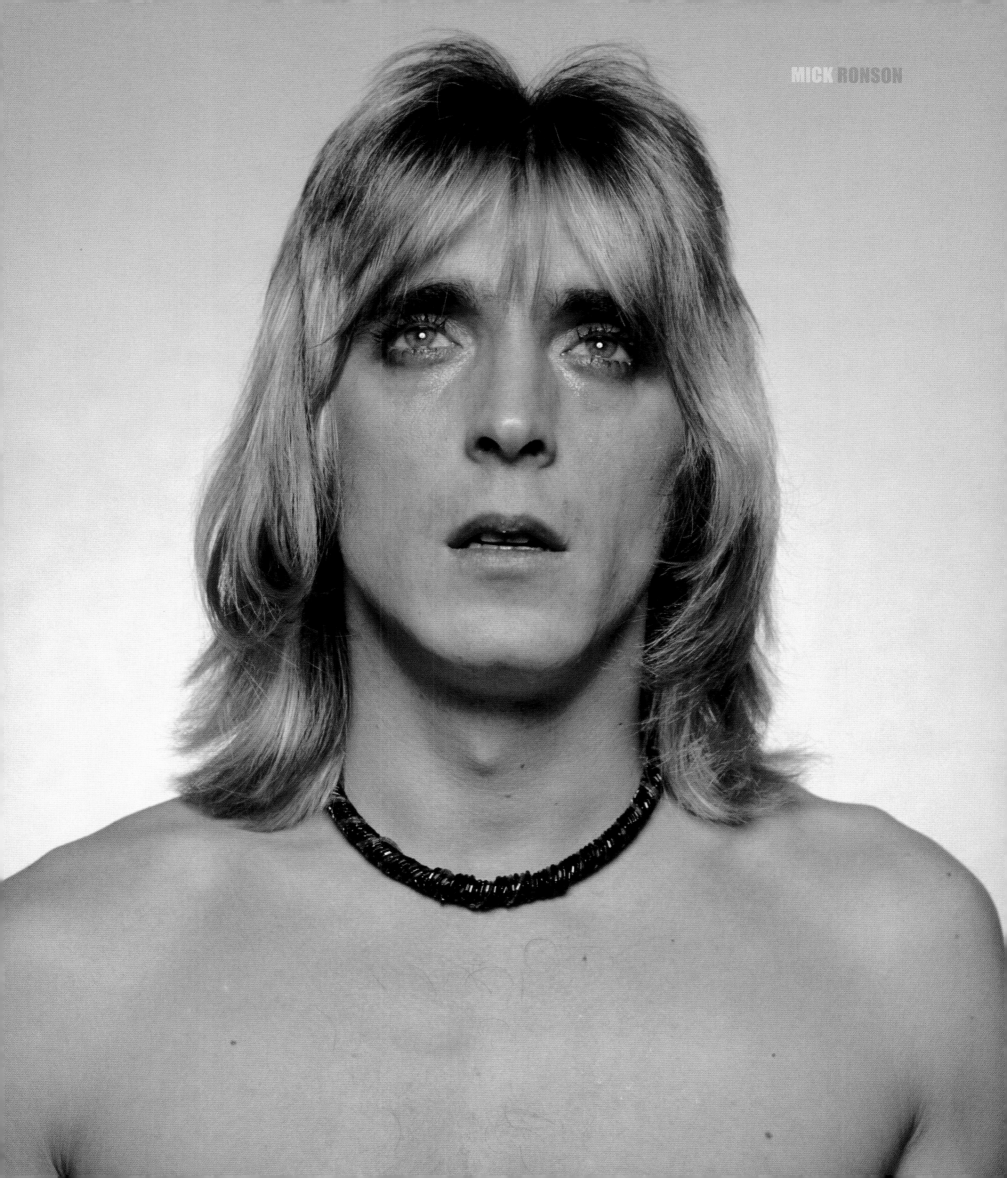

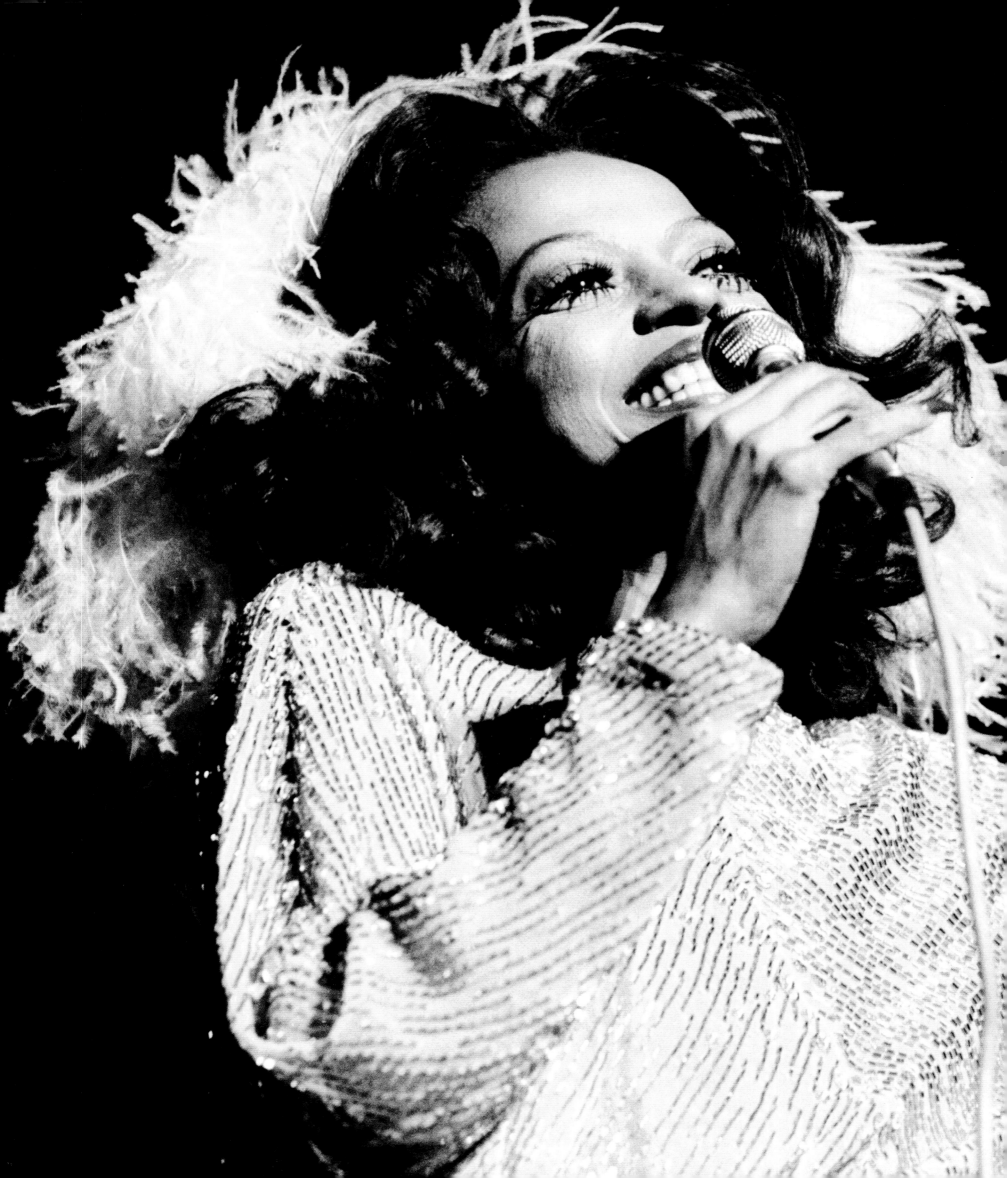

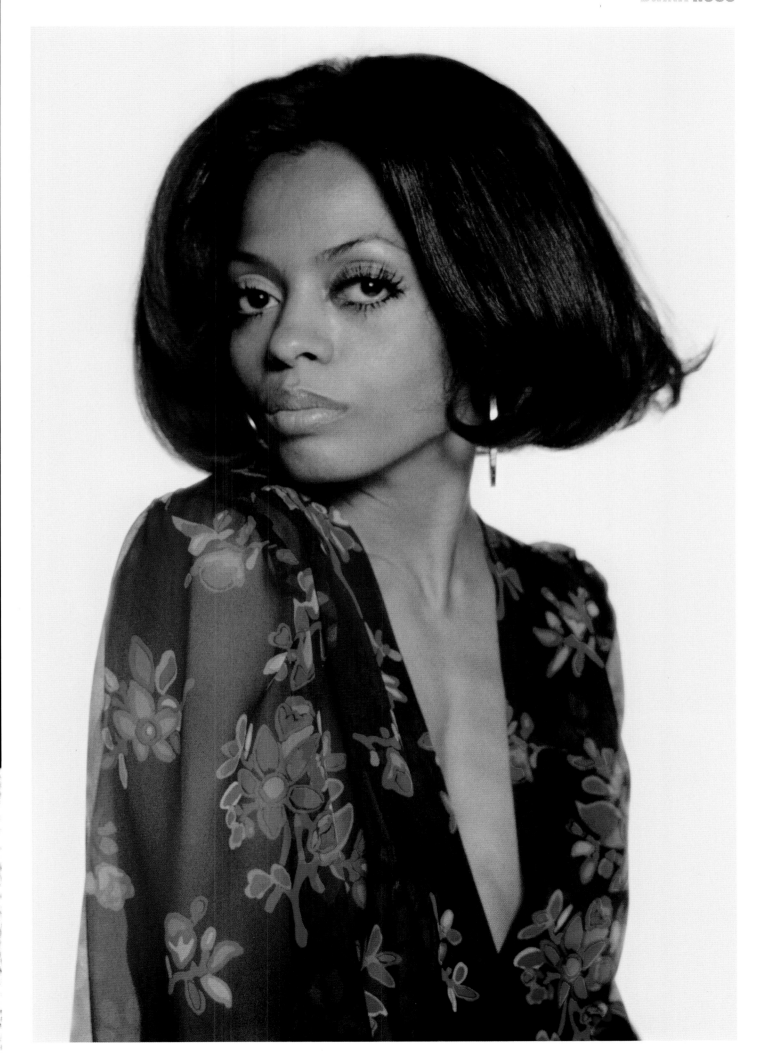

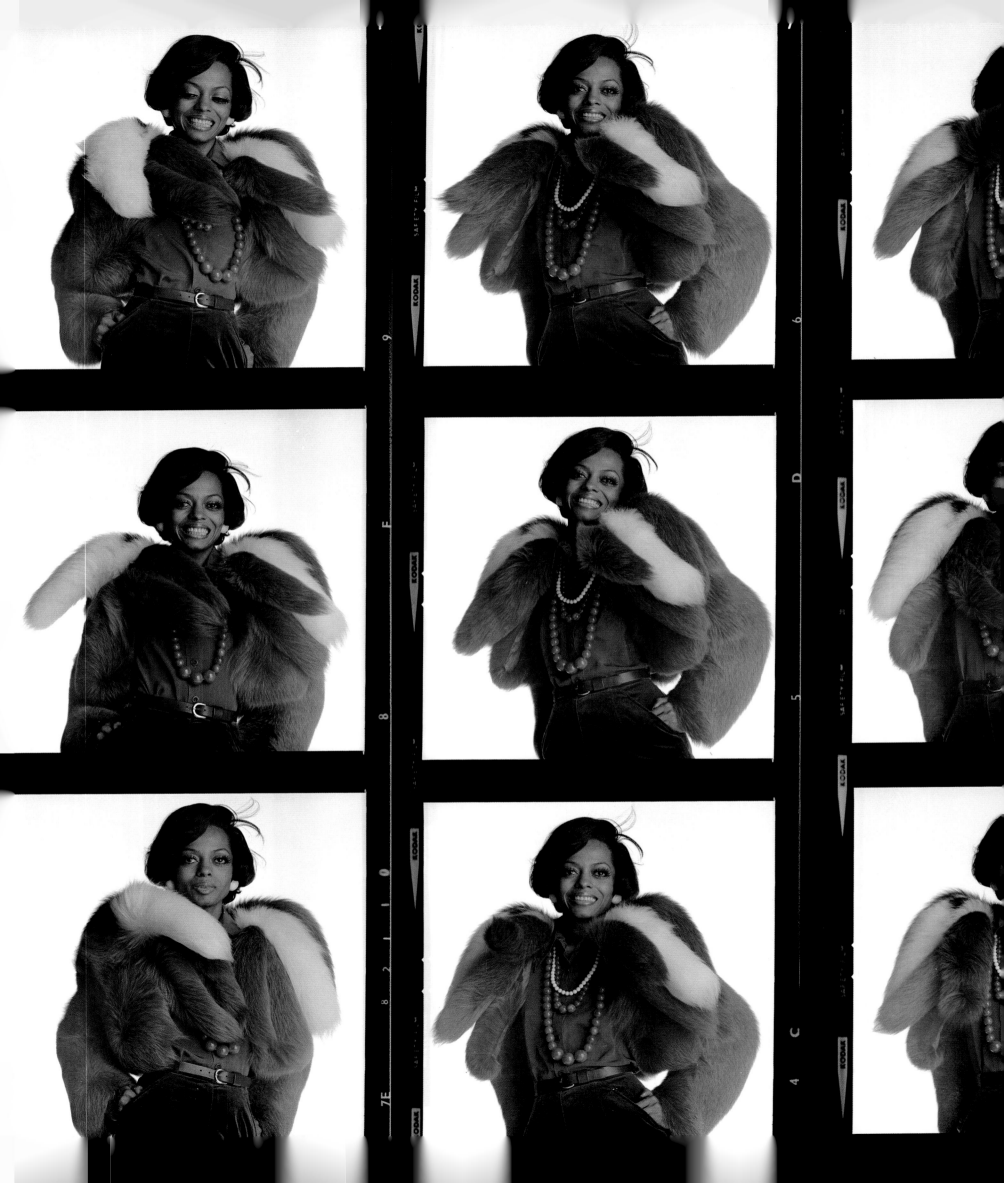

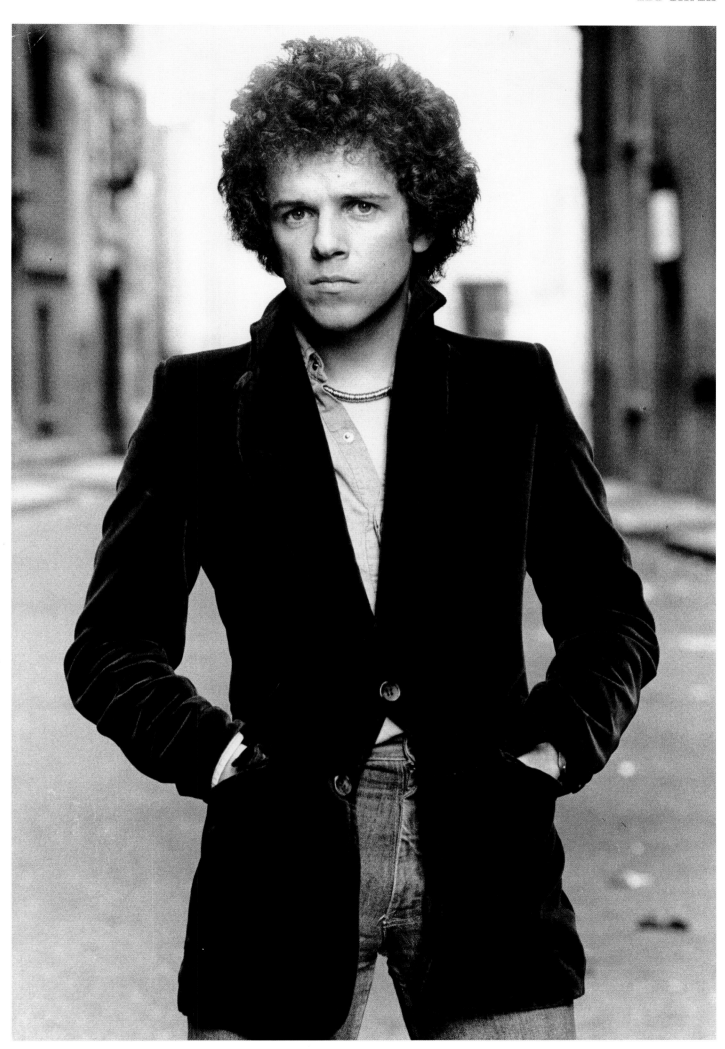

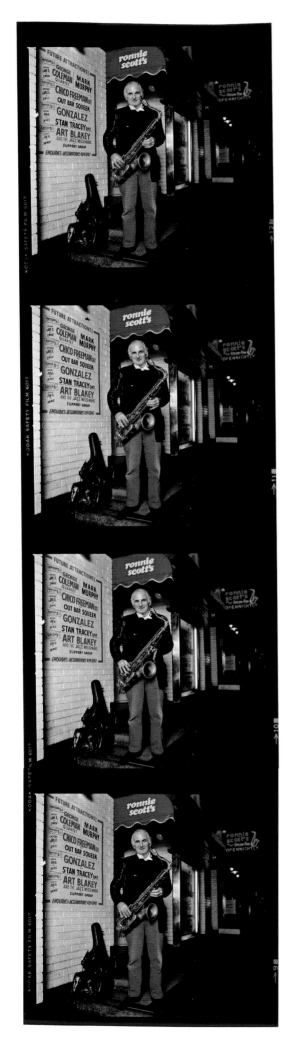
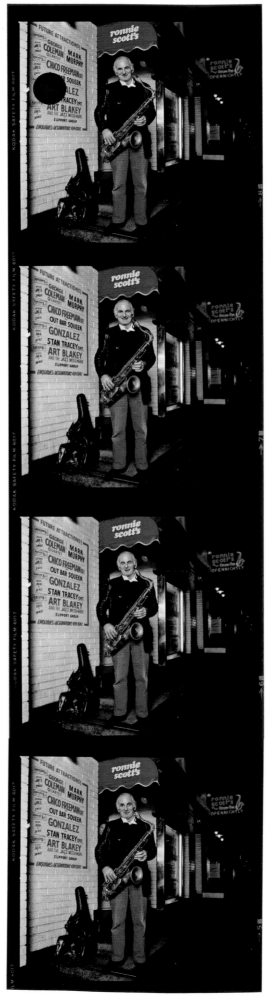
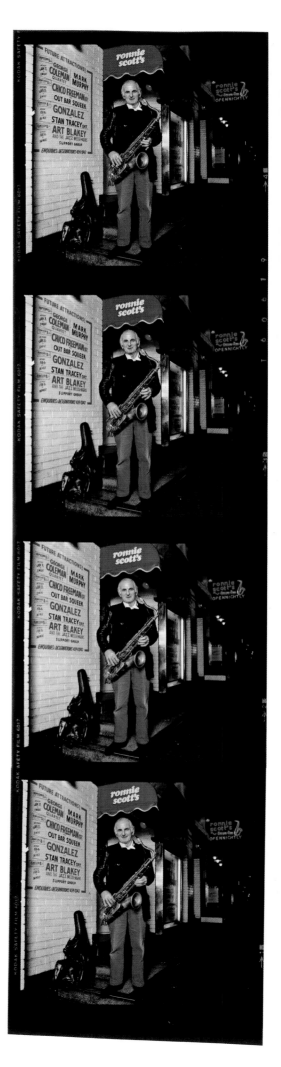

SEAL

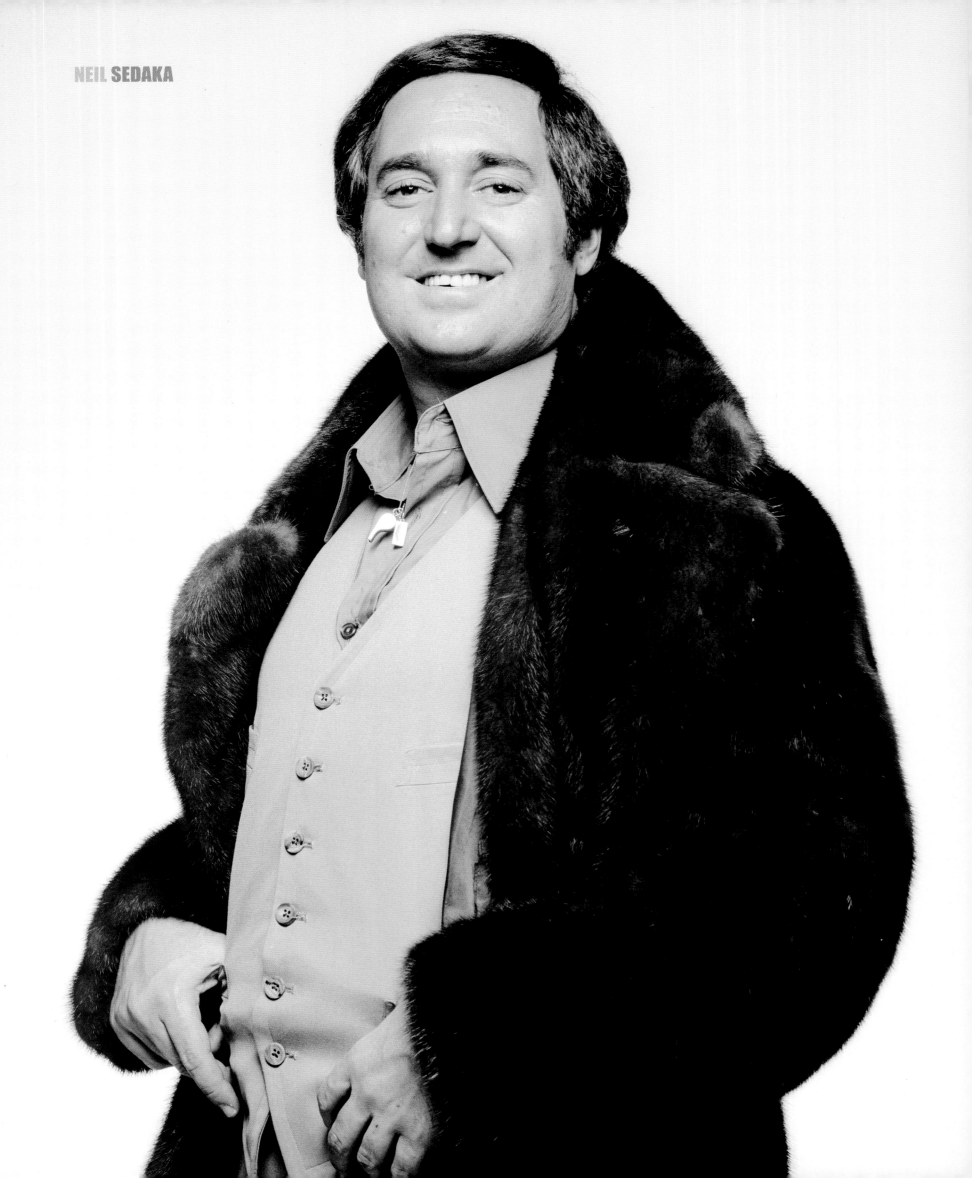
NEIL SEDAKA

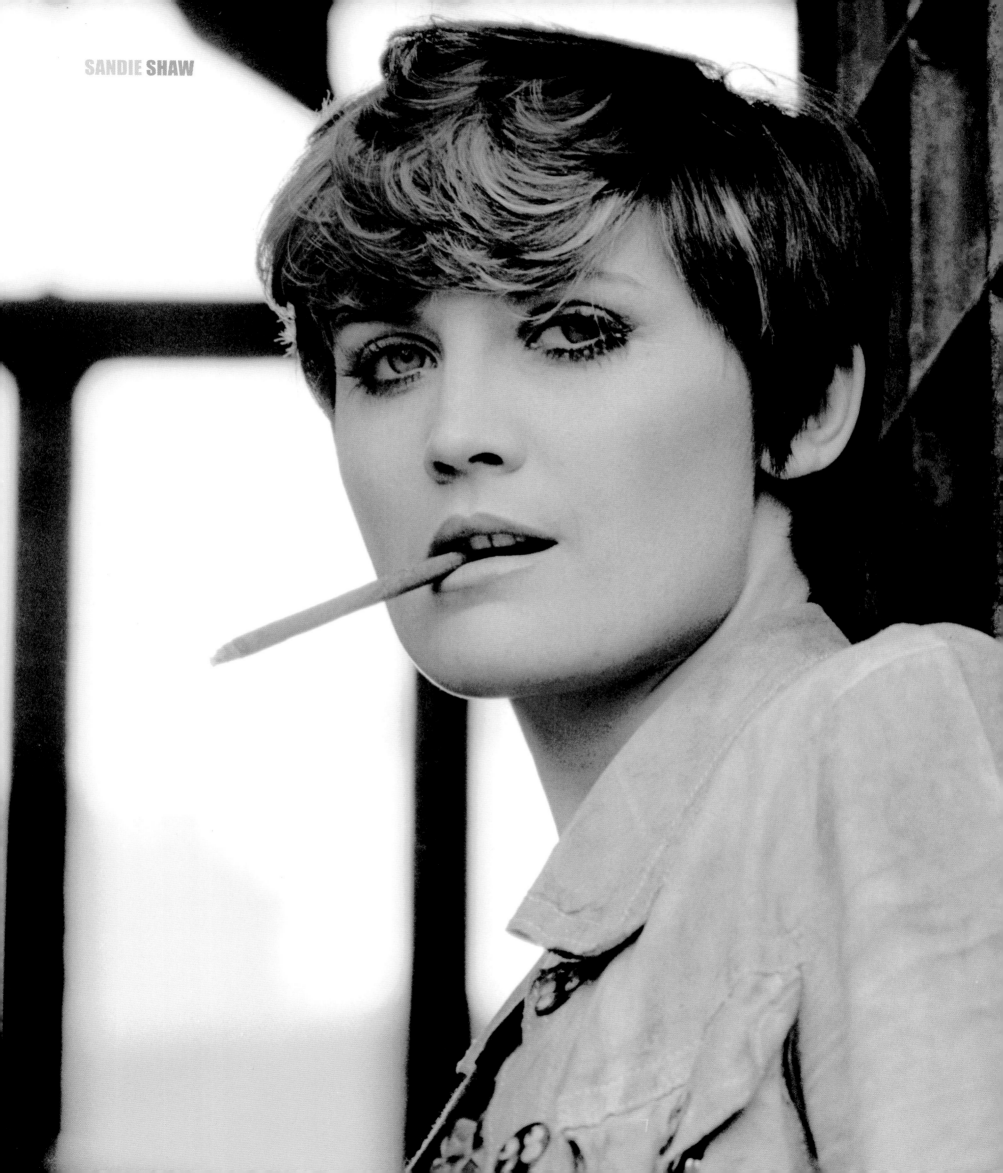

SANDIE SHAW

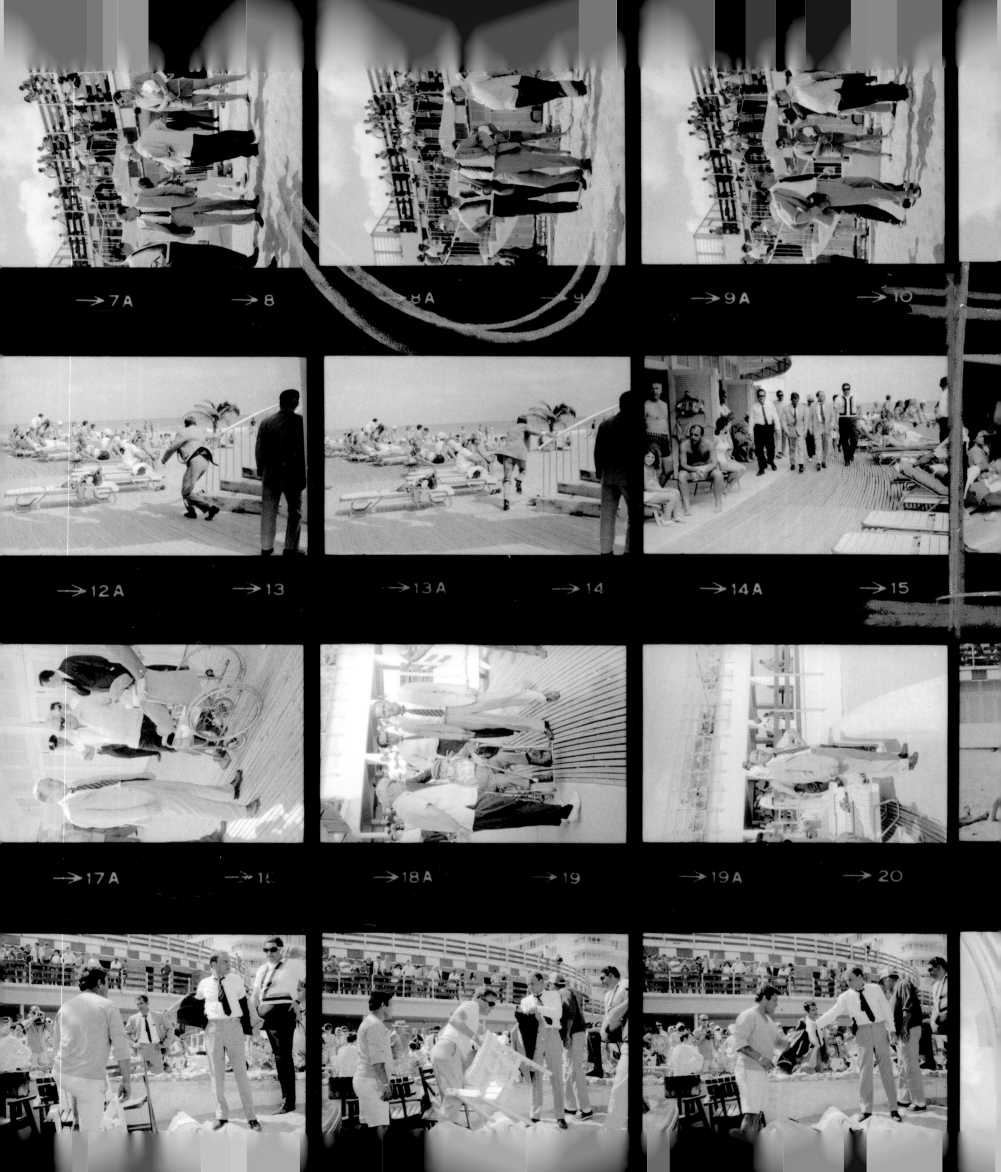

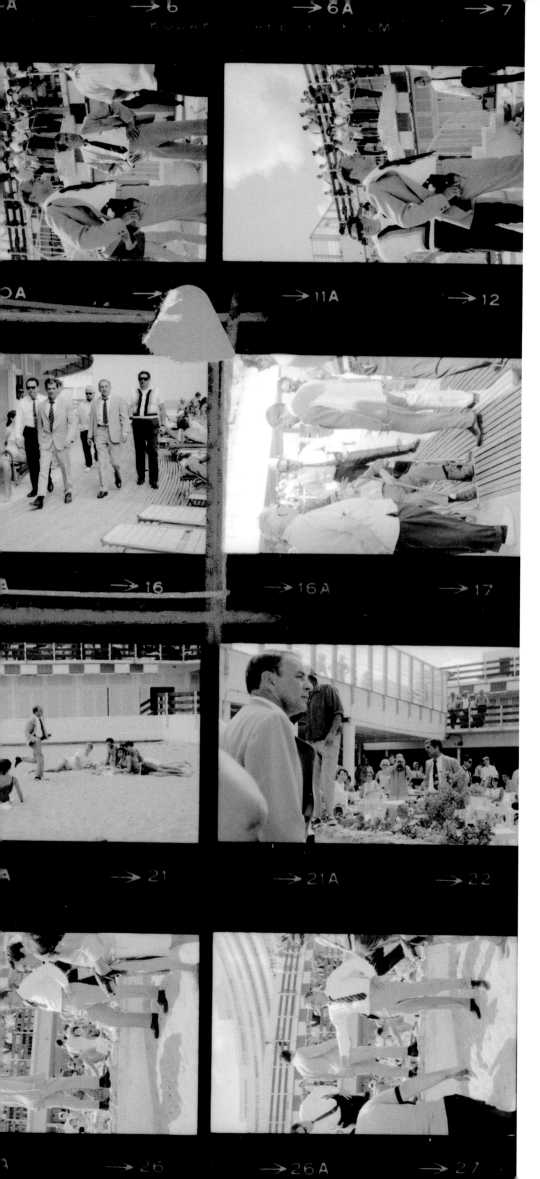

"It was only weeks later when I got back to London and developed the films that I saw 15a. It has become my most famous photograph, the one that has most defined my career"

FRANK SINATRA

I grew up listening to jazz. As a kid, I had picked up drumsticks and began playing jazz in London clubs and American air force bases. Jazz was, and is, my greatest love. To me, the great jazz musicians are heroes. But, in my eyes, the biggest star in the world — and a man who will never be surpassed, for his voice, his musical soul — is Frank Sinatra.

This contact sheet is the first roll of film I ever shot of Frank. It was the first day I met him and I photographed him on and off for the next 30 years. I wouldn't say we were ever close friends. I never wanted to be *that* close to the people I photographed — if I had, I'd have become part of the entourage rather than an independent eyewitness.

We were friendly. We hung out together. He trusted me. I could go anywhere with him with my camera — rehearsals, backstage, relaxing with his friends or in his hotel suites.

This roll of film was shot on the Miami boardwalk in 1967. It was the first and I was shooting all day, but in the back of my mind I knew I'd got one amazing shot on that first roll. It was only weeks later when I got back to London and developed the films that I saw 15a. It has become my most famous photograph, the one that has most defined my career.

Frank is walking to the film set of *Lady in Cement* with his stunt double, the guy dressed exactly like him, plus his assistant, a couple of studio executives and hotel security. Heads are turning. The greatest movie-star musician of the day is striding down the boardwalk among the ordinary folk on vacation.

It bothers me that this picture is constantly used in newspapers and magazines and books, whenever anybody wants to illustrate

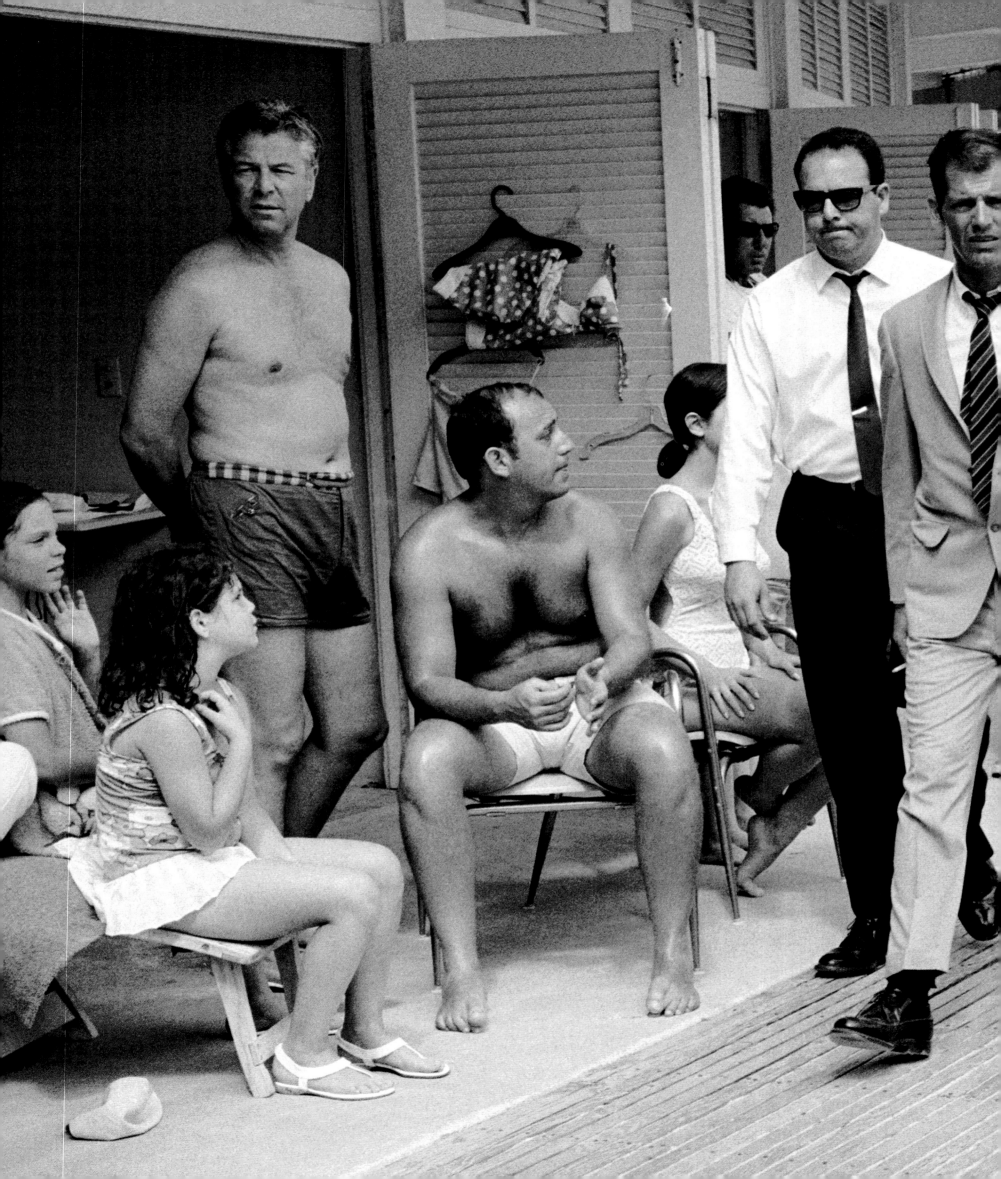

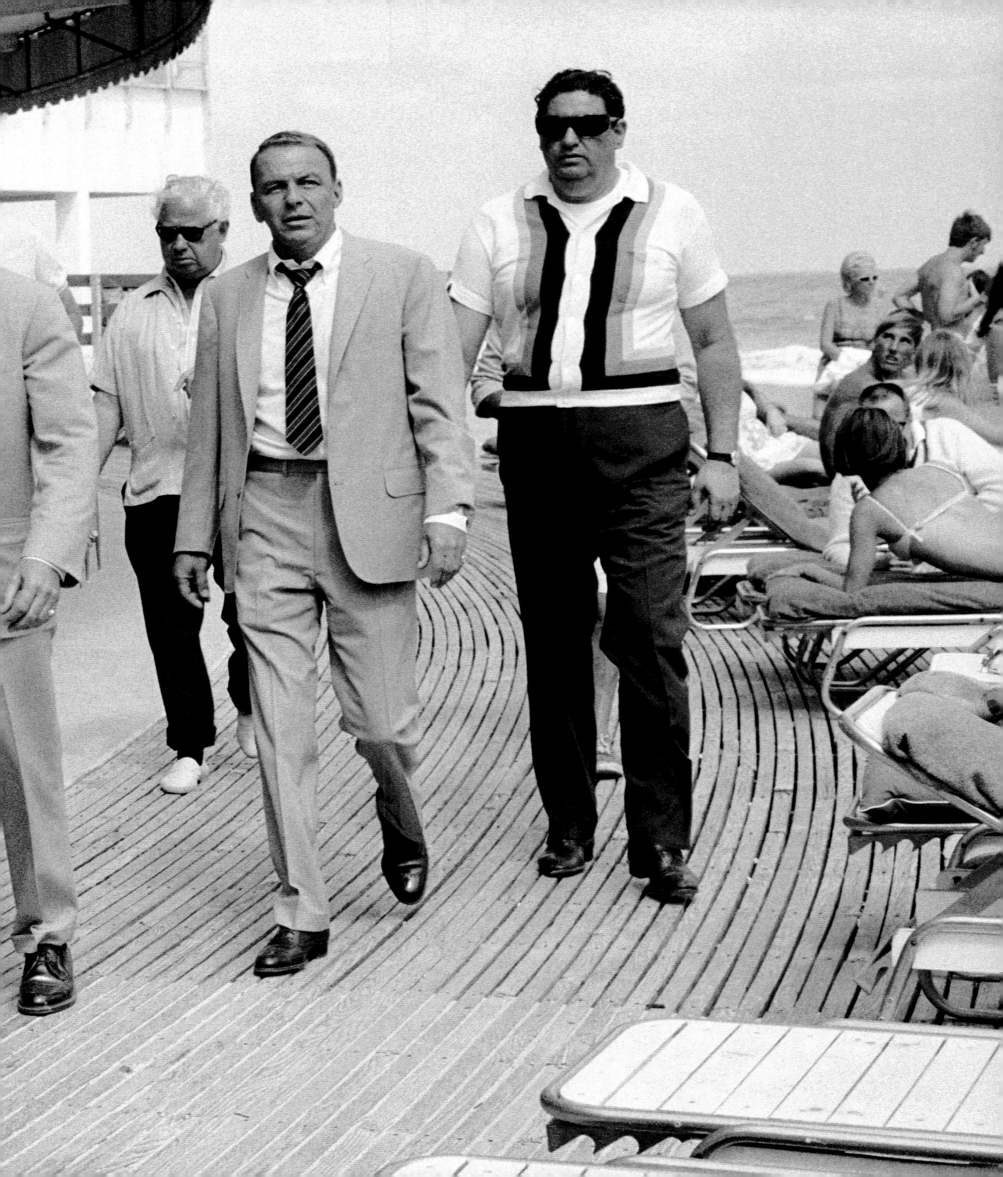

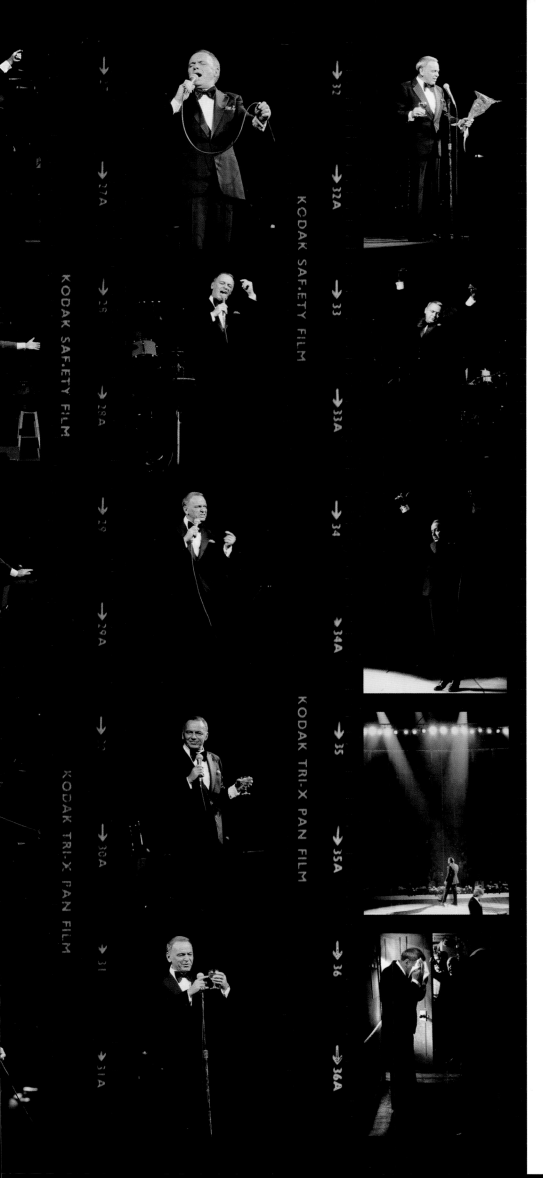

Terry O'Neill's contact sheet for
Frank Sinatra reveals a passionate
man of many talents

speculation about Frank's mafia connections. The guys in the
picture aren't hoodlums, just ordinary guys. I feel both Frank and
my photograph are being misrepresented.

The truth is, of course, Frank Sinatra knew mafia guys and
gangsters — so too did boxers, film stars and politicians. You
couldn't be famous and sing in Vegas or New York and star in
movies and not end up mixing with mobsters; it was often the
mob that owned the venue or the film set and they turned up to be
seen around the star. That didn't make Frank a mobster — and he
didn't play the big shot with them. In fact, I never saw him play the
big shot with anyone. He charmed women, treated them so
respectfully, he loved kids and being around them. He wasn't a
saint, but neither was he a bad man.

How the 15a photograph came about was through jazz. I took
Ava Gardner, Frank's ex-wife who was living in London, to Ronnie
Scott's club. We were thrown out because she liked a drink and
heckled the band. After all, she had been married to one of the
greats, who had played with all the greats, so she had a good ear.
Ava knew I loved Frank, she knew I was going to Miami to
photograph his co-star Raquel Welch in the movie and she said, "I'll
write you a letter of introduction — that will get Frank's attention."

It did. I actually bumped into him on the boardwalk and held
out the letter telling him who it was from. Of course he always
loved Ava, he'd often call her in London. So he took the letter,
opened it, read it, looked me up and down, then screwed it up, put
it in his pocket and turned to his security man and said, "The kid's
with me."

That was it. Amazing. Nobody bothered me, nobody asked me
who I was or tried to stop me doing anything, anywhere, on set,
back in his hotel, backstage. He was doing cabaret in the evenings
at the Fontainebleau Hotel just a few yards from the film set and

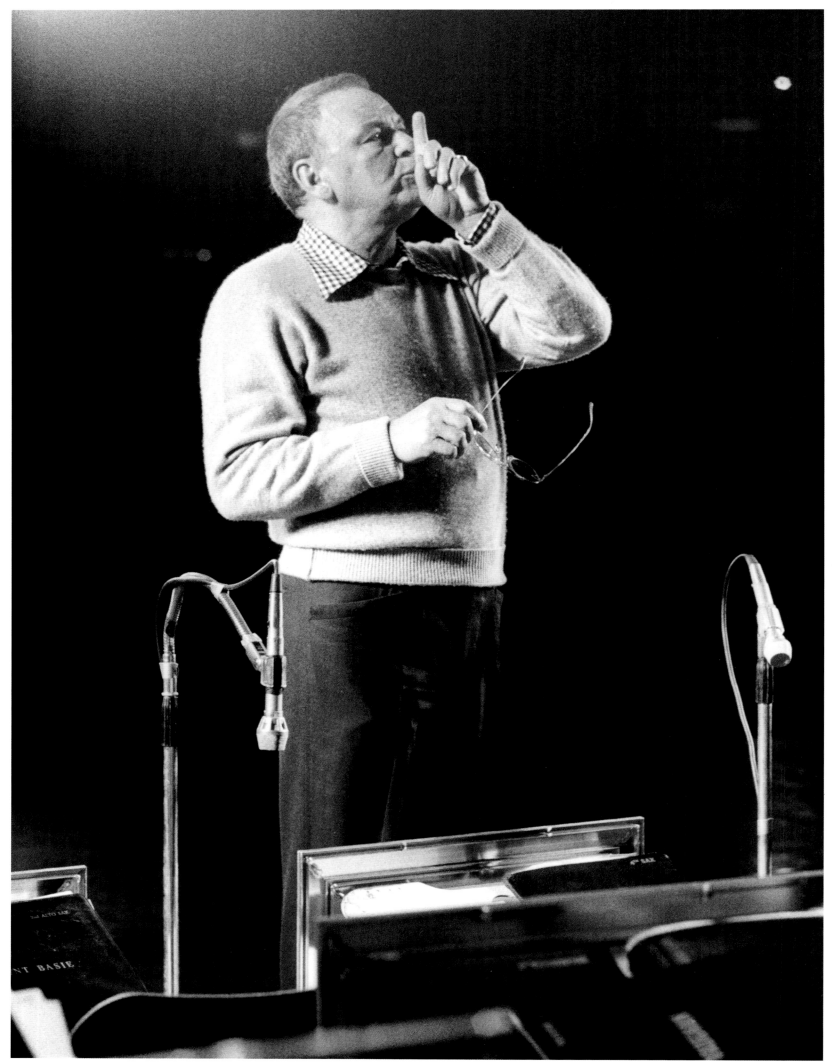

Sinatra asks for a little quiet during rehearsals

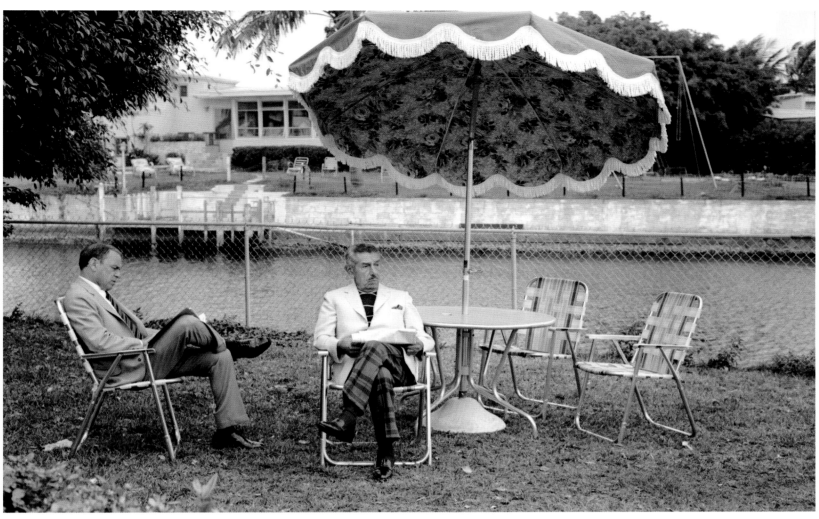

A contemplative moment for the great crooner during a break from filming

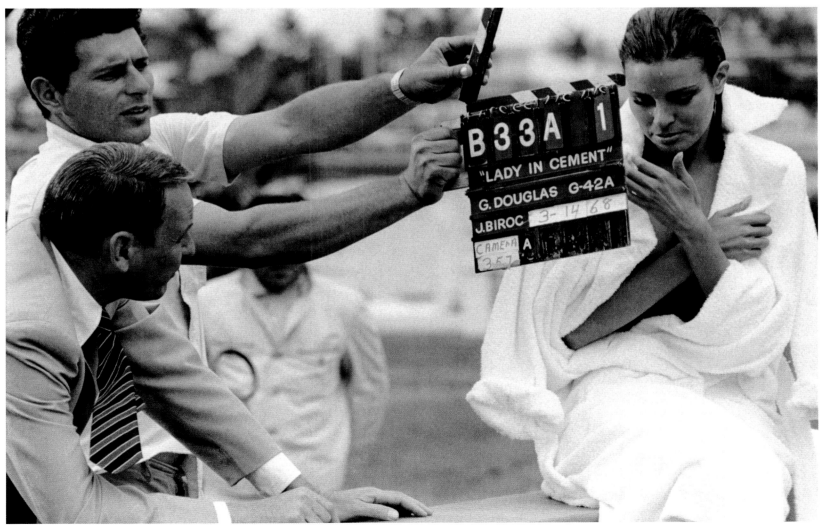

Sinatra starred alongside Raquel Welch (above right) in the 1968 detective film, *Lady in Cement*

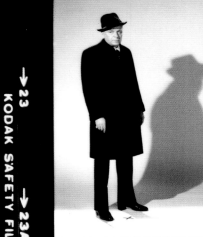

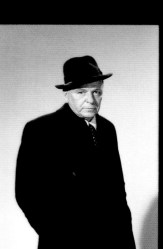

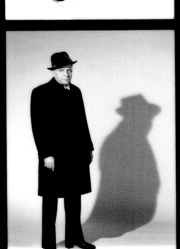

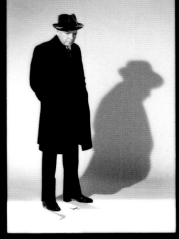
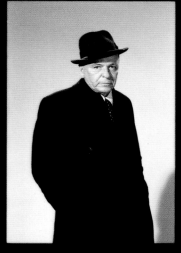
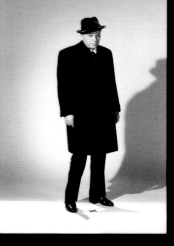
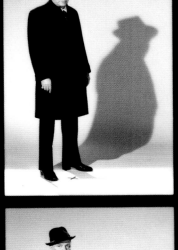
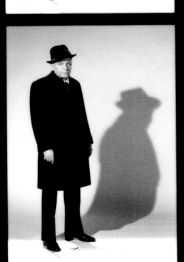
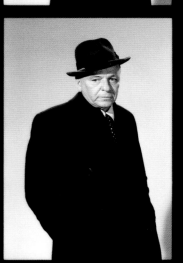
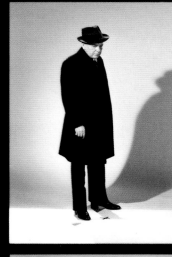
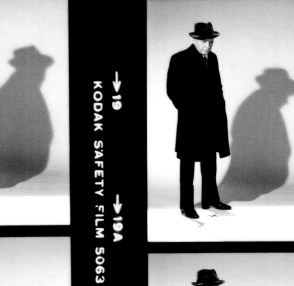
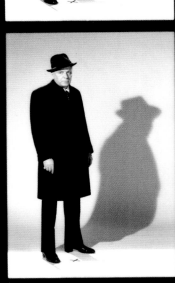
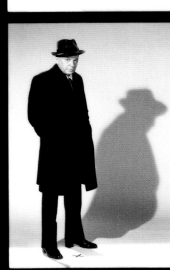
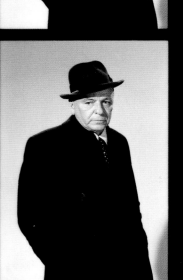
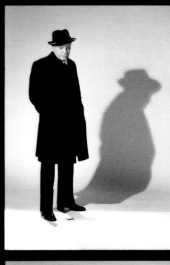
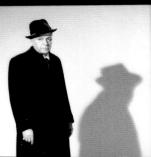
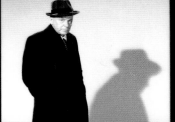
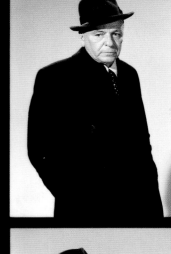

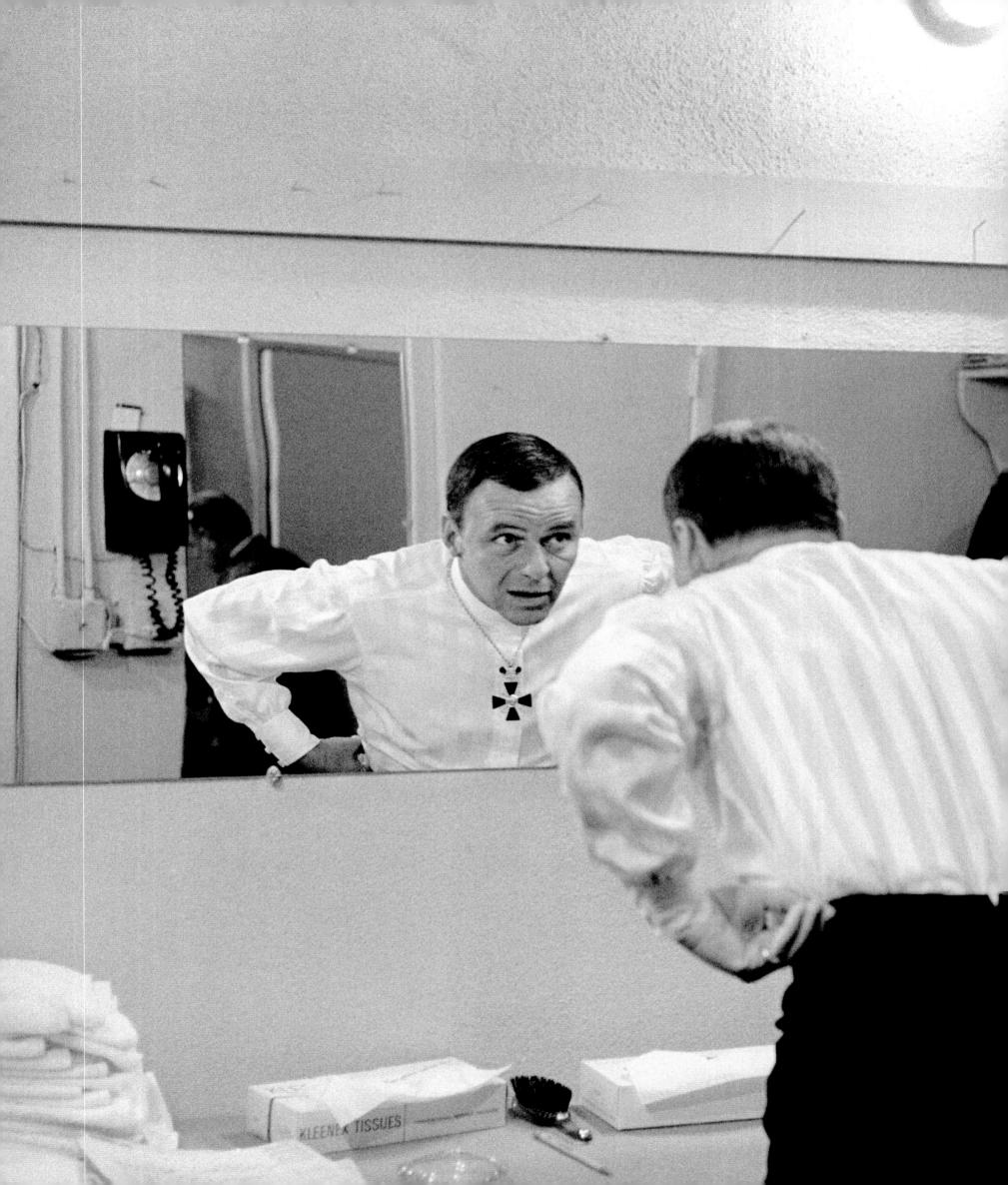

staying in the presidential suite on the top floor overlooking the ocean — and I was "with him".

For three weeks I just shot roll after roll and he paid me the greatest compliment. He ignored me. He didn't pose, he didn't say "stop", he didn't bar any doors, he just let me tag along and do as I pleased, whatever he was doing. I think that was all because of what Ava had said. I don't know to this day what she wrote — I've always wished I did.

The relationship we had lasted for 30 years. Whenever we were in the same town I could photograph him — sometimes he'd phone me and ask me to go over and hang out or just announce, "I'm coming to London, bring your camera." He often carried his own, he was an enthusiastic photographer and painter, too. It was such an honour to be the invisible man around him. Watching him only increased my awe.

I've never known anyone who could just walk into a room and silence it with his presence, other than perhaps Nelson Mandela. Frank just had this natural aura about him — and I'm not exaggerating when I say he exuded power.

He was incredibly professional, rehearsing endlessly with musicians, a perfectionist trying to get the best, but always respectful of an orchestra or a band. He would get off the plane at Luton airport, be driven straight to the Albert Hall or the Palladium and start rehearsing for a show that night.

Before he went on stage he'd peer through the curtain trying to judge the mood of the audience. If they seemed a little low, his first number would be a belter. If they seemed excited and exuberant he'd bring them down a notch.

He played the audience as if they were *his* musical instrument — and his voice and his repertoire, the fingers on the keys. That was his genius ∎

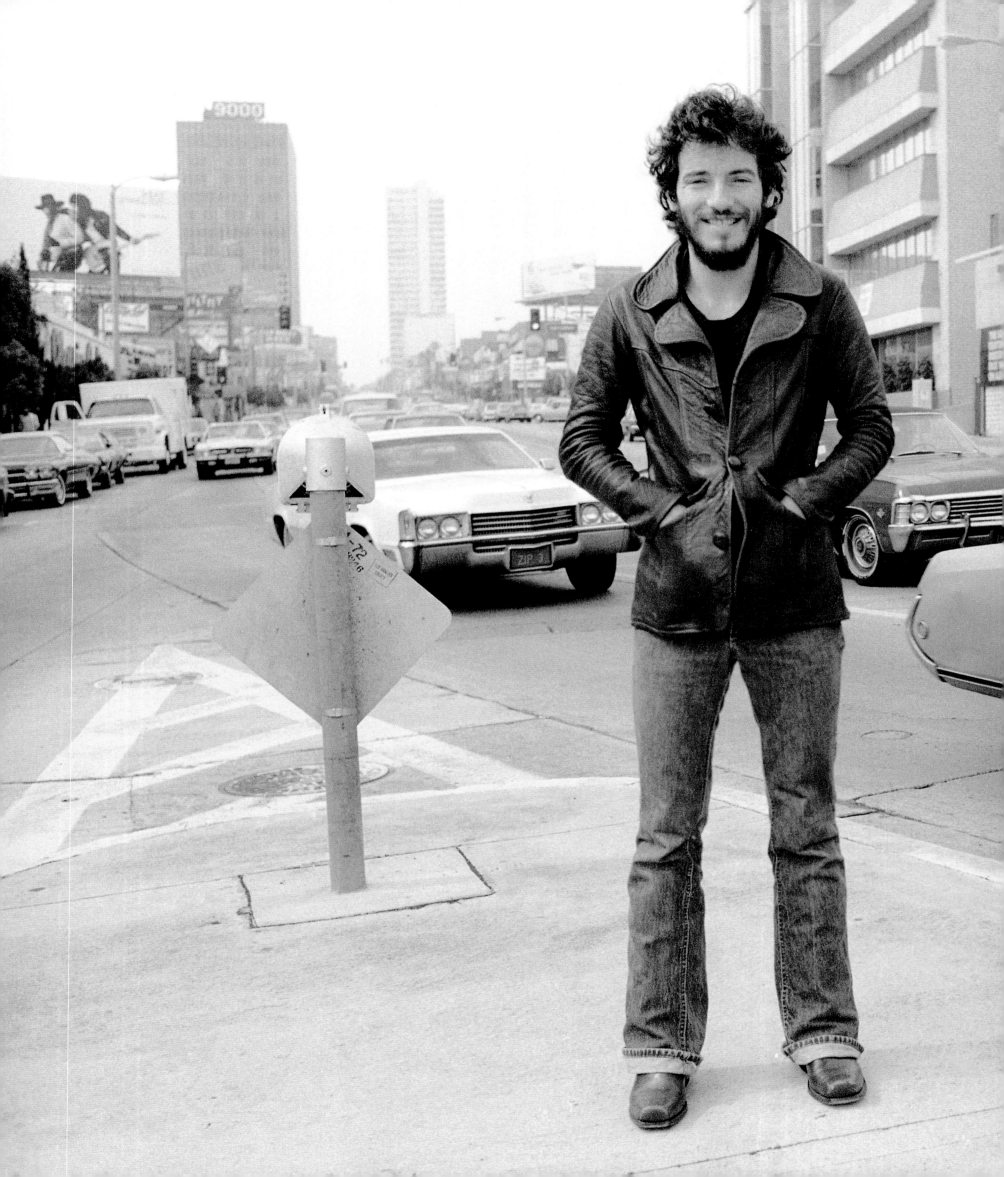

BRUCE SPRINGSTEEN

My shots with Bruce were one of those god-given coincidences. I was living in Los Angeles at the time and I'd gone down to Tower Records on Sunset Boulevard to buy some music.

As I walked out of the store I looked up — there on the big billboard by the side of the road was Springsteen's *Born to Run* album being advertised, clearly intending to capture the attention of people going into the music store.

It was Bruce's third album, but he still hadn't made it into the big time. Columbia Records were hoping to make this one his big break-out album with a $250,000 advertising campaign. It was 1975 and he was still generally unknown.

I was about to jump in the car when I saw this guy walking down the street. It was Bruce. He'd come to see the advertising hoarding for himself. It was just too good an opportunity for me to miss.

I think he was actually pleased I recognised him. The story goes that if this album hadn't made it, Columbia might have given up on him. Of course it's now regarded as one of the Top 100 rock 'n' roll albums of all time.

I thank my lucky stars I had my camera with me. I just stopped him in the street, introduced myself and put him in front of that big sign with the traffic roaring past. He was a good sport, happy to pose, and we had a great 10 minutes taking some really memorable, honest and in-the-moment shots.

This was one of those crazy pieces of good luck we all need — if I hadn't popped out to shop for music that day I may never have stumbled upon the chance to shoot one of the greats ∎

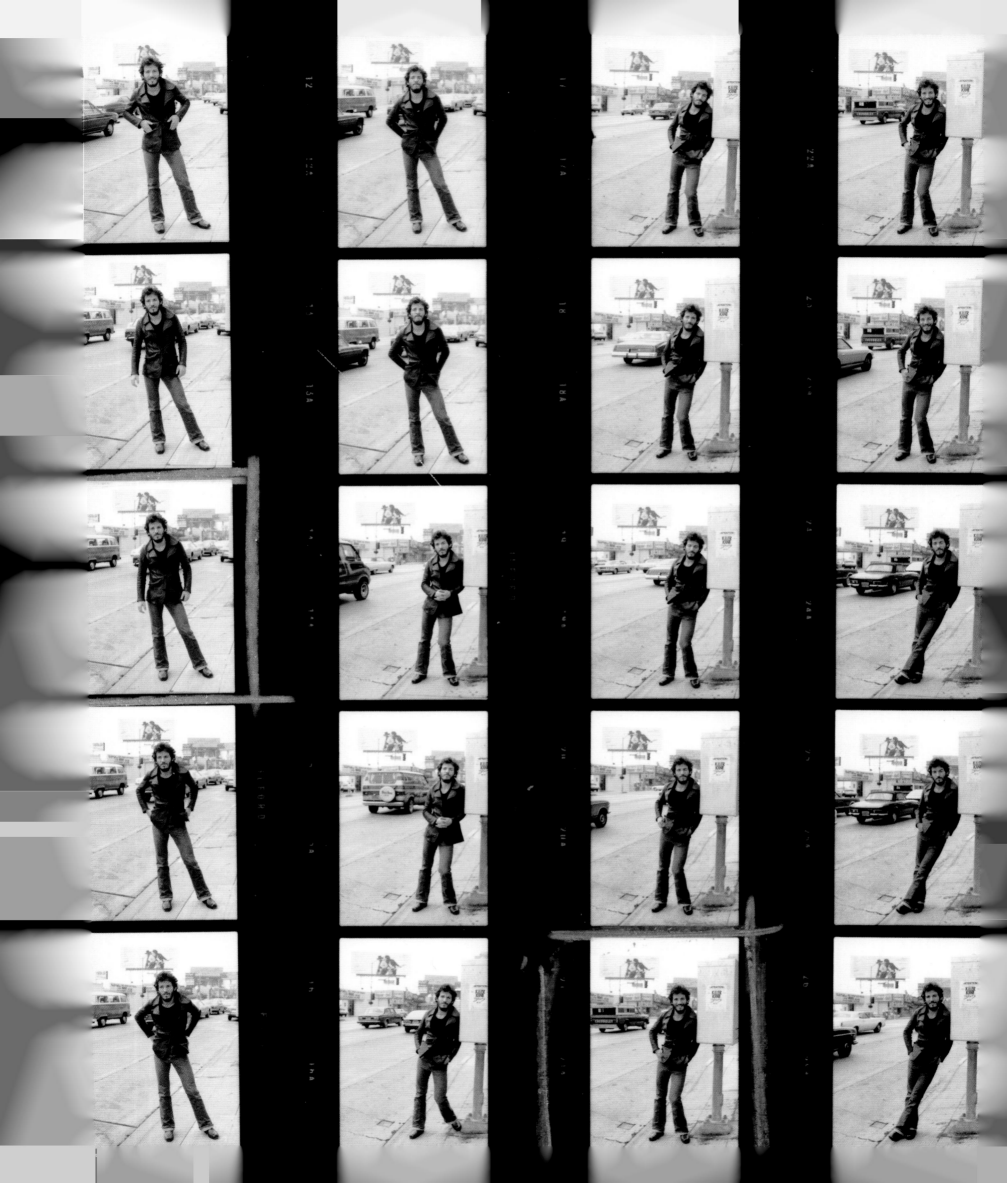

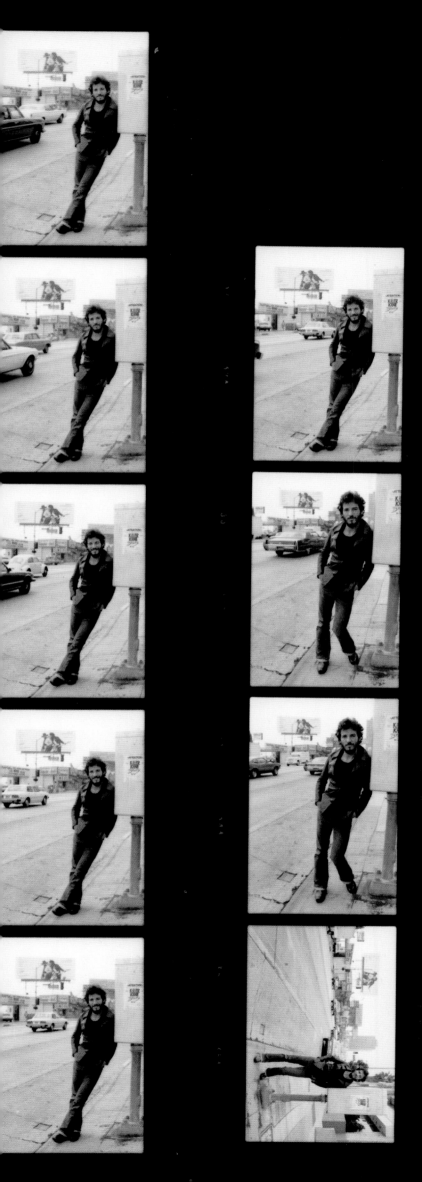

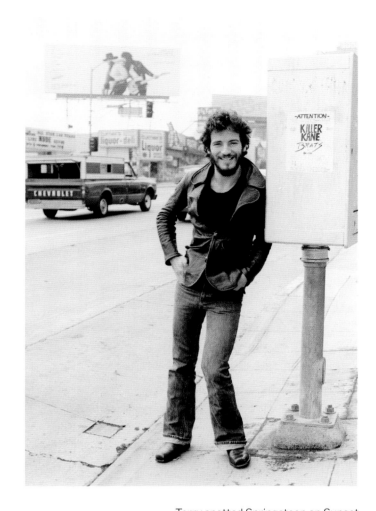

Terry spotted Springsteen on Sunset
Boulevard in 1975, and photographed
him in front of the huge billboard in
the background, advertising his third
album, *Born to Run*

The Boss fooling around on the
streets with his then-girlfriend
Karen Darvin

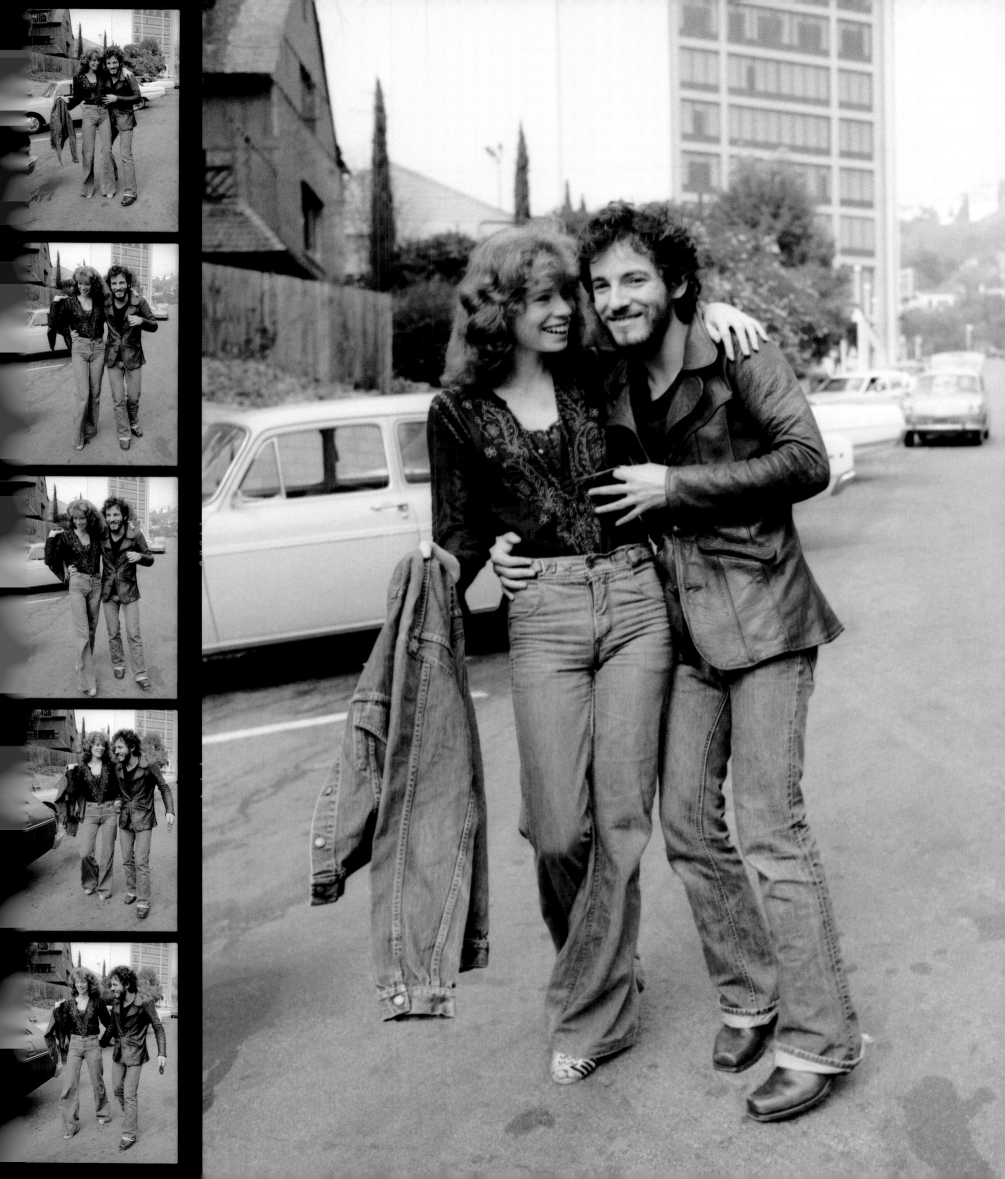

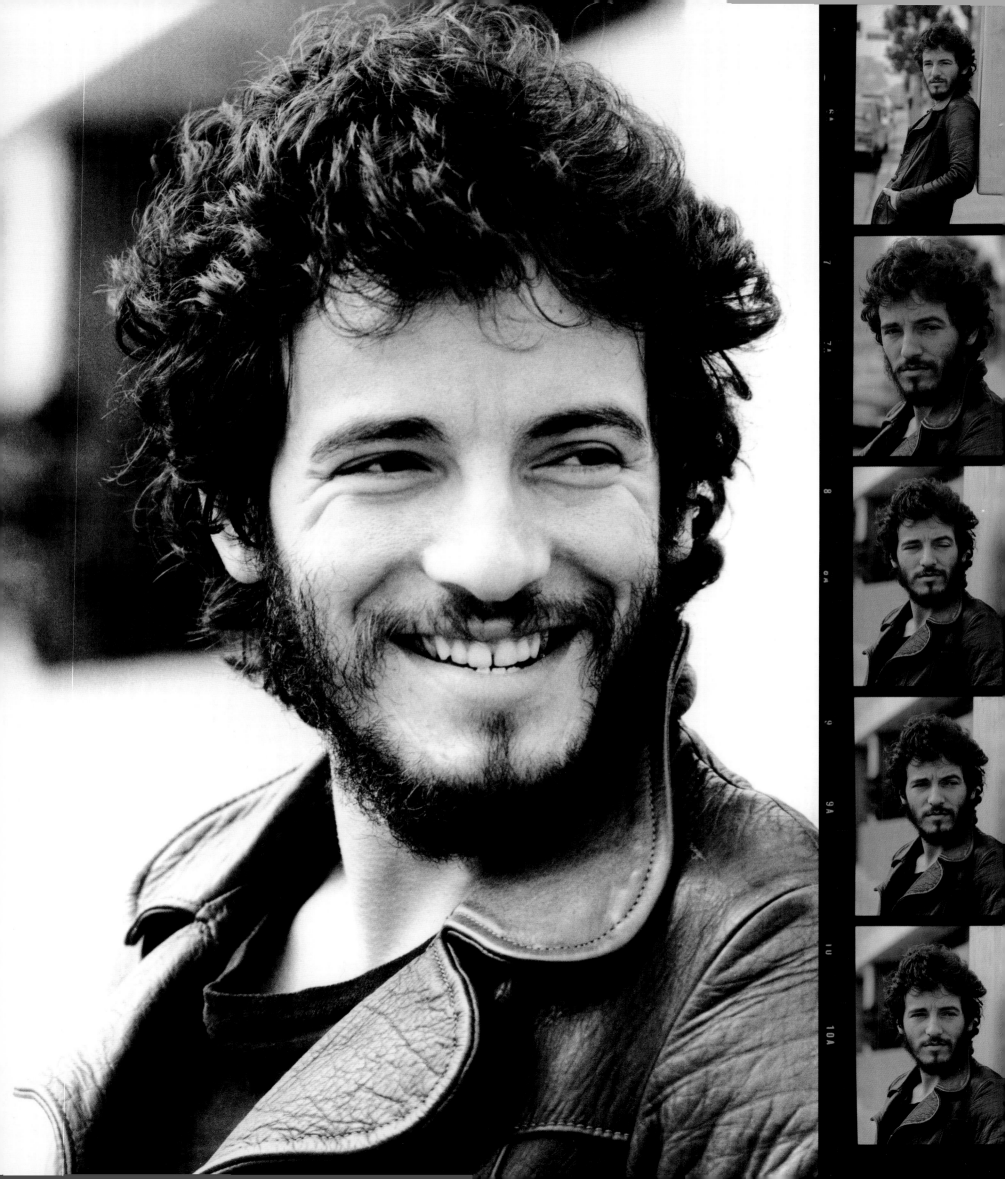

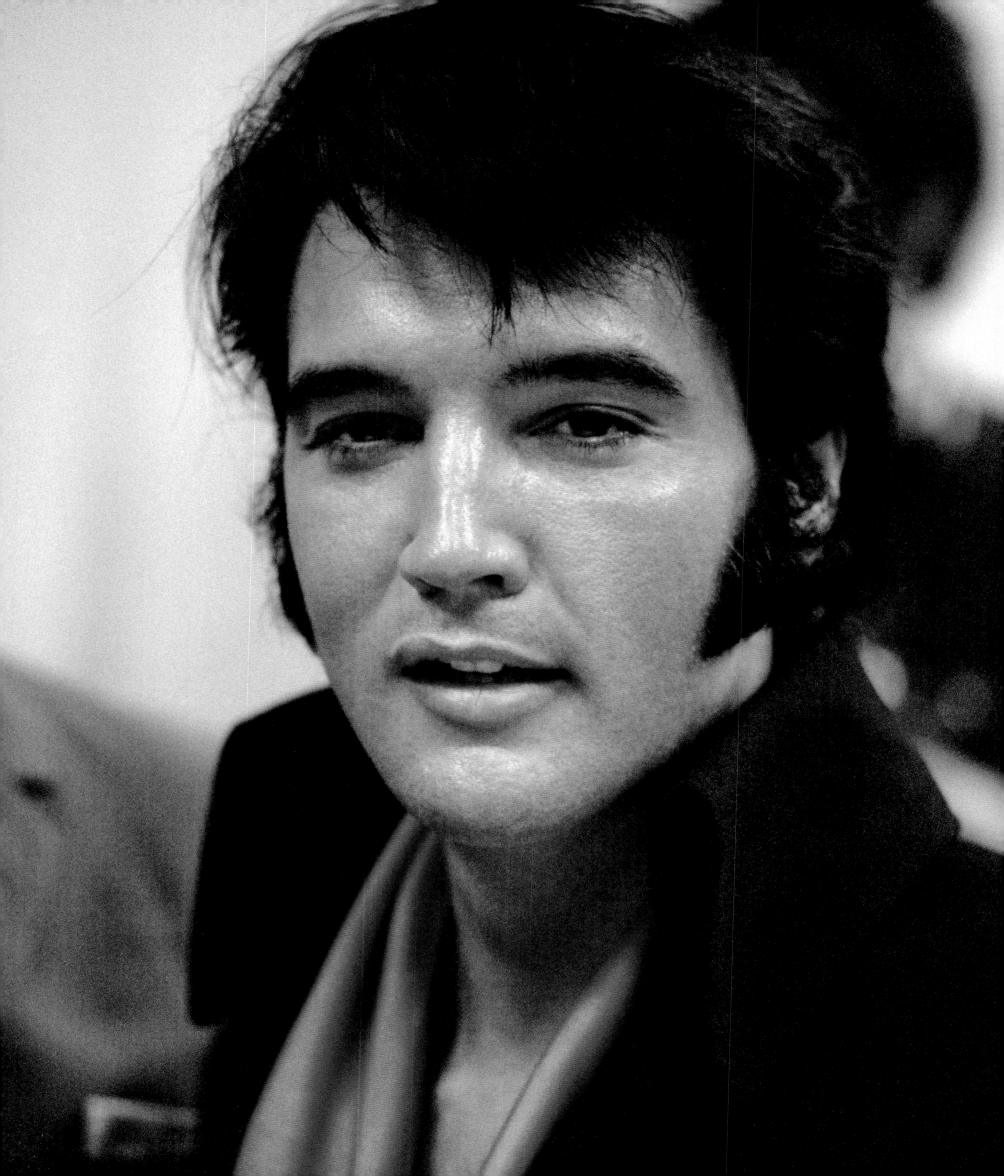

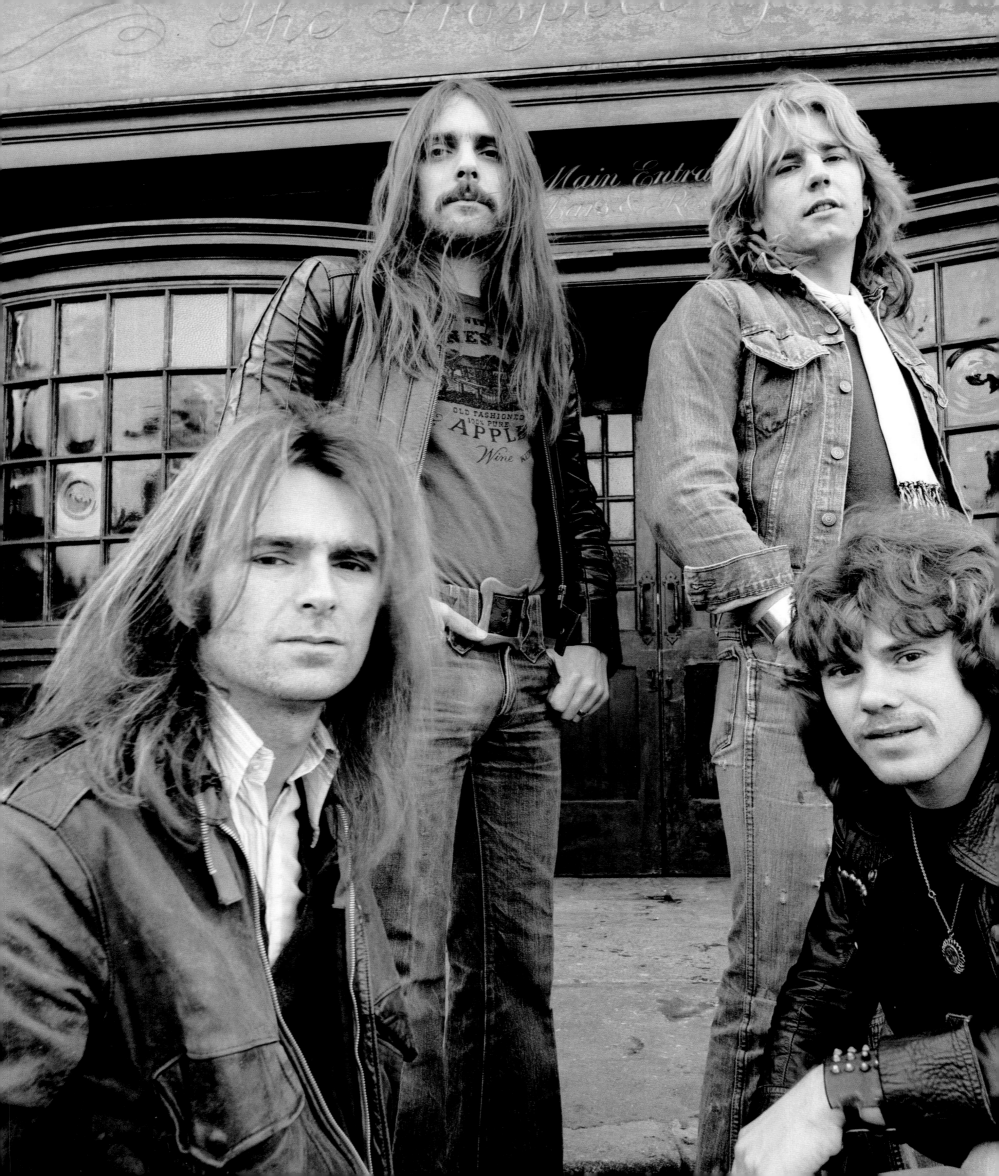

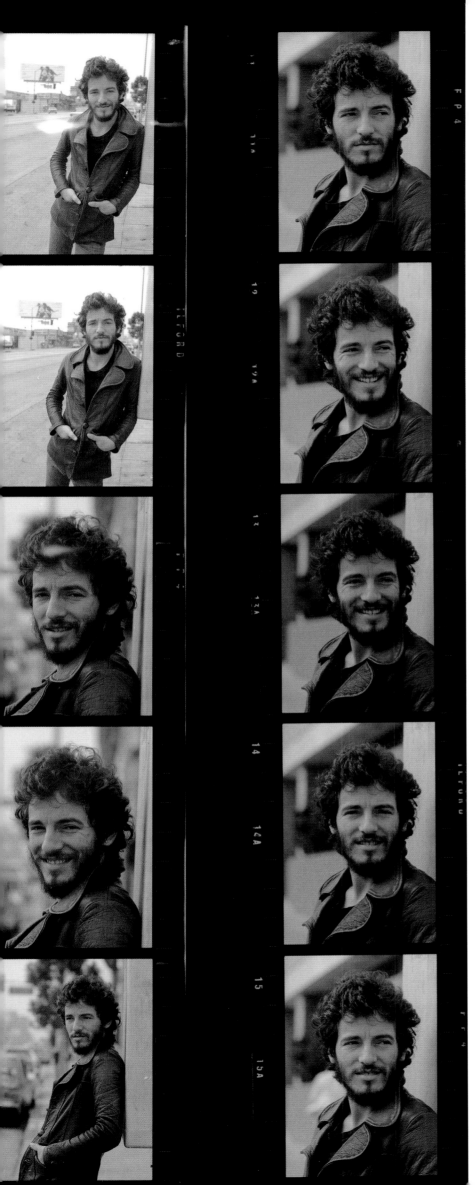

"Bruce was a good sport, happy to pose, and we had a great 10 minutes taking some really memorable, honest and in-the-moment shots"

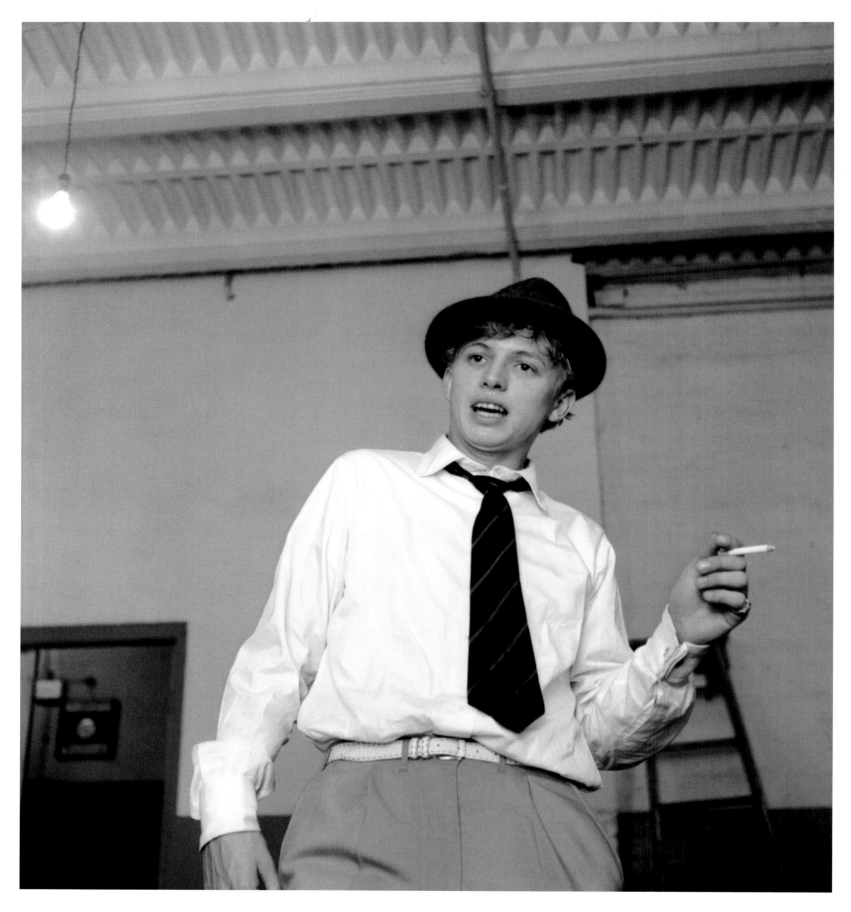

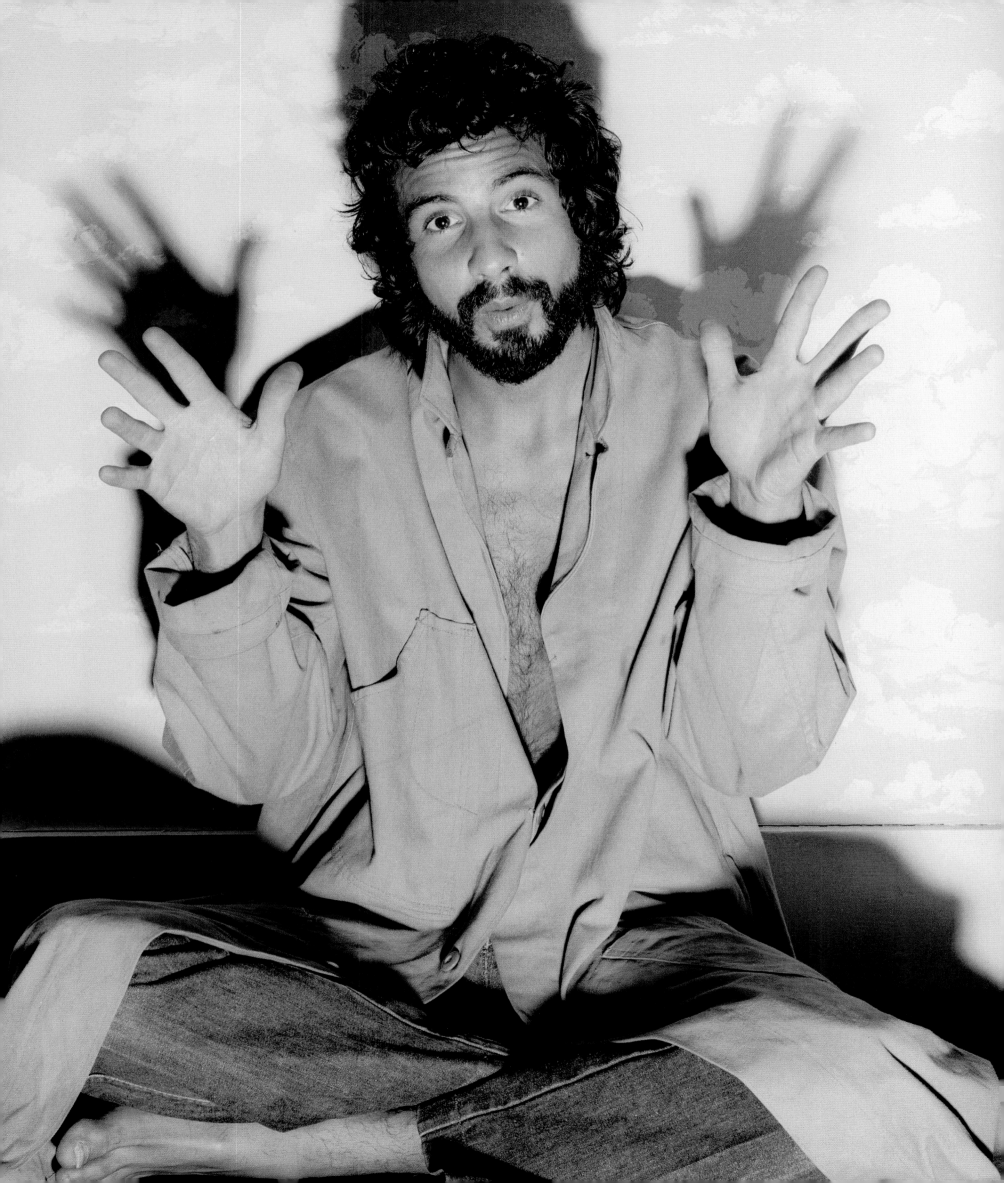

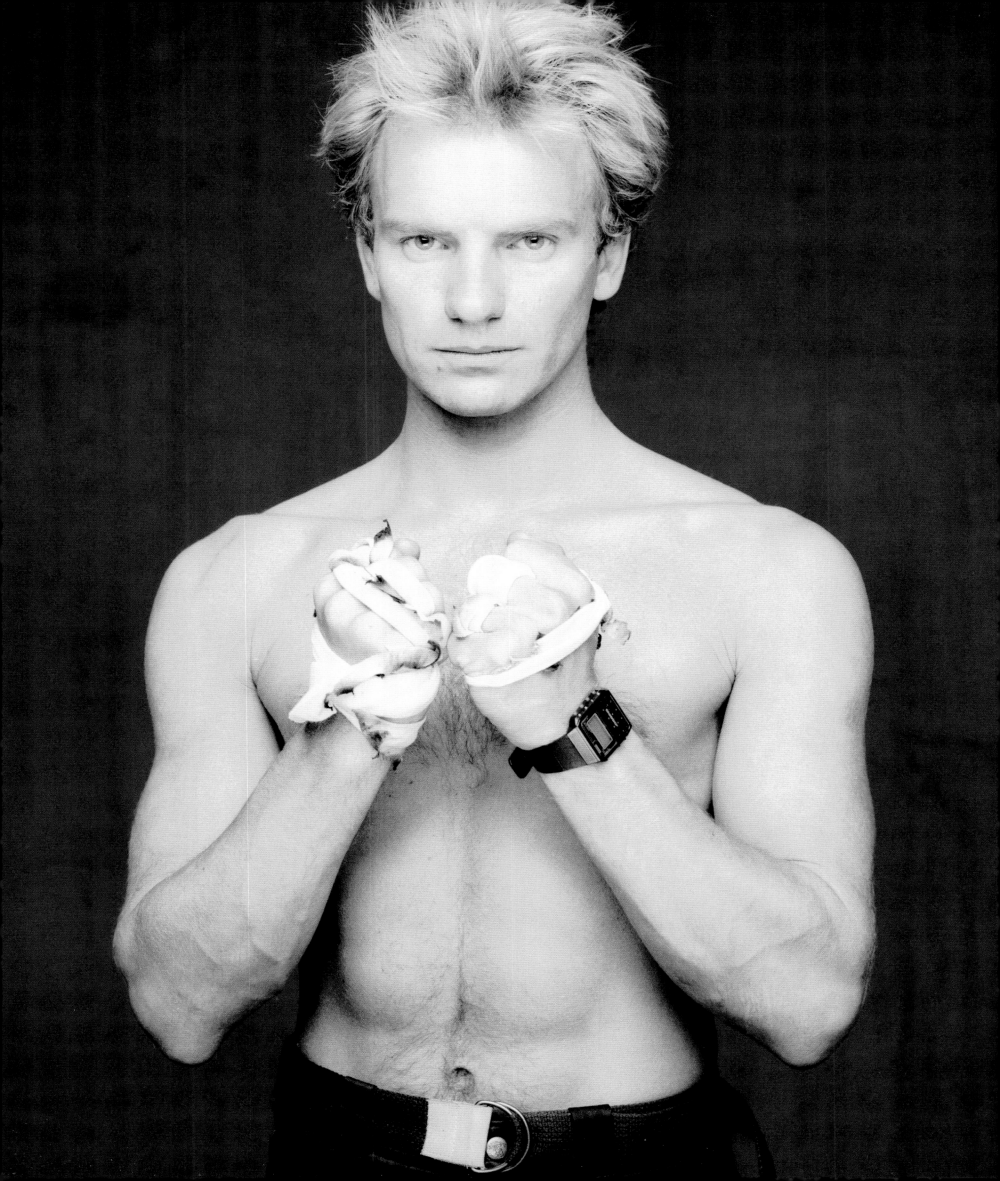

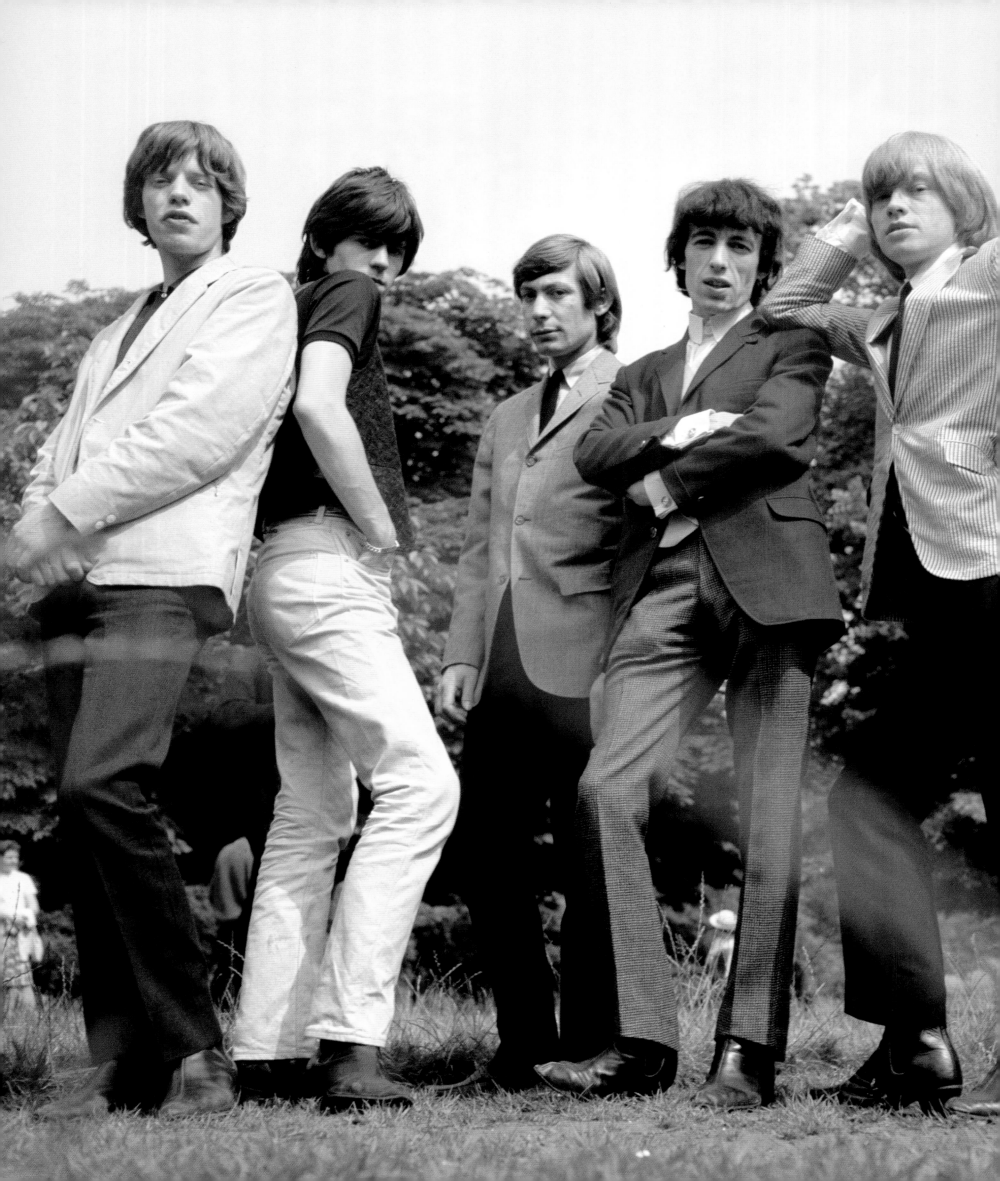

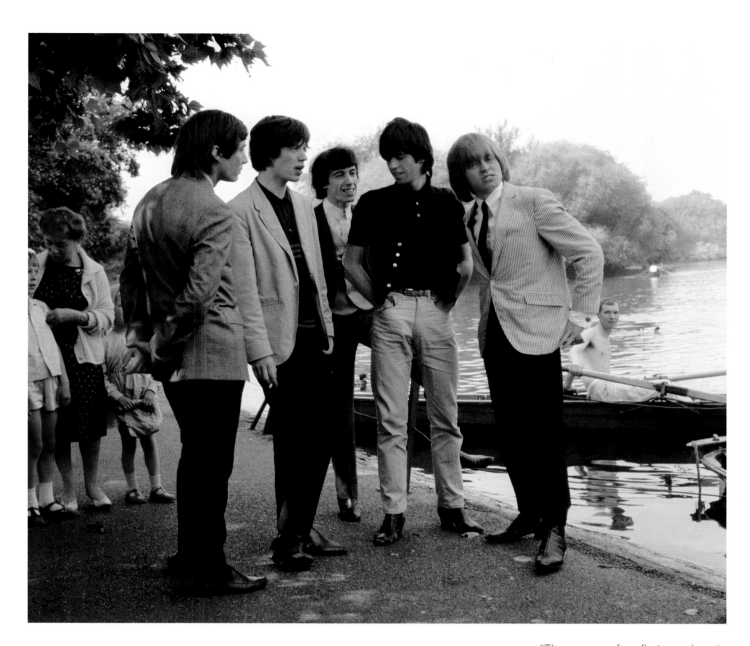

THE ROLLING STONES

I look back at my archive of Rolling Stones' shoots and sometimes struggle to remember where we were or what we were doing or even why we were doing a particular shoot. Back in the early days everything was happening so fast, it was so hectic, a real rollercoaster ride.

Keith Richards says I was everywhere and I can see what he means when I go through the boxes of negatives. I must have a couple of thousand — more — of The Stones, particularly in the early days when we were all young and hungry and ambitious. Each time I look I find more images I'd forgotten about.

These, some of my first experiments with colour film, were taken in Regent's Park, in London in 1963, and turned up only a

year or so ago, 50 years after they first telephoned me and asked me to photograph them.

They had only formed a couple of months earlier, in 1962. Brian Jones was the leader, it was his band with Mick and Keith — and they'd just recruited Bill Wyman and Charlie Watts. The Beatles had just hit the charts and were everywhere. I'd helped put them on the front cover of magazines and newspapers. I knew a young publicist working for The Beatles, a 19-year-old genius called Andrew Loog Oldham. He'd decided he wanted to manage his own band.

He'd heard about The Stones performing in a pub in south-west London from a music journalist who was one of the very few

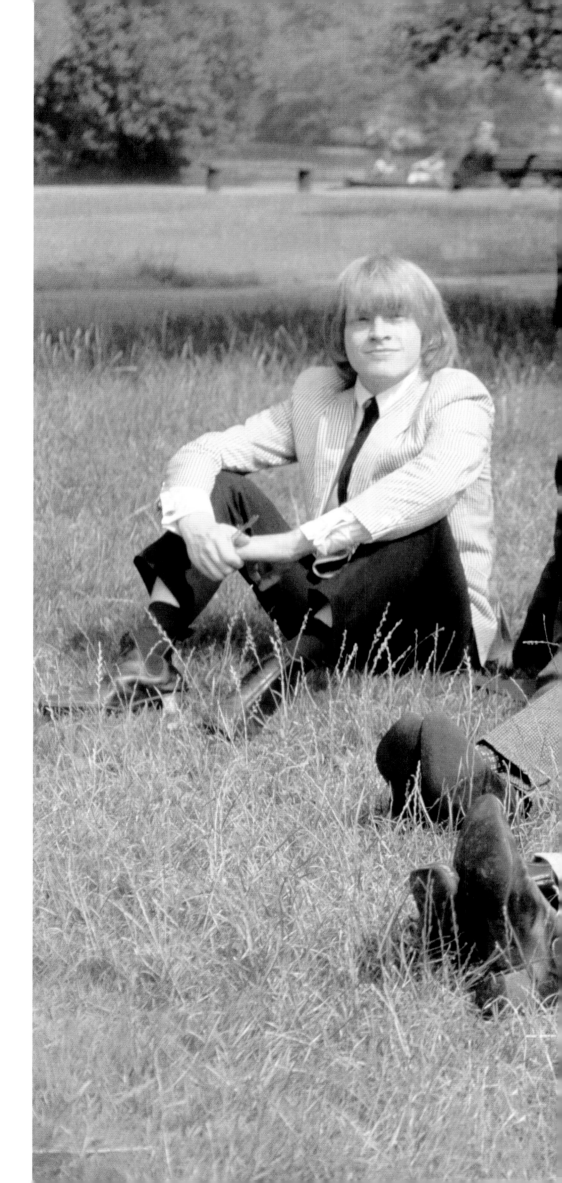

"I was impressed by The Stones. They were dressed very casually, had mischief in them and were different to the other bands"

who were writing about rhythm and blues. It was all about pop and The Beatles and screaming girls in mini-skirts. But this band was educated musically, turned on by Muddy Waters and Little Richard, with a small but loyal following of students and middle-class kids into the black music coming over from Chicago.

Andrew impressed The Stones because he'd done publicity for Brian Epstein and The Beatles, so they signed on with him as their manager. Keith always says Andrew was the "sixth Stone" — and he was. He hustled them into a recording contract, onto television and into the charts. I sometimes wonder if they'd have made it without him.

The story goes that Andrew called the man who turned down The Beatles and said, "You don't want to make the same mistake twice," persuading him to sign The Stones. I believe that emphatically.

It was Andrew who called me and asked me to help him get the band noticed. I told him I was too busy to go to photograph an unknown young band — and it was true, I was. But he wouldn't take no for an answer and brought The Stones up to town on the train to fit into my schedule.

In truth, I was impressed by them. They were dressed very casually, they had mischief in them, they were different to The Beatles and the other bands, who were all wearing suits and ties. The Stones weren't prepared to conform in order to get on tele-

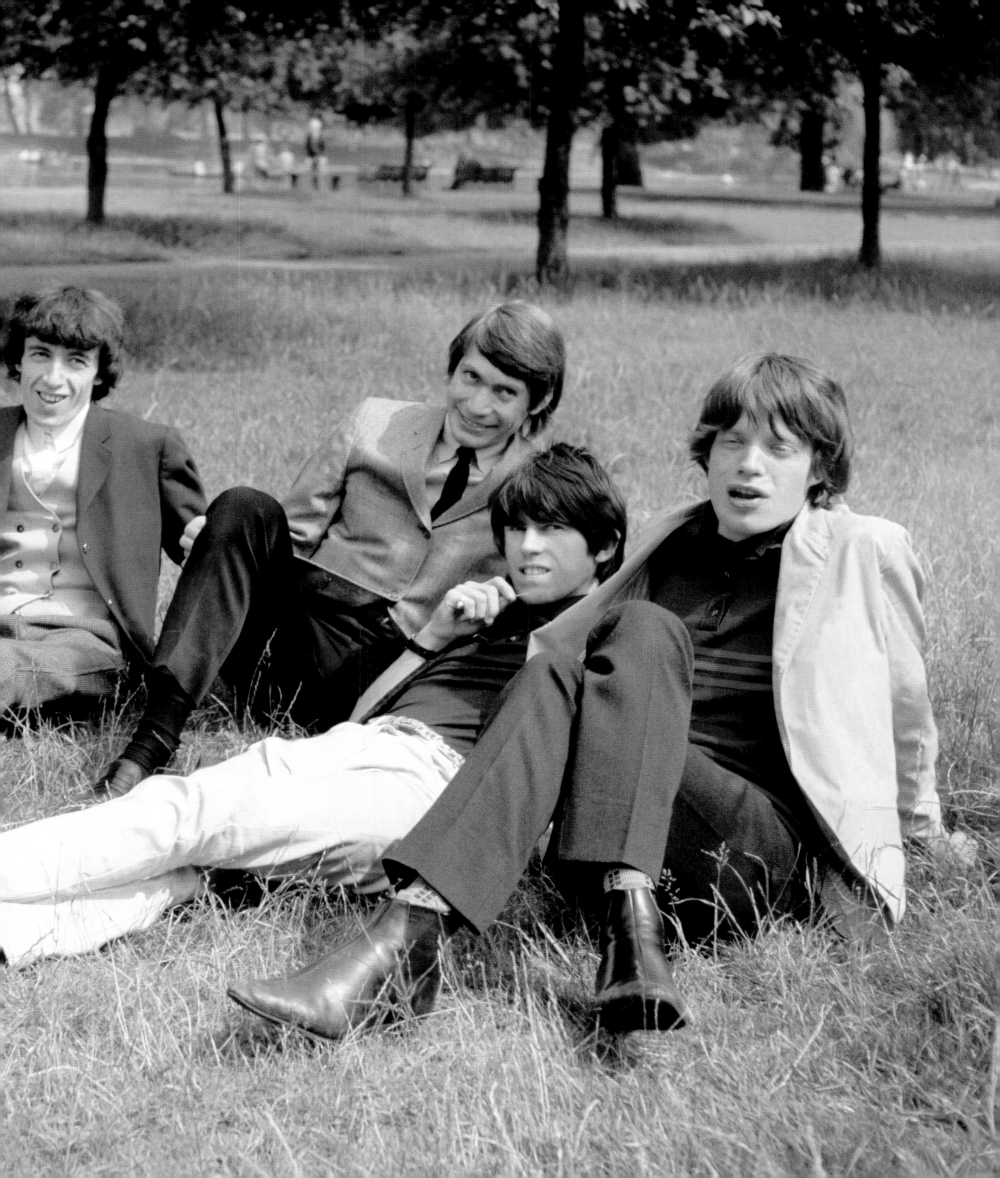

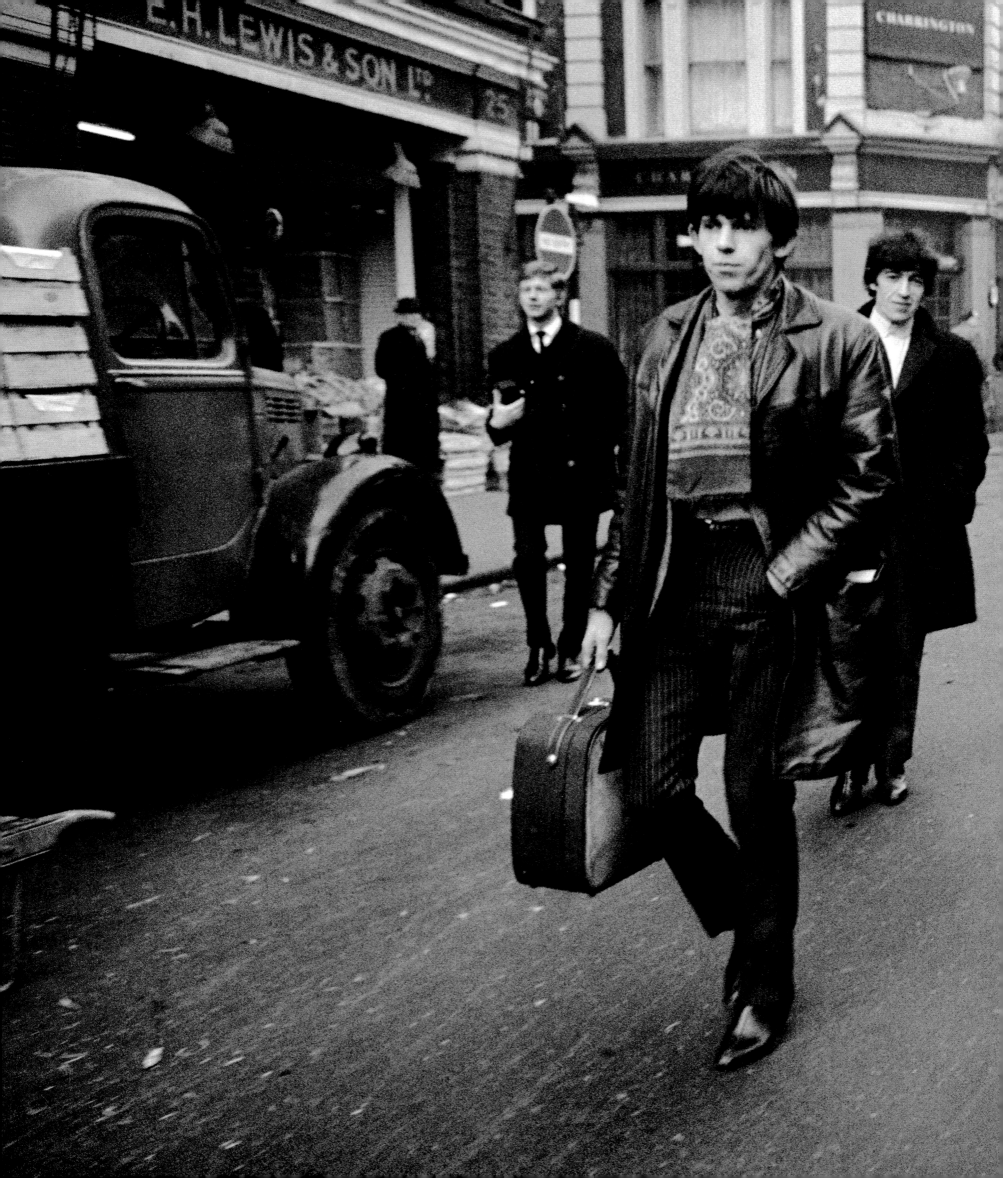

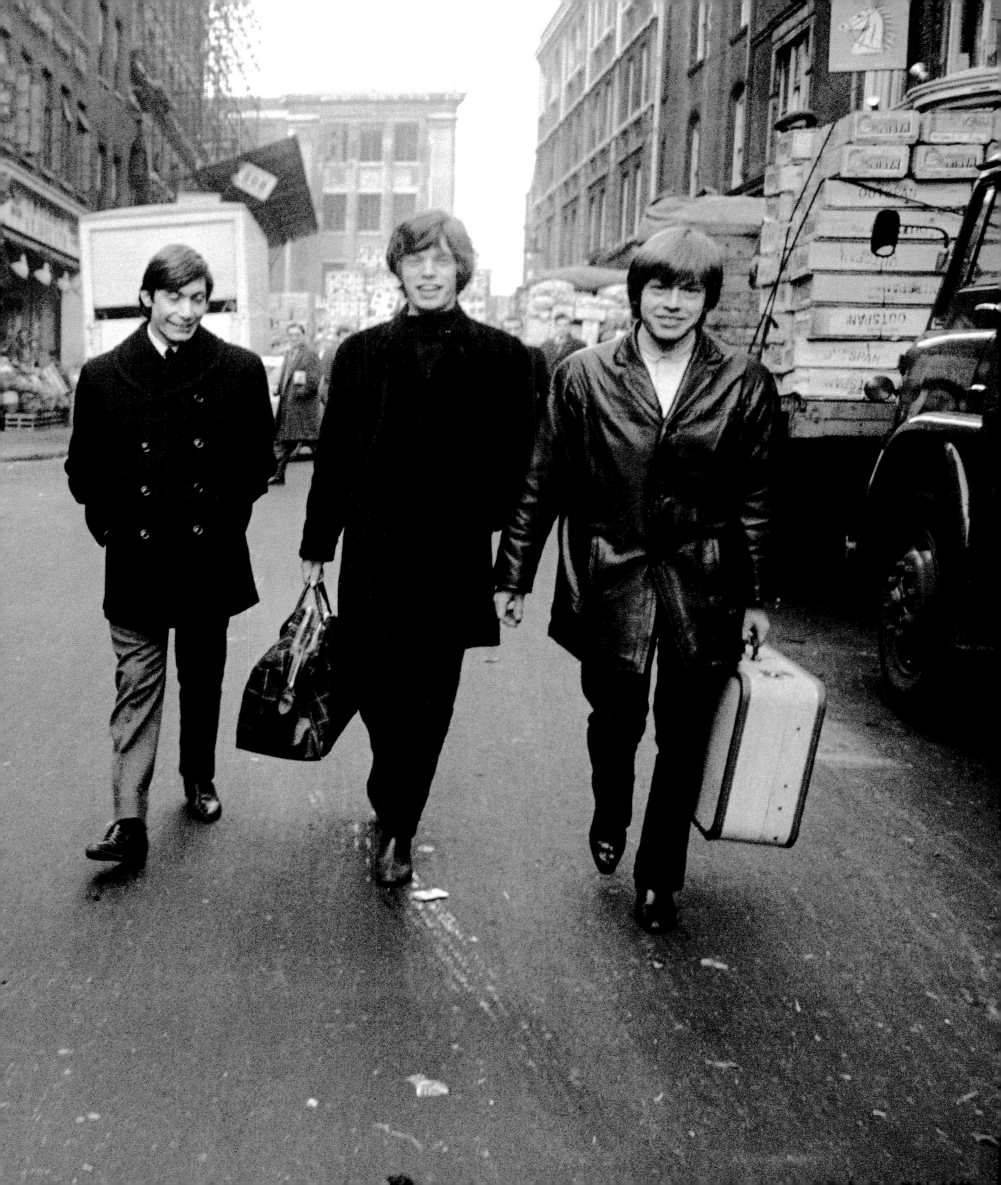

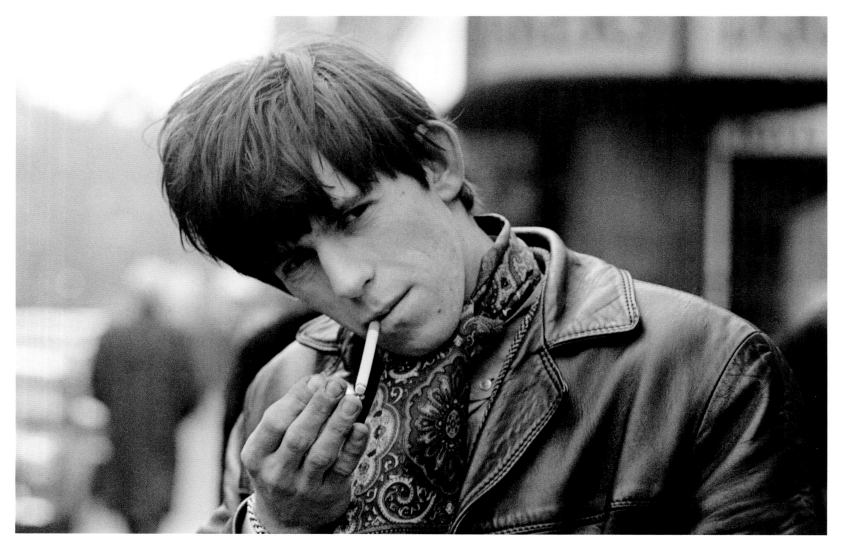

"A newspaper editor said he didn't want 'Neanderthals' in his newspaper and told me to find a 'pretty band' like The Beatles"

Keith Richards lighting a cigarette in London, 1964, just before the band became huge

vision, which was the thing that propelled you to stardom in those days. And I liked their music. It was informed and deep-rooted, not just pop. I think it was the first time I felt that kids were "cool". Keith just had it, he was charismatic. Mick was still a bit of a baby and in Brian's shadow. Brian and Keith were the most musically gifted. Bill Wyman was the mature older guy on bass and Charlie was a brilliant drummer who gave the band a foundation.

I saw them as this band who worked the pubs and clubs and would jump in a van to do a gig for peanuts, so I walked them around Soho carrying suitcases to give the impression of a band on the move. I took them to the park to photograph them and found Andrew had called a press conference. There was a scrum of photographers. Andrew was already positioning The Stones as an antidote to The Beatles. A television executive had said they

were too scruffy to be on television. When I showed a newspaper editor the pictures I'd taken, he said he didn't want "Neanderthals" in his newspaper and told me to find a "pretty band" like The Beatles. I did. They were called the Dave Clark Five, they wore white polo-neck sweaters and blazers. So the editor put their picture next to The Stones with the headline, "Beauty and the Beasts".

Andrew saw an opportunity — he started pushing this line to publicise The Stones: "Would you let your daughter marry a rock star?" with the boys looking long-haired, mean and moody. The girls responded. The Beatles had taken off to America and The Stones started to fill the gap with a completely different identity.

Over the years we became pals. Bill is still a close friend to this day. But back then we'd sit in clubs in London and talk about how long we would be able to have all this fun, them as musicians, me

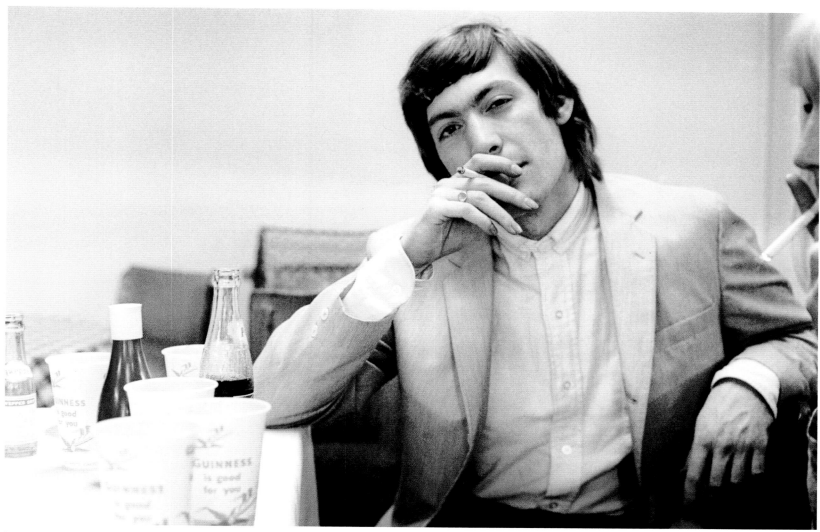

Drummer Charlie Watts relaxes backstage, 1964

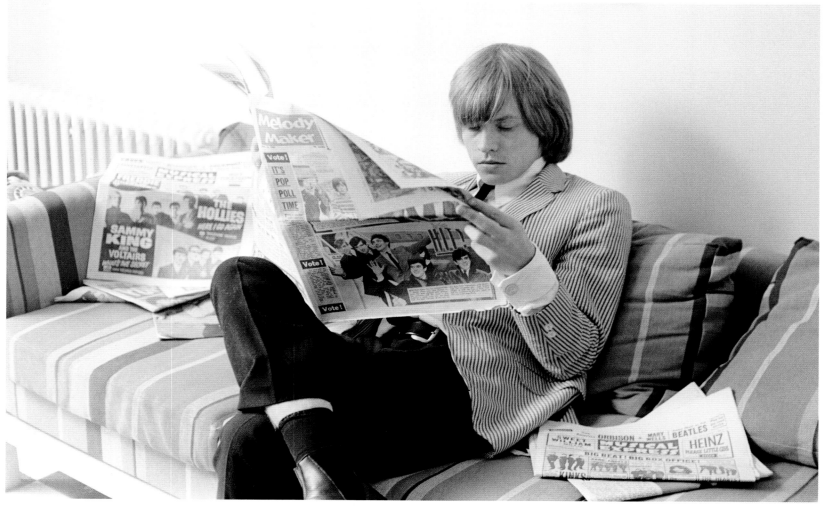

Terry had helped put The Beatles on the front pages of British newspapers and thought he could do the same with The Stones

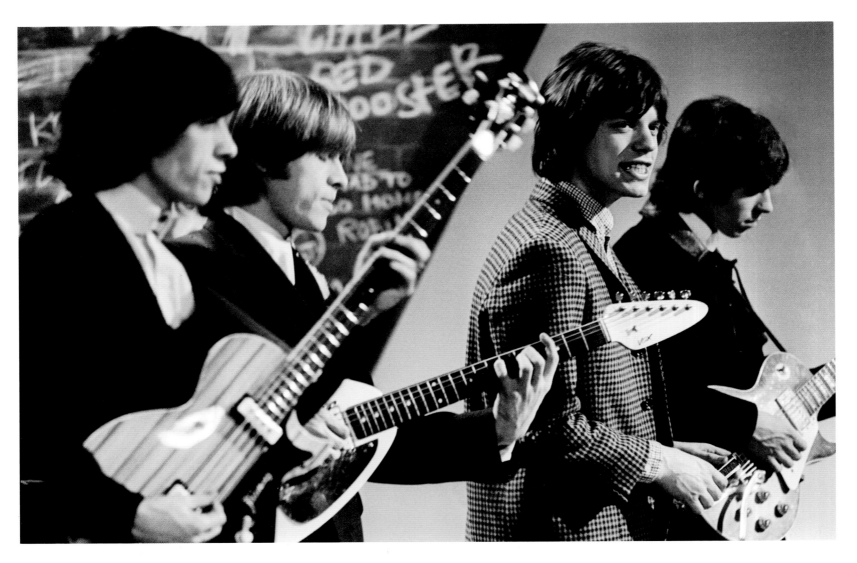

"We'd sit in clubs in London and talk about how long we would be able to have all this fun, them as musicians, me as a photographer. We were nearly all working-class lads and thought it couldn't last"

as a photographer. We were nearly all working-class lads and thought it couldn't last. Today we think of the Sixties as a defining decade in culture, politics and fashion, but then we just thought it was one long party that would soon end.

We talked about the "proper" jobs we'd get. Mick reckoned he'd end up in a bank, Bill was a qualified diesel engineer and would go back to the workshop, Ringo Starr planned to open a hairdressers, maybe two or three. We just didn't realise how fast the times were changing. We were young and naïve and it was fun. We all miss those days before fame and money took over; before the party became a career, a commercial imperative that took over our lives. Back then, we were all in it together.

John Lennon and Paul McCartney gave The Stones their first hit. They were struggling to find something to record and Andrew bumped into John and Paul, who walked back to the studio with him and rapped out 'I Wanna Be Your Man', which they'd just written. I can't imagine two big competing acts doing that today — the lawyers, managers or record companies would have them tied up in small-print contracts. And I wouldn't be able to photograph them as I did back then.

We all remember that sense of freedom: musicians, actors, photographers, fashion designers. We were young, we were friends, we swapped ideas, we were in it together and we didn't know it was a revolution ∎

AK SAF·ETY FILM ▲▤ KODAK TRI-X PAN FILM KODAK SAF·ETY FILM

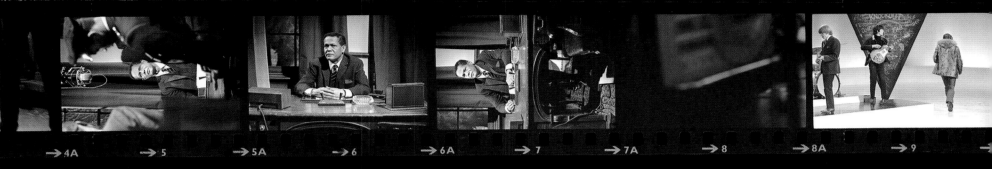

→4A →5 →5A →6 →6A →7 →7A →8 →8A →9

KODAK SAF·ETY FILM ▲▤ KODAK TRI-X PAN FILM K

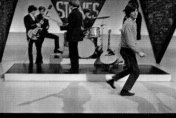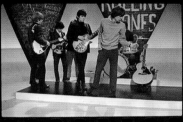

27A 28 28A 29 29A 30 30A 31 3 32

KODAK SAF·ETY FILM ▲▤ KODAK TRI-X PAN FILM

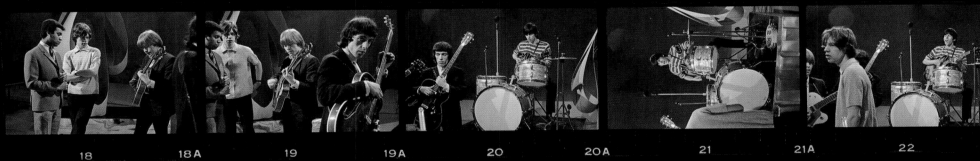

18 18A 19 19A 20 20A 21 21A 22

TRI-X PAN FILM KODAK SAF·ETY FILM ▲▤ KODA

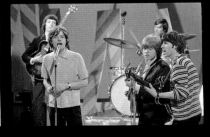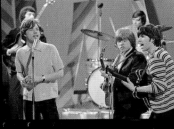

16 16A 17 17A 18 18A 19 19A 20 20A

KODAK SAF·ETY FILM ▲▤ KODAK TRI-X PAN FILM

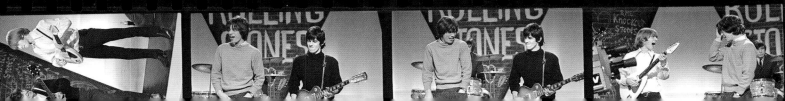

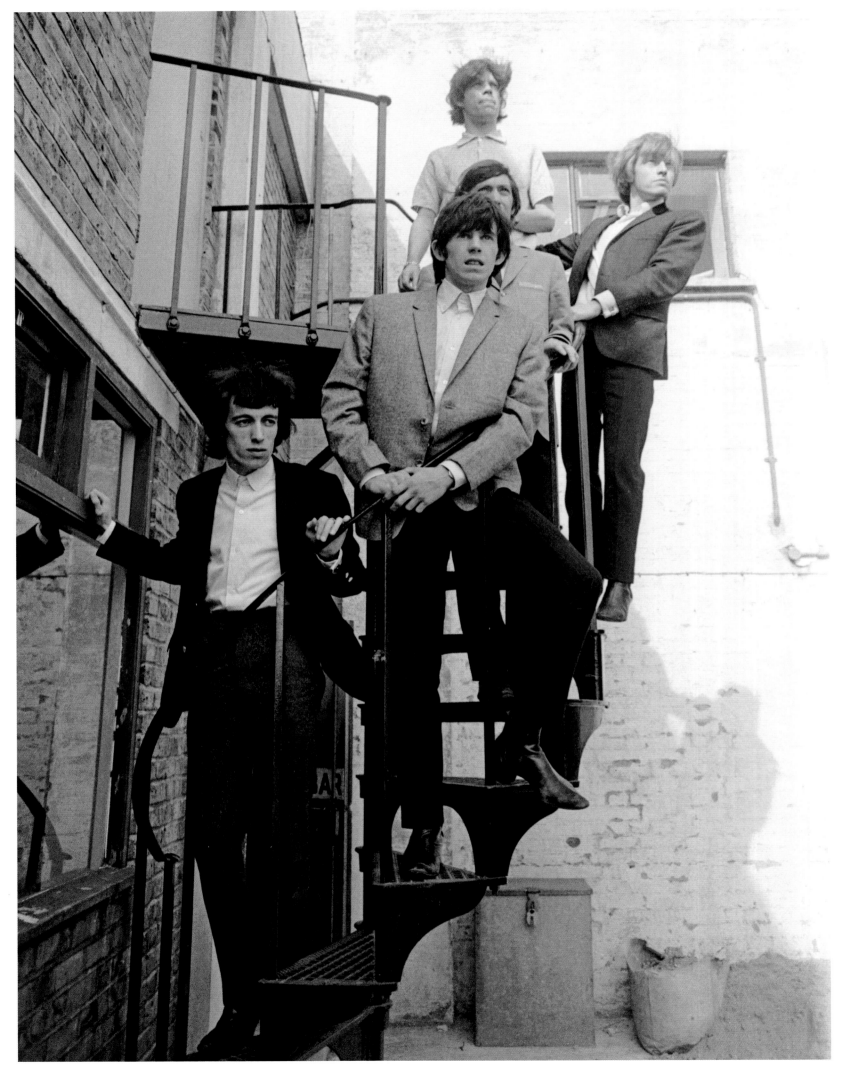

"Would you let your daughter marry a rock star?" The boys were long-haired, mean and moody

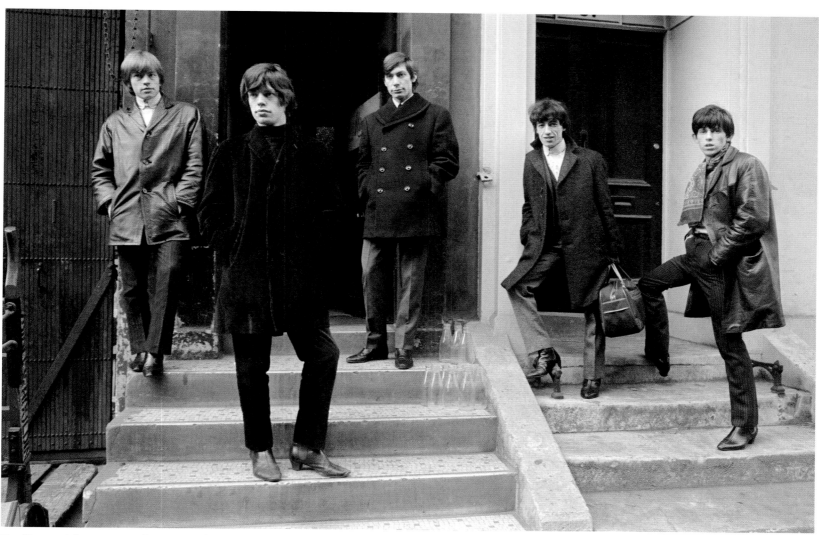

The Stones strike a pose on the streets of London, 1963

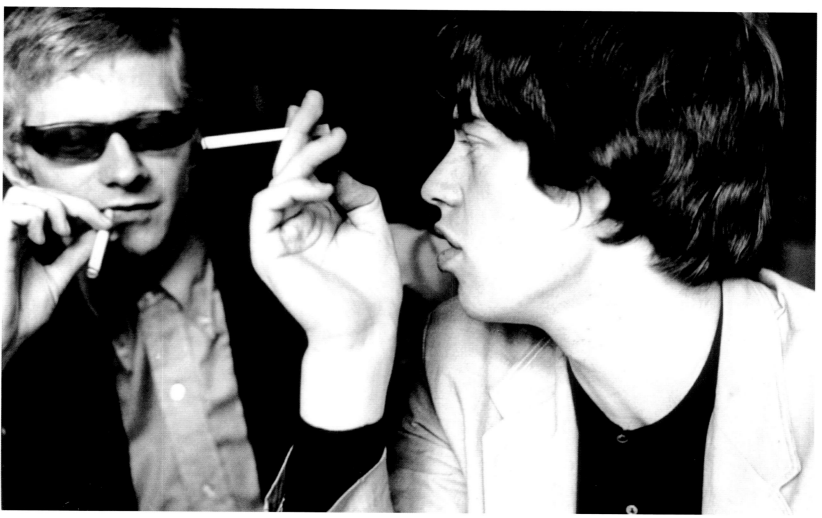

Mick Jagger with Rolling Stones manager Andrew Loog Oldham (left) in 1964

"We were young and naïve and it was fun. We all miss those days before fame and money took over; before the party became a career. Back then, we were all in it together"

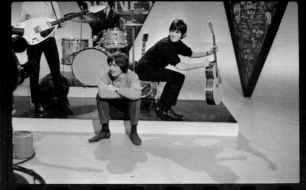
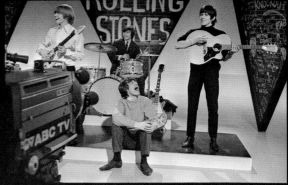

11 11A 12 2A 13 13A

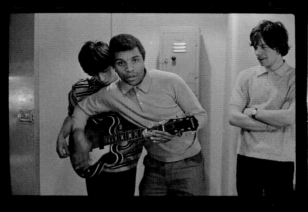
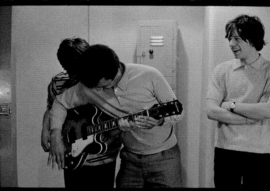

9A 10 10A 11 11A 12

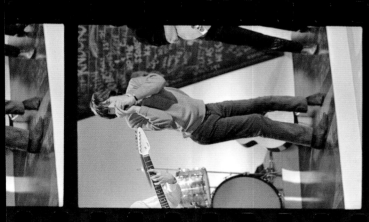
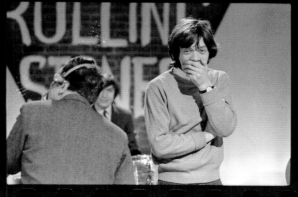
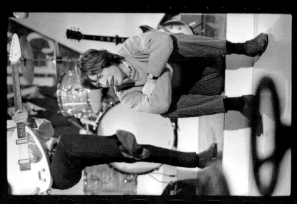

14A 15 15A 16 16A 17 17A

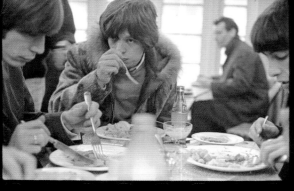
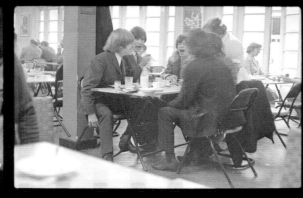
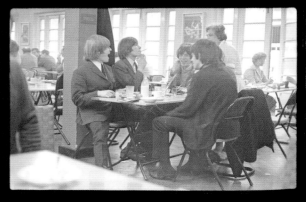

24A 25 25A 26 26A 27

Lead singer Mick Jagger pouts for the camera in a fur parka, London, 1964

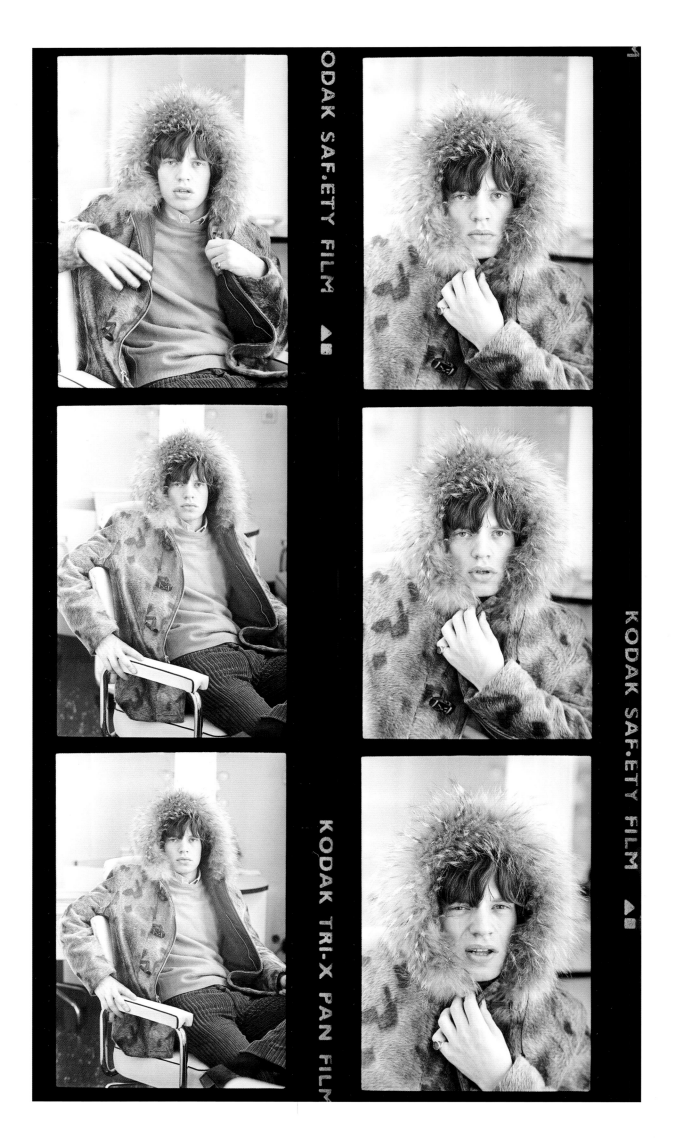

Following spread: An assorted bunch of musicians, including David Bowie on saxophone and Ron Wood on guitar, play at Peter Sellers's 50th birthday in Los Angeles (following pages)

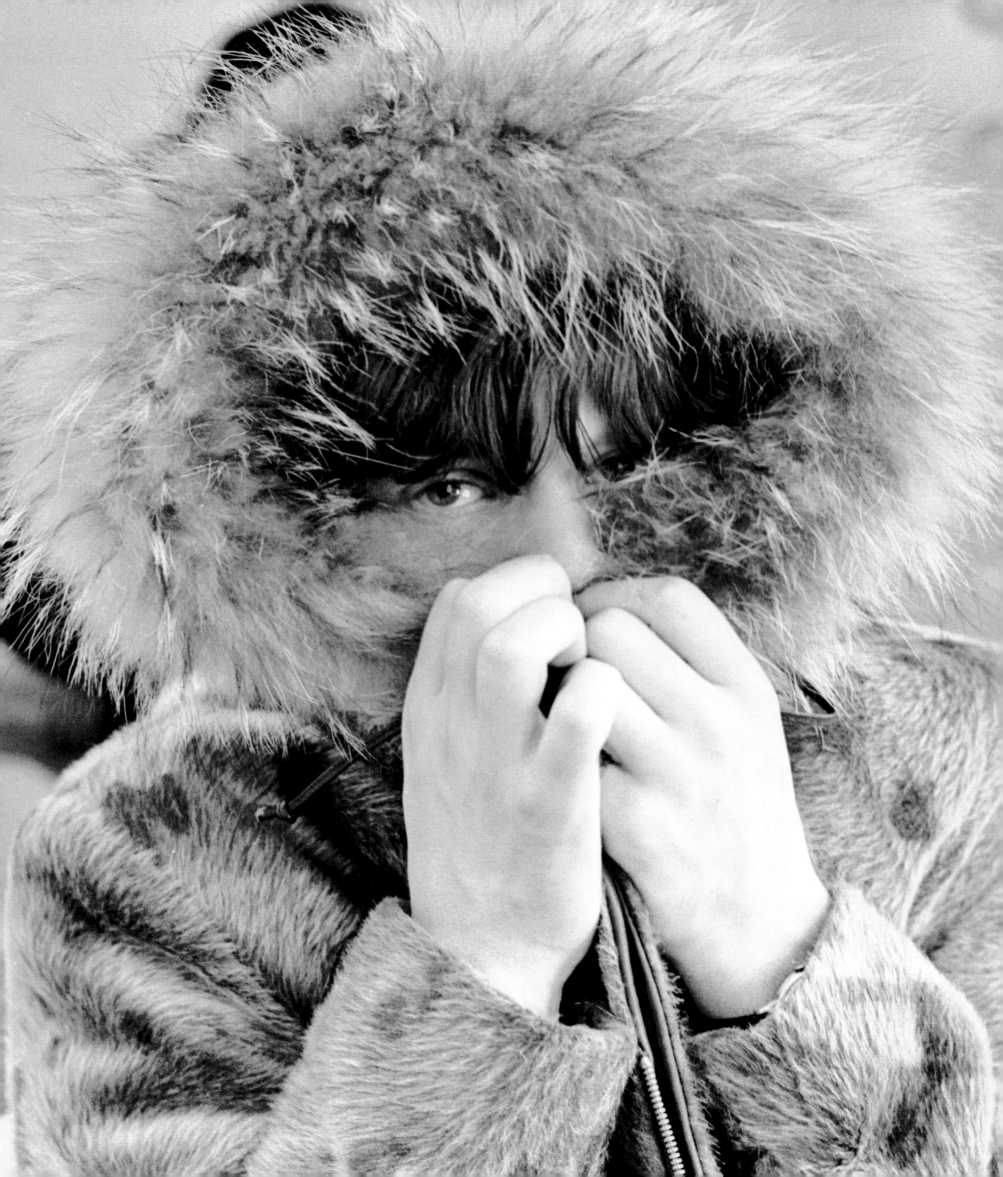

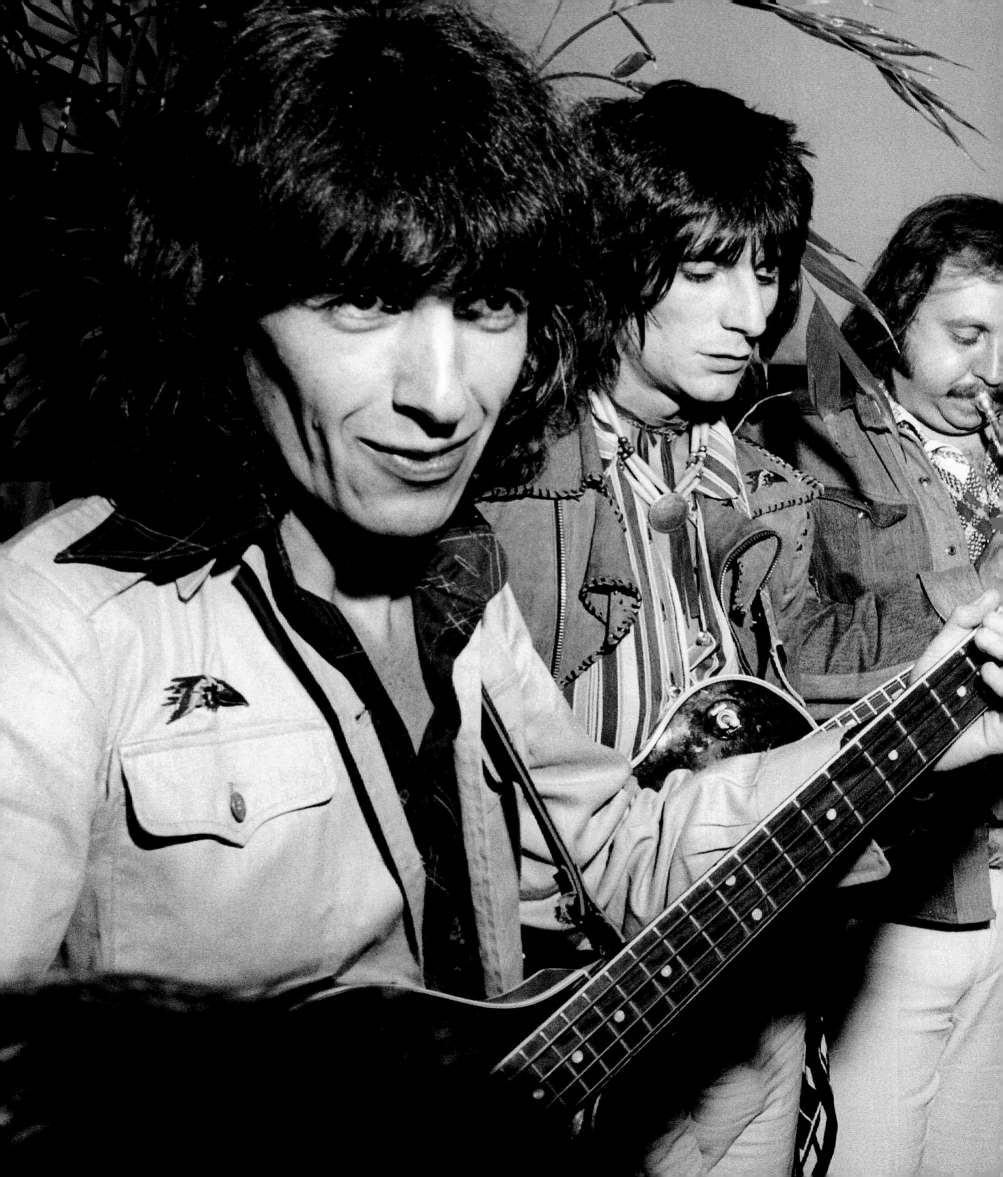

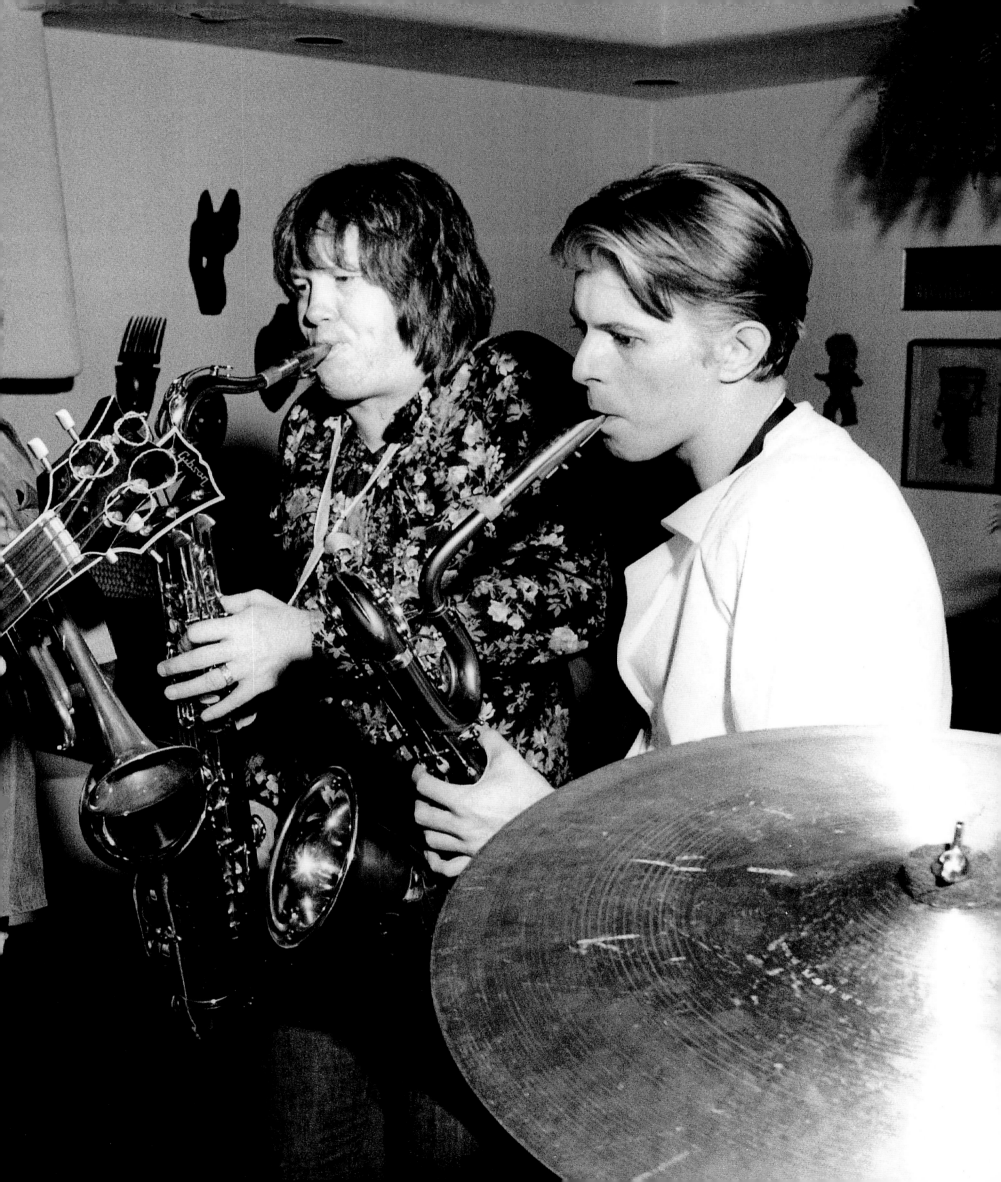

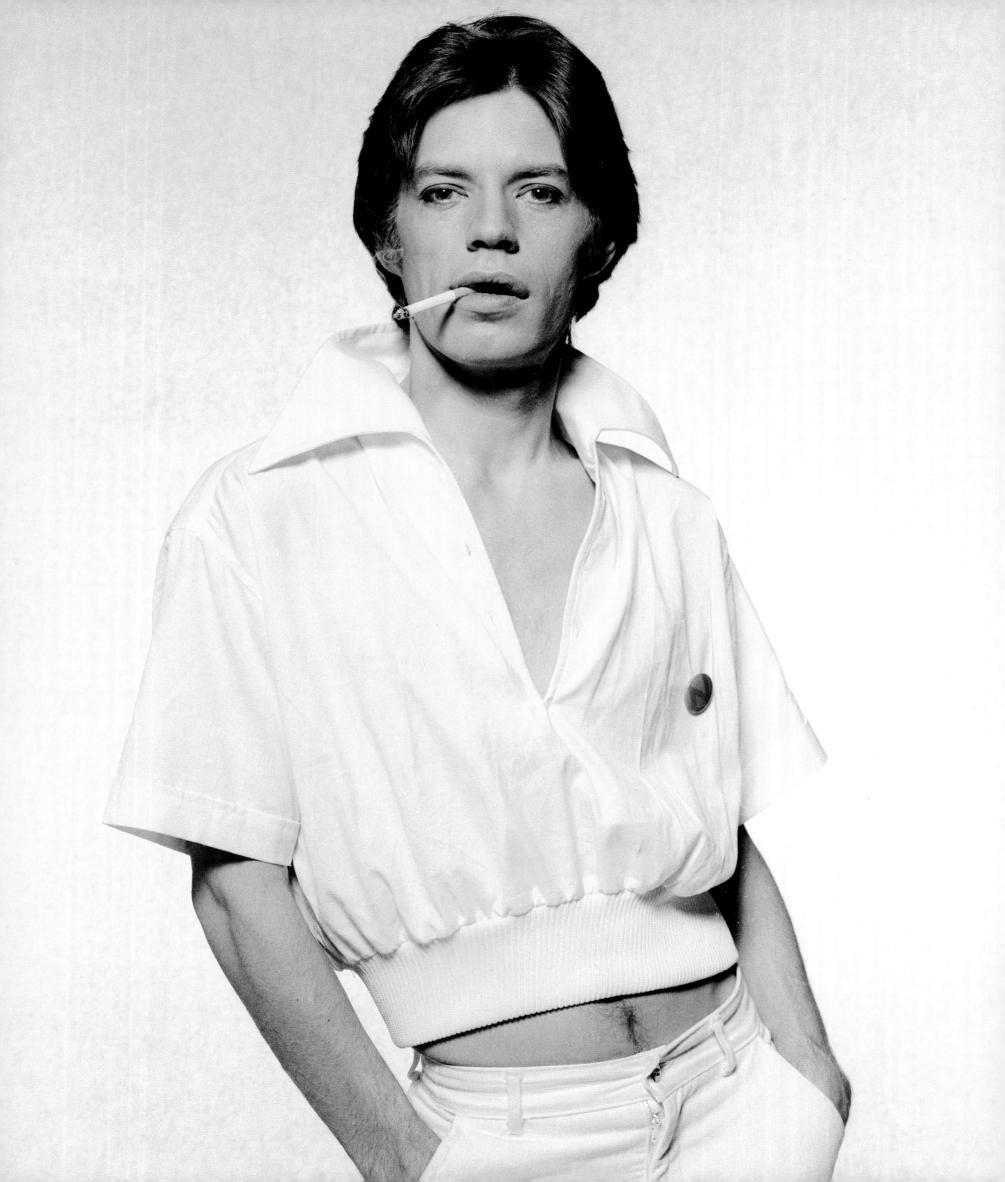

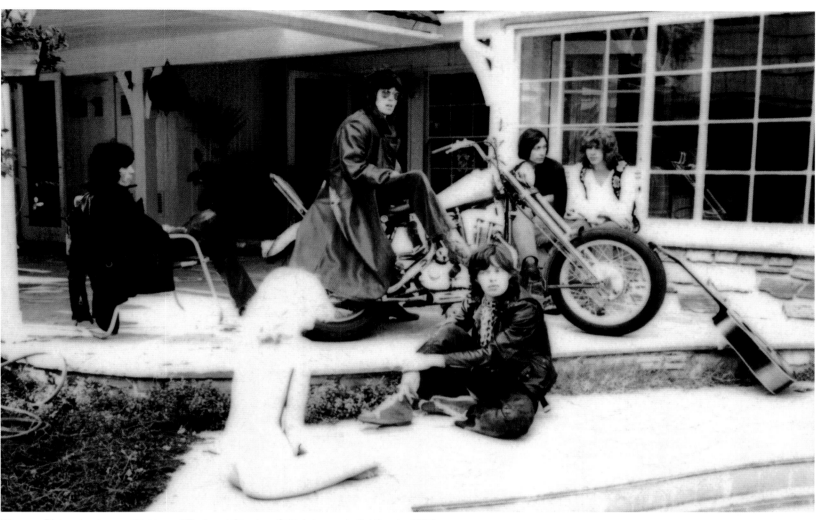

Wyman, Richards, Jagger, Watts and Taylor at Stephen Stills's house in California, 1969

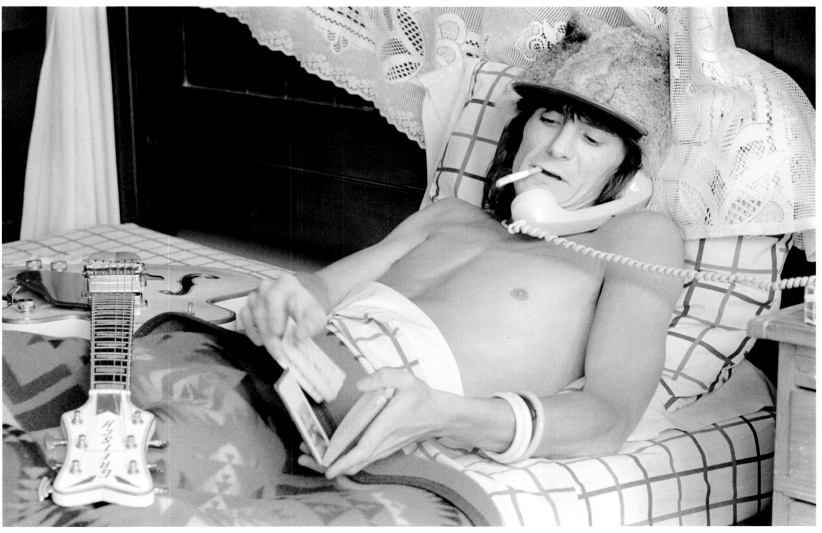

Multi-tasking Ron Wood on the phone, smoking, sharing the bed with his guitar

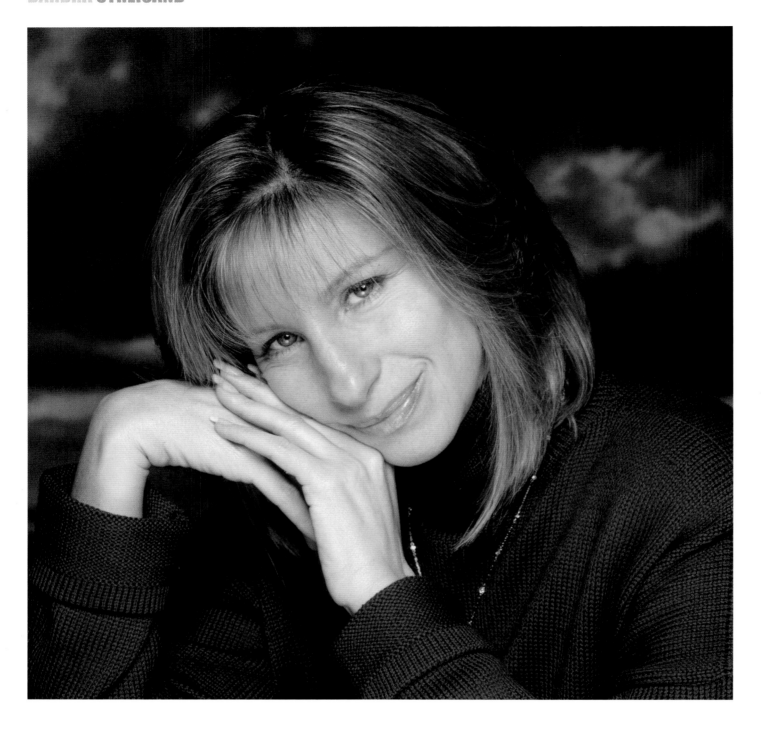
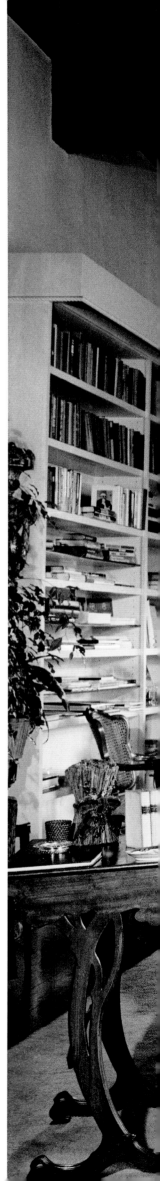

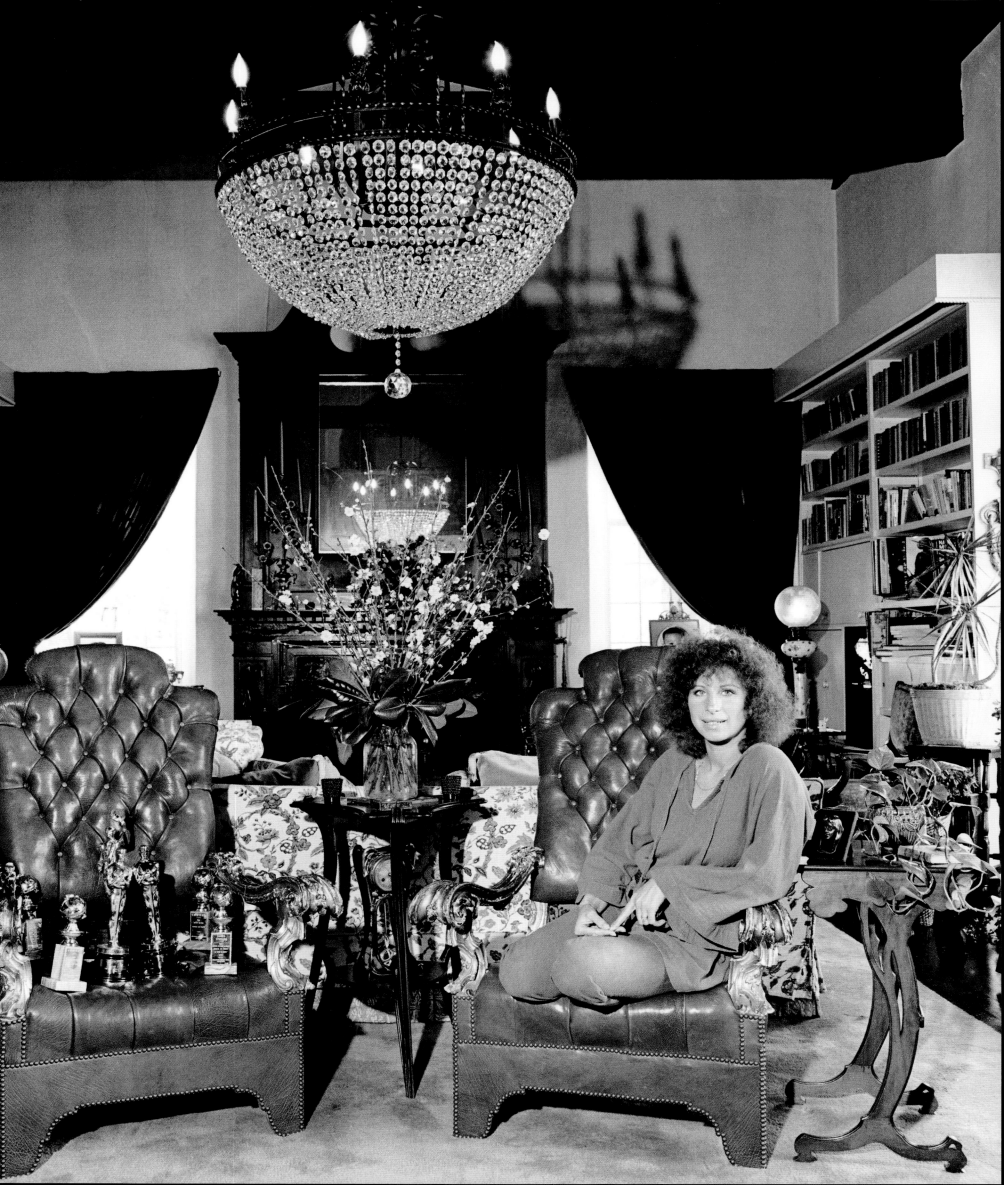

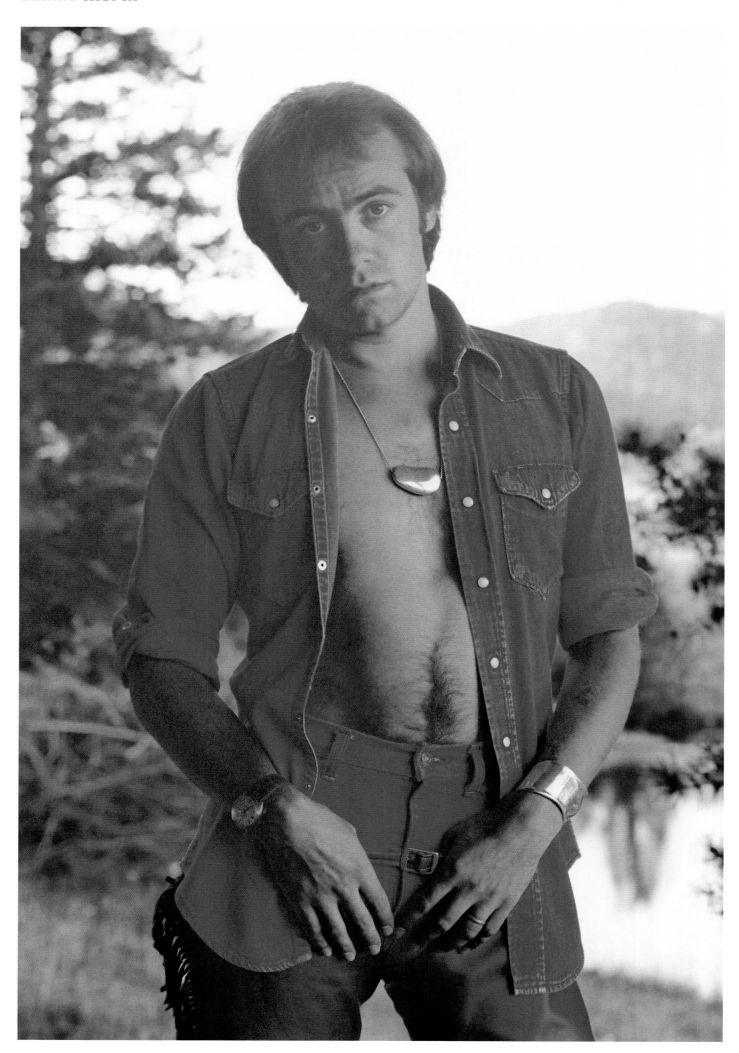

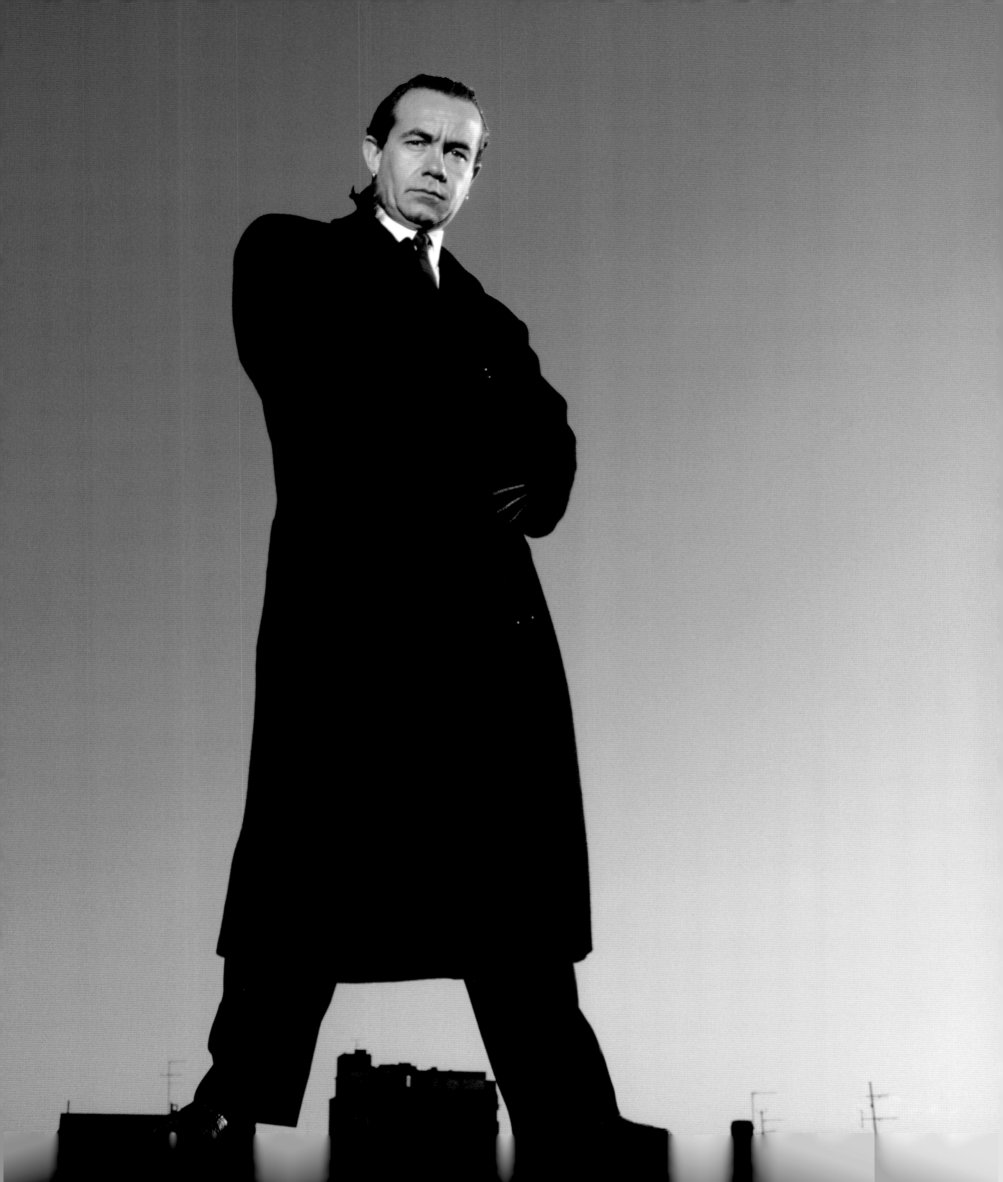

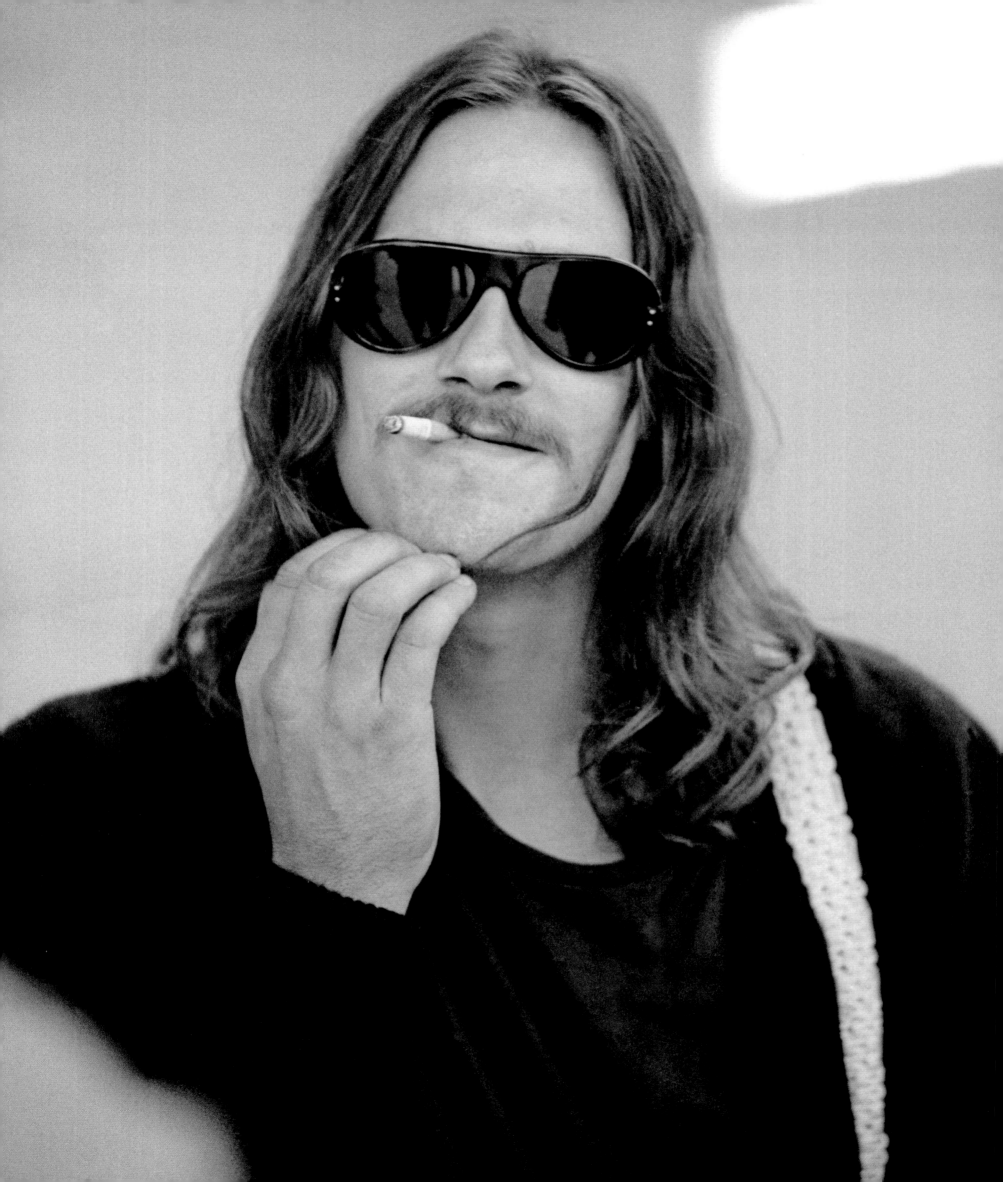

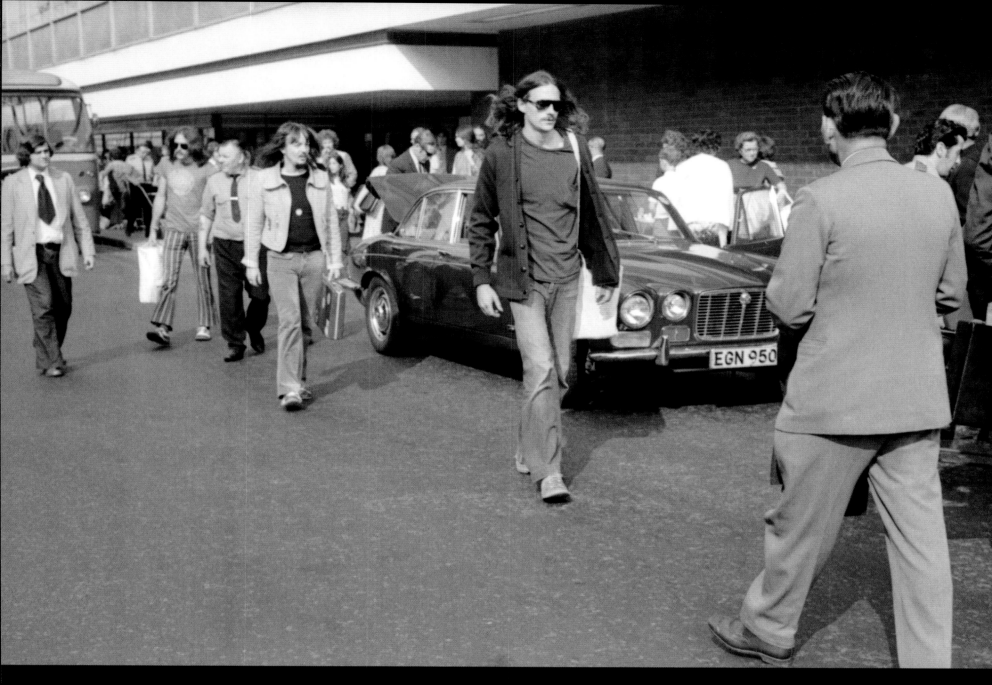

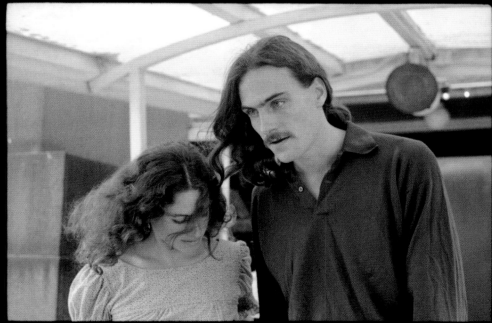

28 ➞ 28A ➞ 29 ➞ 29A

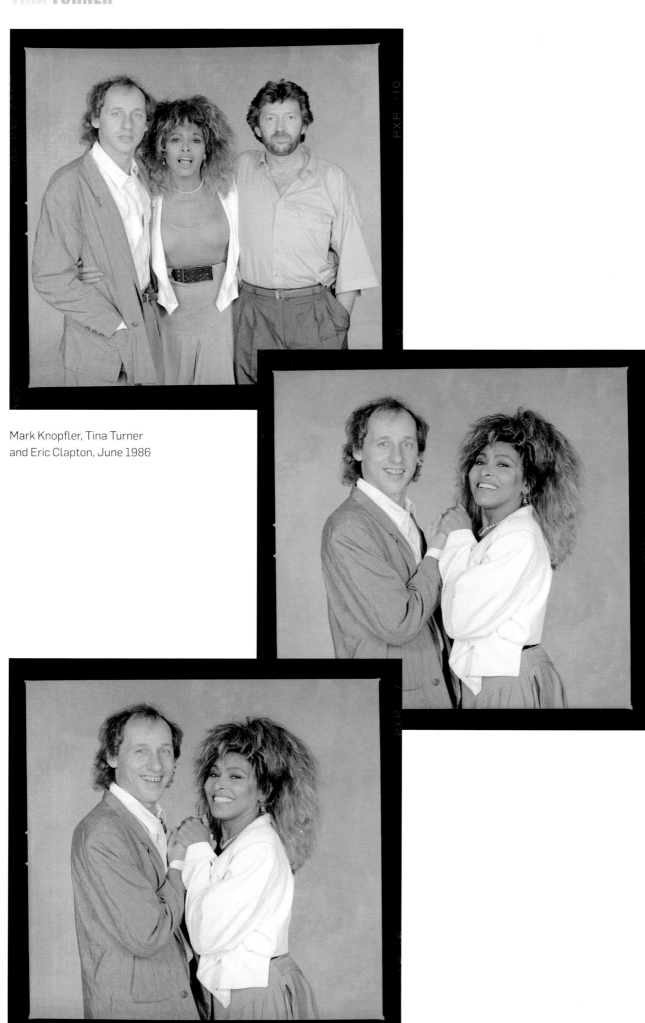

Mark Knopfler, Tina Turner
and Eric Clapton, June 1986

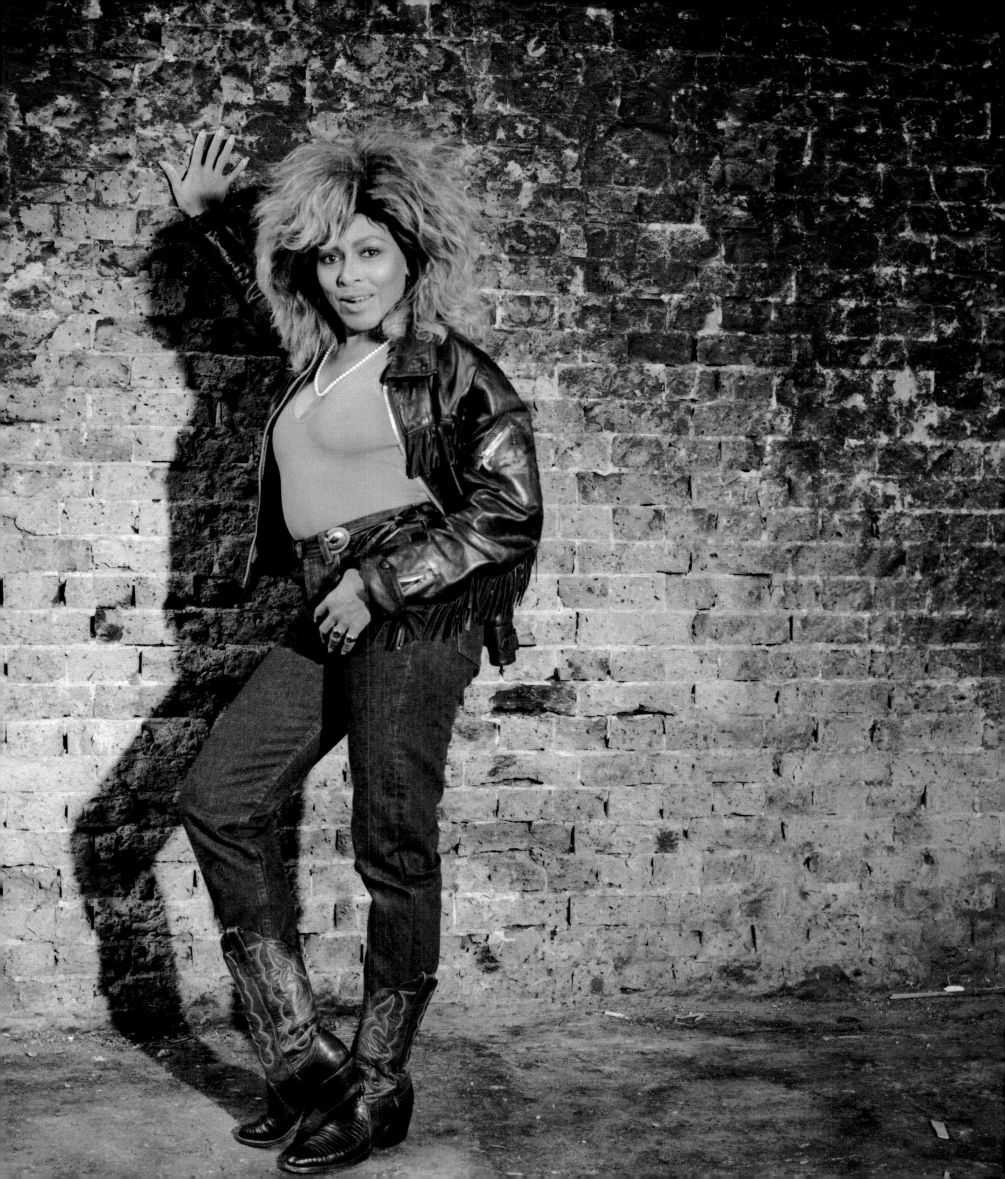

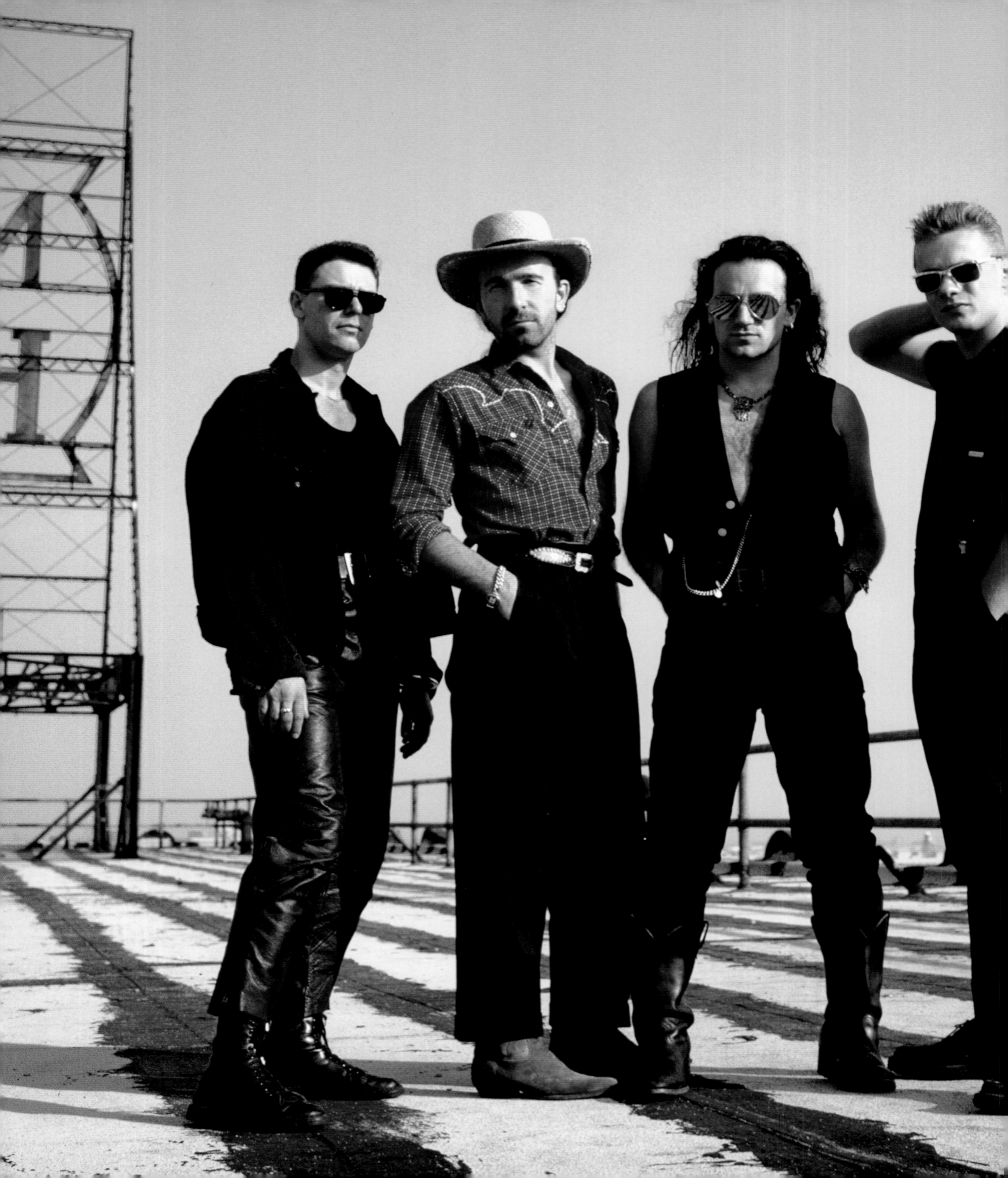

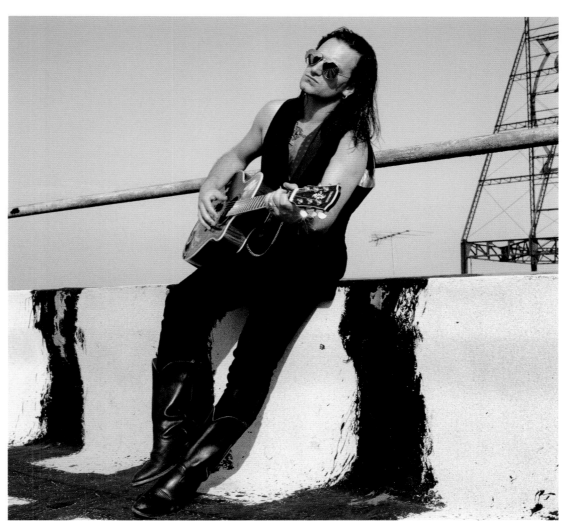

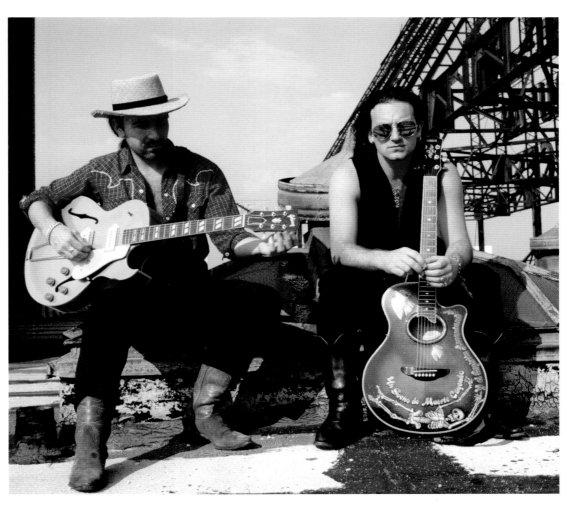

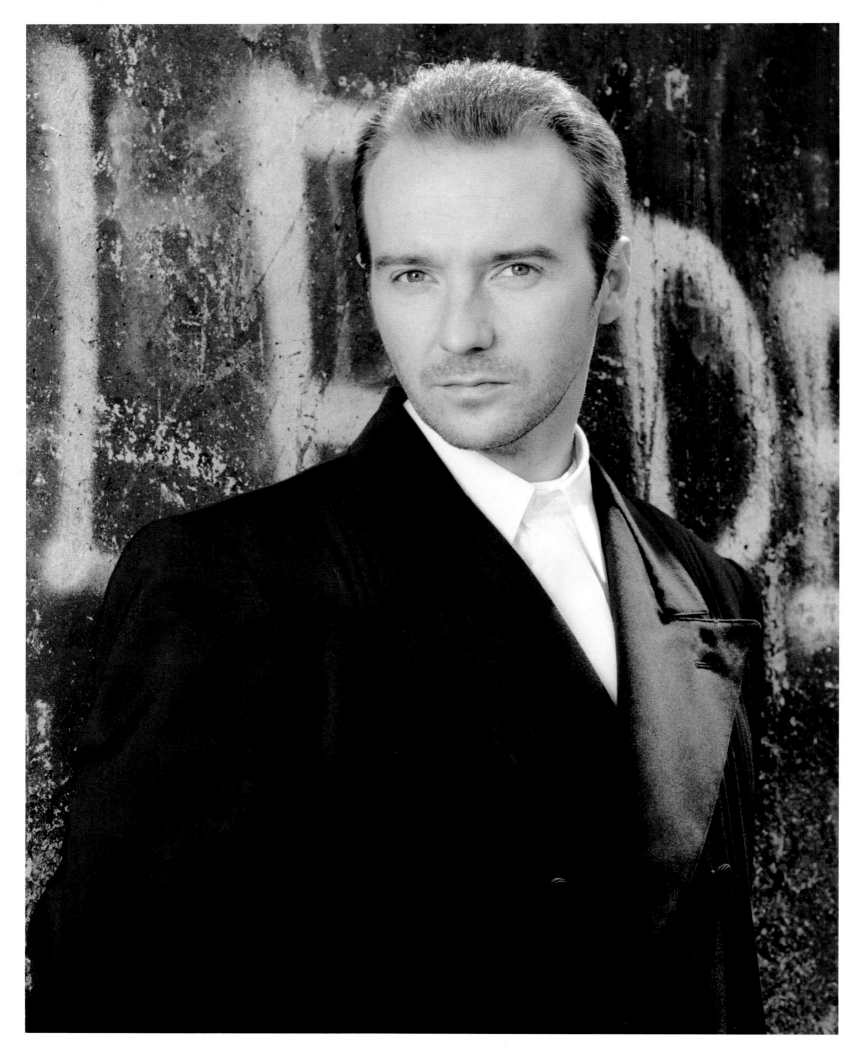

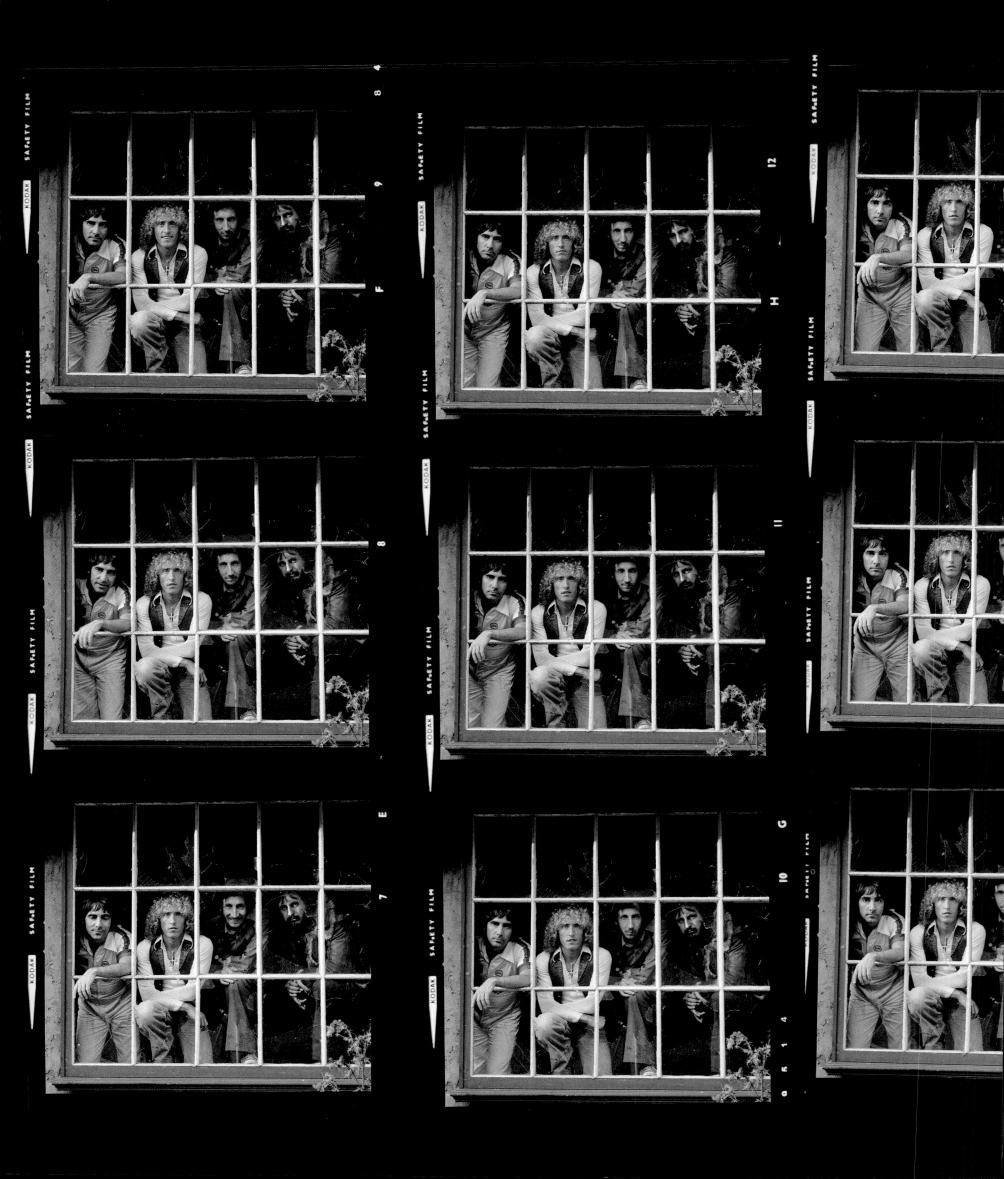

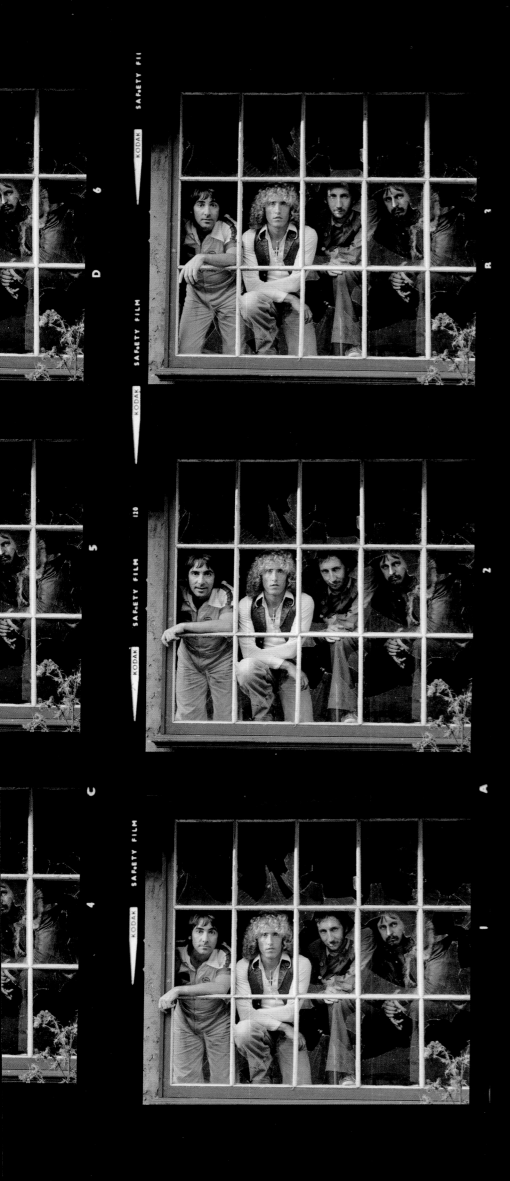

> *"In the space of five years, bands had gone from being boys in suits to high-adrenalin rockers. Drugs, alcohol and groupies were everywhere"*

THE WHO

I started photographing The Who in the Sixties, when they were called The Detours. It amazes me how long they've been playing. They were one of the earliest bands, before The Rolling Stones even — and are still headlining festivals and concerts today.

I remember photographing Roger Daltrey at his home outside London in the late 1960s. It was a mansion in the country. Those were the days when the rockers started buying stately homes — they were the new aristocracy, buying historic homes, vast estates and ostentatious cars. George Harrison, Eric Clapton... all the rock stars had them. They needed privacy, peace and quiet, because their touring lives were so hectic.

The Beatles had split up, Woodstock had happened and suddenly rock stars had long hair, wore jeans and went bare-chested. In the space of four or five years, bands had gone from being boys in suits to high-adrenalin rockers. Drugs, alcohol and groupies were everywhere.

The cops often raided rock stars' estates in those days, but Roger was always a serious man — a thinker, not someone with a death-wish like the drummer Keith Moon.

On stage, Roger would swing his microphone around his head, Pete Townshend would smash guitars, but that was all an act. They weren't crazy like Keith Moon, who was totally unpredictable on stage and off.

I photographed the band for their album *Who Are You?* in 1978 at a London film studio. I grabbed this chair owned by the studio — on it was written "Not To Be Taken Away" (from the soundstage). I sat Keith on it.

It was a terrible irony. Three weeks later Keith was dead. He was an alcoholic and often almost incoherent, on the verge of collapse. He overdosed on a drug he'd been prescribed to stop him drinking. It was a sad loss, he was an amazing drummer ■

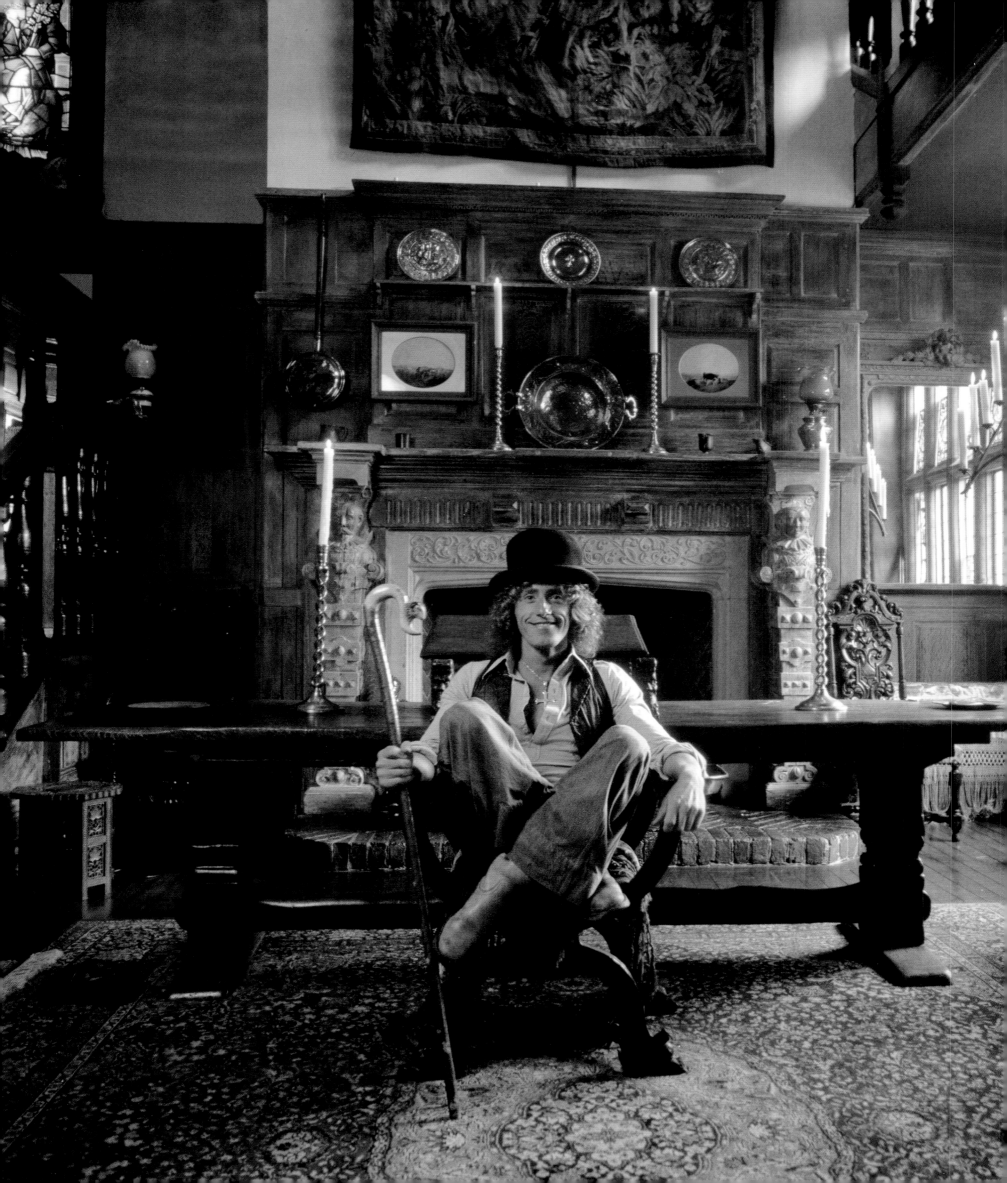

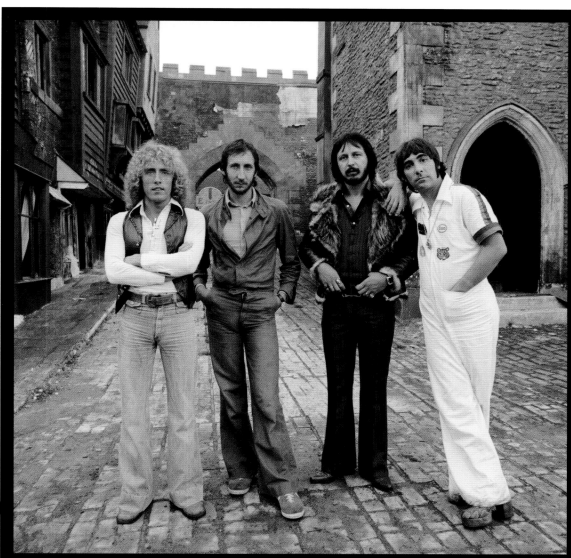

Terry photographed the band for their album *Who Are You?* at a London film studio, in 1978

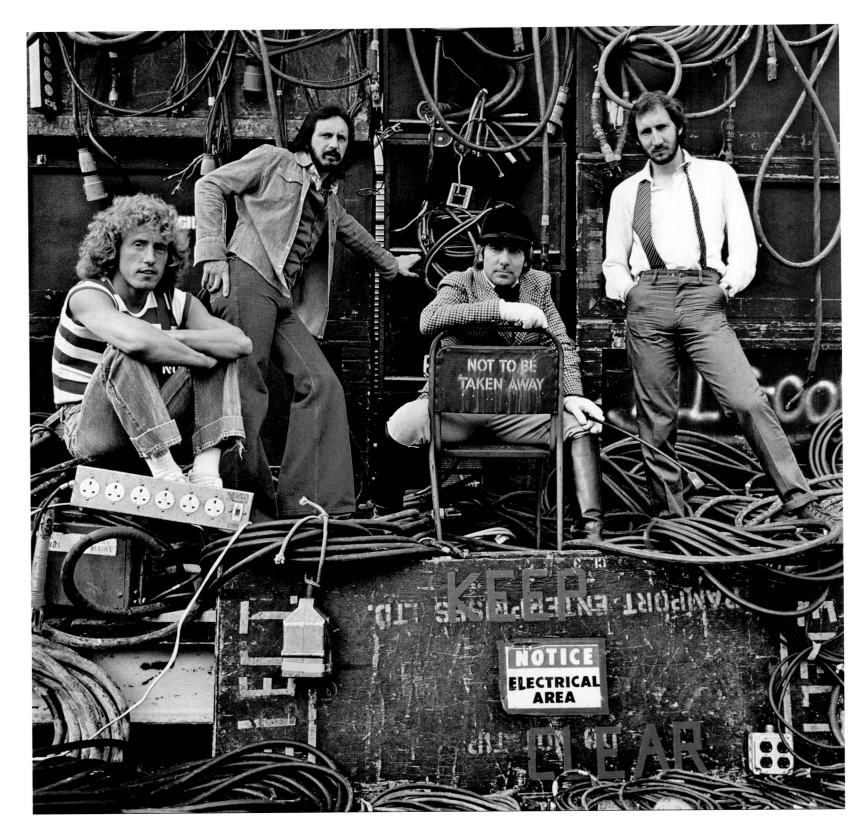

"I grabbed this chair owned by the
studio — on it was written 'Not To Be
Taken Away'. I sat Keith Moon on it,"
says Terry. "It was a terrible irony.
Three weeks later Keith was dead"

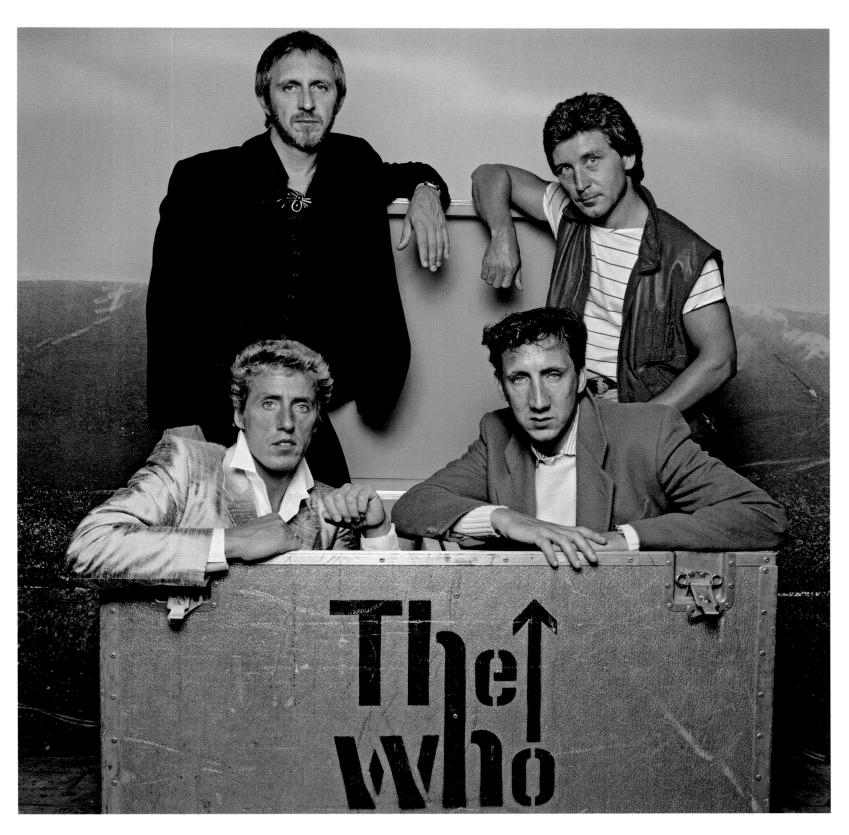

John Entwistle, Kenney Jones,
Roger Daltrey and Pete
Townshend, in London, 1982

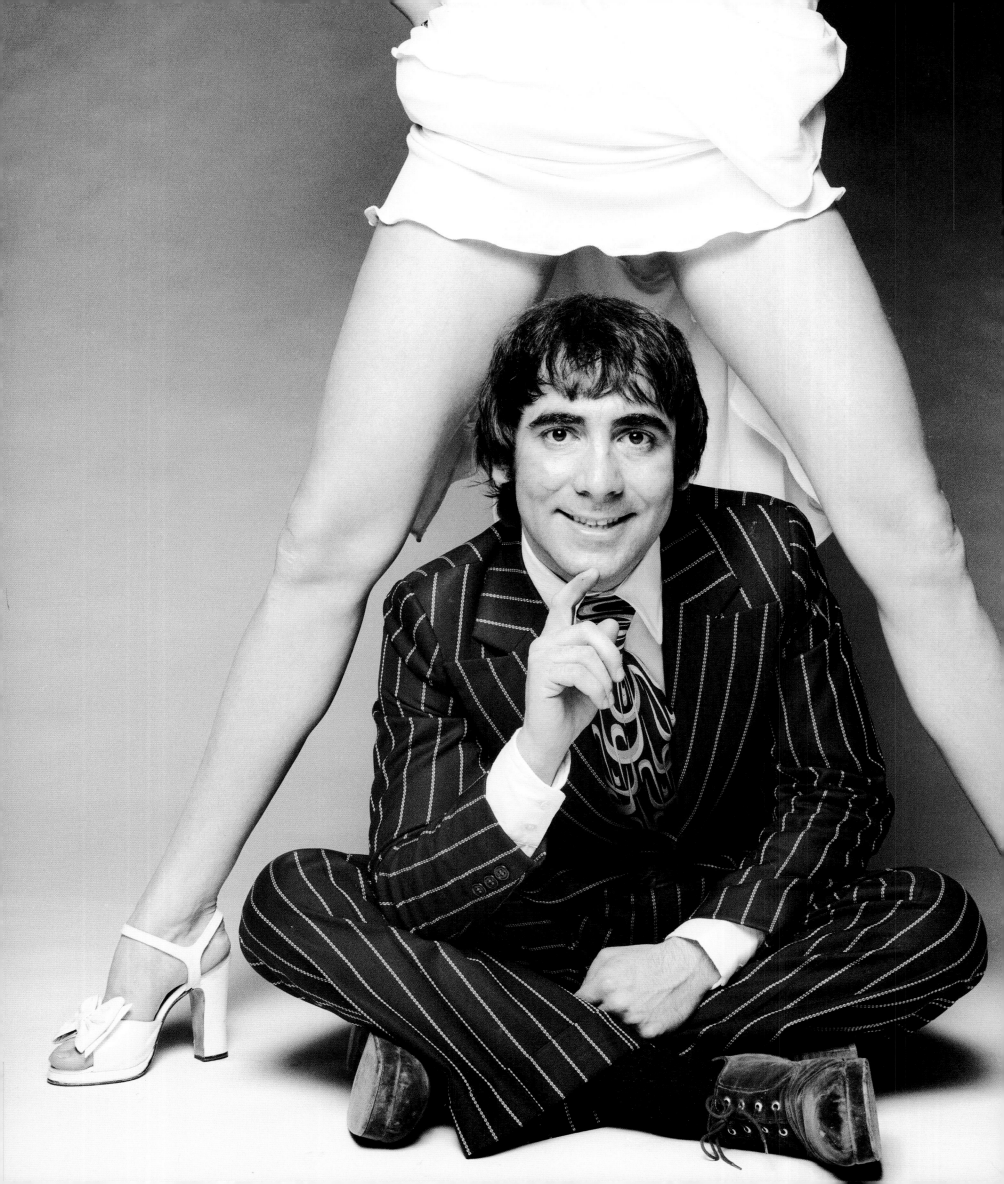

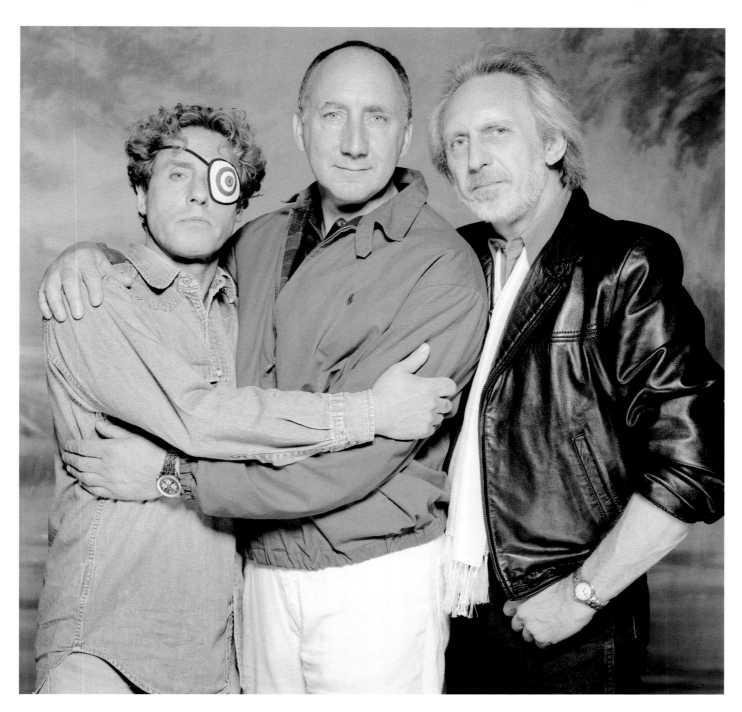

Keith, framed by the legs of Annette Walter-Lax, in London, 1975 (left). The band members, minus Keith Moon, in later life (above). Roger had been knocked out by a mike stand that was thrown around on stage. It broke his eye-socket and gashed his eye, which is why he is wearing a patch

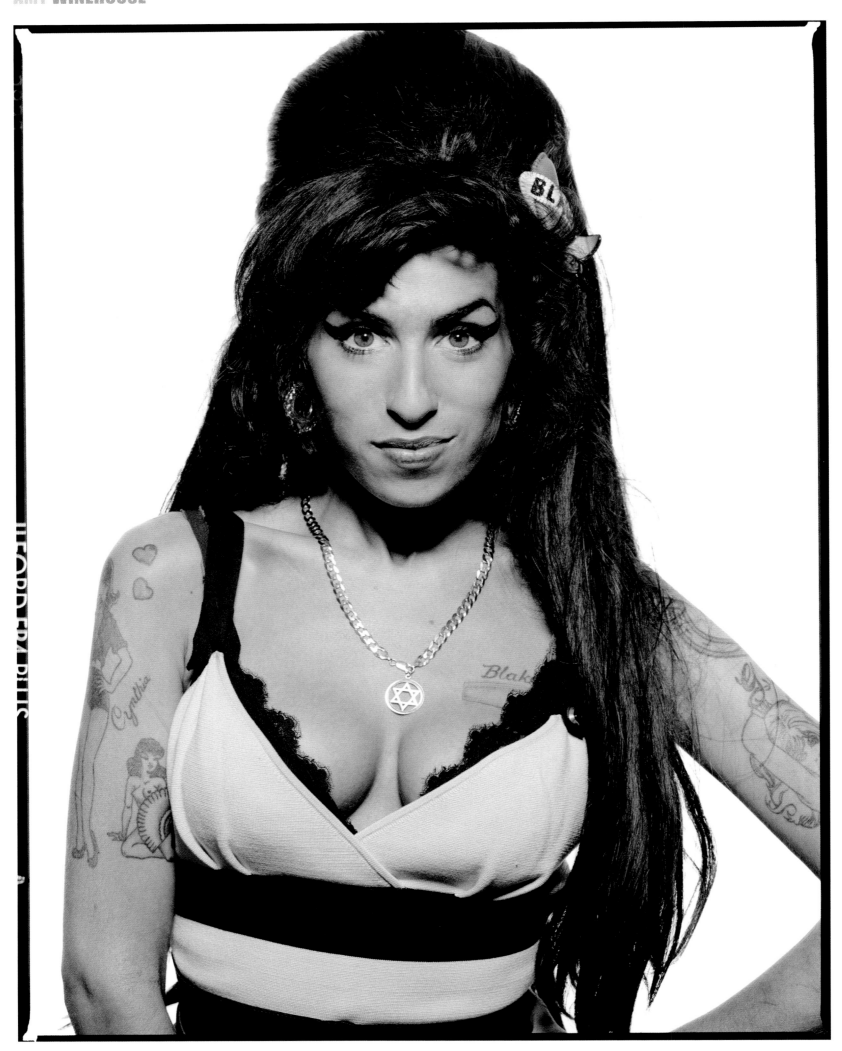

STEVIE WONDER

KODAK SAF·ETY FILM +

→13 →13A →14 →14A →15 →15A →16 →16A →17 →17A

KODAK SAF·ETY FILM +

→8 →8A →9 →9A →10 →10A

KODAK TRI-X PAN FILM

→11 →11A →12 →12A

KODAK SAF·ETY FILM +

→3 →3A →4 →4A →5 →5A →6 →6A →7 →7A

KODAK TRI-X PAN FILM

KODAK TRI-X PAN FILM

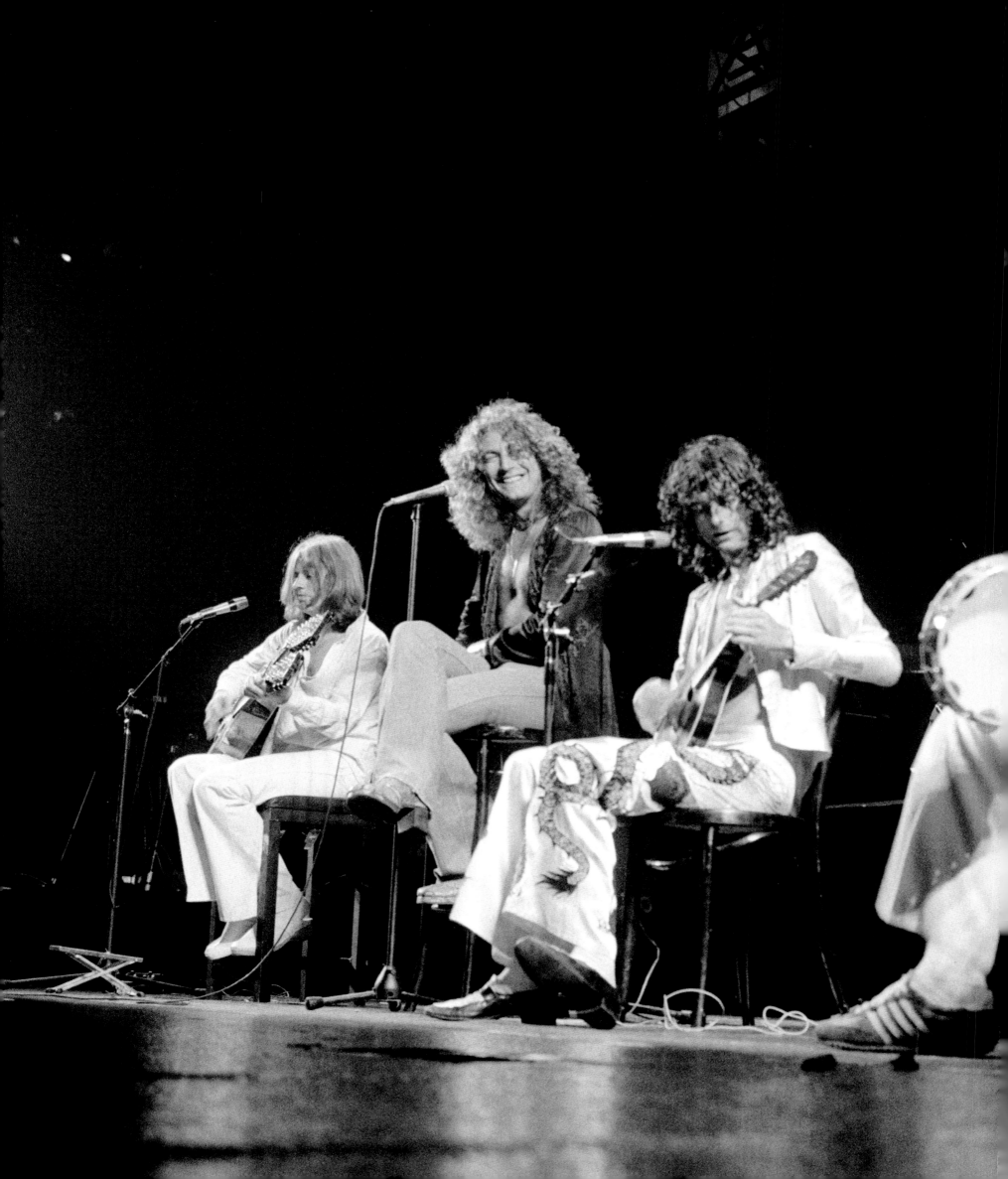

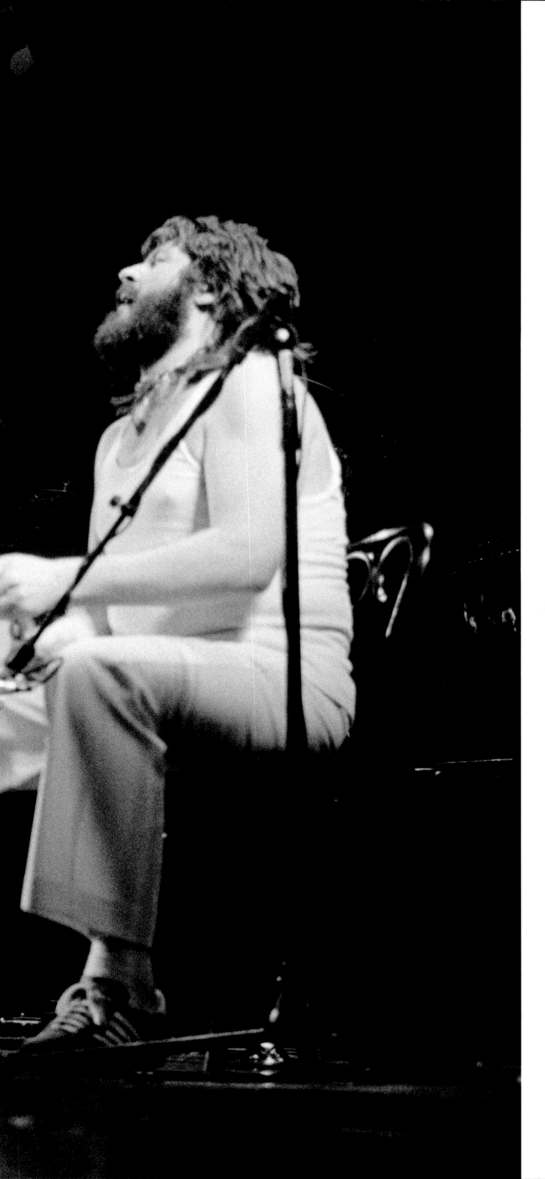

"The Rain or Shine concert of course tempted fate. The heavens opened and with so much electrical equipment on stage they had to call off the show after 20 minutes. There was a riot"

LED ZEPPELIN

In 1977 there wasn't a bigger band in the world than Led Zeppelin. Jimmy Page's guitar, rooted in blues, gave them this label of being the first heavy-metal band. The truth is they were much better and bigger than that, with an amazing repertoire — from rock to folk.

Jimmy formed the band. He'd been a really hot young session musician since the early Sixties and he'd joined The Yardbirds with Jeff Beck after Eric Clapton left. That band spurred the careers of three of the greatest guitarists of all time, but eventually it was only Jimmy. Jeff was sacked for failing to turn up to gigs and Jimmy renamed the band Led Zeppelin when he recruited Robert Plant.

They'd started out around 1968 and within five years they were the biggest draw in the world, outselling even The Rolling Stones. They worked so hard, they were always on tour, building their audience loyalty. By the time I photographed them in Tampa, Florida, in 1977, the cracks were beginning to show. More from exhaustion and burn-out I guessed, than any fall-out. There were by now a lot of problems that seemed to beset the band, not always of their own making either. They were pulling in their biggest-ever audiences for a rock concert and in Tampa the show was billed as the 'Rain or Shine' concert. Of course that tempted fate. The heavens opened and with so much electrical equipment on stage they had to call off the show after 20 minutes. There was a riot.

Most bands reach that point where something has to give — and rivalry, relationships and ambition start to pull them apart. It happened to Hendrix, to The Beatles... and it happened to Led Zeppelin in 1980 when the drummer John Bonham died having drunk himself to death. It just seemed to spell the end ∎

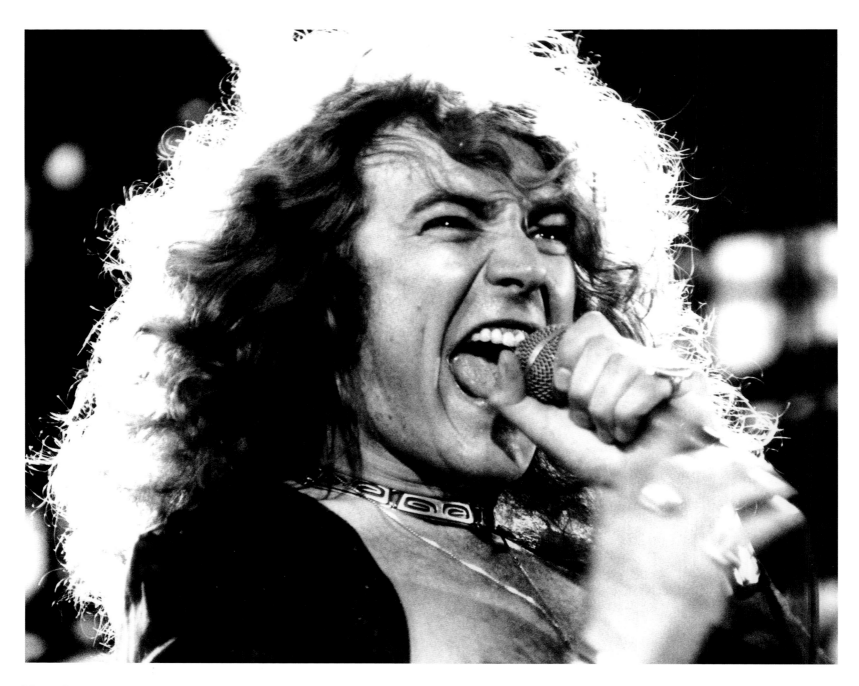

"Jimmy Page's guitar, rooted in blues,
gave them this label of being the first
heavy-metal band," says Terry

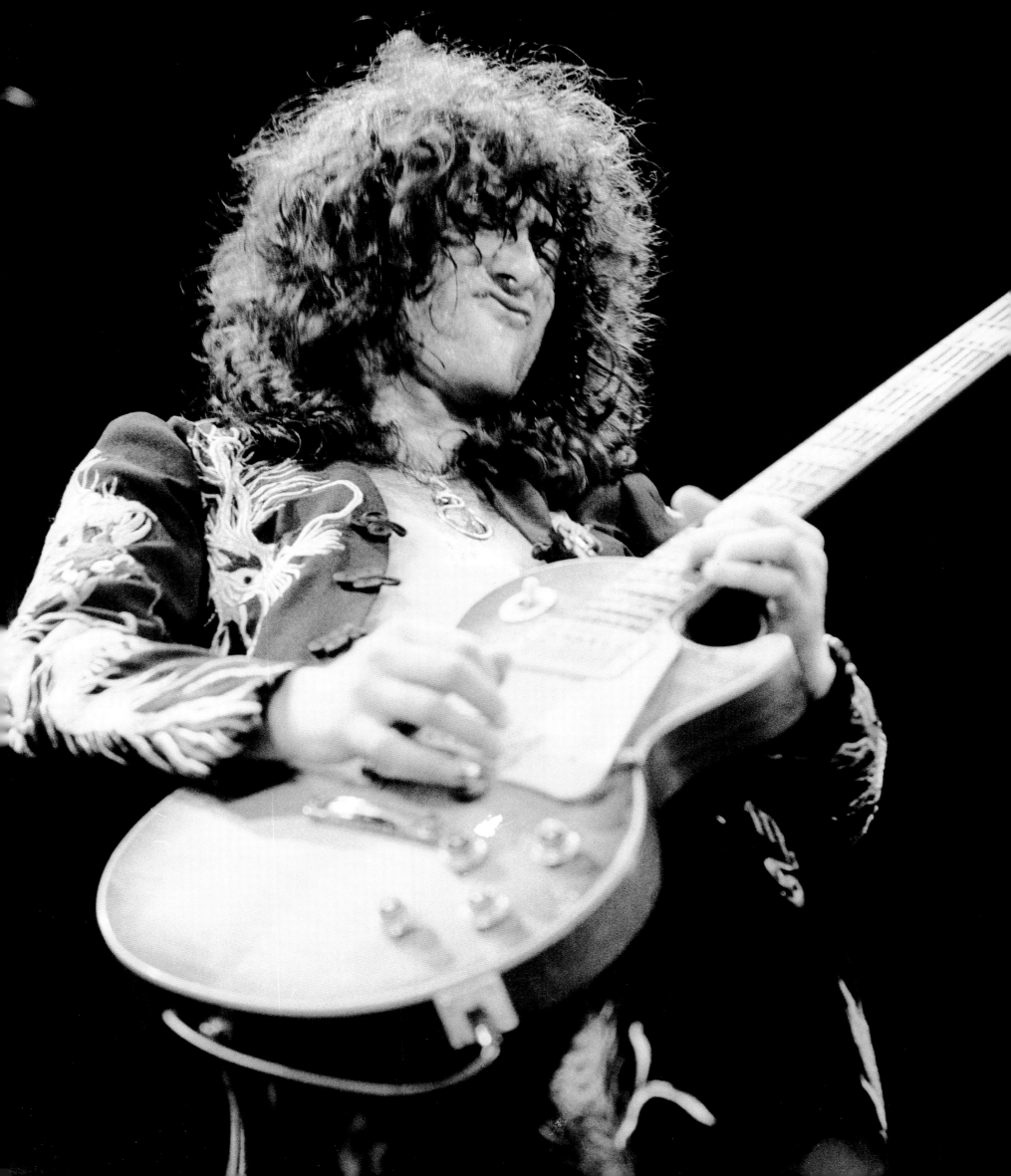

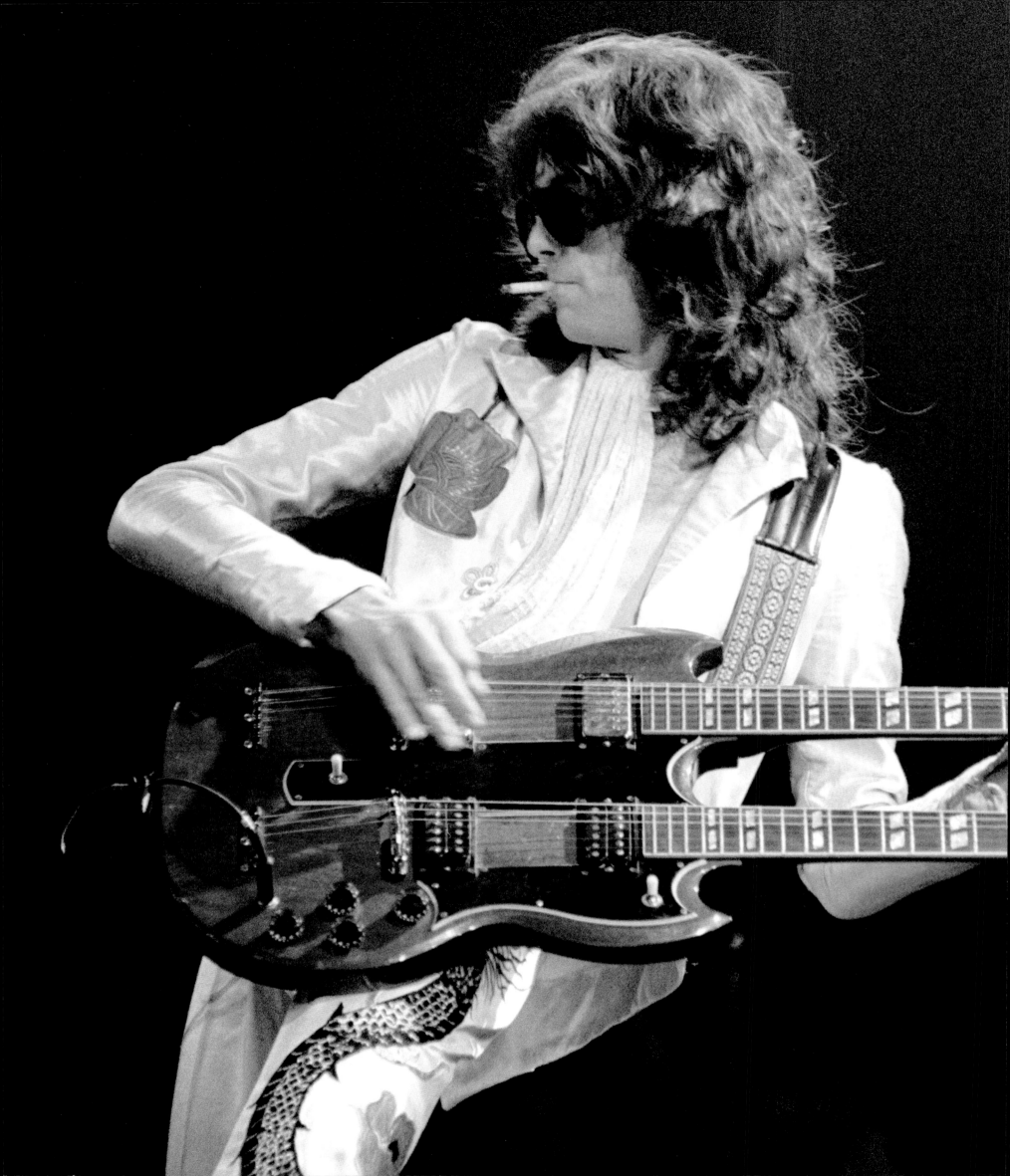

"*Most bands reach that point where something has to give — and rivalry, relationships and ambition start to pull them apart. It happened to Led Zeppelin in 1980 when the drummer John Bonham drunk himself to death*"

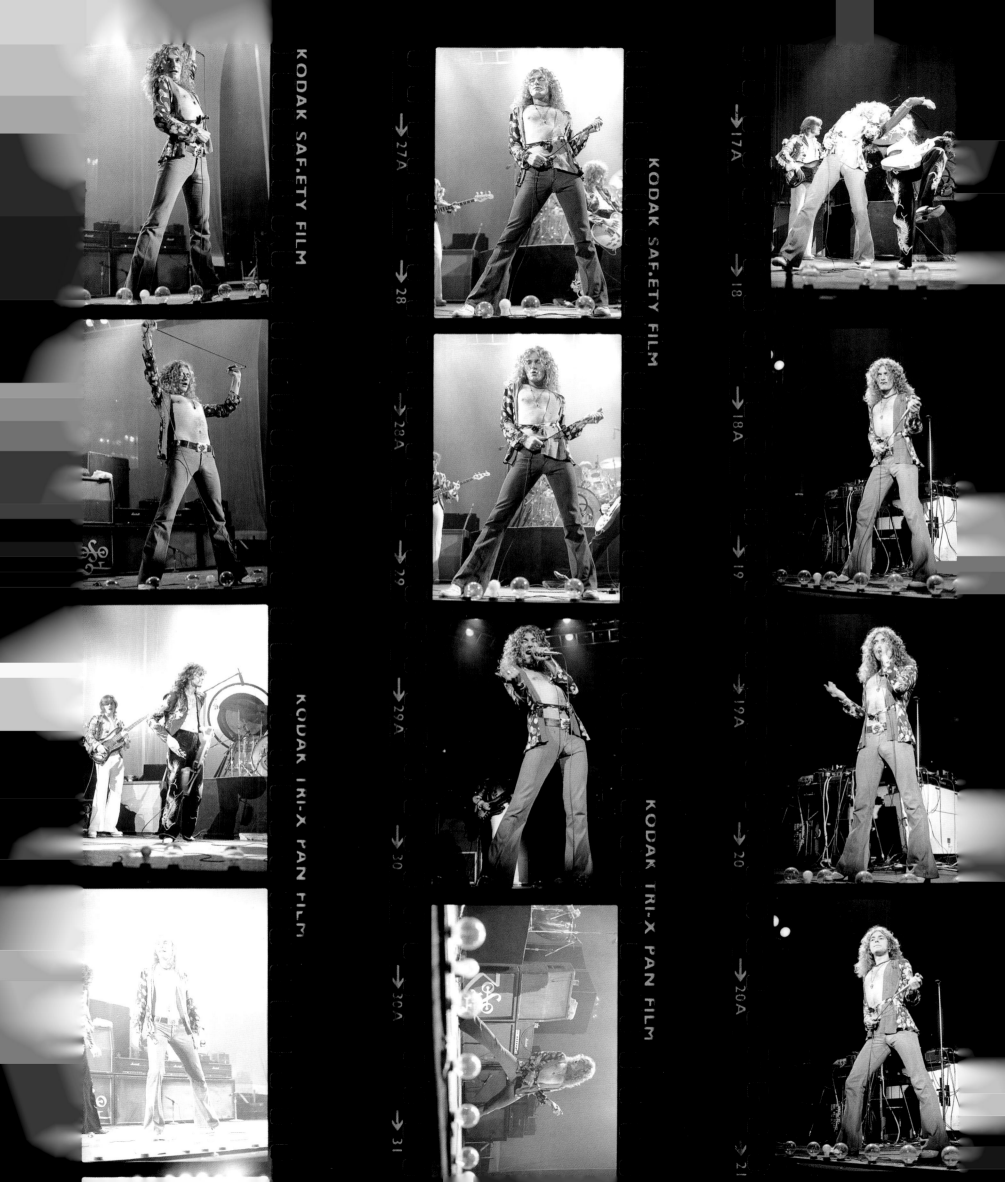

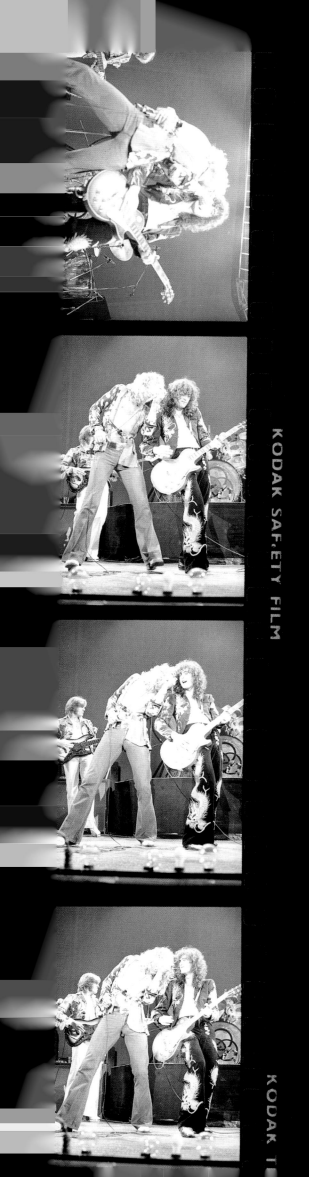
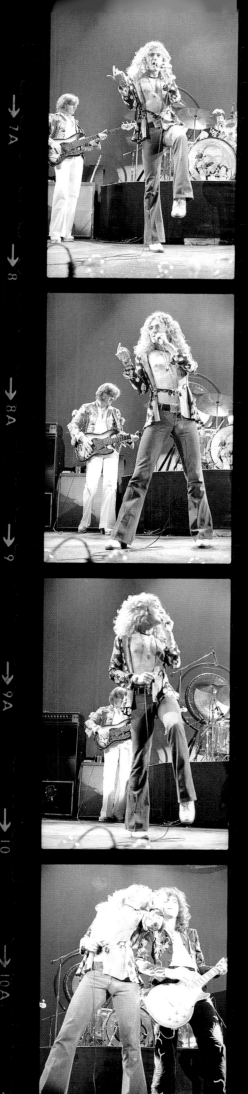

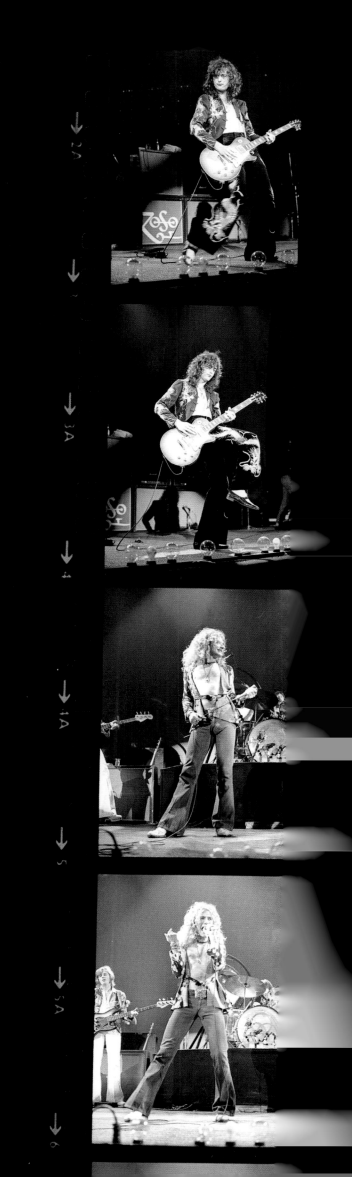

KODAK SAF.ETY FILM

KODAK SAF.ETY FILM

KODAK T

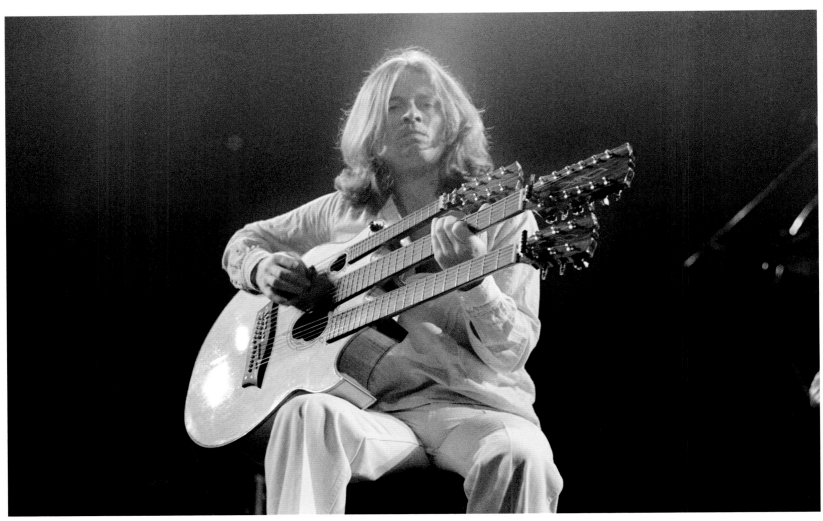

Jimmy Page rocks a three-neck guitar for a Led Zeppelin hit

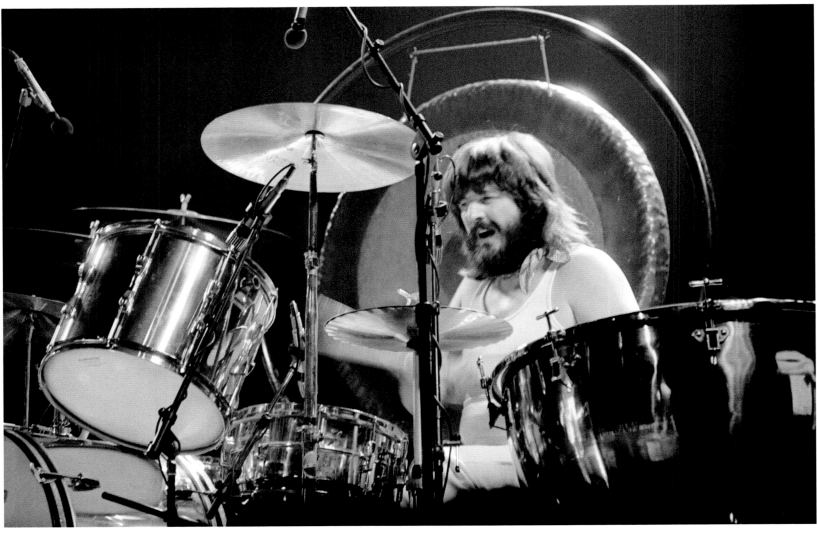

"Drumming was the only thing I was ever good at," said John Bonham

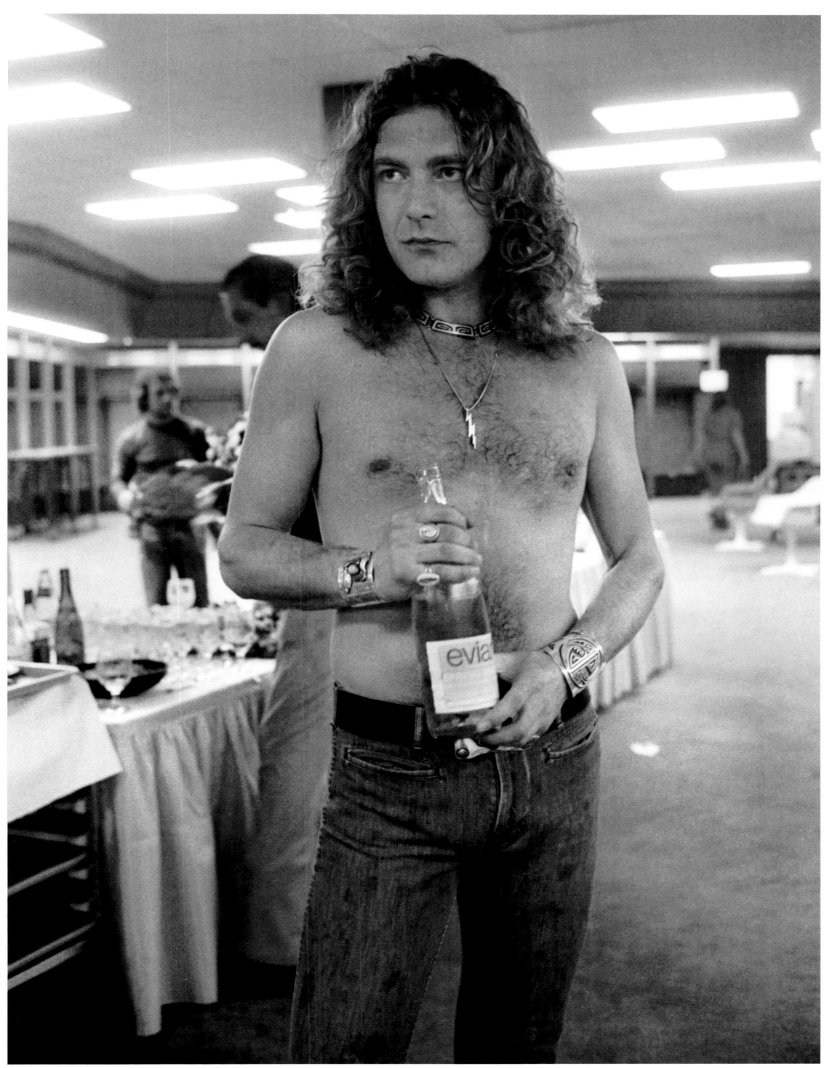

Robert Plant backstage. "They worked so hard, they were always on tour, building their audience loyalty," says Terry

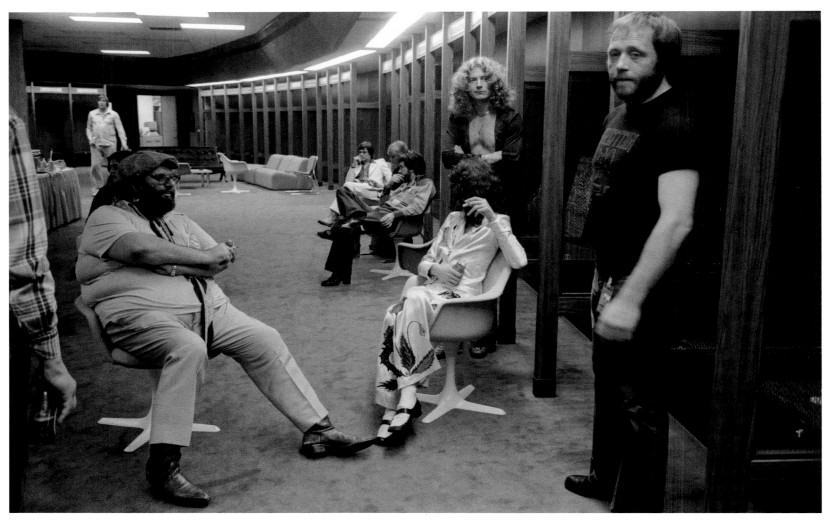

The band enjoy a few minutes of quiet backstage, but the atmosphere seems tense

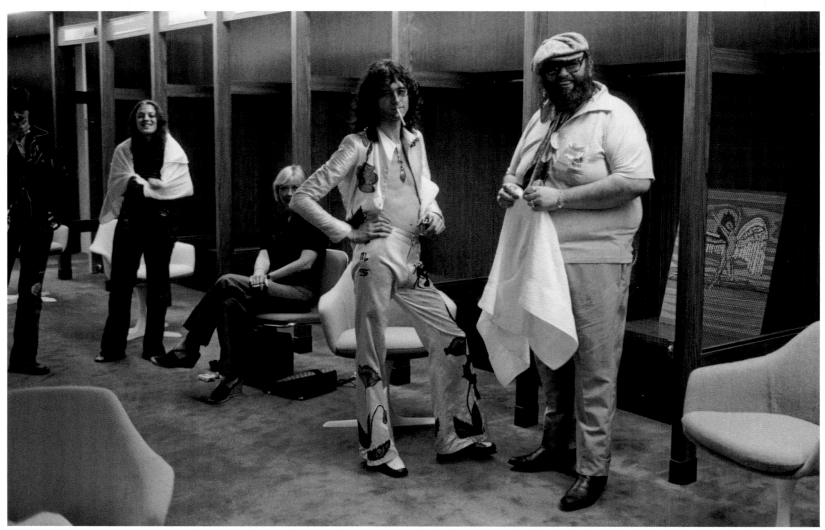

"By the time I photographed them in Tampa, Florida, in 1977, the cracks were beginning to show," remembers Terry

UNIVERSITY OF CHESTER, WARRINGTON CAMPUS

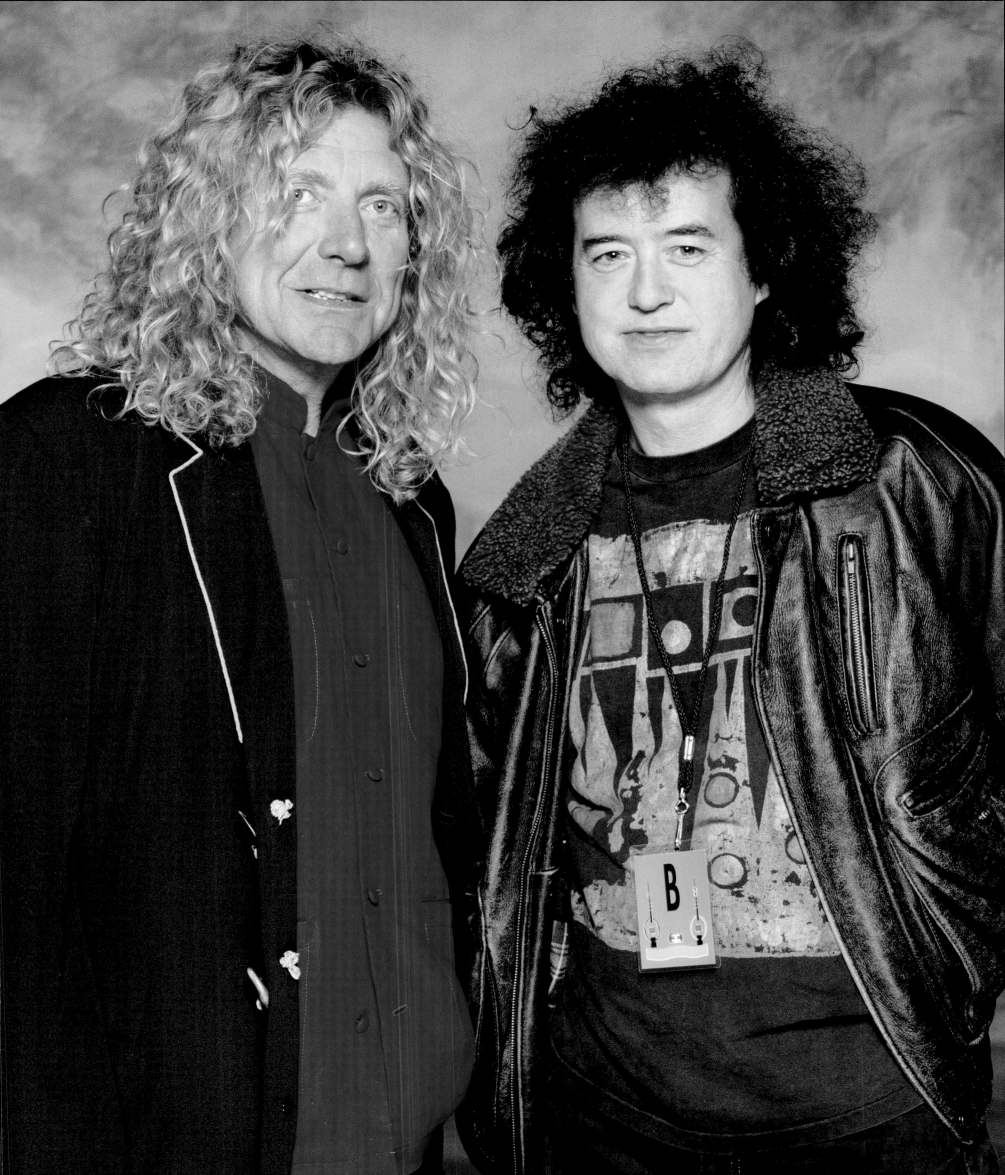

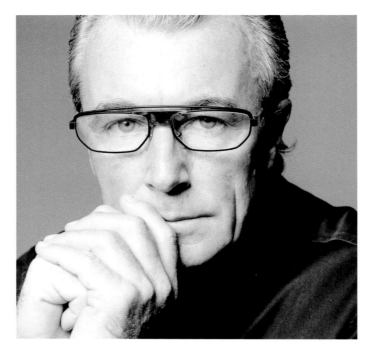

THE A-Z OF ROCK 'N' ROLL

© Terry O'Neill 2014

Sub editing by Sophie Haydock

First published 2014
World copyright reserved

ISBN 978-1-85149-772-0

British Library Cataloguing-in-Publication Data
A catalogue record for this book is available from the British Library

FSC
www.fsc.org

MIX
Paper from
responsible sources
FSC® C104723

Printed and bound in China for ACC Editions
an imprint of the Antique Collectors' Club Ltd, Woodbridge, Suffolk, UK

ACC EDITIONS